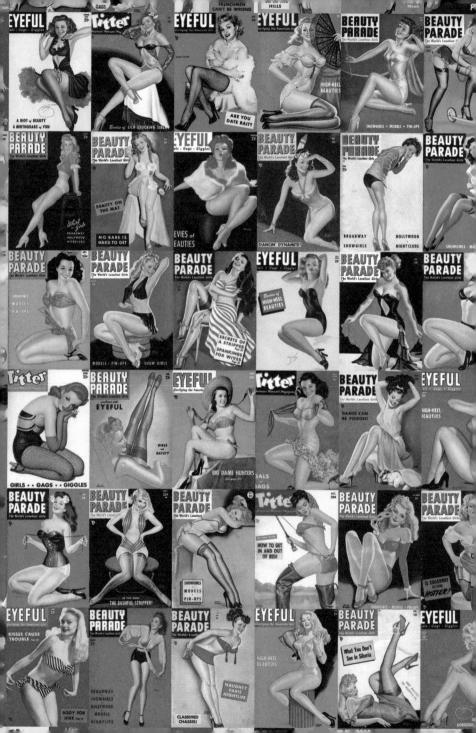

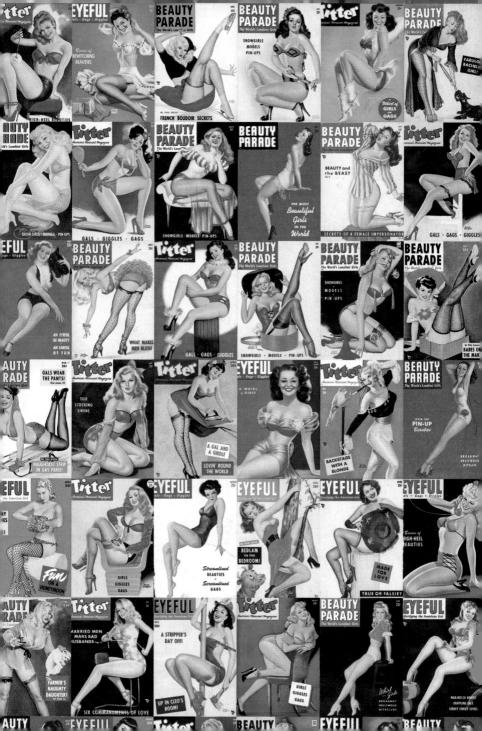

We thank Art Historians Charles G. Martignette and Louis K. Meisel for their assistance in this project.

WE WAR MONEY

THE COST VEEPS US STRIPPED

.1

© 2002 TASCHEN GmbH Hohenzollernring 53, D–50672 Köln www.taschen.com

WEWANT

MORE FOR

WEARING

Original edition: © 1997 Benedikt Taschen Verlag GmbH

Edited by Burkhard Riemschneider, Cologne

Text by Harald Hellmann, Cologne

English translation by Christian Goodden, Bungay

French translation by Catherine Henry, Nancy

Printed in Italy ISBN 3-8228-2094-6

ISBN 2-7434-4332-4 (Edition réservée pour Maxi-Livres)

Preface

When Tom Wolfe met Robert Harrison in the early 60s, the once notorious publisher was little more than an obscure nonentity. Plagued by a series of court actions, Harrison had been obliged in 1958 to sell his most successful magazine project, the scandal sheet "Confidential". Even if he was still living in the same hotel suite that he had occupied in his heyday, he now looked more like a king resigned to permanent exile. The expansive gestures were still there, and his mind was as sharp as ever, but the number of courtly attendants had dwindled to just two: his lifelong companion and his sister Helen, who had been his girl Friday for over twenty years.

People reduced in such a way tend to offset feelings of nostalgia and melancholy by boasting and exaggerating ever more wildly, so that any listener with an ounce of tact reacts with no more than an amazed "Well, I never!", biting back anything that might sound like a searching question. Harrison's bold new plans came to nothing, and he remained forever the one-time publisher of "Confidential", the mother of all scandal sheets, a magazine which in the mid-50s sometimes had a circulation of 4 million copies.

But at least "Confidential" merited a mention in a reference book: Kenneth Anger's "Hollywood Babylon", a distillation from the innumerable scandal magazines of the 50s. Anger aptly described Harrison as the epitome of the sinister figure. The depiction might lack subtlety, painting the gutter publisher blacker than he really was, but Anger could scarcely conceal his enthusiasm for this character with his sulphurous whiff of the diabolic.

Before he became the most hated man in the United States, Harrison had had another existence. In 1941 he provided an object lesson in free enterprise. A more affecting version of events would put it thus. In those days Harrison worked for Martin Quigley, the upright publisher of "Motion Picture Daily" and "Motion Picture Herald". After work the industrious Harrison stayed on in the editorial offices to single-handedly paste together his first girlie magazine, Beauty Parade. As luck would have it, the work was discovered by Quigley on – of all days – Christmas Eve. The boss rewarded Harrison for his efforts with the boot. It is a story worthy of Frank Capra. We see the jobless Harrison wandering through New York's night-time streets, protected against the biting wind by only a thin coat, but warmed by a belief in his mission – and a pile of pin-up magazines pressed to his breast.

But Harrison equally well might have sat quite undramatically with his friend, the pin-up artist Earl Moran, at home in his small two-room apartment, pondering how they could cash in on the current craze for pin-ups. Their idea of a magazine which not only showed pin-ups, but also ran two- to four-page humorous photostories was something new and proved a gold mine. The term 'photostories' makes the idea sound more impressive than it actually was. In fact even the most banal theme sufficed to have scantily clad girls capering through comic slapstick situations. Who would have thought that the attempt to move a carpet could lead to so many provocative poses? Because other publishers did not want to follow him into this new territory, Harrison now cleaned up under the motto "Girls, Gags & Giggles". In rapid succession he brought out a series of titles, all following much the same formula, with names such as Titter (America's Merriest Magazine), Wink, Flirt and Eyeful (Glorifying the American Girl).

Eye-catching covers, painted for Harrison by Peter Driben, Earl Morgan or Billy De Vorrs, ensured that the customer could not fail to see the titles at the kiosk. They showed classic pin-ups mostly against a garish background. Driben, Moran and De Vorrs rank among the finest and most acclaimed illustrators of the pin-up era. But they come from a background more respectable than that of their employer Harrison. Except for the self-taught De Vorrs, they had all been through art college – Driben had even studied in Paris – and they were experienced in the fields of calendar art and advertising. In a word, their fresh, tasteful, "clean" pin-up illustrations satisfied all aesthetic standards. And, of course, the cultural critics, waving their Titter or Wink or whatever, have long since seized on these covers, hailing them as "Art!". However, it is only the title illustrations which have been exalted in this way. The magazines themselves many art aficionados would rather see firmly closed. Why? When it came to the contents of his magazines, Harrison largely took his cue from the tradition of American burlesque – the poorer disreputable relation, so to speak, of vaudeville theatre. The language of the titles was earthier than their tasteful presentation led one to expect.

What in the Old World was originally intended to be a literary parody, a deliberately vulgar farce that made a laughing stock of great and sublime theatrical works, underwent a decisive change in the United States at the end of the 19th century. A key player in this transmission was an English woman named Lydia Thompson, the world's first peroxide blonde. In 1869, at the invitation of P.T. Barnum, she made a guest appearance in the USA with her troupe, the British Blondes. Going beyond the pale was the business of the burlesque, but the British Blondes actually wore pantyhose. In a world where the mere sight of a naked female ankle could drive men to distraction, this was a bold step. But it was a sign of the times, and around 1870 New York stages began putting on burlesque shows which were less parodies of other theatrical productions and more an occasion for showing the female figure in a favourable light. Any suggestions along these lines were gratefully incorporated. For instance, no sooner had the Syrian dancer Fahreda Mahzar, known as Little Egypt, presented her "Egyptian" dance in 1893 at the world exhibition in Chicago than every burlesque show had its own Little Egypt questionably gyrating her hips.

The burlesque shows adopted vaudeville's variety format, transforming themselves into colourful number revues with song and dance routines, sketches, jugglers, acrobats, animal training and above all sex. Their comedy was coarse and bawdy, the jokes smutty, the parodies grotesque. Finally, in the 20th century, when film and later TV began to compete with traditional forms of entertainment, striptease became the dominant element. Indeed, towards the end of the 19th century variety shows had already opened the door to the medium that was to bring about their decline – they started including short films in their programmes. When Harrison founded his girlie-magazine empire, the days of burlesque were numbered. The Second World War helped it stage a last comeback. A whole series of burlesque revue films were even made then: Evelyn West, who had insured her bosom with Lloyd's of London, appeared in "A Night at the Follies", Ann Corio in "The Sultan's Daughter" and in "Call of the Jungle".

"Striporama" saw an array of burlesque stars assemble once more, before they joined the queues for the soup kitchens. In the film "Striporama", produced in 1953 in New York by the Venus Productions Corporation, they all strut their stuff one last time in this rambling and absurd framework story: the great Lili St. Cyr; Rosita Royce who was aided in her stripping by specially trained doves; Georgia Sothern, who had become celebrated for her scandalous appearances in Minsky's Burlesque Theatre; Betty Page appears in sketches with comedians such as Jack Diamond, Mandy Kay and Charles Harris; and for the ladies there was he-man Mr America, who played the harmonica with a belle on his shoulders.

It is precisely this combination of sex and humour that Robert Harrison's magazines went in for, a kind of burlesque show for beneath the pillow. Now and again the titles even alluded to their own roots with pictures of the burlesque queens of the previous century. In many of the comic picture stories the models appear cheek by jowl with burlesque funnymen, who have either been taken from the ranks of venerable revue stars or are simply men decked out in the working garb of the burlesque comic - buffoons in baggy trousers and checker jackets with monster moustaches. Today this kind of humour, which was to have a remarkably long afterlife in the porn film, is found only in dirty postcards at obscure seaside resorts, at least in its printed form. Around his photofeatures Harrison arranged legions of cheesecake models in underwear, bikinis or saucy stage costumes, or he revealed showgirls in their dressing rooms (but of course never actually naked - that was better left to the nudist magazines or "art" books). He also introduced - and this without doubt contributed in no small measure to his success - a strong fetishistic interest, an idea said to have come from a particularly well-read lady editor who knew the works of Krafft-Ebing. Now scarcely an issue went by without a model brandishing a whip, long hair is à la mode, girls wrestle with one another or sport boxing gloves, and a delicate Eve Rydell, whose dastardly master has bound her in chains, is being offered for sale

in an oriental bazaar. A notorious workaholic, Harrison frequently insisted on appearing on his own photosets, regularly turning up in the photofeatures if the story permitted. It is hard to imagine that this man, so unprepossessing in the photos but evidently agreeable to any piece of tomfoolery, was destined to become the publisher of the most infamous scandal magazine.

Harrison was able to select his models from the hoards of strippers, showgirls and cheesecake models who were drawn to New York. Most of them could be grateful if at least their pseudonyms or stage names were mentioned in a caption, and only a few ever achieved any degree of celebrity. Even fewer became stars, such as Betty Page, who started appearing in Harrison's magazines in 1951, rapidly becoming one of the most popular models. But the many anonymous models also paraded through the pages as capable, if sometimes rather silly girls. They were always self-possessed and independent and often the superior half where they shared a picture with a male counterpart. And they were prepared to be photographed in poses which, a couple of years later, no one would be seen dead in. Nowadays it is tempting to laugh at the naivety of these stories or even to find them grotesque. But shining through it all is something the model Jonnie Wilson describes in "Betty Page's Annual" when she talks about working with Harrison: she was having the time of her life.

The greasy male figures accompanying the girls in the photos seem to suggest a readership which wants to be reminded as little as possible that elsewhere in the universe there might be handsome, articulate and distinguished men, clothed in well-cut suits. Were one to ask Harrison's advertisers what kind of person typically read the magazines, they would paint a picture of a small, balding, pot-bellied, spotty-faced man who watched from the sidelines at parties. His inadequacy vis-à-vis the opposite sex he would try to remedy by reading books promising "100 successful chat-up lines" or "how to pick up more girls". He was always short of money, a potential victim for any seedy loan shark, but still had enough to buy a magazine to help him through his lonely hours. And certainly the publishers of specialist sex books such as Dr E. Podolsky's "Modern Sex Manual" (for married couples only, of course) thought it well worth devoting a whole-page advertisement to Harrison's clientele. During the war years the magazines also touted "I Was Hitler's Doctor" by Dr Kurt Krüger, an ex-Nazi – so the reader is constantly reminded – who was (reputedly) Hitler's long-time psychiatrist. The advertisement shows a blubbering Führer pouring out appalling confessions to an incorruptible Dr Krüger, lurking pen-in-hand in the background.

But first and foremost, of course, Harrison's readers were interested in matters sexual. They dreamed of randy girls and hungry thighs. It was a dream that Irving Klaw, the king of the pin-up and one of Harrison's most loyal advertisers, also sought to cater for. In the advertisement sections of Harrison's magazines with their countless mail-order pin-ups, archaeologists of the dark side of popular culture will unearth a veritable Pompeii of sleaze.

Harrison's wildest title was undoubtedly Whisper. A child of the postwar years, this first hit the kiosks in April 1946. Its cover was regularly graced by one of Peter Driben's innumerable pin-up beauties, seen, appropriately enough, through a keyhole. During the 50s the cover illustrations of Whisper were replaced by the pin-up photo, before the whole magazine was visually brought into line with "Confidential", launched in 1952. Whisper, aimed at the adventurous hard-boiled reader, was wild, hard and dirty, serving up a diet of strong stories about bad girls, sex-starved Foreign Legionnaires, horrific murders, the bizarre rites of weird indigenous tribes, and hard-hitting photoreports on street crime. The world as a madhouse. Fittingly, Whisper also featured, among the usual goods on offer, a full-page advertisement for low-cost gravestones with genuine "down-to-earth savings"!

Whisper also dished up the very latest scandals of the type "Gas station rip-off!" or "Mysterious book losses in public libraries!", berating those responsible with the same journalistic indignation as if they had committed some horrendous massacre or unspeakably perverse act.

And Whisper grew ever dirtier, because Robert Harrison had realized that in the fifties the golden age of his girlie magazines was over. Other "more serious" modern titles had meanwhile established themselves on the market which allowed neither burlesque humour nor "smutty" advertisements between their covers. No matter whether they catered for the adventurous actionhungry reader, as did Georg von Rosen's "Modern Man", or for the well-heeled cultivated city-dweller, like Hugh Hefner's "Playboy", they all sought to attract well-known writers as well as the best cartoonists and photographers. The likes of Harlan Ellison, Allen Ginsberg, Jack Kerouac and James T. Farrell now wrote for these new-style men's magazines, and no longer the inky-fingered small-time hacks who littered Harrison's texts and captions with corny jokes. If you bought one of these modern titles, you could be sure that the lion's share of the budget and most of the care had not been lavished solely on the cover.

Evidently Harrison had no desire to fight for a market share on this battleground. Early 1955 he sold off his by now quaint-looking girlie magazines and devoted his whole energy to becoming denounced and ostracized.

In 1952 Whisper had received support from "Confidential", which had been conceived as a scandal magazine from the outset. The senate investigations into organized crime are supposed to have pointed Harrison down this new, potentially lucrative avenue. More precisely, it was the fact that the hearings of the investigative committee had been broadcast on TV and had notched up unbelievable viewing figures, making committee chairman Senator Estes Kefauver of Tennessee a media star overnight. While his colleague McCarthy was pursuing putative "pied pipers of the Politburo", Kefauver was turning up the heat, with cameras running, on mobster bosses such as Frank Costello or Meyer Lansky and transforming more than America's political culture with his conspiracy theories. Some years later he was seen once more heading another senate committee, this time looking into the causes of juvenile crime, where one of his victims was none other than Irving Klaw. The most famous portrait of Kefauver shows him in a racoon-skin cap – perhaps he too was a casualty of the Davie Crocket mania of 1954, started by the TV programme "Disneyland".

It would be nice if one could say that the medium which had spoilt Harrison's burlesque fun had in the process given him the idea for the most successful magazine project of the decade. And perhaps Harrison only came to interpret events this way subsequently. For the tricks which Whisper and "Confidential" employed, and even perfected, he had already learned at the start of his career, as an errand boy working for New York's "Daily Graphic". This scandal sheet of the 20s and 30s thought nothing of shamelessly inventing stories, embroidering on the truth, fabricating intimate confessions, and manipulating photographs. It was hardly likely that Harrison would come away from such an apprenticeship without something of these scams rubbing off on him.

They say that a fool is born every minute, but one would have to be extraordinarily gullible not to see that the comely damsel who in Whisper is just being overpowered by dastardly slave-traders, or the stripper in a negligee who has been abducted by brutal Soviets and is forced now to stand in a basin of icy water, only got into their hapless situations through scissors and paste. Just as with contemporary reveal-all magazines, no doubt much of the perusing pleasure derives from the fact that the reader recognizes the phony set-up, even expects it, and enjoys the impudence of the fraud. However, this mechanism does not work as soon as Jesus, Elvis or some prominent person is involved. And precisely this soon became the stock-in-trade of Whisper and "Confidential": to sling mud at any public figure. Unlike many rival magazines, which happily lifted stories from each other, Harrison maintained a network of snoopers, informants and scouts, and dashed with his characteristic energy to conspiratorial meetings, where he did in fact unearth real scandals. And if that produced no results, he blew up trivialities into sensations. In Harrison's case, however, the healthy survival instinct which ensures that such reports are watertight fell by the wayside, so carried away was he by the euphoria of having made "Confidential" the best-selling title in the United States. In 1957 he faced a flood of lawsuits and a year later sold his two scandal sheets. In the hands of various different publishers Whisper and "Confidential" continued to appear, albeit in a more modest guise, until the early 70s.

Harrison subsequently tried his hand at so-called "one-shots", special single-issue magazines devoted to the star or scandal of the moment, and a new scandal sheet which brought less success.

Einleitung

Als Tom Wolfe Anfang der 60er Jahre Robert Harrison begegnete, war der einstmals so berüchtigte Verleger eine schon fast vergessene Größe. Nachdem er mit einer Unzahl von Prozessen überzogen worden war, hatte Harrison 1958 sein erfolgreichstes Magazin, das Skandalblatt "Confidential", verkaufen müssen. Obwohl er noch in derselben Hotelsuite residierte, die er schon zu seiner Glanzzeit bewohnt hatte, wirkte er eher wie ein Monarch im Exil ohne jede Hoffnung auf Rückkehr. Die großen Gesten waren noch da, seine legendäre Agilität war ungebrochen, aber es antwortete nur noch ein bescheidener Hofstaat: seine Lebensgefährtin und seine Schwester Helen, die über zwanzig Jahre seine rechte Hand gewesen war.

Wer an so einem Tiefpunkt angelangt ist, neigt dazu, durch noch wüsteres Bramarbasieren, noch schamlosere Übertreibungen eine Mauer gegen Wehmut und Trauer zu errichten, so daß sich jeder halbwegs feinfühlige Zuhörer auf ein staunendes "Ah" und "Oh" beschränkt und sich jede kritische Nachfrage verkneift. Aus Harrisons neuen, kühnen Plänen wurde nichts Rechtes mehr und er blieb für immer der Ex-Herausgeber des "Confidential", der Mutter aller Skandalmagazine, einem Blatt, das es Mitte der 50er Jahre mit einigen Ausgaben auf 4 Millionen verkaufte Exemplare gebracht hatte. Wenigstens hat "Confidential" in ein Referenzwerk Eingang gefunden: in Kenneth Angers "Hollywood Babylon", diesem immer wieder aufgelegten Destillat aus den unzähligen Skandalmagazinen der 50er Jahre. Anger zeichnet Harrison naheliegenderweise als vorbildlich sinistren Charakter. Auch wenn er auf seiner Palette für Harrison neben Rabenschwarz und Giftgrün nur wenige Nuancen findet, kann er seine Begeisterung für diesen von dezentem Schwefelgeruch umwehten Charakter kaum verhehlen.

Vor dem Leben als meistgehaßter Mann der Vereinigten Staaten gab es noch ein anderes. 1941 schritt Harrison entschlossen ins freie Unternehmertum. Die anrührende Version lautet wie folgt: Harrison arbeitete damals für Martin Quigley, den biederen Verleger von "Motion Picture Daily" und "Motion Picture Herald". Nach Feierabend klebte der strebsame Harrison in den Redaktionsräumen eigenhändig sein erstes Girlie-Magazin, Beauty Parade, zusammen, was sein Chef ausgerechnet am Heiligabend entdeckte und mit einem Rausschmiß honorierte. Eine Geschichte wie von Frank Capra erdacht. Im dünnen Mantel nur unzureichend gegen den schneidenden Wind geschützt, sehen wir Harrison arbeitslos durchs nächtliche New York streifen, gewärmt nur vom Glauben an seine Mission und einem Stapel vor die Brust gepreßter Pin-up-Magazine.

Vielleicht saß er aber auch ganz undramatisch mit seinem Freund, dem Pin-up-Künstler Earl Moran, zu Hause in seinem kleinen Zwei-Zimmer-Appartement und sann darüber nach, wie man von der herrschenden Pin-up-Begeisterung profitieren könnte. Ihr Konzept eines Heftes, das nicht nur Pin-ups zeigte, sondern zusätzlich zwei- bis vierseitige humoristische Fotostories brachte, war ein Novum und tat eine Goldgrube auf. Fotostories klingt großartiger als es war: Tatsächlich reichte das banalste Motiv, um leichtbekleidete Mädchen durch komische, slapstickhafte Situationen kapriolen zu lassen. Wer hätte gedacht, welche aufregenden Posen ein Mädchen beim Versuch, einen Teppich zu verlegen, einnehmen kann? Weil ihm andere Verleger auf dieses Terrain nicht folgen wollten, stellte Harrison sein Leben fortan unter das Motto "Girls, Gags & Giggles" und schob in rascher Folge Titel wie Titter (America's Merriest Magazine), Wink, Flirt und Eyeful (Glorifying the American Girl) mit ähnlichem Strickmuster nach.

Dafür, daß der Kunde seine Titel am Kiosk nicht übersehen konnte, sorgten die aufdringlichen Cover, die ihm Peter Driben, Earl Moran oder Billy De Vorrs malten: klassische Pin-ups vor meist knalligem Hintergrund. Driben, Moran und De Vorrs zählen zu den besten und anerkanntesten Illustratoren der Pin-up-Ära und verweisen auf einen respektableren Hintergrund als ihr Auftraggeber Harrison. Abgesehen vom Autodidakten De Vorrs hieß das Kunstakademie – Driben hatte gar in Paris studiert –, Kalenderillustration und Werbeagenturen. Kurz gesagt: Die frischen, geschmackvollen, "sauberen" Pin-up-Illustrationen genügten allen ästhetischen Standards. Und längst sind natürlich Kulturbeflissene aufgestanden, winken mit Titter und Wink und den übrigen Magazinen und rufen lauthals "Kunst!". So nobilitiert werden allerdings nur die Titelillustrationen. Die Hefte selbst sähen viele Kunstfreunde gerne zugeklebt. Warum? Inhaltlich orientierte sich Harrison weitgehend an der Tradition der amerikanischen Burleske, die, wenn man so will, die ärmere, anrüchige Verwandte des Vaudeville war. Die Magazine sprachen eine derbere Sprache, als ihre geschmackvolle Aufmachung erwarten ließ.

Was in der Alten Welt ursprünglich eine literarische Parodie meinte, eine manchmal vulgäre Posse, die die hehren, hohen Werke im Theater der Lächerlichkeit preisgab, erlebte in den Vereinigten Staaten Ende des 19. Jahrhunderts eine entscheidende Wandlung. Maßgeblich daran beteiligt war eine stämmige Engländerin namens Lydia Thompson, die erste Wasserstoffblondine der Welt, die 1869 auf Einladung P. T. Barnums mit ihrer Truppe, den British Blondes, in den USA gastierte. Grenzüberschreitung und Normverletzung waren ja das Geschäft der Burleske, aber die British Blondes trugen Strumpfhosen. In einer Welt, in der Männer bereits beim Anblick einer unverhüllten weiblichen Fessel in Raserei verfielen, war das ein kühner Schritt. Aber dies war der neue Geist, und ab 1870 präsentierten New Yorker Bühnen Burlesque Shows, die weniger Parodien anderer Theaterproduktionen waren als vielmehr Anlaß, die weibliche Figur ins rechte Licht zu rücken. Jede Anregung in diese Richtung wurde dankbar integriert. Nachdem etwa die Syrierin Fahreda Mahzar, die als Little Egypt bekannt wurde, 1893 auf der Weltausstellung in Chicago ihren "ägyptischen" Tanz vorgeführt hatte, wartete kurz darauf jede Burlesque Show mit ihrer eigenen Little Egypt auf, die verrufen ihr Becken kreisen ließ.

Die Burlesque Shows übernahmen das Varieté-Format des Vaudeville und wurden zu einer bunten Nummernrevue mit Gesang, Tanz, Sketchen, Jongleuren, Akrobaten, Tierdressuren und vor allem Sex. Ihre Komik war derb und zotig, die Witze waren schmutzig, die Parodien wüst. Im 20. Jahrhundert, als der Film und später das Fernsehen dem traditionellen Entertainment Konkurrenz zu machen begannen, wurde schließlich der Striptease das dominierende Element. Tatsächlich hatten Varieté-Shows schon Ende des 19. Jahrhunderts dem Medium, das ihren Niedergang auslösen sollte, die Tür geöffnet und Kurzfilme ins Programm genommen. Als Harrison sein Girlie-Magazin-Imperium begründete, war der Burleske kein langes Leben mehr beschieden. Der Zweite Weltkrieg verhalf ihr zu einem letzten Comeback. Es wurde sogar eine ganze Reihe burlesker Revuefilme gedreht: Evelyn West etwa, die ihren Busen bei Lloyd's in London versichert hatte, trat in "A Night at the Follies" auf, Ann Corio in "The Sultan's Daughter" und in "Call of the Jungle". In dem 1953 in New York von der Venus Productions Corporation produzierten Film "Striporama" versammelte sich noch einmal ein Aufgebot der Stars der Burleske, bevor die Mehrzahl von ihnen vor die Suppenküchen zog. In eine skurrile Rahmenhandlung eingebettet, treten auf: die große Lili St. Cyr; Rosita Royce, die sich von ihren dressierten Tauben beim Ausziehen helfen ließ; die durch ihre skandalösen Auftritte in Minsky's Burlesque Theaters berühmt gewordene Georgia Sothern; Betty Page erscheint in Sketchen mit Komikern wie Jack Diamond, Mandy Kay und Charles Harris, und für die Damen gab es den muskelbepackten Mr. America, der mit einer Schönen auf den Schultern Harmonika spielt. Auf genau diese Kombination von Sex und Komik setzten auch die Magazine Robert Harrisons, eine Art Burlesque Show für unter das Kopfkissen. Gelegentlich verwies man gar mit den Aufnahmen legendärer Burlesque-Queens des vergangenen Jahrhunderts auf die eigenen Wurzeln. In vielen der komischen Bildergeschichten treten neben den Models Komiker der Burleske auf, entweder aus den Reihen altehrwürdiger Revuestars oder einfach Männer, die man in die Dienstkleidung des burlesken Komikers gesteckt hat: Hanswurste in sackartigen Hosen und grobkarierten Jacketts mit gigantischen Schnurrbärten. Diese Form des Humors, der im Sexfilm erstaunlich lange überleben sollte, ist im Printbereich nur noch auf Postkartenständern besonders entlegener Ausflugslokale zu finden. Um seine Fotofeatures arrangierte Harrison zahllose Cheesecake-Models in Unterwäsche, in Badeanzügen oder verwegenen Bühnenkostümen, oder er zeigte Showgirls in der Garderobe (natürlich niemals wirklich nackt, da hielt man sich besser an Nudistenmagazine oder "Kunst"-Bücher), und – und dies hat sicherlich nicht unwesentlich zu seinem Erfolg beigetragen – ein breites Spektrum an Fetischmaterial. Es heißt, Harrison sei hier der Anregung einer ungewöhnlich belesenen und mit Krafft-Ebing vertrauten Redakteurin gefolgt. So kommt dann bald kaum ein Heft ohne Model mit Peitsche aus, das Hohelied langer Haare wird angestimmt,

Mädchen ringen miteinander oder schwingen Boxhandschuhe, und eine zarte Eve Rydell, die ihr ruchloser Herr in Ketten gelegt hat, wird auf einem orientalischen Basar angeboten. Als notorischer Workaholic ließ Harrison es sich nicht nehmen, regelmäßig auf den Fotosets zu erscheinen und, wenn die Geschichte es anbot, selbst eine Rolle in der Geschichte zu übernehmen. Es fällt schwer, sich bei diesem auf den Fotos so durchschnittlich aussehenden, aber offensichtlich zu jeder Albernheit bereiten Mann den späteren Herausgeber des berüchtigsten Skandalmagazins vorzustellen. Seine Models konnte Harrison aus dem großen Heer der Stripperinnen, Showgirls und Cheesecake-Models, die es nach New York getrieben hatte, wählen. Die meisten konnten dankbar sein, wenn ihnen eine Bildunterschrift wenigstens einen Künstlernamen verlieh, und nur wenige erlangten jemals einen größeren Bekanntheitsgrad. Noch weniger wurden zum Star, wie Betty Page, die ab 1951 in Harrisons Magazinen zu sehen war und bald zu einem der beliebtesten Models wurde. Aber auch die vielen Namenlosen erscheinen als patente, manchmal etwas tölpelhafte Mädchen, jedoch immer selbständig und entschlossen und in den Situationen, in denen ihnen die Regie einen männlichen Mitspieler ins Bild stellte, regelmäßig als der überlegene Part. Und sie waren bereit, sich in Posen fotografieren zu lassen, in denen sich ein paar Jahre später niemand mehr hätte tot erwischen lassen. Heute ist man versucht, über die Naivität dieser Geschichten zu lachen oder sie gar grotesk zu finden. Aber es scheint durch, was das Model Jonnie Wilson, im "Betty Page's Annual" zur Arbeit mit Harrison befragt, beteuerte: Sie habe den Spaß ihres Lebens dabei gehabt.

Die schmierigen Männergestalten, die den Mädchen auf den Fotos zur Seite gestellt wurden, lassen das Selbstbild einer Käuferschicht erahnen, die zweifellos so selten wie möglich an die deprimierende Tatsache erinnert werden wollte, daß es anderenorts in diesem Universum attraktive, redegewandte und edle Männer geben könnte, die gutgeschnittene Anzüge tragen. Würde man den Anzeigenkunden fragen, wie er die Leserschaft einschätzt, so würde er ein Bild zeichnen von einem kleinwüchsigen, von Pickeln übersäten Mann, der auf Parties einsam in der Ecke steht und zusieht, wie sein letztes Kopfhaar auf seinem Spitzbauch landet. Soziale Kontakte, an denen es ihm entschieden mangelt, versucht er durch aus Handbüchern angelesene Witze und Anekdoten zu erzwingen. Notorisch knapp bei Kasse und daher empfänglich für jedes fadenscheinige Versprechen auf schnellen Reichtum, hat er immerhin noch das Geld, sich durch Lektüre über einsame Stunden hinweg zu trösten.

So war Harrisons Klientel den Verlegern sexualkundlicher Fachbücher wie Dr. E. Podolsky "Modern Sex Manual" (selbstverständlich für verheiratete Paare) durchaus eine ganzseitige Anzeige wert. Zu den skurrileren Werken zählt da sicher "I was Hitler's Doctor" von Dr. Kurt Krüger, "Ex-Nazi und langjährigem Psychiater Hitlers", das während der Kriegsjahre beharrlich beworben wurde. Die Anzeige zeigt Hitler, wie er kläglich flennend dem im Hintergrund lauernden, unbestechlichen Dr. Krüger schreckliche Geständnisse ins Psychiaterhandbuch diktiert.

In erster Linie aber loderte in Harrisons Leser natürlich die durch ehehygienische Bedenken kaum abgeschwächte Flamme sexueller Begierde. Auf seine Träume von lockeren Schenkeln und Mädchen mit hoher Fallgeschwindigkeit setzte auch Irving Klaw, der König des Pin-ups, als einer der treuesten Inserenten in Harrisons Magazinen. Archäologen auf der Nachtseite der Populärkultur finden im Anzeigenteil mit seinen zahlreichen Pin-up-Mailordern ein wahres Pompeji des Sleazes.

Das Wildeste unter Harrisons Heften war sicherlich Whisper, ein Nachkriegskind, das im April 1946 zum ersten Mal an die Kioske kam. Auf dem Cover war regelmäßig eine der zahllosen von Peter Driben gemalten Pin-up-Schönheiten abgebildet, sinnigerweise durchs Schlüsselloch gesehen. In den 50er Jahren wurden die Illustrationen erst durch Pin-up-Fotos ersetzt, und schließlich paßte sich Whisper auch optisch dem 1952 gestarteten "Confidential" an.

Whisper visierte den abenteuerlustigen, abgebrühten Leser an, war wild, hart und schmutzig und wartete mit wüsten Geschichten über böse Mädchen, sexhungrige Fremdenlegionäre, grausame Mordfälle, bizarre Riten seltsamer Eingeborenenstämme und rüden Fotoberichten über Straßenkriminalität auf: die ganze Welt ein Tollhaus. Passenderweise findet sich in Whisper neben den vertrauten Annoncen auch eine ganzseitige Anzeige, die mit echten "Downto-earth savings" besonders günstige Grabsteine bewarb.

Zum Stil von Whisper gehörte es aber auch, brandheiße Skandale wie "Betrügen uns Tankwarte beim Ölwechsel?" oder "Skandalöse Bücherdiebstähle in öffentlichen Bibliotheken!" mit der gleichen journalistischen Empörung zu geißeln wie gräßliche Massaker und unglaubliche Perversitäten.

Und Whisper wurde immer schmutziger, denn Robert Harrison hatte erkannt, daß die goldene Zeit für seine klassischen Girlie-Magazine in den 50ern endgültig vorbei war. Längst hatten sich "seriösere" moderne Magazine auf dem Markt etabliert, die weder den burlesken Humor noch die "schmutzigen" Anzeigen in ihren Heften zuließen. Ob sie sich nun wie etwa Georg von Rosens "Modern Man" an den abenteuerlustigen, actionhungrigen Leser richteten oder wie Hugh Hefners "Playboy" an den solventen, kultivierten Städter, sie alle bemühten sich um namhafte Autoren und die besten Karikaturisten und Fotografen. Für die modernen Männermagazine schrieben Leute wie Harlan Ellison, Allen Ginsberg, Jack Kerouac, James T. Farrell und nicht mehr die keinen Kalauer auslassenden Sensationsschreiber, die mit tintigen Fingern Bildunterschriften für Harrison ersannen. Wenn man eines dieser modernen Hefte erwarb, konnte man gewiß sein, daß die größte Sorgfalt und der größte Teil des Etats nicht allein für das Cover verwandt worden waren.

Harrison wollte sich offensichtlich nicht auf diesen Kampfplatz um Marktanteile begeben. Anfang 1955 stieß er seine mittlerweile antiquiert wirkenden Girlie Magazines ab und konzentrierte sich voller Elan darauf, geächtet und gebrandmarkt zu werden.

1952 hatte Whisper Unterstützung von "Confidential" erhalten, das von Anfang an als Skandalmagazin konzipiert war. Die Senatsuntersuchungen zum organisierten Verbrechen sollen Harrison diesen neuen, gewinnversprechenden Weg gewiesen haben. Genauer gesagt, die Tatsache, daß die Anhörungen des Untersuchungsausschusses (zum organisierten Verbrechen) im Fernsehen übertragen wurden, unglaubliche Einschaltquoten erreichten und ihren Vorsitzenden, Senator Estes Kefauver aus Tennessee, über Nacht zum Medienstar machten. Während sein Kollege McCarthy vermeintlichen "Pied Pipers of the Politburo" nachstellte, nahm Kefauver vor laufender Kamera Gangstergrößen wie Frank Costello oder Meyer Lansky ins Gebet und veränderte mit seinen Verschwörungstheorien mehr als nur die politische Kultur in Amerika. Einige Jahre später sah man ihn erneut an der Spitze eines Senatsausschusses, diesmal ging es um die Ursachen der Jugendkriminalität, und eines seiner Opfer sollte Irving Klaw werden. Das berühmteste Porträt von Kefauver zeigt ihn unter einer Waschbärenmütze, vielleicht war auch er ein Opfer der durch die TV-Sendung "Disneyland" ausgelösten Davie-Crocket-Manie des Jahres 1954 geworden.

Es wäre ja nur recht und billig, wenn das Medium, das Harrison den burlesken Spaß verdorben hatte, ihm so den Anstoß zu dem erfolgreichsten Magazinprojekt des Jahrzehnts gegeben hätte. Vielleicht hat es sich Harrison auch nur im nachhinein so zurechtgelegt. Denn die Praktiken, die Whisper und "Confidential" anwandten und vielleicht perfektionierten, hatte er schon zu Beginn seiner Karriere im Zeitungswesen kennengelernt, als Laufbursche beim New Yorker "Daily Graphic": einem Revolverblatt der 20er und 30er Jahre, in dem das dreiste Erfinden von Geschichten, das "Wahrlügen", das Türken intimer Geständnisse und das Fälschen von Fotografien zur täglichen Routine gehörten. Kaum wahrscheinlich, daß Harrison das vergessen hätte.

Sicherlich ist die Welt nicht knapp versorgt mit Narren, aber man muß schon außergewöhnlich leichtgläubig sein, um nicht zu erkennen, daß die Schöne, die in Whisper gerade von schurkischen Sklavenjägern übermannt wird, oder die Stripperin im Negligé, die von brutalen Sowjets entführt wurde und nun in einer Schüssel mit Eiswasser stehen muß, nur durch Schere und Klebstoff in diese mißliche Lage geraten sind. Wie bei den modernen Enthüllungszeitschriften dürfte ein Großteil des Lesespaßes daher rühren, daß man den Schwindel erkennt, ja voraussetzt, und sich über die Frechheit der Lüge amüsiert. Allerdings greift dieser Mechanismus nicht, sobald Jesus, Elvis oder irgendein auch nur halbwegs Prominenter beteiligt ist. Und genau das wurde bald zum Hauptgeschäft von Whisper und "Confidential": jede Gestalt des öffentlichen Lebens mit Schmutz zu bewerfen. Anders als viele seiner Konkurrenten, die ihre Geschichten gerne voneinander abschrieben, unterhielt Harrison ein dichtes Netz von Informanten, Spitzeln und Zuträgern und eilte mit dem ihm eigenen Elan zu konspirativen Treffen, bei denen er tatsächliche Skandale ausgrub. Gelang ihm das nicht, blies er Nichtigkeiten zu Sensationen auf. Allerdings blieb der gesunde Selbsterhaltungstrieb, der dafür sorgt, daß solche Meldungen hieb- und stichfest sind, bei Harrison auf der Strecke, der sich von seinem allgemeinen Schwung und der Begeisterung, "Confidential" zum meistverkauften Heft der Vereinigten Staaten gemacht zu haben, mitreißen ließ. 1957 sah sich Harrison einer Flut von Prozessen gegenüber, und ein Jahr später verkaufte er seine beiden Skandalblätter. Unter wechselnden Verlegern überlebten Whisper und "Confidential", bescheiden geworden, noch bis Anfang der 70er Jahre.

Harrison versuchte sich danach mit sogenannten "one-shots", Sonderheften, die sich einem gerade angesagten Star oder Skandal widmeten, und wenig erfolgreich mit einem neuen Skandalblättchen.

Introduction

Lorsqu'au début des années 60, Tom Wolfe rencontra Robert Harrison, l'éditeur à la réputation jadis si sulfureuse n'était déjà plus qu'un personnage presque oublié. A la suite d'une foule de procès, Harrison avait dû se résoudre en 1958 à vendre celui de ses magazines qui avait connu le plus de succès, le journal à sensation «Confidential». Même s'il occupait toujours la même suite de l'hôtel où il résidait déjà du temps de sa splendeur, il faisait plutôt l'effet d'un monarque en exil privé de tout espoir de retour. Certes, l'ampleur du geste demeurait et sa vivacité était intacte, mais elles n'avaient plus pour auditoire qu'une cour des plus modestes, à savoir sa compagne et sa sœur Helen, qui avait été son bras droit pendant plus de vingt ans.

Quand on est descendu si bas au point de toucher le fond, on a tendance à exagérer la fanfaronnade et à aller plus loin encore dans la surenchère dans le seul but d'ériger, contre la nostalgie de la perte, un mur propre à décourager toute interrogation critique, de sorte que l'interlocuteur un tant soit peu délicat s'en tiendra à l'exclamation étonnée d'un «ah» ou d'un «oh». Quoiqu'audacieux, les nouveaux projets d'Harrison n'aboutirent pas, et il demeura pour toujours l'ancien éditeur de «Confidential», le père de tous les magazines à sensation, une publication qui au milieu des années 50 avait vendu en quelques numéros 4 millions d'exemplaires. Mais «Confidential» aura du moins pris place dans un ouvrage de référence, à savoir cette bible des innombrables magazines à sensation des années 50, et sans cesse rééditée, qu'est «Hollywood Babylon» de Kenneth Anger. Celui-ci fait d'Harrison le type même du caractère ombrageux. Mais même si, entre le noir corbeau et le vert criard, sa palette ne connaît guère de nuances, elle ne parvient qu'à peine à dissimuler l'enthousiasme que lui inspire ce personnage autour duquel flotte une légère odeur de soufre.

Avant de devenir l'homme le plus détesté des Etats-Unis, comment Harrison avait-il mené sa vie. En 1941, il s'était lancé résolument dans la libre entreprise. On peut donner de la chose une version émouvante : Harrison travaillait alors pour le brave Martin Quigley, l'éditeur de «Motion Picture Daily» et de «Motion Picture Herald». Après les heures de travail, Harrison restait dans les salles de rédaction où il s'appliquait à coller de sa propre main Beauty Parade, son premier Girlie Magazine, ce que son patron découvrit la veille même de Noël ; en guise de félicitations, celui-ci le flanqua dehors. Une histoire qui semble tout droit sortie d'un film de Frank Capra. On imagine Harrison, qu'un manteau léger protège mal du vent cinglant, errer, sans travail, dans la nuit de New York, réchauffé par sa seule foi en sa mission et une pile de magazines de pin up pressée contre sa poitrine.

Mais peut-être que, à mille lieues d'en faire un drame, il était tout simplement chez lui, dans son deux-pièces, en train de réfléchir avec son ami le dessinateur de pin up Earl Moran, à la façon dont ils pourraient tirer profit de l'engouement dont les pin up faisaient alors l'objet. Leur conception d'une publication qui non seulement montrerait des pin up, mais raconterait en photos des histoires humoristiques de deux à quatre pages, était une première qui devait leur ouvrir une mine d'or. Le terme d' «histoires en photos» est un bien grand mot : en réalité, le sujet le plus banal était prétexte à faire caracoler des filles en tenue légère dans des situations drôles, voire des gags. Qui aurait pensé qu'une fille en train d'essayer de poser un tapis pouvait prendre des poses aussi excitantes ? Comme les autres éditeurs refusaient de le suivre sur ce terrain, Harrison plaça dès lors son existence sous la bannière «Girls, Gags & Giggles» (des filles, des gags et des petits gloussements), et des titres comme Titter (America's Merriest Magazine), Wink, Flirt et Eyeful (Glorifying the American Girl), tous conçus sur le même modèle, se succédèrent à une vitesse fulgurante.

Avec les couvertures tape-à-l'œil de Peter Driben, Earl Moran ou Billy De Vorrs, qui représentaient des pin up classiques sur un fond le plus souvent très vif, Harrison pouvait être sûr que le client ne raterait pas ses titres sur les présentoirs. Driben, Moran et De Vorrs comptent parmi les meilleurs et les plus reconnus des illustrateurs des années pin up, et ils ont des antécédents respectables, ce qui n'est pas le cas de leur commanditaire Harrison. A l'exception de l'autodidacte De Vorrs, ils étaient tous diplômés des Beaux-Arts; Driben avait même fait des études à Paris et acquis par ailleurs une expérience en matière de calendriers d'art et dans des agences de publicité. Bref, la fraîcheur, le bon goût, la «propreté» des images de pin up satisfaisaient à toutes les normes esthétiques. Et bien entendu, il y a longtemps que le public cultivé salue les qualités artistiques de Titter, Wink et les autres titres. Mais seule la couverture a de telles lettres de noblesse. Quant aux magazines eux-mêmes, beaucoup d'amateurs d'art préfèrent les voir fermés.

Pourquoi ? Au niveau du contenu, Harrison s'est en grande partie inspiré de la tradition américaine du théâtre burlesque, qui était si l'on veut le parent pauvre et louche du vaudeville. Les magazines parlaient une langue plus crue que ne le laissait supposer le bon aloi de leur présentation.

Ce qui sur le vieux continent avait valeur de parodie littéraire, de farce volontiers triviale qui tournait en ridicule le sublime des grandes œuvres du répertoire théâtral, connut dans les Etats-Unis du 19e siècle une mutation décisive dans laquelle une robuste Anglaise du nom de Lydia Thompson, la première blonde oxygénée du monde, joua un rôle de premier plan. En 1869, elle répondit en effet à l'invitation de P.T. Barnum et entama avec sa troupe, les British Blondes, une tournée aux Etats-Unis. Le dépassement des limites et la transgression des normes étaient certes l'affaire du théâtre burlesque, mais les British Blondes portaient des collants. Dans un monde où les hommes devenaient fous à la seule vue d'une cheville féminine dévoilée, voilà qui était d'une grande audace. Mais tel était l'esprit nouveau, et à partir de 1870, les scènes new-yorkaises se mirent à présenter des spectacles burlesques qui étaient bien moins des parodies d'autres productions théâtrales que prétextes à montrer le corps féminin sous son vrai jour. Toute idée qui allait dans ce sens était adoptée avec gratitude. Peu après que la Syrienne Fahreda Mahzar, plus connue sous le nom de Little Egypt, eut présenté sa danse «égyptienne» à l'Exposition Universelle de Chicago de 1893, chaque spectacle burlesque voulut avoir sa propre Little Egypt qui, elle aussi, saurait rouler des hanches.

Se calquant sur le schéma du vaudeville et du music-hall, les spectacles burlesques devinrent des revues très colorées qui associaient le chant, la danse, les sketches, les numéros de jongleurs, d'acrobates et d'animaux dressés, et surtout le sexe. Le comique en est lourd et paillard, les blagues cochonnes et les

parodies grossières. Au 20e siècle, quand le cinéma et plus tard la télévision commencèrent à faire concurrence aux divertissements traditionnels. le strip-tease finit par en devenir l'élément principal. Les spectacles de music-hall avaient en réalité ouvert la porte, dès la fin du 19e siècle, au média qui devait sonner leur glas en acceptant de programmer des courts métrages. Au moment où Harrison fondait son empire de Girlie Magazines, on ne donnait plus cher de la vie du théâtre burlesque. La Seconde Guerre mondiale lui fournit l'occasion d'un dernier retour en vogue. On tourna même toute une série de films de music-hall : Evelyn West, qui avait pris une assurance pour ses seins chez Lloyd's à Londres, joua dans «A Night at the Follies», Ann Corio dans «The Sultan's Daughter» et «Call of the Jungle». «Striporama» rassembla encore toute une brochette de stars de la comédie burlesque qui, par la suite, devaient pour la plupart faire la queue à la soupe populaire. Production new-yorkaise de 1953 de Venus Productions Corporations, «Striporama» les fait toutes apparaître une dernière fois dans les situations grotesques d'un récit-cadre figé : la grande Lili St Cyr ; Rosita Royce, que ses colombes dressées aident à se déshabiller ; Georgia Sothern, que les scandales provoqués par ses apparitions aux Minsky's Burlesque Theaters ont rendue célèbre ; Betty Page apparaît dans des sketches en compagnie de comiques tels que Jack Diamond, Mandy Kay et Charles Harris, sans oublier pour les dames le Mr. America tout en muscles qui joue de l'harmonica, une belle sur les épaules. C'est sur cette même combinaison de sexe et de comique que misent, eux aussi, les magazines de Robert Harrison, une sorte de show burlesque à mettre sous l'oreiller. Il arrivait même que les photos de grandes reines du burlesque du siècle précédent renvoient le spectateur à ses propres racines. A côté des modèles figuraient dans nombre des histoires drôles en images des comiques de la scène burlesque, soit qu'ils fussent sortis des rangs de vénérables vétérans du music-hall, soit qu'il s'agît simplement d'hommes qu'on avait affublés de l'uniforme du comique burlesque : des pitres à moustaches gigantesques dans des pantalons qui tombaient comme des sacs et des vestes à gros carreaux. Dans le domaine de l'imprimé, on ne trouve plus cette forme d'humour, qui curieusement devait survivre longtemps dans le film porno, que sur les présentoirs de cartes postales d'auberges de campagne particulièrement perdues. Autour de

ses vedettes, Harrison disposait toute une flopée de pin up en sous-vêtements, maillots de bain ou dans des costumes de scène osés, à moins qu'il montrât des girls dans les loges (qui bien entendu n'étaient jamais complètement nues, il valait mieux pour cela s'en tenir aux publications naturistes ou aux livres «d'art») en déployant – ce qui certainement ne compta pas pour peu dans le succès qu'il devait rencontrer – une vaste panoplie de fétiches. Harrison se serait en cela conformé à la suggestion d'une rédactrice d'une érudition peu commune, qui était une intime de Krafft-Ebing. C'est à peine si désormais un numéro sortait sans que le modèle eût un fouet, les longues chevelures étaient à l'honneur, on voyait des filles avec des gants de boxe lutter entre elles, et une tendre Eva Rydell, que son maître infâme avait enchaînée, était à vendre sur un bazar oriental. Le bourreau de travail notoire qu'était Harrison insistait pour apparaître régulièrement dans le décor des photos et, lorsque le scénario le permettait, dans l'histoire elle-même. Il est difficile d'imaginer en regardant ces photos, que cet homme d'apparence si insignifiante, quoique manifestement prêt à n'importe quelle bêtise, allait devenir l'éditeur le plus décrié des magazines à sensation. Harrison pouvait choisir ses modèles parmi la grande armée des strip-teaseuses, girls et pin up qu'il avait fait venir à New York. Elles pouvaient pour la plupart s'estimer heureuses si une légende sous l'image leur concédait la mention d'un pseudonyme, et rares furent celles qui parvinrent jamais à dépasser ce niveau de notoriété. Plus rares encore furent celles qui accédèrent au statut de star comme Betty Page, que l'on put voir à partir de 1951 dans les magazines d e Harrison et qui devait rapidement devenir l'un des modèles les plus populaires. Mais les plus nombreuses, les anonymes, apparaissent elles aussi comme des filles formidables qui, même si elles étaient parfois un peu lourdaudes, se montraient toujours énergiques et décidées et qui, lorsque la mise en scène leur adjoignait un partenaire masculin, savaient régulièrement tirer la couverture à elles. Et elles étaient prêtes à se faire photographier dans des poses dont plus personne, quelques années plus tard, n'aurait pu se remettre. On est tenté aujourd'hui de sourire de la naïveté de ces histoires et même de les trouver grotesques. On y détecte néanmoins ce que déclarait le modèle Jonnie Wilson, interrogée par le «Betty Page's Annual» sur son travail avec Harrison : elle aurait connu là le grand bonheur de sa vie.

Le côté adipeux des figures masculines que l'on voit sur les photos à côté des filles, laisse deviner par analogie une catégorie d'acheteurs dont il est évident qu'elle veut s'entendre rappeler le moins souvent possible le fait déprimant qu'il puisse y avoir, ailleurs dans cet univers, des hommes distingués, qui s'expriment facilement et qui portent des costumes bien coupés. Si l'on demandait au client de publicité comment il se représente le lecteur type, il dessinerait un homme de petite taille, couvert de boutons, qui dans les soirées reste tout seul dans un coin à observer la chute de son dernier cheveu sur son gros ventre. Il essaie de forcer les contacts, dont il manque singulièrement, en racontant des histoires drôles et des anecdotes qu'il a lues dans des manuels. Radin notoire, ce qui par conséquent fait de lui la proie désignée des requins véreux de la finance, il lui reste quand même toujours de quoi se payer quelques heures de réconfort par la lecture solitaire. Aussi les éditeurs d'ouvrages spécialisés dans la sexualité tels que «Modern Sex Manual» (bien évidemment à l'intention des couples mariés) du Dr E. Podolsky considéraient-ils que la clientèle de Harrison valait tout à fait la peine de passer une annonce publicitaire en pleine page. Pendant la guerre, les magazines de Harrison firent également la promotion de «I was Hitler's Doctor» du Dr Kurt Krüger, cet ancien nazi – c'est du moins ce qu'on ne cesse de répéter – qui soi-disant avait été pendant de longues années le psychiatre d'Hitler. La publicité représente le führer en train de pleurnicher pitoyablement tout en faisant de terribles aveux au Dr Krüger qui, en retrait, tend l'oreille et les consigne dans son carnet sans se laisser ébranler.

Mais c'est surtout la flamme de la concupiscence qui, cela va sans dire, embrasait les lecteurs de Harrison. Irving Klaw, le roi du phénomène pin up, misait lui aussi sur ces rêves de cuisses souples et de filles à haute vitesse de chute, en devenant l'un des plus fidèles annonceurs des magazines de Harrison. Les archéologues de la culture populaire dans ce qu'elle a de moins reluisant sont en présence, avec la partie publicitaire (des magazines de Harrison) et ses nombreuses propositions de vente par correspondance, d'un véritable Pompéi de la trivialité. Celle qui allait le plus loin parmi les publications de Harrison fut

certainement Whisper, un rejeton de l'après-guerre qui sortit pour la première fois

en kiosque en avril 1946. La couverture représentait régulièrement une des innombrables beautés que Peter Driben, judicieusement, peignait à travers le trou d'une serrure ; ce n'est que dans les années 50 que les photos de pin up remplacèrent les peintures ou les dessins, et Whisper finit par s'harmoniser, même du point de vue de son look, avec «Confidential», lancé en 1952. Le lecteur qu'émoustillait le goût de l'aventure était la cible de prédilection de Whisper, magazine hard qui racontait des histoires de filles cruelles, de légionnaires affamés de sexe, parlait d'affaires criminelles sordides et de rites bizarres que pratiquaient d'étranges tribus indigènes, et proposait des reportages photos particulièrement corsés sur la criminalité urbaine. Bref, le monde était représenté comme une immense maison de fous. Pour ne pas s'arrêter en si bon chemin, on trouve également dans Whisper, à côté des annonces publicitaires habituelles, une publicité pleine page pour des pierres tombales à des prix particulièrement avantageux.

Il était également caractéristique de Whisper de fustiger des scandales d'actualité brûlante du type «Sommes-nous escroqués par les pompistes quand nous faisons faire la vidange ?» ou «Scandaleux vols d'ouvrages dans des bibliothèques publiques» avec la même indignation que d'épouvantables massacres ou d'incroyables perversités.

Alors Whisper devint de plus en plus hard, car Robert Harrison avait compris que dans les années 50, l'âge d'or de ses Girlie Magazines était définitivement révolu. Depuis longtemps, des magazines modernes «plus sérieux» qui n'admettaient ni l'humour burlesque, ni les annonces «cochonnes», avaient fait leur entrée sur le marché. Qu'ils s'adressent, comme par exemple «Modern Man» de Georg von Rosen, à un lecteur ayant le goût de l'aventure et affamé d'action, ou comme «Playboy», de Hugh Hefner, au citadin solvable et cultivé, tous recherchaient des auteurs de renom ainsi que les meilleurs photographes et caricaturistes. Des gens comme Harlan Ellison, Allen Ginsberg, Jack Kerouac, James T. Farrell écrivirent pour ces magazines masculins modernes, et non plus ces écrivailleurs qui ne rataient jamais un calembour pour faire sensation et inventaient, les doigts maculés d'encre, des légendes pour les images de Harrison. Quand on faisait l'acquisition d'une de ces publications modernes, on pouvait être certain que le plus grand soin et la plus grosse part du budget n'avaient pas été mobilisés par la seule couverture.

Manifestement, Harrison ne tenait pas à entrer dans l'arène où se taillaient les parts de marché. Début 1955, il se détourna de ses Girlie Magazines devenus entre-temps obsolètes pour consacrer toute son énergie à se faire honnir et stigmatiser.

Whisper avait obtenu en 1952 le soutien financier de «Confidential», conçu dès son origine comme un magazine à sensation. Ce sont vraisemblablement les enquêtes du sénat sur le crime organisé qui ont mis Harrison sur cette nouvelle piste qui promettait de rapporter gros, ou plus exactement le fait que les audiences de la commission d'enquête étaient retransmises à la télévision, qu'elles atteignaient des taux d'écoute incroyables et qu'en une nuit, elles firent de leur président, le sénateur Estes Kefauver du Tennessee, une star médiatique. Tandis que son collègue McCarthy faisait la chasse aux présumés «joueurs de flûte du Bureau Politique», Kefauver passait un savon, devant les caméras, à de grandes pointures du gangstérisme comme Frank Costello ou Meyer Lansky, et il n'y eut pas que la seule culture politique américaine à être transformée par ses thèses de complots. Quelques années plus tard, on le revit à la tête d'une commission sénatoriale qui enquêtait cette fois sur la délinquance des jeunes, et dont l'une des victimes devait être Irving Klaw. Le portrait le plus célèbre de Kefauver le représente une casquette de raton laveur sur la tête; peut-être était-il lui aussi victime de cette Davie-Crocket-mania qu'avait déchaînée en 1954 l'émission de télévision «Disneyland».

Il n'aurait été que juste que le média qui avait gâché l'amour de Harrison pour le burlesque l'eût incité, par la même occasion, à concevoir le plus grand magazine à succès de la décennie. Mais peut-être Harrison n'a-t-il eu cette idée qu'après coup. Car les pratiques étant utilisées et peut-être perfectionnées par Whisper et «Confidential», il avait déjà eu l'occasion de se familiariser avec elles dès ses débuts dans le journalisme, alors qu'il n'était encore que coursier pour «Daily Graphic», une revue à sensation new-yorkaise des années 20 et 30 dans laquelle les affabulations les plus éhontées, le «mentir vrai», les aveux déformés et les photos truquées faisaient partie de la routine quotidienne. Il est peu vraisemblable que Harrison ait oublié tout cela.

Les idiots ne sont certes pas une denrée rare dans ce monde, mais enfin il faut être singulièrement naïf pour ne pas se rendre compte que la belle dont viennent de s'emparer de perfides chasseurs d'esclaves dans Whisper, ou encore que la strip-teaseuse en déshabillé, que des brutes de Soviets ont enlevée et qui à présent a les pieds dans un bassin d'eau glacée, ne doivent leur désagréable situation qu'aux ciseaux et à la colle. Comme dans les magazines modernes censés publier des révélations, l'intérêt du lecteur devait en majeure partie provenir du fait qu'il détectait les présupposés bobards et s'amusait de l'incongruité du mensonge. Mais le procédé ne fonctionne plus à partir du moment où interviennent Jésus, Elvis ou n'importe quelle célébrité, même si elle est seulement en voie d'en devenir une. Et c'est justement cela, c'est-à-dire cette volonté de couvrir de boue tous les personnages publics, qui constitua bientôt le fonds de commerce de Whisper et de «Confidential». A la différence de nombre de ses concurrents qui copiaient leurs histoires les uns sur les autres, Harrison entretenait un réseau compact d'informateurs, d'indicateurs et de balances et courait, avec la fougue qui était la sienne, à des rendez-vous clandestins dont il exhuma des scandales bien réels. Et s'il n'en trouvait pas, il échafaudait des histoires à sensation à partir de trois fois rien. Mais le solide instinct de conservation qui fait veiller à l'absolue véracité de ces révélations, faisait défaut à Harrison, qui se laissa emporter par son élan et l'enthousiasme d'avoir fait de «Confidential» la publication la plus vendue aux Etats-Unis. Il se vit exposé en 1957 à un déluge de plaintes, et un an plus tard il dut se résoudre à vendre ses deux magazines à sensation. Changeant souvent d'éditeur, Whisper et «Confidential» parurent encore, mais sans plus faire de tapage, jusqu'au début des années 70.

Par la suite, Harrison tenta sa chance avec ce qu'on appelle les «one-shots», c'est-à-dire des numéros spéciaux consacrés à une toute nouvelle star ou à un scandale, et il publia un nouveau petit journal à sensation qui n'eut guère de succès.

Beauty Parade was Harrison's first girlie magazine. The early issues look very tame, but they already feature the photostories characteristic of all Harrison's magazines: scantily clad models at some harmless hobby or grappling with some object with a will of its own. A typical picture story runs as follows: a model in panties, bra, high heels and perhaps saucy headgear strives through a number of scenes to erect a deckchair, but to no avail. Mildly peeved, she has a little rest before finally chopping the chair to pieces to make a campfire. The girl would also be wearing panties, bra and high heels if the story were set in the Arctic or on the Moon. Over time, and as elements of burlesque comedy were integrated into the stories, the humour grew somewhat earthier. But Harrison only hit on the right mixture when he began to add a fetishistic angle to his wholesome and ever cheerful cheesecake models. Initially Harrison cited himself as the publisher, but later the names on the imprint page changed quicker than you could say "Oh-la-la!".

Beauty Parade war Robert Harrisons erstes Girlie Magazine. Die frühen Nummern wirken noch recht verhalten, aber sie bieten bereits die für alle Harrison-Magazine typischen Fotostories, die leichtbekleidete Models bei einem harmlosen Hobby oder im Kampf mit der Tücke des Objekts zeigen. Eine typische Bilderstory verläuft etwa so: Ein Model in Schlüpfer, BH, High Heels und mit vielleicht verwegener Kopfbedeckung müht sich einige Szenen hindurch vergebens, einen Liegestuhl aufzubauen, erholt sich dann milde verstimmt, um schließlich mit neuem Elan den Stuhl kleinzuhacken und ein Lagerfeuer daraus zu machen. Schlüpfer, BH und High Heels würde das Mädchen auch tragen, wäre die Geschichte in der Arktis oder auf dem Mond angesiedelt. Im Laufe der Zeit und mit der Integration männlicher Hanswurste in die Stories wurde der Humor etwas derber. Die richtige Erfolgsmischung aber war erst gefunden, als Harrison begann, den unverdorbenen und stets gutgelaunten Cheesecake-Models Fetischmotive zur Seite zu stellen. Zeichnete Harrison anfangs selber als Herausgeber, wechselten die Namen im "Impressum" später schneller als man "oh-là-là" sagen konnte.

Beauty Parade est le premier Girlie Magazine de Robert Harrison. Les premiers numéros sont encore très sages, mais ils contiennent déjà les histoires en photos qu'on retrouvera dans tous les magazines de Harrison et les modèles en petite tenue en train de se livrer à un innocent hobby ou aux prises avec la malignité des choses. Voici par exemple un scénario typique : un modèle en petite culotte, soutien-gorge, hauts talons et peut-être un bibi effronté s'évertue en vain à mettre sur pied une chaise longue ; légèrement contrariée, elle se repose quelques instants avant de se précipiter dans un regain d'énergie sur la chaise, d'en faire du petit bois et finalement de la jeter au feu. La fille porterait de la même façon un slip, un soutien-gorge et des hauts talons si l'histoire se passait dans l'Arctique ou sur la lune. Au fil du temps et à mesure que les histoires intégraient des éléments du comique burlesque, l'humour allait devenir un peu plus lourd. Ce n'est que lorsque Harrison se mit à flanquer les gentilles pin up de fétiches que l'amalgame fut véritablement réussi. Si dans les premiers temps, c'était Harrison lui-même qui signait en tant que directeur de publication, par la suite on vit fréquemment les noms de l'éditorial.

THE MOST Beantiful Girls IN THE

lift

SE

2.

World

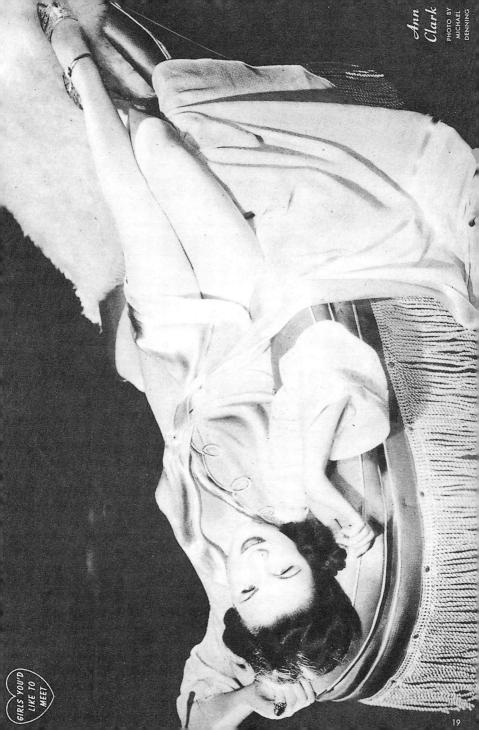

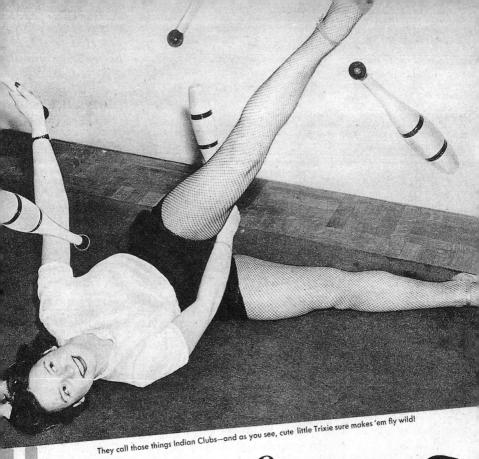

Swing It

Trixie is full of tricks that keep her in trim, but she's at her bes when she throws the Indian Clubs around. Like W. C. Fields Trixie is a first-class juggler and she has adopted that good American motto, Keep 'em Flying. We know you won't be able to keep your eye on the clubs, so let's admit right now that Trixie has two of the trickiest gams we've ever seen and a smile that sends us out of the world. Swing it, Trixie you're a hot melody in motion-and you're in the groove Benny Goodman may be the king of swing, but you're the queen!

My, what a feat-and what feell You can't help but admire Trixle, who never-loses her balance-or her figure. What particular element of her skill do you like best, folks? As for as we're concerned, it's a toss-upl

0

THE SUN SHINES EAST, THE SUN SHINES WEST, BUT I LIKE TRIXIE'S TRICKS THE BEST!

1

Now Trixie is really getting into the swing of things—and she's staging a demonstration that shows plenty of oomph! Keep it up, Trixie, you're clicking!

Į.

This is very good for the hips-but Trixie doesn't really need the exercise, and is only showing off for the benefit of her less fortunate sisters! Better duck, Trixiel

)

Above, we see Trixie in the most difficult stunt of all-but it's not hard for us to take. When Trixie gets through with all this, she'll use the Indian Clubs as rolling pins - so beware of getting fresh!

BEAUTY PARADE

he World's Loveliest Girls

Steffa

AN. 25c

BROADWAY SHOWGIRLS

HOLLYWOOD , NIGHT CLUBS

yrna Veldon N QUARTER HOTO BY RAY KORMAN

BERNARD BERNARD PRESENCE PRESENCE PRESENCE The World's Loveliest Girls

arch 25c

BROADWAY SHOWGIRLS * HOLLYWOOD MODELS * NIGHTLIFE Steffa

Whirl girls

Steffa

BROADWAY HOLLYWOOD NITECLUBS Ah, well, it's wonderful what Yvonne de Carlo, of the musicals, can do in these days of priorities with so little material to work with.

PIN 'EM UP, FELLERS AND MAKE YOU'

No wonder ostriches have long necks; they crane 'em to look at lovelies like Nita Louise of Frisco's Club Shanghai. What could be Nita?

WN GARDEN OF BEAUTY

Margo Lane can't stick around long, because she's going places. In fact she's on a party line right now — some phone, eh kids?

BEAUTY DARADE he World's Loveliest Girls

combined with **EYEFUL**

GIRLS and GAYETY

JAN. 25¢

lles Pin

Supporter S

TACK IT OR LEAVE IT!

There may be plenty of pin-up gals around, kiddies, but here's one of the best. It's Renee Haal of RKO Radio Pictures, who's gorgeous enough to be framed.

You can bet Renee likes to listen. As a matter of fact, here she is lending an ear! And we're glad to pay interest!

Have you heard the song somebody wrote about this costume. It's called "Black Magic." Can you imagic anything nicer?

BEHULY PARADE The World's Loveliest Girls

OVER 100 PIN-UP Beauties

BROADWAY HOLLYWOOD NITELIFE

250

the district of

(WW)

ARCH 25¢

ų

SERUTY PARADE e World's Loveliest Girls

SHOWGIRLS * MODELS * PIN-UPS

25

BAUTY BARADE World's Loveliest Girls

CUNWRIDIC + MODELC + DIN HE

NOVEME 25

PETER

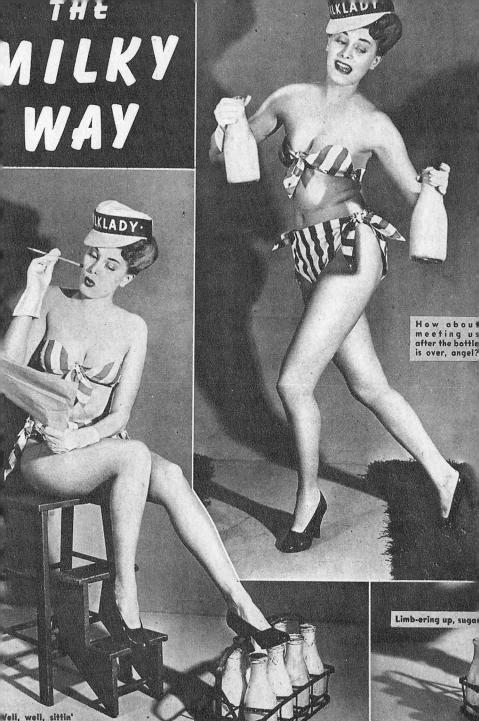

Vell, well, sittin' retty. eb. sugar?

SHE'S IRICTLY JRADE A

Now, that's a nice pick-up!

was writing her book "Gutter-ca Dairy", fellers, and is going to p up a little change selling milk. not exactly the best way to earn living, but how can a milkmaid udder-wise? You guys might interested to know that Ethel is only dairywoman in the country ever give her own cows a rubdo with a toothbrush so they'll g dental cream. "Don't believe hin a bum steer." Okay, baby, we pass on that one, but let's hear y explain how you can sell ten qua of milk when your cow gives or five. We suppose you're trying become a milkman of the first wa . . . oh, yeah!

KLADY

Let's play spin-the-bottle toot

UST T_.HE REAM IN UR COFFEE

What's the matter, baby? Did you have aches for breakfast?

ADY

NIM

Oh, you pour, pour girl!

16

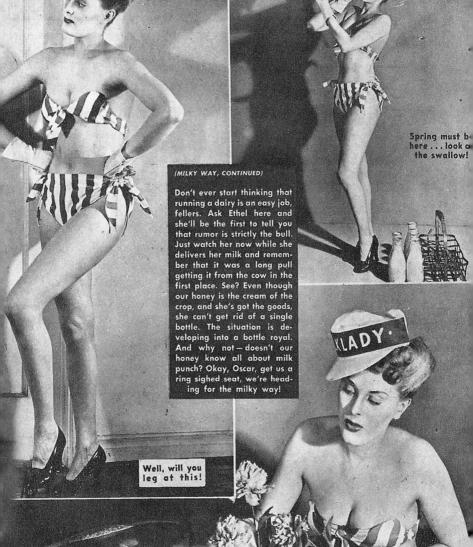

JANUAN 25¢

SHOWGIRLS * MODELS * PIN-UPS

ER BENG

SEAUIY ARADE e World's Loveliest Girls

CH C

> PETER DRIBEN-

> > G

ODELS + PIN-UPS

BEAUTY PARADE he World's Loveliest Girls

25

SHOWGIRLS * MODELS * PIN-UPS

PETER

Long, tapering white fingers clasp a slim, shapely ankle, as Sunnie McKay, exquisite golden-haired siren, stoops to adjust the skyscraper shoe which promises to lift her to greater heights of beauty and glamour.

D

III as as III

Glamour

HEELS

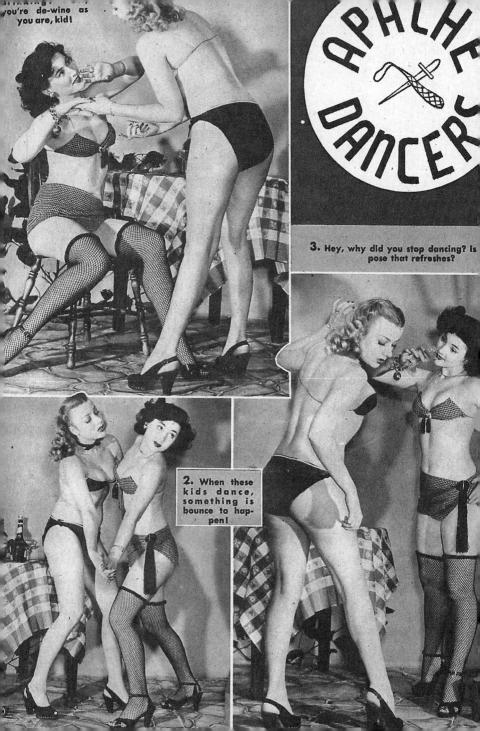

ck trip to Gay Paree and fraternize with a e of delicious French mademoiselles! Fifi is ntalizing brunette's name, and the voluptuplonde is Mimi. These cuties are Apache rs which means they do their daily tossin' e approval of customers in a cafe. The gals good friends until just the other night when caught her G.I. boy friend and Fifi discussing try tactics. (That's right, Oswald, he had her unded!) So the honeys had a terrific quarrel, hat night they put on a dance that really ed the show! Oh, gosh, won't someone septhese shapely scrappers? Sweeties like Mimi and Fifi should be seen but not hurt!

The Wrestle's

Yet to Come!

cuties want a little 'armless

funl

5. Don't strike he chick! "Why not? She fist on my hit parade

TAKE A LOOK, GANG, IT'S SLAUGHTE WATCHING THESE TWO KNOCK-FIGHT IT OUT! HAVE YOU EVER CUTIES WITH SO MUCH SOCKS AP

Hair, hair, what's s? Pull-ease, gals, ake it easy!

ACHE DANCERSI (CONTINUED)

ell, our two babes started out dancing nicely gether, but before the customers knew it, they d an order of squabble on toes! The cuties and clawed each other-a real scratch-asratch-can tussle! You can see that both gals are ock-outs, and for awhile it looked like they'd d up singing a duet of Bruise in the Night! But i finally von out; she took Mimi over her knee d administered an old-fashioned spanking with bottle of French absinthe! But gosh, gents, that ould make these darlings love one another. ter all, absinthe makes the heart grow fonder!

THESE GALS KNOW ALL THE Jangles!

minum

11-7

y, kids, how meeting us after brawl is over?

O will

10

2

7odays Weather:

m

FAIR and UHAMMER!

9. So it ended up with a spanking! Just a couple of slap-hippy cuties!

BEAUTY PARADE he World's Loveliest

SHOWGIRLS MODELS PIN-UPS

de 2

BEAUIY DARADE he World's Loveliest Girls

SHOWGIRL MODEL PIN-UP

PETER DRIBEN-

2

Abject misery and sufferin are etched strongly on the de icate features of Agnes Dan who depicts a slave-girl upo an ancient auction bloc. Like the unhappy lovelies old, Agnes assumes the po of fearful surrender.

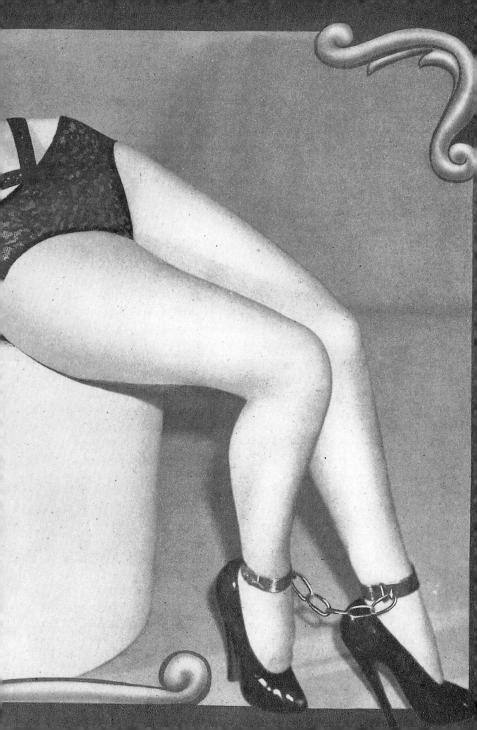

25

SHOWGIRLS MODELS PIN-UPS

TITIAN TEMPTRES

Long, lustrous, gorgeously glistening tresses drop in rich, silken rivulets down the alabaster, gently curved back of luscious looking Betty Howell. This fascinating, golden adornment is not the least of Betty's many charms which encompass a small 24 inch waist 'mid full 35 inch bust and hips.

Mrs. Americ

No, GENTLEMEN, she's not eligible, but if you are perspicacious you'll read on, so that you can set your standards for the future "missus" along these very curvaceous lines. If ever you set up ideals for the perfect to meet the actual possessions of blonde, buxom and beautiful Peggy Payne, the gal who has everything including a husband. However, if you overlook that one very important item, we'll set out to prove that this is as tantalizing a toatsie as you'll ever meet.

Just a few short years ago, this sweet Southern siren set out for fame and fortune via a modeling career "up No'th." No sooner had she planted her stakes at a wholesale house in New York that things began to "pop." Peggy took the town by storm, and left a trail of broken hearts behind as she walked off with one gloriously lucky man, Charles Danny Payne, a vocalist with a band.

But even so final a conquest failed to stop the unconquerable Peggy for she entered a beauty contest where just one glance from the judges proclaimed her Miss "Perfect." But at this intersection fate stepped in to obstruct her-but just temporarily. It seemed that as a married woman, Peggy could not compete against the other maidens. So though Atlantic City did not see her that year, she became a national figure by entering and winning the Mrs. America contest.

One-hundred and 48 gorgeous girls of all assorted sizes, shapes and descriptions pitted their lush, white bodies for the great honor which Peggy copped with little effort.

It was then that the nation in general was privileged to observe this stunning creature as she set out in a triumphant tour across the country to prove that girls can be glamorous though married.

The particular girl in this case was the true, living example. Peggy stands five feet six and one half inches in her stocking feet and weighs a full 127 pounds. But for purely statistical purposes, we hasten to assure you that this 127 assorted pounds is not just a figure; truly it is a measure of delicious, white avoirdupois so symmetrically distributed as to encompass a full high 35 inch bust, a wee, indented 25 inch waist and a round, ample 36 inch hip measure.

Lovely Peggy makes no effort whatsoever to keep her weight down-she's had far too many a compliment on her buxom beauty! Food is, a passion without which Peggy would be frustrated indeed. High on her list of delicious things to eat, Peggy lists strawberry shortcake, cheese blintzes, potato pancakes and steak.

Currently, the luscious Mrs. Payne, voted Mrs. Broadway for 1947, is wowing them in nightclub engagements, while keeping a bright, blue eye peeled for Hollywood offers. When gorgeous Peggy hits the film mecca, we're bound to predict she'll set the town afire, and sadden the hearts of the Hollywood wolves.

Yet, though pretty Peggy Payne may wear a "TAKEN" sign prominently displayed across her gorgeous chest, we're sure the boys will never stop looking—and hoping that they'll cop a prize as delightfully luscious for their own in the matrimonial sweepstakes.

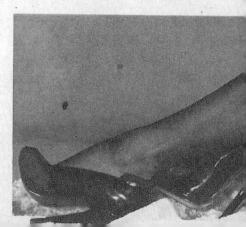

Meet Luscious Peggy Payne, a Curvey Cookie who Scores as the Nation's Top Wife

un C

to Town

SHOWGIRLS MODIS + PIN-IIP

PETER

BEAUT PARADE The World's Loveliest Girle

er thrilling little torso shaded ightly by the silken folds of n old-fashioned parasol; her reamlined stems poured into ilf-high, patent leather boots-thel Norris is indeed a saucy tale tid-bit snipped, thypeke, from the pages of grandad's memoirs, and presented the ultra-super 1947 manner.

L

Naughty

Nymph

BEAUTY PARADE The World's Loveliest Girls

SHOWGIRLS MODELS PIN-UPS

BEAUIA BARADE ne World's Loveliest Girls

SHOWGIRLS * MODELS * PIN-UPS

FEB. 25¢

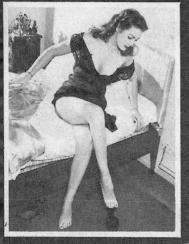

Monday

Unatia Wool To

What a day! And it all started so early, too. Heck, there it was, only 10:30 in the morning (middle of the night, as a matter of fact) and the blankety-blank phone kept ringing like blazes. Gosh, it was loud enough to wake the dead, and for all that last night had been a killer. I was still too alive to be a corpse. A masculine voice said, "Miss Andre—Miss Eve Andre? How would you like to be in my show?" Well, if ever there was a time for a girl to say "yes," that was it. So I simply shouted into the phone _ "Yes, oh. yes." "That's fine." said the voice, hanging up. After I recovered from the shock, and finished counting the dough. I realized I hadn't asked who was calling.

Dear Diary-Tuesday Well, you'll never believe it, but that little call was on the level. I really am going to be in a Broadway show. It was noon this morning before the phone started to ring. The same voice as yesterday spoke to me. This time everything was clear. "Miss Andre," he said, "it was very unfortunate that we didn't get together conversationally yesterday." Then I blubbered and explained how surprised I was, "Look, Miss Andre," he continued, of saw your picture in BEAUTY PARADE, Bob Marrison, the publisher, tells me you're a very talented girl. I want you for my show, "Tee For Two."

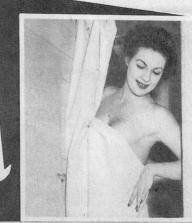

m L

Tife

Wednesday

Dear Diary-

Well. I got the job. I walked into the Superb Theatre all shakes. A stageful of girls, all of whom looked prettier than I, greeted my eye. But the director seemed to know all about me. I got up on the stage, and it seemed as if all the floodlights in captivity centered on me. "How tall are you," the director asked. "I'm 5 feet 6 inches tall. I weigh 118 pounds, have a 36 bust, a 25 inch waist and 36 inch hips _I'm a Methodist and I come from Santa Barbara," I blurted. "Thank you," said the director, "I really wanted to know your height but the extra information helps. And incidentally, how about your telephone number?" After that it was all easy.

7 - 1

霮

Dear Diary_

Thursday

I've got 33 sides which in theatrical lingo means I'm practically next door to a star. I guess I'll never memorize all the lines I have to say and all the songs I have to sing, to say nothing of all the steps I have to dance. Boy, I never knew it was this hard being an actress. Why. I hardly have any time left for any kind of real love life. Maybe it's too early in the game to judge, but from where I sit it looks like a lot of work, and I do mean work. We rehearse till we drop, then I rush home, drop my clothes, drop onto the sofa and rehearse some more, while the phone rings like mad, and the men in my life begin to think that Erie doesn't live here any more.

Friday

I spoke to Mr. White personally to-Dear Diaryday, which, if I haven't said so before, is a great and rare privilege. He made me back off while he took a good look at my legs. "Joe" he said to the press agent, "These are the gams we're going to publicize. Take her around to the photographer and let's make some super-sexy cheesecake photos. This baby's got stuff. Just look at her eyes, too." We ran off to a studio where a photographer had me strip, and then draped me in black velvet looking for the oomphiest effects. Do you think it's right. Diary, for me to send the very "oomphiest" photo of all to BEAUTY PA-RADE, even before I get to be a star?

maisur Madal

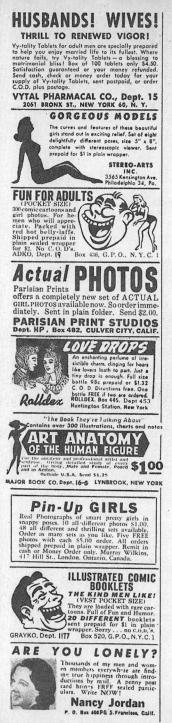

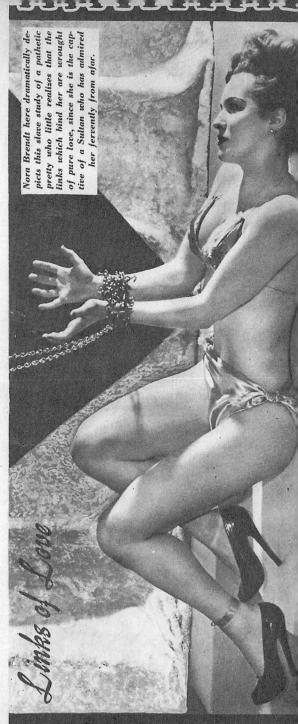

BEAUTY BARADE e World's Loveliest Girls

APRIL 25^c

Correspon beauty parade's gener

Butte, Mon.

Dear Sir:

When it comes to feminine loveliness, in my mind nothing can surpass the long, glowing, shimmer-ing appeal of well-cared tresses. There is something in the soft, glimmering appeal of long hair that strikes a responsive chord with me, and I am greatly attracted to this most feminine of attributes. The hair must be waved slightly, but must hold its softness and allure. Additional charm is added when the silky tresses fall across the woman's face or body, giving the effect of partly concealing and partly revealing her fleshly beauty. Yours for more and better pictures of long-haired lovelies showing their crowning glory. CONNOISSEUR

Detroit, Mich.

Dear Editor, I think one of the finest of the new fashion fads are these shiny boots women and young girls wear during winter or when it rains. The boots seem to do something for the leg line and especially the calf (if it is bare) is greatly enhanced by the fact that it rises from the edge of a black, shiny boot. Boots have long been worn for riding and hiking, but they seem ideally suited for everyday wear as well, and I only hope the fad spreads and more women recognize what boots can do to help their leg-appeal.

ARTHUR K.

nce Corner

Pottsville, Pa.

You are right when you say it takes a woman of great theatrical ability to adequately enact the role of a dominant woman. This is a part that calls for (1) physical strength and ferocity so she really looks like she stepped out of the jungle, (2) a savage expression that shows she means business, and (3) a pose where you can see her determination and desire to dominate. I saw a female animal trainer at the circus this year who had all those qualifications. How about picking out a Savage Siren just for me, Editor? I'll really appreciate it.

Editor.

Dear Sir:

SLAVE TO BEAUTY

Freeport, L. I.

Yours is a unique and wonderful magazine. Permit me to say at last how much I've enjoyed it.

Although you are progressing in a direction that I certainly like, I do have a request--if it has not already been granted in the plans for your next issue. Please let's have more and more and more beautiful slave girls, some in the lovely misery of surrender, chained hand and foot or roped severely and tightly. Perhaps I speak for the majority--I don't know. But at least one of your ardent fans would be most highly pleased. May I say thanks.

H. S. L.

BEAUT BARADE he World's Loveliest Girls

\$

^{4 S} JUNE 25^c Whip and knife in hand, exciting Elaine Rost, talented Broadway model and starlet, shows us how a Jungle Juno would bend the wild beasts to her iron will. Against a palmtree background, this lithe and ferocious feline poses in a perfect portrait of startling feminine mastery.

TORRID TAMER

BEAUTY PARADE the World's Love

200

AUGUST

SHOWGIRLS MODELS PIN-UPS

PETER DRIBEN-

BEAUTY BARADE 1e World's Loveliest Girls

SHOWGIRLS * MODELS * PIN-UPS

DEC. 25°

100

SHOWGIRLS MODELS PIN-UPS

TEB. 25

USED MARATINES ...

occusivity

Res

NOW, Order this Famous Classic!

Now obtain one of the world's nere cleaners for pour private collection "THE DECAMERON" is again validable in complete, unableded, unexposured edi-terpiece of mitch. Beautifully hound. Over 300 pages, including ment will help you engogy life. You'll never alop the lifting to it: Order most

SEND NO MONEY

Send THE DECAMERON. If at end of 10 days I'm delighted, I may return book for prompt refund. C Nend C.O.D. 111 pay postuman only \$2.08 plus postage. C I euclose \$2.208, Send book postpatd. Name. Address. NEW MAGIC DICE FUN Here's a special pair of tun dice that certunity and be under: It's amainty's rows to profile aumbers, perform anuscing tricks. No use can Display amainty "control" yet the real resourts hereity concreled from everyone, Fun and fraction-inn Easy direction-septial dealers. Berform many "mappic tricks, Price and 5228, the a Cu today, "mappic tricks, Price and 5228, the a cu today of the second second second second second provide the second second second second provide the second second second second front deliabled. Address Hallister, While Co, Det, 4777-5218 M Mediaga Are, of Golga 1, IL.

only ONEY BACK GUARANTEE LARCH BOOK CO.

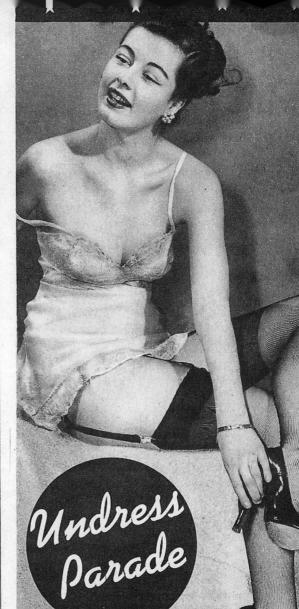

Tempting, tantalizing Ruth Everett in slinky satin, mesh hose, and spike heels is a one-gal heat wave. Warm yourselves over these figures-36" bust, 25" waist, and 35" hips. Nice!

E fallet nad - :

are ever the state of

SERUT PARADE Ne World's Loveliest Girls

APRIL 25¢

SHOW GIRLS * MODELS * PIN-UP

EVORSS

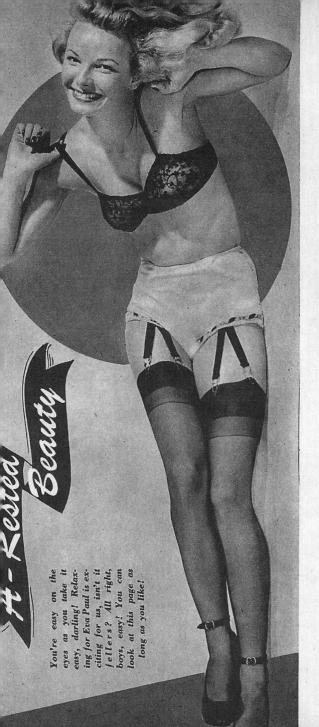

BE A WHINKER AT ANTIMAS YOU THORE WE	ALL 5
IN DARLING THAT	FAMOU
with the second	HEROMOTION. JOWETT
	Volum
	250
Let's Go, Pall I'll pr	
an "ALL-	AROUND"
	AAN
	Warld's
FAST-or HD COSTI says Roorge F. Jewett	Warid's Breatest Body Builder
A CARLES AND AND A SHORE AND	
System is the greatest in the world's any B. F. Kelly, Physical Di- retor, Atlantic City	Enjoy F "Progressive Power Strength Secretsi Gi Me 10 Easy Minutes Day—Without Straini
R. F. Kelly.	Mo 10 Easy Minutes
Atlantie City	I'll teach you the "Progre
1. 2	I'll teach you the "Progre sive Power Method through which I rebu
M. A	wreck the doctors co demned to die at 1
11 20 31	to the holder of me strength records th
	athlete or teache "Progressive . Powe
	to build the stronge
1 And	And I stand ready to show y on a money back basis-of no matter how flabby or mi
4	you are I can do the same s you right in your own hor Let me prove I can add inch
	to your arms, broaden yo shoulders, give you a ms should chest, powerful legs a a Rock-like back-in fact, pc
	er pack your whole body quickly it will smase you! Y
5 12	confidence to master any a uation-to win popularity-a
	Through my proven secrets bring to life new power in y.
V. 14	fully satisfied you are the minou want to be.
	Aulty satisfied you are the mirror want to be. PROVE IT TO YOURSES IN ONE NIGHT Bend only 25c for my 5 cas boldlow. Dicture pack courses now in 1 comple yourses now in 2 comple
	Send only 25c for my 5 eas to-follow, picture-pack; courses now in 1 comple
	courses now in 1 comple volume "How to Become Muscular He-Man." Try it f one night! Experience t invilling strength that surg
BEDRAFF, JOWETT	through your muscles.
whom experts call "Champion of	through your muscles. 10 DAY TRIAL! Thick of li-all five of the famous course how one point only as a set of the famous course how one of the only set of the set of the set of the set of the set of the weeks and your money will wenputy refunded!
World's wrestling	volume for only 25c. If y
champ at 17 and 19 World's Strongest	within ONE WEEK, send back and your money will " promptly refunded!
SEDREF.JBWEIT whom superir call "Champions" 9. World's Hilling champ do H Milling champ do H Milling champ do H Milling champ do H Milling the World's Horrisol World's Perfect Bdy-chus oth- 67 records oth-	E. B. F.
er records!	naking a drive
for thousan fast-REGA	naking a drive da of new friends RDLESS OF COSTI
SO SET NOW M	y 5 Muscle C BASES at 50 each) t Complete Volume
All in 1 Grea Packed W	t Complete Volume Ith How-To-Do-It Ictures!
Now, this "get-a	ictures!
Now, this "get-a extremely low pr 23c is your chan a body you"ll be	squainted," The of only For proud of only 25c any northod * NOW!
a body you'll be Follow Jowett's e of muscle buildin	k NOWI
	ASI ISA
FREE!	1
OF FANOUS	TECOMEA
STRONG MENT	New PORAR HE-MAN
	A
3	
FREE G	IFT COUPON!
Jowett Institut	e of Physical Culture
george F. Dear George	ue, New York 1, N.Y. H-94 lease send by return mail
Schampion of Men, along with	wett's Photo Book of Strong
4. Molding a Mighty Arm	. 3. Molding a Mighty Grip.
Legs-Now all in come a Muscular I	ue, New York 1, N. Y. H-94 lesse stend by return mail. wet's Pholo Book of Strong h all 5 Muscle Building ra Mighty Chest. 2. Mold- . 3. Molding a Mighty Grip. One Yolume "How to Be- Ha-Man," Enclosed find 25c.
(Please Print Plainly.	Include Zouje Number)
ADDRESS	

Sign herel demands dainty demonstrator, as sign nerer demands danny demonstrator, as model boss tears his hair over their contract.

WHAT gives here? Now the gais who model for those pictures we love have gone on strike! To the hills men, it's the end of the world! It seems the babes want more for wearing less, and they've gone and formed a union, The United Cheesecake Models.

The girls have opened a campaign to get the male public on their side (where else would we be) and to force the bosses to pay them more because the cost of living keeps them stripped. Is that bad, boys?

Fortunately we were able to get some pictures of the picket line-and such picket lines you never saw! They have invaded the offices of the lucky dogs who hire their charms, and tried to force them to sign a contract covering their demands. So far the bosses haven't given in. What are those guys made of, stone?

City authorities view the strike with alarm, and are keeping a watchful eye on the proceedings. We don't blame them-so are thousands of other males.

We've interviewed several of the picketing pretties, and believe us, they do have a leg to stand on in this controversy. Their picket line has curves and their strike is going to be no bust.

Even the law treads lightly in dealing with these striking strikers. The girls stand right up to the cops, and many a tough gendarme forgets his hardboiled routine when confronted by one of these scantily clad demonstrators. We know how you feel, flatfoot!

Glamorous Gals

Now girls, we want to be fair about this, but your strik has assumed the proportions of a calamity. Food we ca do without, but cheesecake girls we must have. Let's sta a back-to-the-form movement!

THE COST

OF LIVIN

KEEP

strikers to

time out from picket

for a Gin Rummy ga

Sit-down

We have a plan to settle the dispute. If the bosses wor give in, the customers should be glad to pass the hat. O the other hand, why not let the strike go on? That picks line is something to see! Yeah, you shed it, girls!

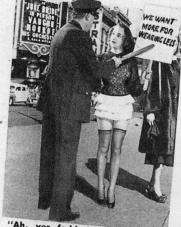

"Ah, yer fadder's got flat feet!" says the babe to the law.

Gams Want

he

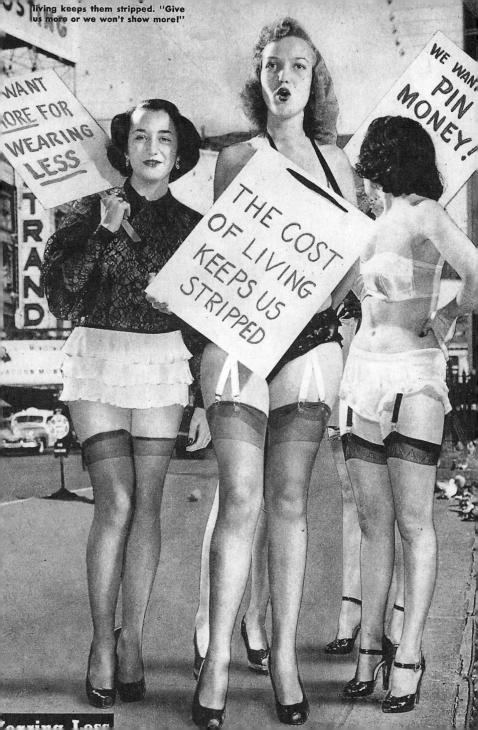

121 CCOOTH HE

JUNE 25¢

> SECRETS OF A STRIPPER Page 26 SPANKINGS FOR WIVES Page 36

KISSING AROUND THE WORLD Page 12

JULY 25

Sneak a peek at the latest arrival from Paris, petite Renee Stewart, curvy and coquettish model whose luscious lines are—ooh, la la! Ravishing Renee, five-foot-three of Parisian oomph, "theenks ze Amairican men are terreefic!" Ze Amairican men—after seeing Renet's luscious curves and trim gams, vote her the cutest package of pulchritude to reach our shores in years! Berd.

STOI

Quick, men! Memorize those lines before gorgeous Anita Collins blows out the candle! This retiring Miss, who's about to be mean and leave us, is one of America's most popular artists' models, and combines a perfect figure with unusually vivid coloring! From her raven hair to her high arched feet in those skyscraper slippers Anita's a dream who's sitting pretty!

INCES

BEAUTY PARADE The World's Loveliest Gr

BEAUTY and the BEAST Page 34

USED MAGAZINE

SECRETS OF A FEMALE IMPERSONATO

eina's curvy con urs peek teasingly trough the flowers

> Another view of the brunette bombshell with the beautiful, dimpled back.

111

A Toast to Rei

ntoxicating

Rosita is Sure to Go to Yo

mber

RINK to me only with thine eyes Baby-says red-headed Rosita Davis, daring dancer at New York's Savannah Club, seen here taking a wee sip of the cup that cheers. A dynamic dish, Rosita has a pair of the most shapely legs around and in her sixinch high heels, she's an exciting toast all over town, say audiences. With her 35-inch bust and other admirable measurements, she's a dazzling darling, eh?

*

ead!

SEAUTY ARADE 2 World's Lovelie

ġ

NOV.

NAUGHTY PARIS NIGHTLIFE

SEX IN THE HILLS

BAUTY ARAD e World's Loveliest Girls

NO BABE IS HARD TO GET

BEAUTY ON

THE MAT

JAN. 250

BEAUTY BEAUTY PARADE he World's Loveliest Girls

MAY

250

DAMES CAN BE POISON!

Ø

BAUTY ARADE World's Low

NOV.

25¢

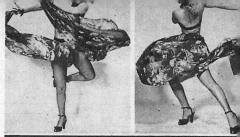

Dagmar is a fast femme with a foot. When she sha

y n a m i c

Da

Dagmar

DAGMAR'S dance is like a Swiss watch. It has a 17-jewel movement. It really ticks. And the way she handles that swirling skirt would get any toreador's applause. Who's Dagmar? She's a New York gal who didn't have to come to the Big City to make good. New York came to Dagmar instead!

, she really shakes it. Swing low, sweet Dagmar!

Dagmar, the blonde bombshell, explodes comph with a bang!

-

BEAUIY SEAUIY PARADE he World's Loveliest Gir

Ø

jan. 25¢

PETCR DRIBEN-

DANCIN' DYNAMITE!

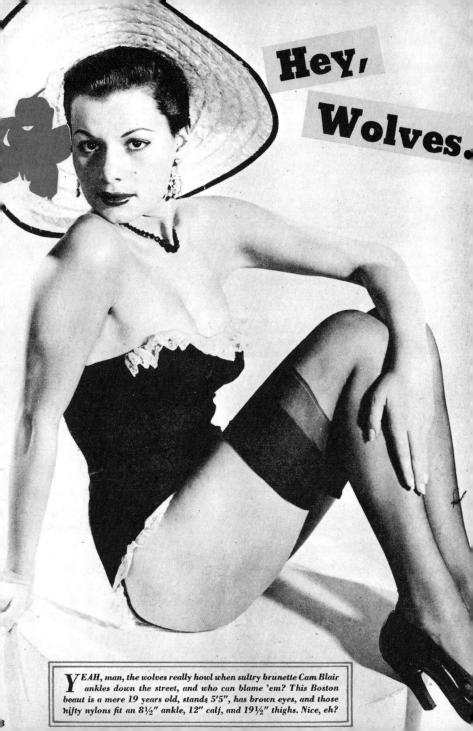

PETER DRIREN-

SPECIAL ISSUE FOR GUYS HUNDREDS OF Beautiful Dolls

25¢

Peep Show

Shh! Secret info on Dee Abel: Red hair, blue eyes, only 21 years old and 121 lbs. And don't tell a/soul we told ya!

> Those natty nylons grace the 30" gams of Janet Fare. Hmm!

X Sec

FROM Napoleon to Pancho Villa, the big military brass has always known that there's nothin' like a dazslin' doll or two to pep up the troops' morale. That figures, and when a babe has a frame like taffy-tressed Nelva Moore (above), the figure is right. This shapely doll stands a trim 5'8" in her sheerest nylons, and measures 35" at bust and hips, 25" at the waist. And Nelva weighs 125 lbs. Like her, GIs? Morale Boosters

HERE'S a case where a Thorn can be a shot in the arm—Thorn Milo, that is, a jet-haired lovely from Idaho who'd be a cinch to knock 'em dead on the batile front or the home front. Thorn has coco brown eyes and a pair of eyefilling gams that measure $8\frac{1}{2}''$ at the ankle, 12'' at the calf, and 20'' round the thighs. This is the deluxe model, Sarge!

BEAUTY DARADE Ne World'e Loveliest Ge

WHAT MAKE MEN BLUSH

JUL

SEAUTY ARADE e World's Loveliest Girls

IS BROADWAY

GETTING

HOTTER?

3

Peter

SEPT. 25¢

Seven Types of Bables:

LOOK 'EM OVER, AND DECIDE FOR YOURSELF. YOU'RE ON YOUR OWN!

THEY'RE nobody's sweetheart now! They may be awfully pretty pal, but they're poison! Run, don't walk, to the nearest escape hatch if you meet any of these seven deadly dames. Once they get their hooks into you, they'll make a toothache feel like bliss, and you'll head for the North Pole. Take Clara, the Weeping Willow, ar Sickly Sue who's always gat a headache. Yessir, take 'em, bays – and duck 'em in the nearest river!

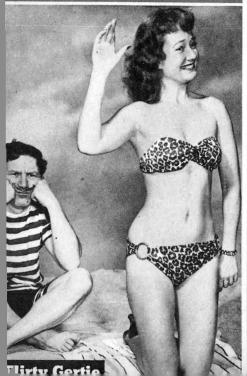

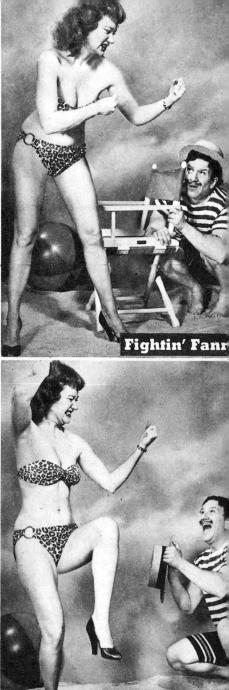

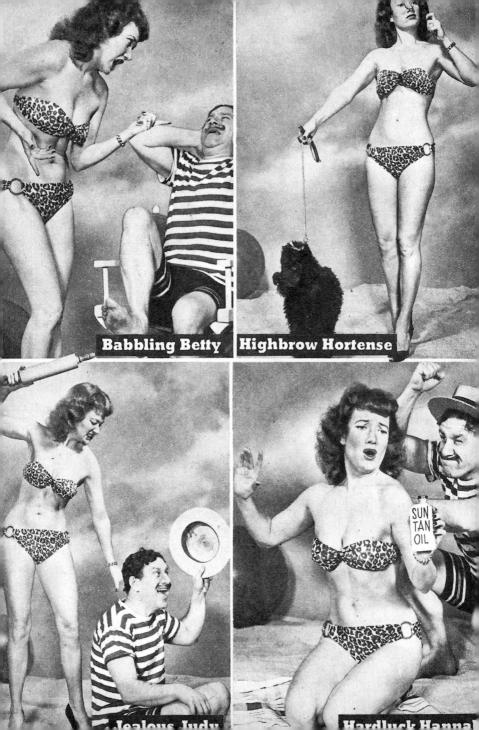

FRENCH BOUDOIR SECRETS

IN THIS ISSUE:

Ż

BEAUTY

PARADE

he World's Low int Girls

25¢

In This Issue: BABES ON THE MAKE

MAY 25¢

BEAUTY PARADE he World's Lovelings'

25¢

Pereil

THE BASHFUL STRIPPER!

P.R.

Gags DOLLS!

> Here's a timely tip from dancer Terry Ryan: "When a girl sneezes, it's a sign she is catching cold – but when she yawns, it's a sign she's GETTING cold!"

> > 31

BEAUTY BARADE 18 World's Loveliest G'

ov. 25¢

01

IN THIS ISSUE: FROM BOP TO BUMPS!

STO

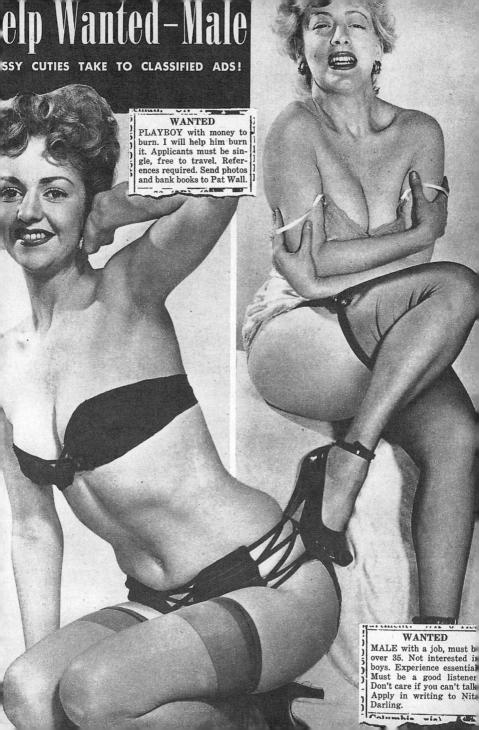

How many honeys can you find in this harem? If you can't spot at least a dozen, you'd better run — do not walk — to the nearest eye doctor!

C

30

26

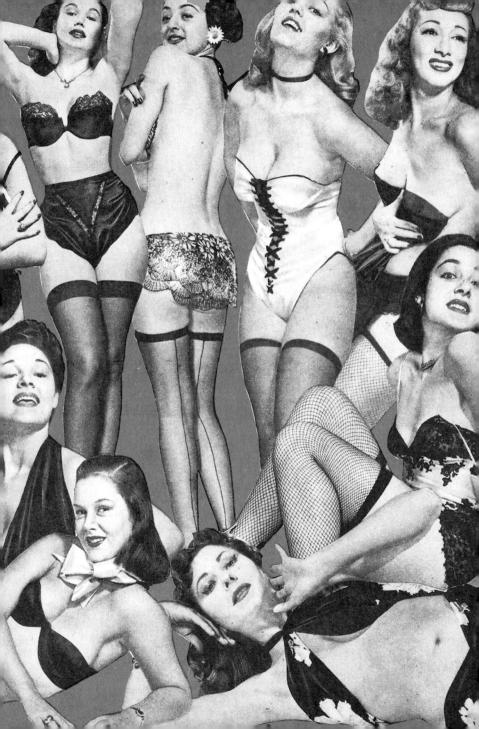

BEAUTY BEAUTY BARADE The World's Lovelie

The FARMER'S NAUGHTY DAUGHTER! SEE PAGE 24

JAN.

254

VOL. 11 JANUARY 1953 NUMBER 6 L. BENNETT, Editor REALE, Art Director

Contents

				Page
LATEST MODELS F.O.B				
WATCH THAT BAG! .				10
STRIPPIN' SIOUX!				12
HOW DO YOU REACT?				14
TEN CENTS A THRILL! .				16
MY MOST EMBARRASSING MOM	IEN	IT!		18
HERE KITTY, KITTY!				20
IT ONLY SEEMS LONGER				22
THE FARMER'S NAUGHTY DAUGHTER!				24
LOVE METER				26
HOW TO KILL YOUR DAT	TE			28
PIPS AND QUIPS				30
MAID IN BRONZE				32
SNAPPY STORY				34
MOVING PICTURES!				36
LISA FEY				39
WOTTA DREAM!				41
CURVY MEMO				43
JEAN DUFFY, TYRA MON	E			44
SNEAK A PEEK!				46
ROMA PAIGE				48

Beauty Forcide is published bitmanship by Beauty Parade, Insta 201 West Sand Street, New York, N. Y. Copyright Instantiation of the second strength of the second August 26, 1248, at the past office on New York N. Y. under the act of March 3, 1877 Single cosy 25c – Yearly subscription 51.50 – Foreign subscription 52.50. All rights reserved by Beauty Parade, Inc. All meterical submitted will be given careful attention, but such material must be mitted got the authors risk. Finited In U. S. A.

ale man

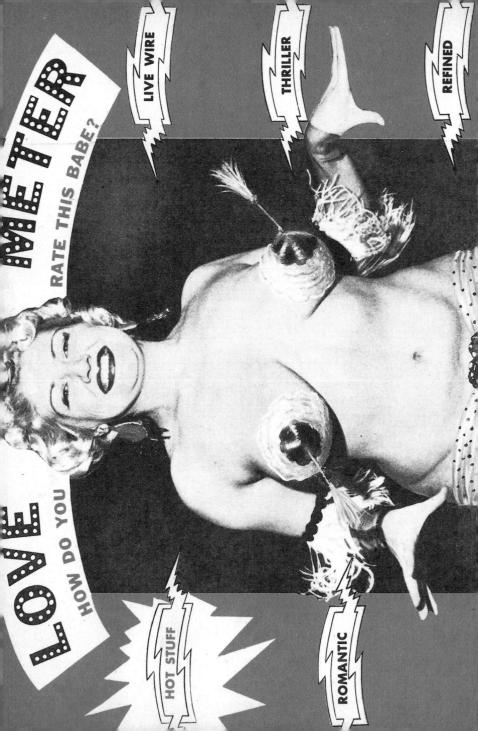

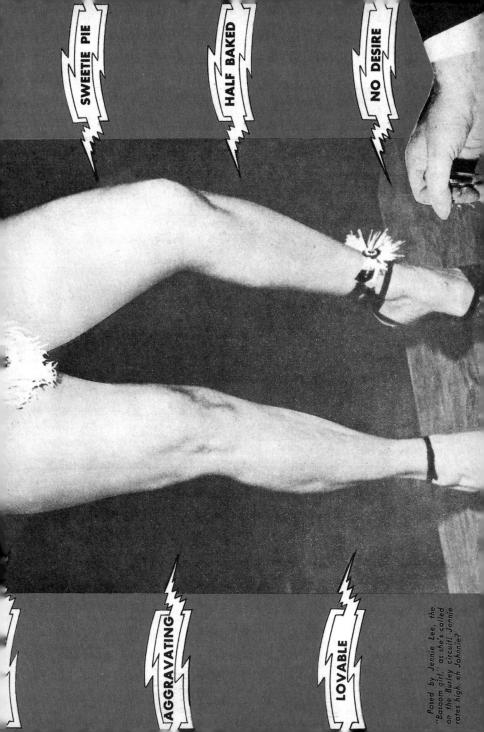

BEAUTY PARADE The World's Longliest Girls

3

GALS WEAR THE PANTS! See page 10

MAR. .

IN THIS ISSUE NAUGHTIEST STRIP IN GAY PAREE!

25¢

SHOWGIRLS MODELS PIN-UPS

SPIDER And The GUY!

The

"Ahai" said the Spider. "And what do I spy?"

"Come into my parlor!" said the Spider to the Guy!

2.

THERE ONCE WAS

WHO GOT CAUGHT

N A WENCH'S WEB!

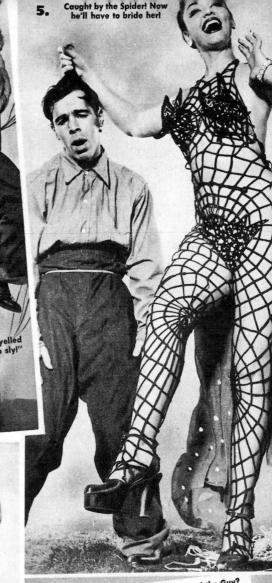

"Not for me!" yelled the guy. "I'm too sly!"

"Aha, dear Jeb, what think you of my web?"

VER hear the story of the Spider and the Guy? Saddest thing you ever knew and sure to make you cry! The Spider, tall and tempting, set her eyes upon the Guy! And first he knew she had him hooked, 'n' hangin' high and dry!

His name was Jeb, and in her web the dopey clown did fall! Now he's caught, and though he

fought, he ne'er gets out at all So heed this tale, stranger, and save yourself

headaches and tears! You ain't no match for a Spider if she's one o' those wily dearst

10

25¢

SHERRY BRITTON ON PAGE 32

Whirl girls

Steffa

BROADWAY HOLLYWOOD NITECLUBS

STRIPPIN' PIPPIN

NEW BLONDE TORNADO has the boys at the burleycue strainin' their eyes as she does her stuff. Terry Jean, known as the Bundle of Beauty, has the statistics to merit the Bitlel She's 5'2'', weighs a bare 105 libs, but has 36'' bust 'n hipsi Ibs, but has 36'' bust 'n hipsi This torrid torso-tosser from Mean phis prefers dark-haired men who are very masculine—even rough!

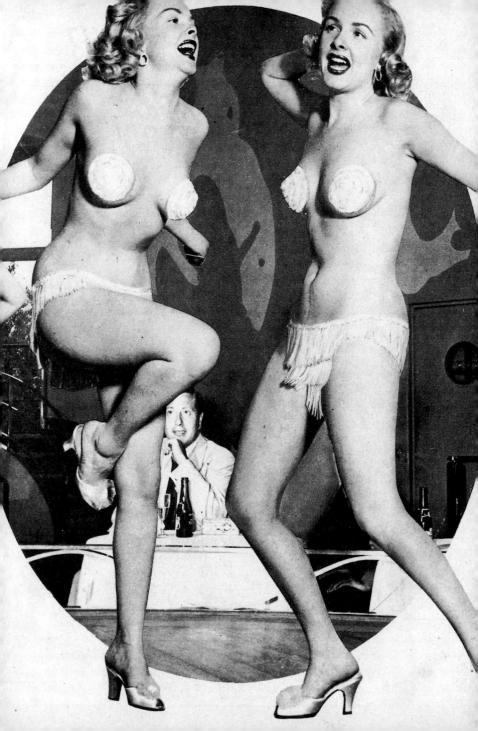

EAUTY ARADE e World's Loveliest Girls

Four Lies About Blondes Zing On A G-String

> Peter Drigen

jan. 25¢

EAUTY ARADE World's Lovelin

55 APR. 25c

NAUGHTY PARIS NIGHTLIFE

CLASSIFIED CHASSIS!

PETE

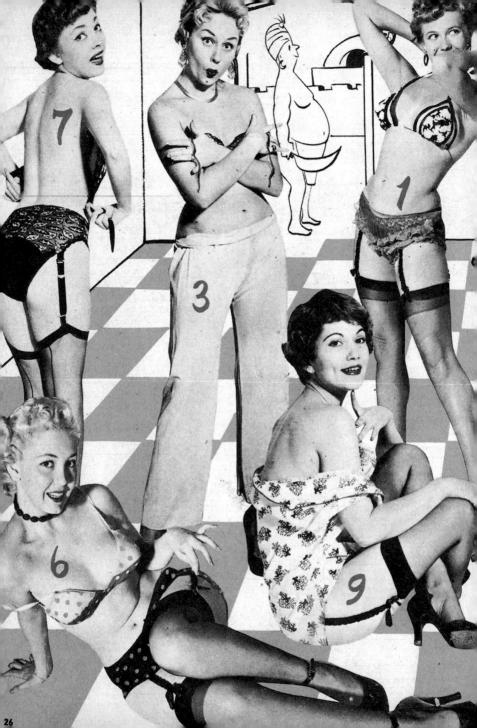

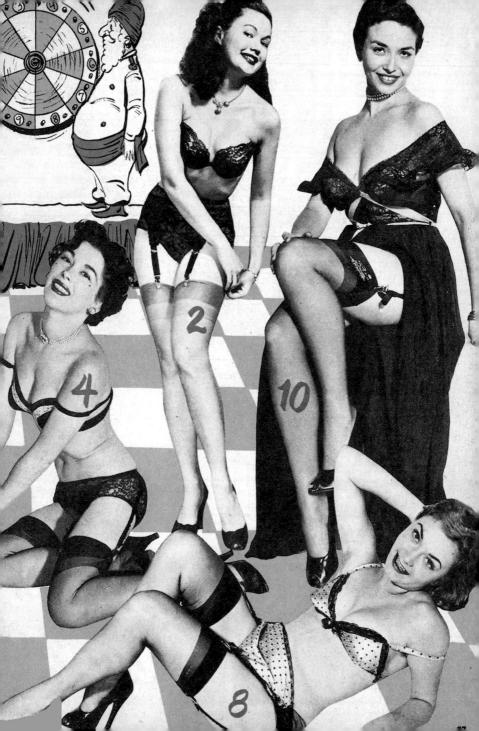

BEAUTY BEAUTY PARADE The World's Love!

10

TOO TORRID FOR T.

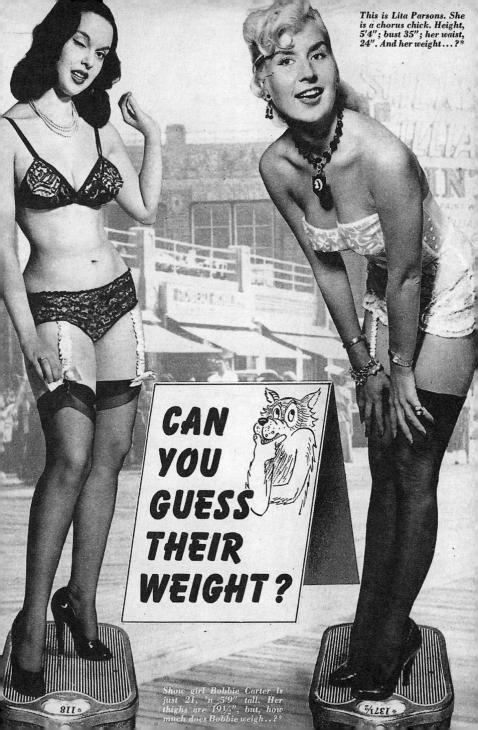

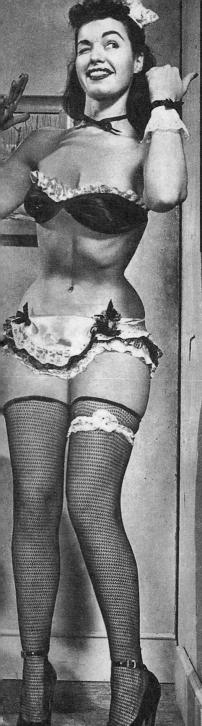

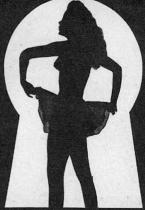

"Why ees eet I don't look so good in ze lace scanties like Madame?" You look pretty good, Marie gal!

...what th Frencl Maid saw

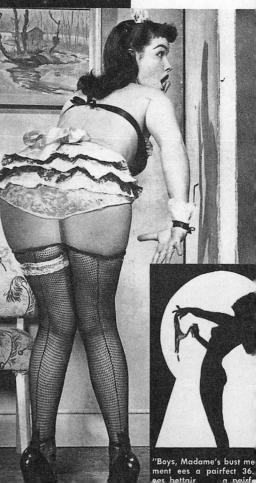

"Ah, ze nylons she take off! Weesh I owned them. I theenk my stems are bettair than Madame's, eh, boy?"

Ø

OH, THE THINGS A FRENCH ND SEES WHEN SHE PEEKS!

MADAME comes out of ze boudoir and catch naughty Marie peeping through ze hole, zere weel be new job open for ebody! It's ze scandal of Paree ze way rie peek on her curvy boss, Gaby Bleu re Folies Bergere!

eems like a waste of time to peek at dame, but wise Marie say you never can when it might be real fun!

"Zis ees shocking! Such a shape. Like ze American ciggrette so round so firm "

Trade-Mark Reg. U. S. Pat. Off. VOLUME 15 FEBRUARY 1956 NUMBER 1

L. BENNETT, Editor

REALE, Art Director

Contents

		Page
THESE TEACHERS ARE PETS		8
LITTLE GUYS HAVE IT TOUGH!		10
WHAT YOU DON'T SEE IN SIBERIA!		10
WOLF BAIT!		14
HOW TO HANDLE TWO BABES AT ONE TIME!		16
GORGEOUS GLORIA DE HAVE	N	18
CAFE DE PARIS		20
STORY WITHOUT WORDS .		22
THE JEAN HARLOW OF THE RUNWAYS!		24
BETTIE PAGE		26
UP IN CLEO'S ROOM		
WHAT'S THEIR LINE?		30
"MISS EVERYTHING"		32
THE BABE AND THE BARKER		34
ARE YOU SLIPPING?		36
CASSIE TYLER		39
SIGHTS YOU'LL NEVER SEE!		41
BABS BAIRE		43
"IT ISN'T OFTEN ONE SEES A DERBY THESE DAYS	!"	44
MISS DIXIE		46
NICE FORM!		

Beauty Parade is published bi-monthly by Beauty Parade, Inc. 1897 Bradway, New York 19, N. Y. Copyright 1955 by Beauty Parada, Inc. Entered as second-class matter August 26, 1948, at 1the past office at New York, N. Y., under the act of Marth 3, 1879. Single copy 25c – Yearly subscription 31.50 – Foreign subscription 325.0, All rights reserved by Beauty Parade, Inc. All material submitted will be given careful attention, but such material must be accompanied by sufficient pastage reterun and is submitted at the author's risk. Printed in U. S. A.

ROMA PAIGE

Glorífying the

American Girl

1943–1955

Why change a successful recipe? The subtitle trumpeted "Girls, Gags & Giggles", and that was what the pages served up. Besides ogling starlets in swimwear, backstage photos from the nightclub world or harem beauties, the reader could chortle over cartoons or follow the progress of models through two- to four-page photostories as they flitted through their apartments, washed their nylons in the sink, romped around the swimming pool in marine look, or demonstrated incredible incompetence attempting some technical task. That each of them, no matter how intimate the surroundings or sweltening the heat, was wearing enough by today's standards to fully clothe a crowded pool was not just to appease the censors. Harrison himself found nudity offensive. It was only after the war that Eyeful, like the other magazines, managed to appear on a steady bimonthly basis.

When Eyeful bade its readers goodbye in April 1955, the pin-up paintings on its covers had long been superseded by photos. The subtitle now proclaimed "Glorifying the American Girl", and Betty Page posed as the centrefold, having started out on her road to fame in Harrison's magazines four years earlier. Warum ein Erfolgsrezept ändern? "Girls, Gags & Giggles" prangte auf dem Titel, und das war Programm. Zwischen Cartoons, Starlets in Bademoden, Backstagefotos aus der Nachtclubwelt oder Haremsschönheiten darf man verfolgen, wie Models in zwei- bis vierseitigen Fotostories Fliegen durch ihr Appartement jagen, ihre Nylons im Spülstein waschen, im Marinelook am Pool herumtollen oder außergewöhnliches Ungeschick bei handwerklichen Arbeiten demonstrieren. Daß jedes von ihnen auch im privatesten Rahmen und bei außerordentlicher Hitze genug Stoff am Leib trug, um damit ein gut besuchtes Strandbad heutiger Tage komplett anzukleiden, lag nicht nur am Respekt vor den Zensurbehörden. Es heißt, Harrison selbst habe Nacktheit als anstößig empfunden.

Wie die anderen Magazine erlangte auch Eyeful erst nach dem Krieg eine regelmäßige zweimonatige Erscheinungsweise. Als sich Eyeful im April 1955 vom Leser verabschiedete – der Untertitel lautete nun "Glorifying the American Girl" –, posierte Betty Page als Centerfold. Vier Jahre zuvor hatte sie in Harrisons Magazinen ihren Weg zum Ruhm angetreten.

Pourquoi changer une formule qui marche ? Le sous-titre accrocheur «Girls, Gags & Giggles» était en soi tout un programme. Entre les dessins humoristiques, les starlettes en costumes de bain, les photos qui montraient les coulisses des boîtes de nuit et les belles pensionnaires de harems, on pouvait suivre, racontées sur deux, trois ou quatre pages de photos, les péripéties de modèles qui, sans jamais connaître l'ennui, chassaient les mouches dans leur appartement, lavaient leurs bas en nylon dans l'évier, folâtraient en costume marin au bord de la piscine ou déployaient une singulière maladresse au niveau des tâches manuelles. Le fait que chacune d'elles portât, même dans l'intimité ou par une chaleur accablante, suffisamment de tissu pour vêtir aujourd'hui toute une armée de baigneurs ne tenait pas seulement à la crainte de la censure. Harrison lui-même aurait en réalité ressenti la nudité comme quelque chose de choquant. Comme pour les autres magazines, ce n'est qu'après la guerre que la parution de Eyeful prit son rythme de croisière d'un numéro tous les deux mois.

Lorsqu'en avril 1955, Eyeful prit congé de ses lecteurs et prit comme nouveau sous-titre «Glorifying the American Girl», Betty Page occupa la double page centrale. Quatre ans plus tôt, elle avait commencé à gravir le sentier de la gloire en posant dans les magazines de Harrison.

EVIES of

steffa

ma 2:

EXEFUL An Eyeful and an Earful

MARCH 1943

VOLUME 1, NUMBER 1

GAGS AND GIGGLES . . 8, 17, 24, 32, 39, 43, 49, 53, 56, 63

COVER BY STEFFA

TONY LEEDS, EDITOR ART DIRECTION BY MAGAZINE ART

Eyeful is published bi-monthly by Eyeful Magazine, 220 West 59th Street, New York, N. Y. All rights reserved by Eyeful Magazine, Alt material submitted will be given coreful attention, but such material must be accompanied by sufficient postage for return, and is submitted at the author's risk. Printed in U.S. A.

26

34

40

50

54

ls + Gags + Gíggles

AN EYEFU OF BEAUTY AN EARFU OF FU

2.

Streamlined

25

BEAUTIES * Screamlined

GAGS

THIS GAL ROLLS HER OWN

TRIX

ON A

BALL

Trixie's a gal who sure knows her stuff with that rubber ball. She learned it from bouncing around in night clubs with a guy who passed rubber checks. But the juggling's something she inherited from her grandfather, who used to be an accountant before the Government gave him a long run. That guy juggled his company's books so well that he got \$10,000-and ten years. Balancing one of these spheroids isn't easy, gang; it's all in the poise you have. And, even though Trix has plenty of poise around her all the time (she can't get rid of them), it's still a neat trick. In fact, she's a pretty neat trick herself! Incidentally, Trixie's a gal who doesn't have to worry about priorities, even if there is a shortage on rubber, because she can always count on you guys rubber-necking.

> "Gosh, I'm warm. Guess I'll treat myself to a highball!"

Looks like the "Standing Room Only" sign is out —and it's a pretty sign! Are you sighin'?

> The little ball goes 'round and 'round and where it stops ---Trixie nose!

"Heavens, I feel just like the slipping beauty. And I'd better wake up before this ball is over!" "Aw, gosh, I wonder how I got myself all balled-up like this?"

The reason Trixie always wears a leopard skin costume is because she likes to pick her spots. And the spots we have before our eyes now, Trixie, sure are a treat. The customers just flock to the night club where our little bouncer docs her act, because they never know where this incendiary blonde is going to land next. The ball our sweetie is using, is genuine India rubber, so you'd better be careful Trixie doesn't get India heart! Or maybe you wouldn't mind that at all, eh? (It's O.K. to stretch for a gag like that, lads; after all, this is an elastic subject.) Incidentally, Trixie isn't only good with rubber balls, but you should see her with a couple of highballs. She not only makes a hit everywhere she works, but she's made a hit with everyone with whom the ball comes in contact. Step aside, gang, and give our artiste some elbow room -she's a gal who believes in rolling her own! Well anyway, it's time to move on, boys, the ball is over.

Some wise guy tried to elbow himself into this picture but Trixie got there first!

A neat trick, Trixie, in fact, what could be neater, chums?

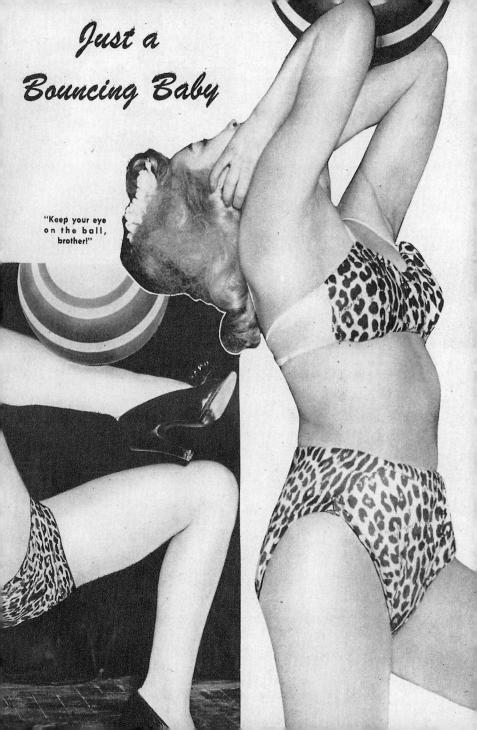

ls * Gags * Gíggles

IG I E

C

BEVIES @ BEAUTIE

Popular PIN-U Models

21

Something for the BUOYS

One thing the Hollywood lovelies like to do with their time off is swim. And no wonder. You see, an eyeful like Carole Landis gets along swimmingly everywhere, in fact, she sure is some one to wave about! Well, we think we'll go fishing now, down by the sea. Just to see if we can Landis a honey like Carole. Or do you Carole a lot for her yourself? After all, you must admit she is a sight to sea!

This is one of the new swim suits — swimply lovely and no waste either.

Walnut

h! Beauty an he Beach water peach

ls * Gags * Gíggles

1551 2:

A RIOT of BEAUTY A MIRTHQUAKE of FUN

525

Here's lovely Minerva Chancellor, boys, an Earl Carroll sighfull, and she's sure a sigh for your ayes.

Sighs Right!

15: 2

A WHIRL & GIRLS

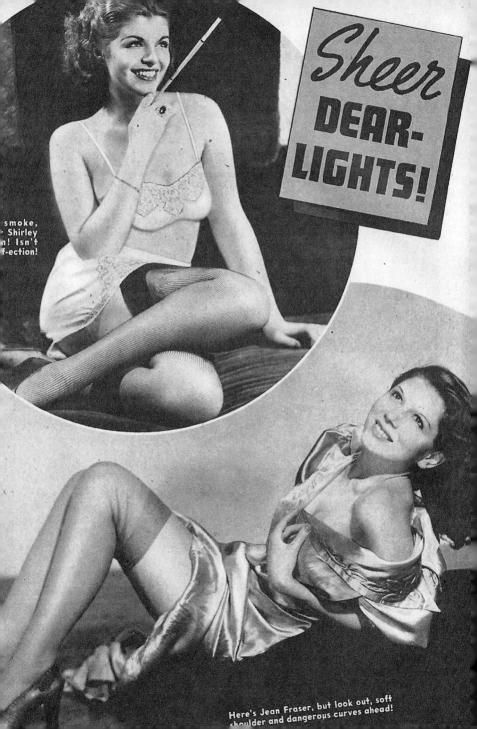

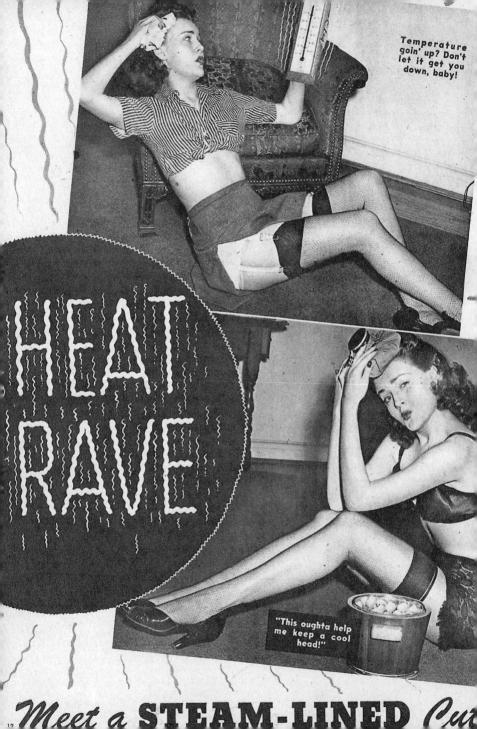

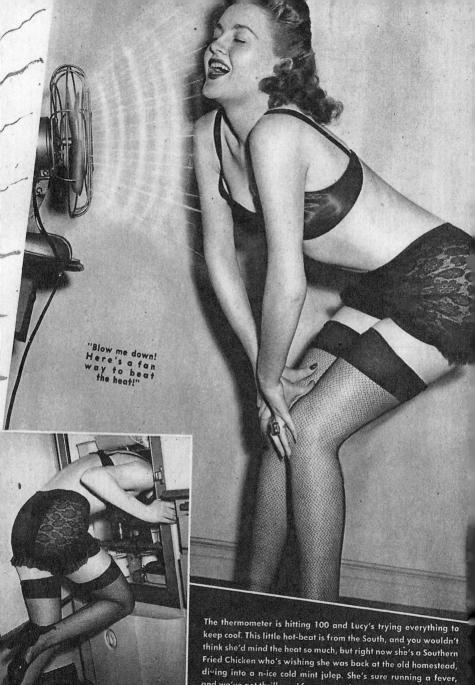

Ah-just a frigid-dear tryin' to keep cool!

and we've got thrills and fervor ourselves just watchin' her! Well, if there's any way to get cool, our heat rave will be shower to find it—you can blaze your bets on that! If she doesn't, guess we'll just have to put har in the - it t

UE

ida 30c

OVER 100 GORGEOUS GLAMOUR GIRI

Jerry Deane

How would you like to megaphione call to lovely Jerry Deane? Isn't she hooray of sunshine?

CREAMLINED

ls * Gags * Gíggles

50

Bevies of EWITCHING BEAUTIES

ziny De Vor.

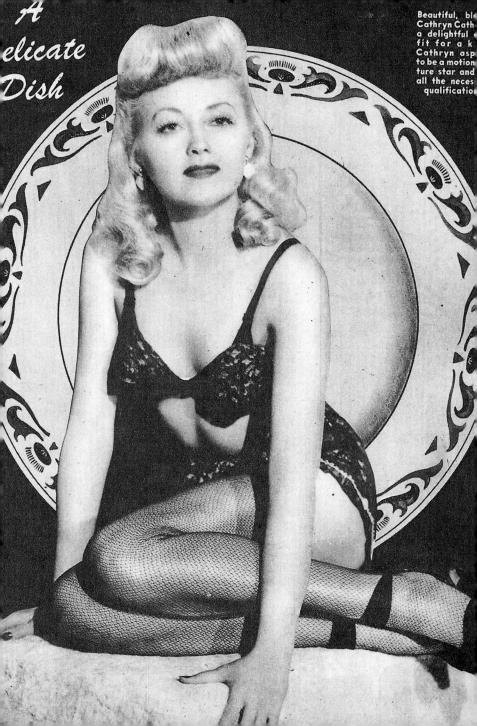

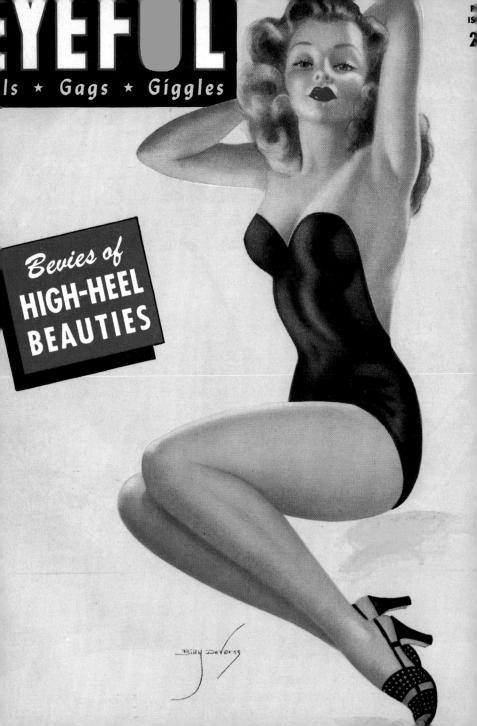

GH-HEEL AUTIES

14

Bewies of IGH-HEEL EAUTIES

fying the American Gir

HIGH-HEE BEAUTIE

775

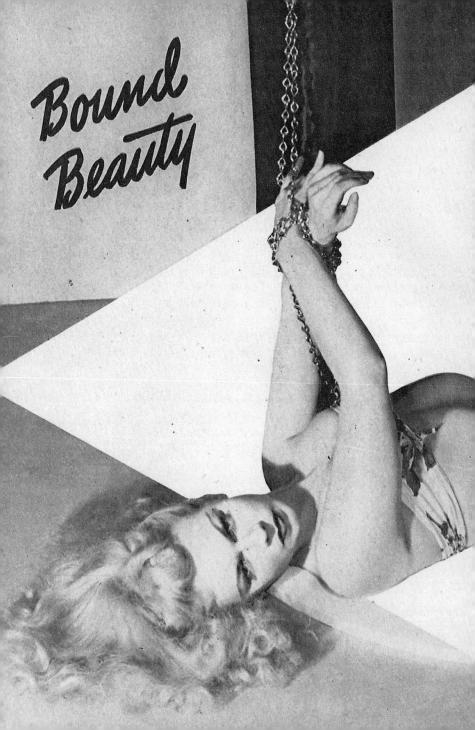

A bewitching blonde beauty is Eve Rydell who so thrillingly throws herself into the role of a bound beauty. Eve's fame as a model has long been established. Now she aspired to score as an actress. If any producer has cause to doubt the histrionic ability of this exquisite eyeful, all that he has to do is catch the intesity of her enactment, the amazing depiction of her sorrowful resignation. We feel justified in predicting that Eve will soon reach the peaks of Broadway stardom.

orifying the American Girl

HIGH-HEEL BEAUTIES

A TERRIF U TRIO

For every taste-we offer every type, in this all inviting trio of terrific tootsies who combine all the attributes of feminine pulchritude to spell-perfection.

STAL IES

1

PAT JOYCE VIDA ROBER

EF rifying the American Girl

]

1

HIGH-HEE

C

re is plenty of girl, s, with plenty of ves – and all in the ht places. She's Roz eenwood, and all 6 t of her, spell full, ninine beauty. A ht corset transforms r figure into increde proportions with a -inch waist below a ' inch bust and a 39 inch hipline.

ASP-WAISTED

Amazon

6

MANN

THINK W MUM

1. Doesn't the key fit? Maybe that's because it's a keys in the dark! She

went

on a

HING

TRUNK and DISORDERLY

2. Still playin' with that lock, aby? On you it locks good! Gee, honey, hat coat and kirt would suit anybody.

Did you ever plan a trip, gents, and try to pack a trunk? Well, here's Julie, a gripping beauty right in the muddle of packing. She's having the time of her life, and, if she has any more trouble, she's gonna call a valise-man. Don't be too worried, honey, 'cause if you ask us, everything is in the bag. For some reason, even the lock won't catch, and it's beginning to look like our honey is out of lock. 4. If you're han panties on a han we'll step-in a hanger round

5. Gee, you're sure pressin the clothes in that trunk "Well I like 'em well-pressed.

8. Honey, just luggage y

(()

ζ 🤰

Ser a

-

5

7. If that trunk does close soon, baby, yo have to call a vali man. Don't crawl into the ink, somebody may iwl the express company.

> 10. Hay, fraulein, you look lovely in a trunk. "Oh, trunkashein."

Π

How poor Julie struggled to clothes the trunk! When the babe sat on it, the lock slipped. When toots stood on it, toots slipped. Gee, it got so bad that cutie removed all the petticoats just to eliminate the slips. "But I had to give it up, boys. Somehow, I was barkin' up the wrong tree." (No, sweetie, you were lockin' up the wrong trunk, that's all.) But finally Julie got a swell idea. The babe emptied the trunk and packed herself inside. "Now maybe they'll send the trunk to Europe." Yeah, in a trunk, Julie's bound to go a-broad.) Gee, fellers, get your suitcases. If your suitcase is really a cowhide, then it's big enough to hide a wolf. But valise hurry, boys!

HIGH-HEEL BEAUTIES

2

HIGH-HFFI BFAUTIFS

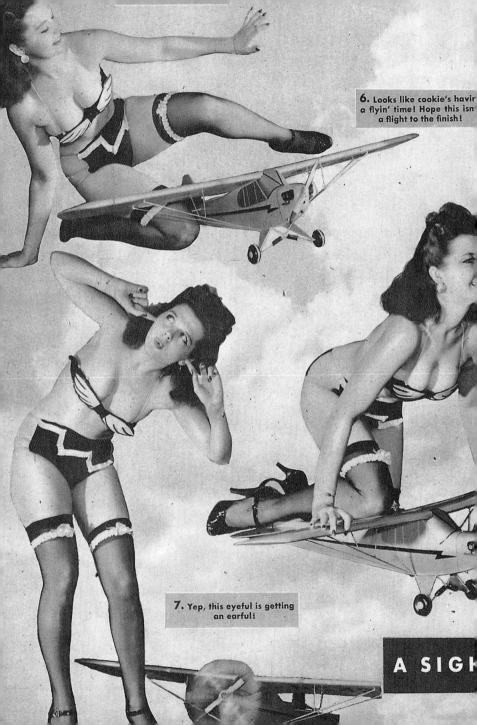

Contact? Contact! And away we go up into the clouds! Yeah, Elmer, no matter where this baby goes, there's always a cloud (of boys!) following her! Isn't it wonderful up here with Marie? Honey will never let you down, but you'd better make sure you've got your parachute anyway! Whee, our angel can certainly handle a plane. This darling must be from Chicago 'cause she can really knock you for a Loop! Hey, sweet, where have you spin all our life? Gosh, look out! Someone started singing, "Roll out the barrel!" and now baby's going into a barrel roll! Jump, fellows, jump! If your parachute doesn't open, they'll exchange it! Wow, from now on we stay on terra firma, 'cause the more firma, the less terral

8. Our darling's slippin That's no altitude to tak

9. As long as you're fall babe, how about giving tumble?

OR SOAR EYES!

orifying the American Girl

UICU UEEL DEALITIES

PETER DRIBEN- FEB 25

YEFUL ifying the American Gir

0

25

PETER DRIBEN-

HIGH-HEEL BEAUTIES

Help yourself to half-a-dozen long-stemmed

2460 14

dei

BETTY HOWELL-Buxom bachelor's button

> MLLE. FLEURETTE coquettish camelia

ican beauties.

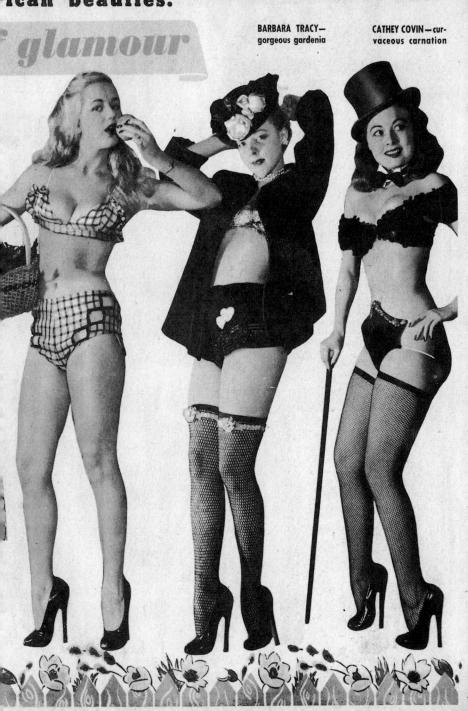

PETER DRIBEN-

22 R 2

Bevies of

HIGH-HEEL BEAUTIES

Precious Pixy

U V V V V

Here's a precious little package of feminine loveliness all done up in a slinky black chemise, destined for immediate delivery to the environs of your bedazzled eyes. So feast upon the many charms of slim and svelte Penny Enders—charms that encompass a 34 inch bust, a slight 25 inch waist, and 34 inch hips.

ч ч Ч ч Ч ч

A

e j

HIGH-HEEL BEAUTIES

can trifle with the affecf this femme fatale. Her ack eyes shoot sparks of a her glance makes the st cringe. Her whip hand irmly about the head of chide lash as Chici Peters picts a wild Apache.

Jearless Femme

*

PETER

DRIP

SILK STOCKING SIRENS

YEFUL ifying the American Girl

PETER DRIBEN-

VEY CORSET CUTIES • HIGH-HEELED HONEYS • FIGHTIN' EMMES

FEB. 25°

EVERUL Glorifying the American Girl

RIL 5c

> SILK-STOCKING SIG Brawling Beau Wasp-waisted Ven

orifying the American Girl

HIGH-HEELED HONEYS GRAPPLING GALS CURVEY CORSET CUTIES

PETER

יוחר 25

rifying the American

EF

BUST

HIGH-HEELED HONEY BRAWLING BEAUTS CURVEY CORSET CUT

teducing Specialist Says: LOSE

where it shows most

VEIGHI

"Thanks to the i Reducer I lost i inches around hips and three in around the waist! Spot four the around It's ami Martin, City, N. ng

REDUCE most any part of the body with

iss Nancy ace, Bronx, Y., says: "I ent from size dress to a size with the use the Spot Re-used it."

the a maric wand, the "Spot Reducer" way our every with. Most any part of your where it is loose and flabby, wherever a have extra weight and inches, the "Spot outer" can aid you in acquiring a youth-it, slender and graceful figure. The beauty of this scientifically designed Reducer is that the method is so simple and easy, the results quick, sure and harmless. No exercises or starvation dets. No steam-bath, drogs or laxatives. Thousands have lost weight this way- in hits, abdomen, Thousands have lost weight this way-in hips, abdomen, legs, arms, neck, buttocks etc. The game method used by many stage, serven and leading reducing salons. The "Spot Reducer" can be used in your spare time, in the privacy of your own room. It break, down fatty tis-sues, tonce the muscles and fiesh, and the increased, awakened blood circulation awakened blood circulation awakened blood circulation carries away waate fat. Two weeks after using the "Spot Reducer." look in the mirror and see a more glamorous, better, firmer, alliamer figure that will de-light you. You have noth-ing to lose but weight for the "Spot Reducer" is sold on a on .

MONEY-BACK GUARANTEE with a 10-DAY FREE TRIAL

' the "Spot Reie wonders for ou as it has for thers, if you don't se weight and ches where you ant to lose it ost, if you're not 10% delighted 10% delighted ith the results, our money will be sturned at once.

Marle Hammel. New York, N. Y., says: "I used to wear a size 10 dress, now I wear size 14, thanks to the Spot Reducer. It was fun and I en-joyed it."

large size jar of Special Formula Body assage Cream will be included FREE with ar order for the "Spot Reducer."

AAIL COUPON NOW!

THE "SPOT REDUCER" CO., Dept. GP 871 Broad St., Newark, New Jersey Send me at once, for \$2 cash, check or money order, the "Spot Reducer" and your famous Special Formula Body Massage Cream, postpaid. If am not 100% satis-fied, my moncy will be refunded. Name Address City. State

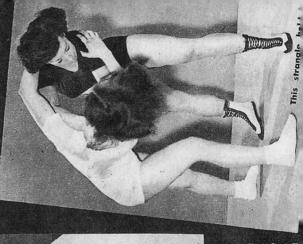

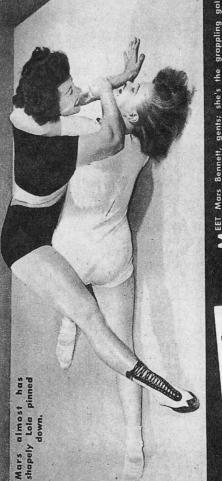

sport -uoW queen country's was challenged coordination and gents; she's the grappling any field, new blonde and shapely Lola black trunks, and she's the new of the to the natural make her tops in is one when she Mars took the Mars has and water. Mars maidens. muscled acrobats, ş Bennett, would wrestling match beautifully mat the that aerial \$ Mars wearing of America's duck agility foremost EET tague, 0 Z like and 2

1. If you're looking to Buffalo, toots, don't er any. It's bison!

2. Gee, sweet, you really look like the neatest trigger the week!

IF ALL INDIANS WERE LIKE BILLIE, WE'D HAVE NO SQUAW-KS!

4. Hmm. looks like our baby is making whoopie!

Indian. Look out, we're on the squaw-path!

BILLIE was a quiet gal till someone told her Buffalo Bill Cody was her great uncle. Yessir! The babe went out West and bought herself an enticing little cowboy outfit; that is, everything except the pants. You see, Billie had decided to give up men, and the cute kid didn't want any chaps hanging around! Well, one morning Buffalo Billie, armed with lasso and pistols, set out to hunt for Buffalos. "I'll be able to find 'em by the smell," Billie thought. "After all, they say buffalos are extinct!"

lalo Rillie 50 knots per nour!

BUFFALO BILLIE (Continued)

After a long, long hike across the range Buffalo Billie finally sighted a buffalo. The cutie began to tremble with excitemen She knew the hide of the buffalo wa very valuable. Our babe didn't know whe the hide was used for, except that she knew amongst buffalos, wearing a buffal hide was considered the hide of fashion Anyway, our dauntless huntress advance bravely on the unsuspecting buffalo. was a big moment. Suddenly, Billie sprans

5. Ah, Billie is on the march. Naw, she ain't no tramp!

OUR HONEY IS DRESSED FOR AN-SWERING THE CALL <u>OF THE WILES!</u>

7. Billie's aiming her gun at a pawn broker (must be the Loan Ranger!)

> 8. Well, whaddya know, a buffalo nickel. Ah, pinknees from Heaven!

sweetle grappled with the buffalo, after a flerce struggle our Billie was phant. Yep, Buffalo Billie had capa buffalo! In fact, the shiny, new o nickel lay in her hand utterly less! Please fellows, put down that Gosh, don't hang us just because owe from a high-strung family. We

ot a bum steer! We thought Billie a buffalo hunter, and it turned out id was a fortune hunter after all! NICKEL

Orifying the American Gi

25

HIGH-HEELED HONEYS FIGHTIN' FEMMES LONG-HAIRED LOVELIES

rifying the American G

FASHIONS, like the seasons, constantly come and go—but the sweet little femmes underneath the frilly stuff remain always the same, which is one thing we can be thankful for. Yes, the Form Divine was certainly an architectural job on which no improvement can be made! But those soft curves and thrilling indentations can be made more inviting with tantalizing bits of lace, skimpy patches of silk, and fuffy lengths of tight wool—as we know you'll agree after running your appraising eyes over the three charmers pictured herewith.

Lois Ganz smiles invitingly, with the hope that you'll approve of her stilted pumps, long silk hose, and concealing-revealing panties.

Three Terrific Temptresses Who Boa

Adorable Carla Wynn is a thrilling eyeful in a sheer black chemise bedecked with rows of filmy lace.

ne lush charms endowed upon Sherry ason are made more excitingly bold y the addition of a skin-tight sweater.

OH BOY!

Spine - Tingling Curves and Contours

LONELY? WHY BE LONELY?

America's friendly club will arrange a romantic correspondence for you. Sealed Particulars Free.

DIAMOND CIRCLE Box 1203 Dept.-13, St. Louis, Mo.

GET ACQUAINTED CLUB

If you want a "wife," "husband" or "new friends," tell us your age, description of your "ideal" and by return mail you will receive particulars in a plain sealed envelope of how you can become a member of one of the oldest, most reliable clubs in America representing ladies, gentlemen, in all walks of life.

R. E. SIMPSON, Box 1251, DENVER, COLO. WANT TO STOP TOBACCO?

ALERT DICE MEN Lend the field with Evans 'Improved Tapping Dice. Swift, Sure and Silent. Always ready. Changed in-stantly from fair to percentage and back to fair. Only dice house making a practical shifting weight dice. Passers or Missouta. Each per set \$25.00. Write for free card and dice catalog.

. C. EVANS & COMPANY, Dept. HG-5 1528 W. Adams St., Chicago 7, III. H.

LUNRELI Join old reliable club, 41 wars dependable service, Correntmendens most event dependable service, Correntmendens most event dependable service, esting photos, descriptions RREE.

Parisian Prints offers a completely new set of ACTUAL GIRL PHOTOS available now. So.order immediately. Sent in plain folder. Send \$2.00.

PARISIAN PRINT STUDIOS Dept. HP-5, Box 482, CULVER CITY, CALIF.

BOOKLETS

The kind grown up like, Each one of these booklets is POUKDE NIZE, also contains 81 LL/DETIATIONS, and is foll of fan and entertainment. 13 of these joke book-ter a ALL, DEPERENT, shipped prepaid upon receipt pression of a S1, cash or mount DEPERENT shipped prepaid for 82, cash or mount DEPERENT shipped (.O.D. Print mane and address and mail to; and the shipped prepaid to a star-TREASURE NOVELTY CO., Dept. 31-P Box 28, Cooper Station, New York 3, N.Y.

Illustrated Comic Booklets

Bell our LLUPERATED COMIC BOOKLEPER and other NOVELTTES. Each bookle size 45/22, vor will send 25 assorted bookles prepaid upon receipt of 100 error assorted bookles prepaid upon receipt of 25.00 Wholesal novelly price lits send with order only. No orders sent C. O. D. Bend Cash or Monzy-order.

REPSAC SALES CO. 65 Fifth Ave., Dept. 34-P, New York 3, N. Y.

Lovely Paula King is always the center of attraction. It's easy enough to see why!

Maureen Murphy is desirable little eyeful whose personality attracts like a magnet.

> Above all else, a curvey cutie must be sparkling to have real popularity. Whatever she may possess, all is lost without this one important factor-of which these two honeys have plenty!

orifying the American Girl

CURVEY CUTIES ON PARADE

00000

orifying the American Girl

RIL Sc

EDROOM

MANNERS

Page 20

OW STRIPPERS ARE HIRED Page 24

YEFUL rifying the American Girl

25

ISSES CAUSE ROUBLE Page 30

D.

BODY FOR HIRE Page 20

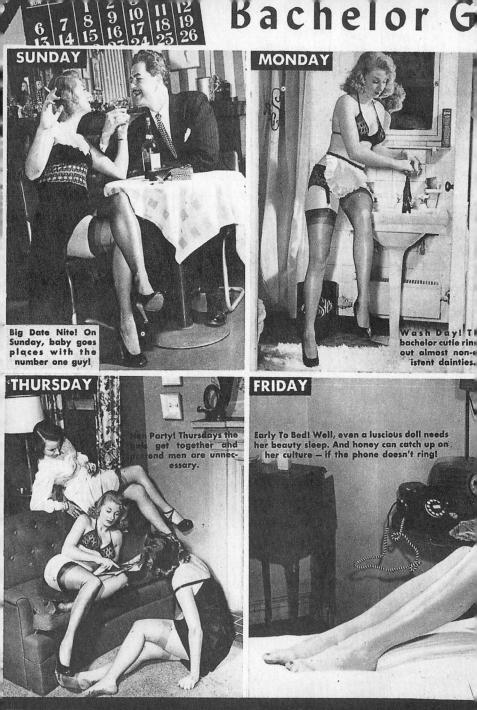

Here's the inside dope on how a lovely bay

l's Calendar

Parlor Duty! The boy friend gets a break Wednesdays – she's very entertaining at home!

SATURDAY

WEDNESDAY

Bath Nite The body gets an extra scrubbing. Hate to see the last of you, bachelor gall

lor gal spends her time all during the week

ifying the American Girl

OMEN ARE

NACKY Page 30

RES FOR ARRIAGE 18

25

MEET another blonde, showgirl Rena Saunders, who owns a pair of the veliest gams in show business, as you can ell see. In a picturesque picture hat and er long kid gloves, she's a dazsler. Those ams, by the way, recently won Rena the tle of Showgirl with the Loveliest Legs. In is picture the pins are encased in the veerest black nylon, something which is heavs a joy for us to see. How about the 'st of you gentlemen?

Delightful

Dreams

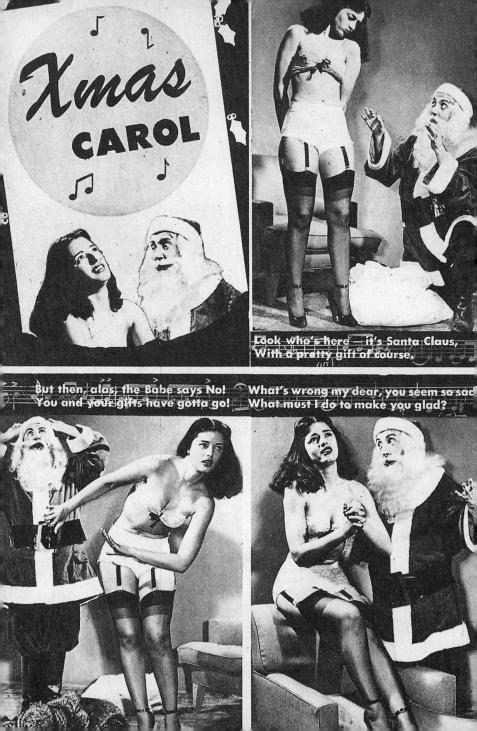

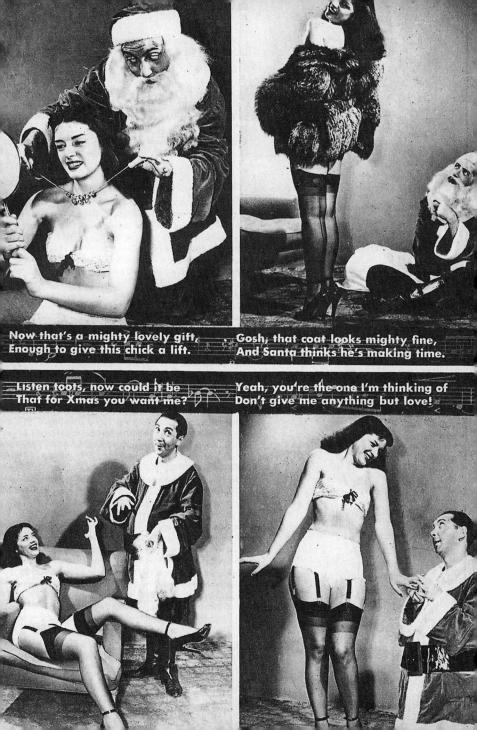

SYLE FUL prifying the American Girl

ст. 5°

SHE STRIPS TO CONQUER Page 18 KINSEY WAS

RIGHT Page 22

SHOWING off a pair of kerchiefs to best advantage is a teasing tid-bit from our box of sweets, luscious Bonnie Adair. From dazzling smile to the bewitching beauty of her perfectly proportioned 108 pounds, Bonnie is a gal designed to set the wolves on fire. O.K., Bud, look but don't touch!

DEC. 25c

10

FIFTY MILLION FRENCHMEN CAN'T BE WRONG

YEFU

rifying the American Gi

ALL BABES ARE WOLVES

FEB. 25°

A teaser. Just beaming the old glamour around and trying to get a rise out of you. Steer clear, Scout!

Time on her bandel May

A perfect bust! Curvy but

She's on the make. Wants a good scout's attentions.

The S.O.S.! What are you waiting for . . . Christmas!

Could mean temper or even passion! What's your guess?

1

ere's

A

ess

Sweet innocence. Good if you haven't much to spend.

....

BOY Scouts and Signal Corps men are not the only ones who can send messages by hand. Every electrifying little doll can give you a charge by the flutter of a teasing pinkie inviting you to love. At the same time, she can shut off your current, make you blow a fuse, when her hands signal, "No, no!" just when the goal is in sight.

So don't be a Tenderfoot! Learn the code and be her Scout Master! Put plenty of feeling into this subject and you'll be surprised at how far you progress as teacher makes some interesting revelations.

orifying the American Girl

a

TRUE OR FALSIE

MADE FOR LOVE

ifying the American Girl

YEFU

QUEEN OF THE RUNWAYS

IS APPLEGATE

HOW TO STAY A BACHELOR

SORRY, boys, you're only allowed one look at lovely blonde Vera arret, a winsome, blue-eyed 6-footer 'rom 'Frisco.

Of course, a wise driver takes it casy when he comes to soft shoulders, so if you make it a real loong look, you can't be blamed for that! Easy loes it, we always say. Whatta you ulways say?

43 fying the American Gi

5

25

BLIND DATES

CAN BE FUN

MARY COLLINS

When Norma draws her bow, every Joe in sight wants to be her beau! Bell

S HE shot an arrow into the air, it fell to earth she knew not where. Beautiful blonde Norma Bartlett loses more arrows that way! But Norma's not worried, Oscar -with a face and frame like hers she's got li'l Dan Cupid on her side, and between 'em, they can't miss! Who's duckin'?

ith a Bow

RIAN SAVAGE

ARE YOU DATE BAIT?

25

SPEAK up, chum! It's O.K. to rave about this blonde vision! Here's Joy Lane, 5'5" of ermine-wrapped, blue-eyed Georgia peach! Joy's 118 lbs. of sheer beauty, and just 21!

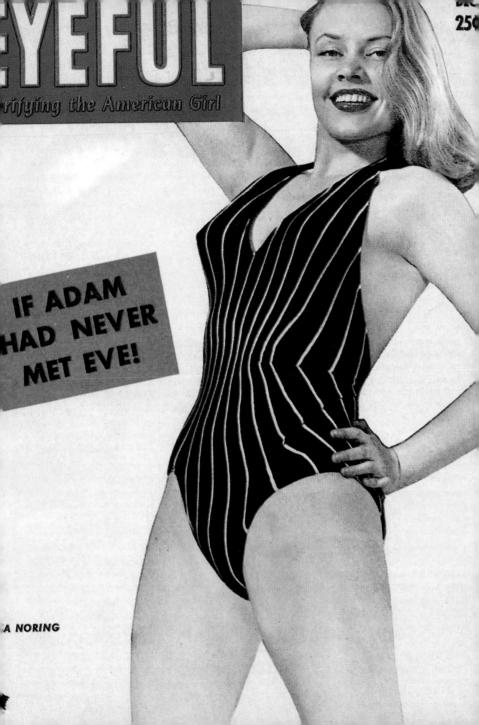

orifying the Ame

25¢

FEMME FIGHTERS RE COMING BACK!

LIE NELSON

Honey's very happy, pals. She interview-ed a soda jerk and picked up a scoop!

ma kante Winf

erkl

oing Tr.

Tangletov

Atlins Tarster

Headline Honey

YETCHA mawnin' 🗸 papers, fellers, all of the news you wantta read! It's the whirl before your eyes, brought by cuddly Marge Wilson, a neat 5' 4" of flash from Pittsburgh, Pa.

Extra! A Blonde in the Ne

Helenson and

Trib

n

30

flerk Wi

Sing Trik

unga Wins T

Sing Tr.

us Ta. ms

Tangleto

Good for a Headline Any Day in the Week. Extra!

INEFUL rifying the American Giv

A PAIGE

LOADED WITH G. I. Dream Girls

25

THREE-MASTED SCHOONER LOST IN THE WAVES

E VERYBODY'S playing the new game of handies! It's gay, it's funny, and it's simple as whistling at a beauteous babe. All y'gotta do is make with the imagination, strike a pose that illustrates your idea, and say, "What's this?" Just to make it easier for you, curvy Kate Darling shows you how it's done in these photos. If she can do it, so can you, chum, so let's go! Ready, boys? Turn on the guess!

CONTENTED COW

What's 7his?

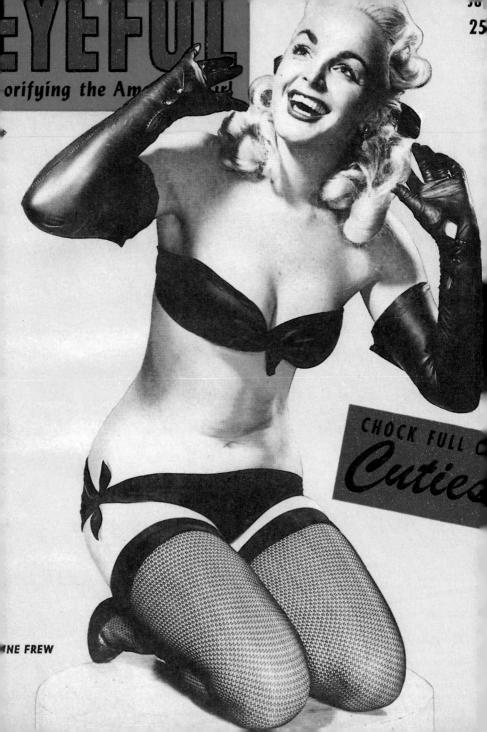

orifying the American Girl

OT PEPPER ROM PARIS

LIS APPLEGATE

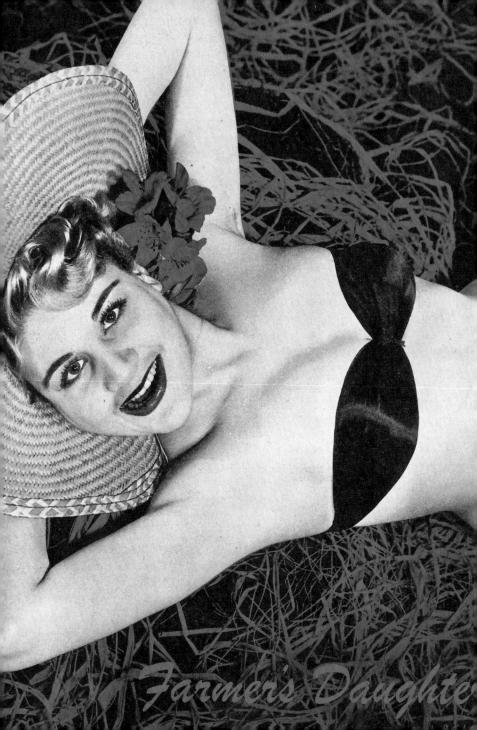

Now listen here, all you travelin' sales. men, take a long linguity sales. men, take a long, lingerin' look at this farmer's daughter and you'll forget about all the others you been talkin' about. The ash-blonde beauty with the laffin' brown eyes is Ero Michaels, from way out in Ioway where the tall corn grows. Seems like the honeys grow tall out there, too, 'cause Ero stands 5'11" in her sheerest nylons, weighs 131 lbs., and measures 24" at the scaist, 36" at hips, with a 341/2" bust. Shall we go back

LANA YEARNER and VAN PLOTNICK in **elle from Mexico** See what happens to a souse of the border in seven dizzy reels!

Minute Movies A Colouse - al Production!

Here's the picture of the scentury, the dramatic story of the capture of a gay desperado with heart of gold and teeth to match. If you like it, you're nuttier than the producer!

> "Ah, senorita, you are so pretty. You lak Pedro, eh?"

> > Sint

TI

So Gilda dances for Pedrol

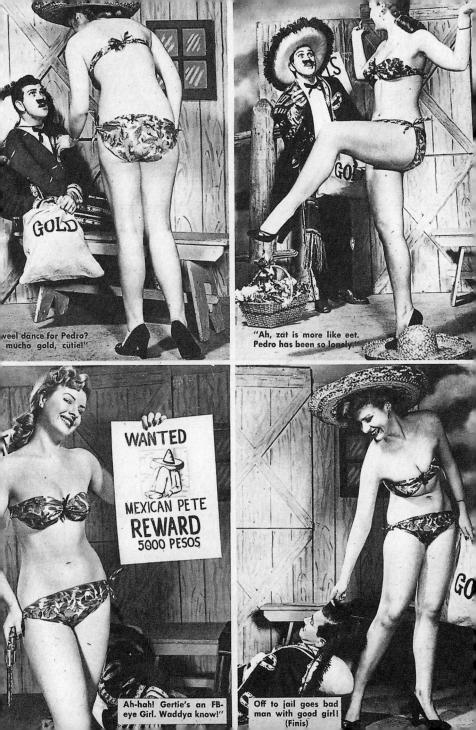

ROOTIN' TOOTIN' TOOTSIES

1

rifying

G-STRINGS OVER BROADWAY

LYNN STORM

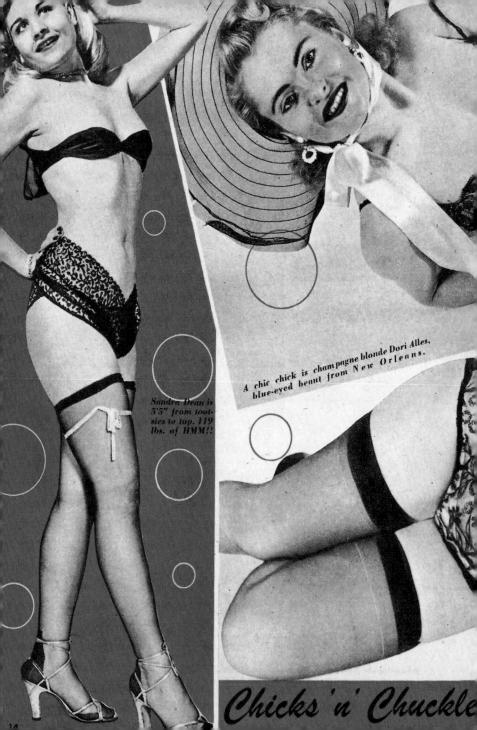

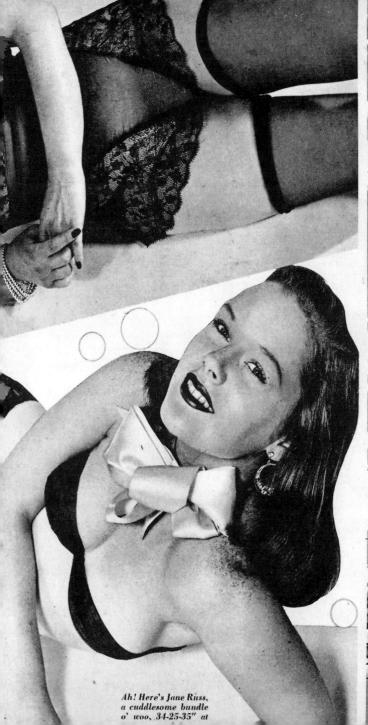

"I WENT TO NIAGARA FAL WITH THE URGE TO MERGE., THEN LEFT FOR RENO WITH THE ITCH TO DITCH!"

THE AMERICAN Gir

B. 54

500

XXX

HOW NAUGHT CAN THE GET!

APRI 250

anas:

FUNI

HONEYMOON

UMMY JMMIES from AREE!

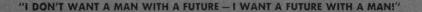

Posed by Marla Savage, 21-year-old Broadway dancer and model. Marla is 5'3", 116 Ibs., with brown hair and hazel eyes.

BEDLAM IN THE BEDROOM!

IN THIS ISSUE:

JUN 25

Ht

VE WAYS O TAKE A BATH!

This Issue:

he YANKS are COMING!

MARGIE USED TO BE A DRILL SERGEANT!

Margie doesn't know she's really gonna get the drill of a lifetime. Re-lax, honey, this won't hurt the bit!

Margie's running a fervor! Beside's she's all plate out, now!

> Peggy's trying to pull a fast one, but Margie says, "Tongues, no dice!"

WHEN Peggy got out of the WAC she went right back to work in a dentist's affice. But wearing those stripes made her drunk with power, pals, so you can't blame her for wanting to do the boss' job. Here's our killer-driller taking care of her first pain customer. She's sure got poor Margie behind the ache ball, and that's the tooth, fellers, the whole tooth and nothing but!

*

*

*

*

Stop runnin' out, you cad, before there's a cad and dog fitel

\$5000

a gorgeous green-eyed model fr Tennessee. Betti is exactly 23

F A LONELY HEARTS CLUB SENT YOU THESE PIX, JOE, WHICH WOULDJA WRITE TO?

Lonely Hearts

> Howdya liké Marie Jack? Her round nu are 36″ at the bus waist, and 36½″ hi ★₩

**

A STRIPPER'S DAY OFF!

UP IN CLEO'S ROOM!

Pere

0

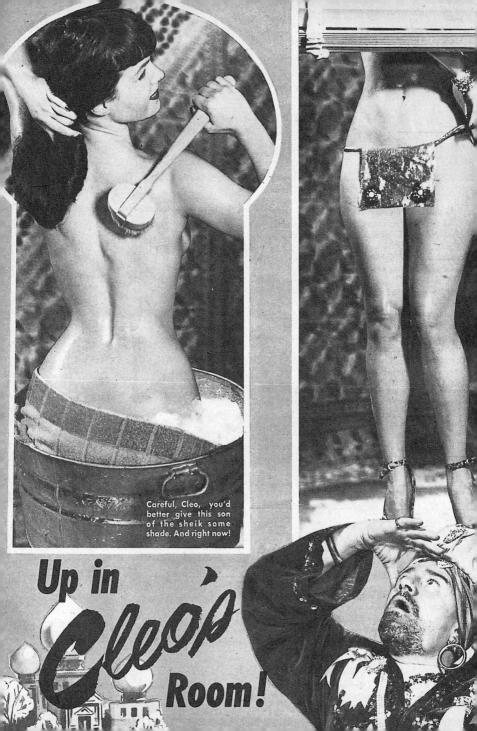

o's plenty rich, Wilmer. at do you think of her ance? Knee-s, ain't it?

AREM-scarems, look what's happening to lesert wolf, Abdul-ele. And it's all 'cause Cleo forgot to pull the s in the harem. In r words, gang, the ue is off, and we're n' all the ingredients. 'ersian peepin' Tom's a get himself in plenty uble if Cleo sees him gazin'! Duck, Pasha!

Cleo's still on the gold standard, fellers, and on her it looks good!!!

> That's rare Egyptic perfume, fetters, ar honest, it Sphinx

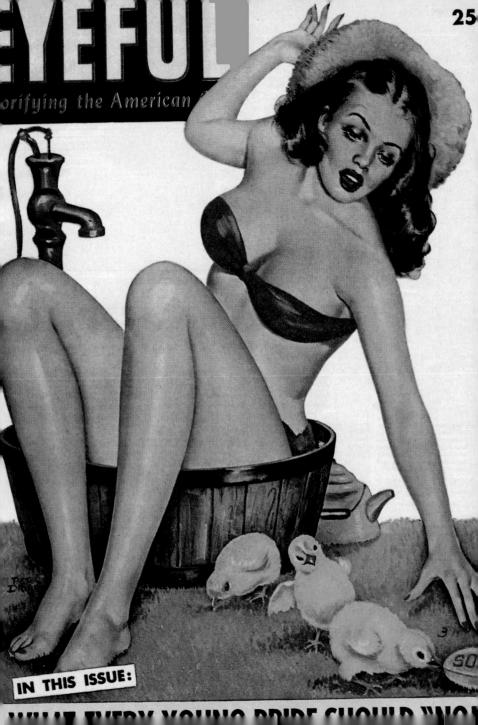

Frankly, I'm off all the men, But the worst of it is, I've found That they are the only member. Of the other sex around!

Posed by Betti Bage, artists' model, dancer

BABES IN THEIR BIRTHDAY SUITS!

IN THIS ISSUE:

PRIV NO TRE.

SYEFU

в. 5¢

lorifying the American Girl

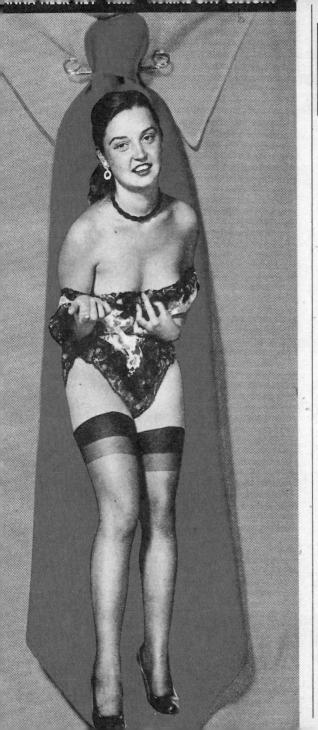

Men and women "are bed animals," say the authors, and praced to prove it with the frickiest discussion of nightline initmacies you have aver read full of roguich, devilish wit that will keep you loughing from cover to cover. For the strangest adventure of all is to find yourself lacked in a bedroom, with someone of the opposite sex with whom you are required to go to bed and get up for thousands of nights. This is called marriage. It may have just happened to you or it may happen just when you least expect it and are least prepared. But whetherer your marrial stator, you'll want to send for this hilarious book of Bediquette for married people today!

Now selling in its 12th Edition - Millions of readers can't be wrong!

CLEVER GIFT FOR BRIDES AND GROOMS Only \$1.98 postpaid I Money-back guarantee if you are not delighted! 247 riotous pages!

Haw to be well-bed in 37 sparkling, wise-cracking chapters. Full of devilish illustra-

tions. • • • Now in one volume:

BED MANNERS and BETTER BED MANNERS by Dr. Ralph Y. Hopton

and Anne Balliol with illustrations by John Groth Rip off the coupon and

Rip off the coupon and mail it now! It's worth ten times the amount as

a gag for friend wife or husbond—for their secret little foibles are oil herel 37 hilarious chapters include dissettations on "How to Get Undressed," "A Short History of Sed Manners" (the early French hed some peculiar, ones!). "Barth Control in the Steeping Car," and "The Seven Great Problems of Marriage."

Act Quickly and Get This Rare, Witty, Two-Books-in-One Volume by Return Mail!

THE BATTLE OF THE BOSOMS!

IN THIS ISSUE:

25

YEFU

orifying the Americy

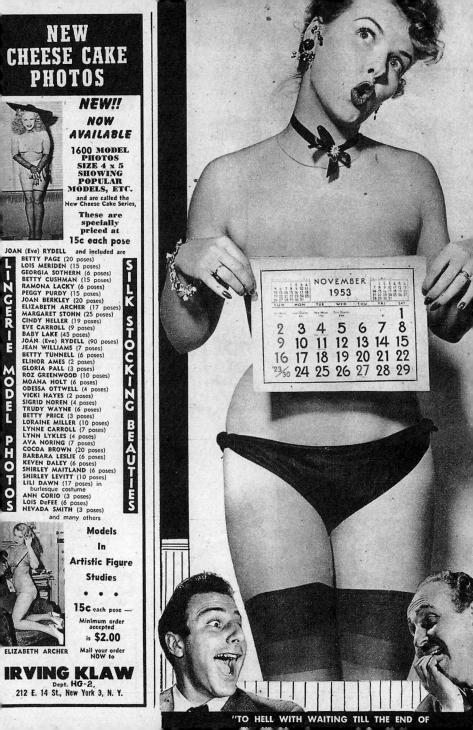

Aha! We see you adjusting your scanty panties, June King! And we like your 38" hips! That smile for us?

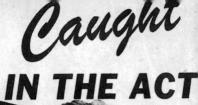

Hold it, Baby! Cute Blonde Jeri Barron is snapped just as she looks enticingly over her shoul der! Jeri weighs exactly 111 lbs.!

QUICK! SNEAK A PEEK AT WHAT THESE DAZZLIN' DOLLS ARE DOIN', BUSTER!

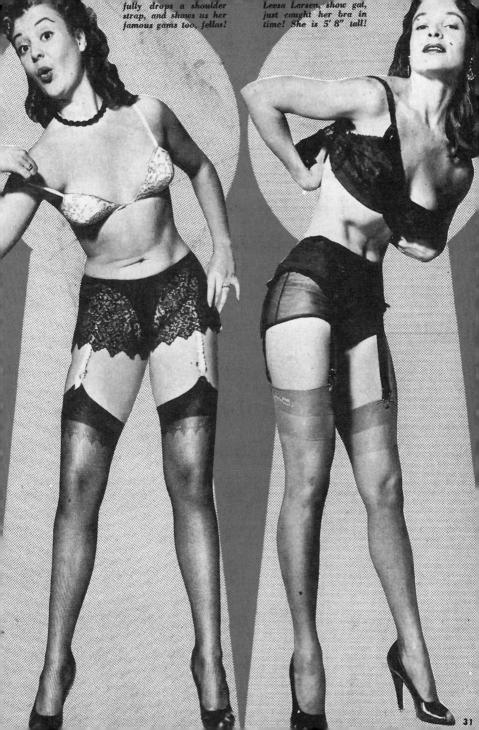

FIFTURE American

HAT APPENED D THE AN HO OOK HIS HOTO?

CHRIS CHRISTENS

25

RE YOU BROAD-NINDED? See page 24

YEFU

ifying the American Girl

AUGU 25

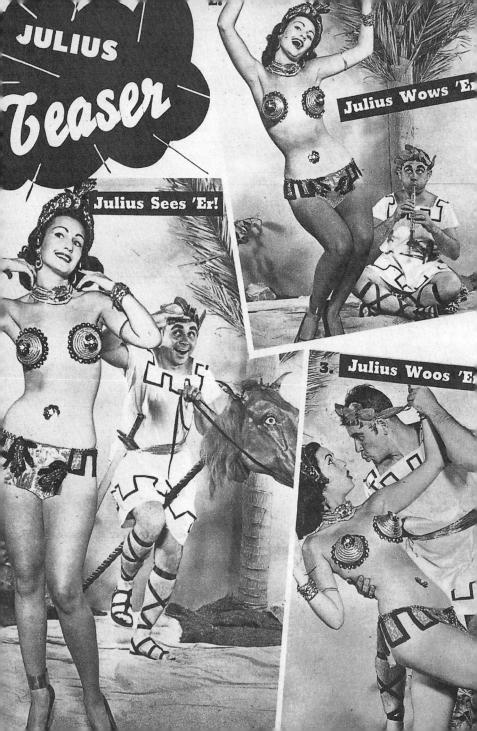

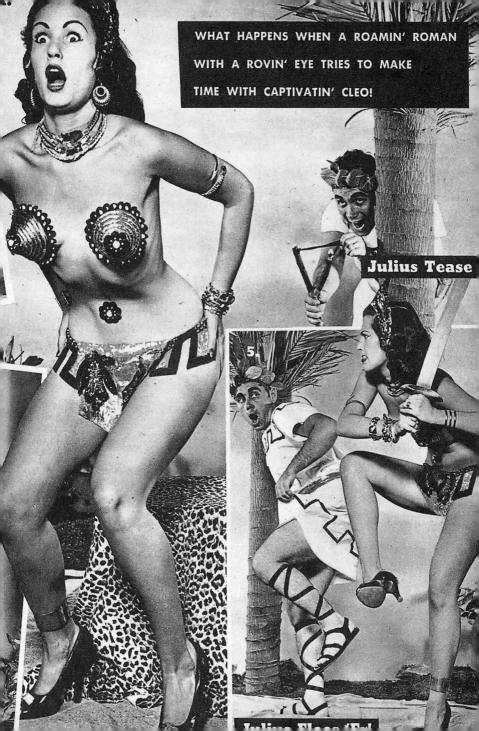

Stage Undies

Stage Unutes)
OPERA HOSE, LASTEX MESH -Black, Sun Tan	\$5.00
& Flesh OPERA HOSE, NYLON, Black, Flesh & Nude	\$5.00
OPERA HOSE, Pure Silk, Black, Flesh & Nude	\$5.00
OPERA HOSE, SUPPORTER,	
	\$2.50
Sun Tan & Flesh	\$7.50
TIGHTS, Wast High Laster Mesh. Black & Sun Tan & Flesh BLACK LAGE PANTY AND BRA SET PERKABOO 2 PC. MIDRIFF & PANTY SET	\$4.00 \$6.00
LASTEX MESH LEOTARD, Black, Suntan	
White	\$6.50
D PANTIES, CABLE NET, Full Chorus, Flesh, Black & White	\$1.50
BRASSIERES, CABLE NET, Full Chorus, Flest Black & White	
G. STRINGS, NET, Fine Elastic Trimmed Flesh	
& Black	150
GARTER BELT, MESH NET. Sizes 24 to 32	\$4.00 \$5.00
CAN-CAN GARTER BELT, Flesh - Black CAN-CAN LASTEX MESH HOSE, Black	\$4.00
CAN-CAN MESH ELBOW GLOVES, Black	\$3.00
Black or Flesh	\$1.50
T STRIP PANEL & BRA SET	\$10.00
STRIP PANEL & BRA SET Sequin Trimmed	\$20.00
STRIP BRASSIERES. FINE NET. Black of Fies	Support Proves
Flesh and Black	\$2.00
RHINESTONE G. STRING, Beaded or Silk Chainette, Size by Hip Measurement	\$20.00
EDINCED BRASSFERP To March	\$5.00 \$3.50
DANCE BELT, Girdle Elastic, Flesh REMEARSAL SET, Midriff and Trunk PIN UP TYPE, Silk or Velvet; Panty and Bra S	\$4.95
PIN UP TYPE, Silk or Velvet; Panty and Bra S	ets.
	\$5.00 \$4.00
BIKINI SET, Bra and Panty SKATERS SKIRT, Circular Type SKATERS TRUNKS, French Cut	\$4.95
SKATERS TRUNKS, French Cut	\$2.95
LEOTARD, Mercerized, Black Short Sleeve	\$4.25 \$4.75
TIGHTS, Mercerized, Black, or Royal Blue	\$4.00
RUFFLED SHORT SKIRT, Black, Linen	\$5.00
STAGE UNDIES Dept. HG-I	08.1
302 WEST 51st STREET NEW YORK	
J CHECK EACH ITEM WANTED	
MAIL TODAY	1
Check Size Small D Medium	Large i
I enclose \$ you pay postag	. 1
Name	i
Address	i
CityState	
Cash or C.O.D.	
DDAVE	
	HIP CA

21 IL ST is a Tremendous Mighty Fowerl Are you facing dif-cult Problems? Paor Health? Money or Job Troubles? piness of any kind! Woild you like more Happiness. Success and "Good Fortune" in Life? Li you have you end way the piness of any the second bir you have you end way the piness of a remark-able New WAY of PRAYER that is helping thousands to borious NEW happiness and 1031 to storious NEW happiness and 1031 bir XIO and the second second second bir XIO and the second second second bir XIO and the second second second second bir XIO and second second second second second bir XIO and the second second second second second bir XIO and second second second second second bir XII about the FREE!

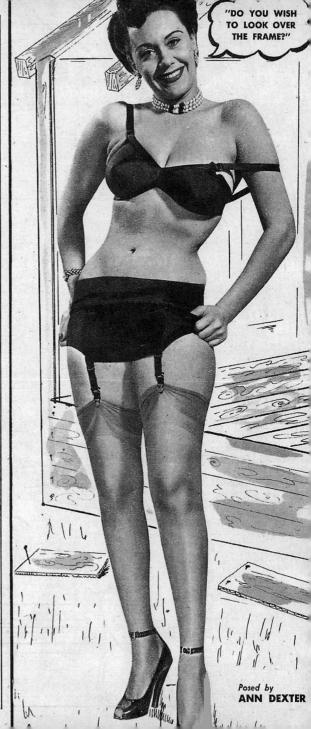

Iorifying the American Girl

IN THIS ISSUE:

NIGHT LIFE U. S. A.!

LINDA LOMBARD

25

ause Fido meets such inter-ng guys on the street, as ay makes time on her walkst

NO POOCH CAN REALLY PUT ON THE DOG UNLESS HE HAS A LUSCIOUS LASS

ERY DOG

Should Have a

WELL, why not? How can a pooch be really doggy unless he owns a curvy doll so he can put on the dog? We know a spaniel who had a nervous breakdown 'cause all the other hounds owned a luscious babe, while he pined in a pet shop! Five reasons every dog should have his dame!

'Cause he's got nothin' to whine about when Baby's givin' him exercise!

in

6.0

ALC: N

Cleanliness is next to loveliness when a lucky pup can have a back with a chorine!

Well, after all, how can any

O.

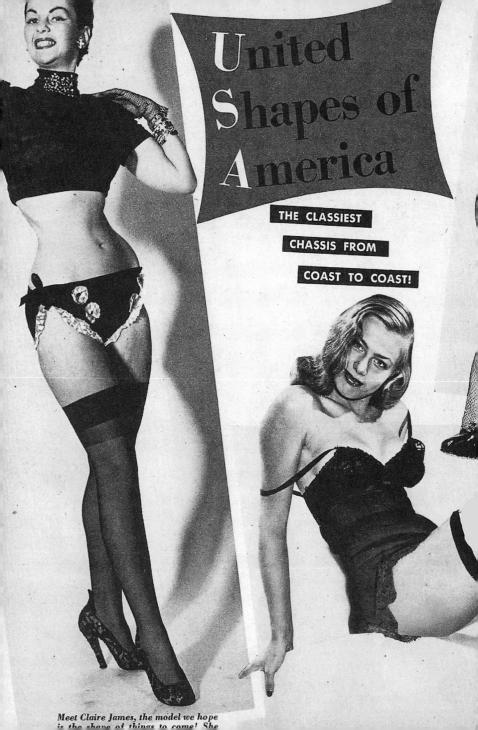

Say hello to Cherie Karen, scanties model! Cherie is 118 lbs. of flirty charm, and her waist is only 23"!

101

"I'm Ginger Grey! I'm only 19, and a farm girl, but I know enough to keep an eye on you, you rascal! Scram!"

Cindy Barron, dancer from St. Louis, likes big tough guys! Her bust meas-

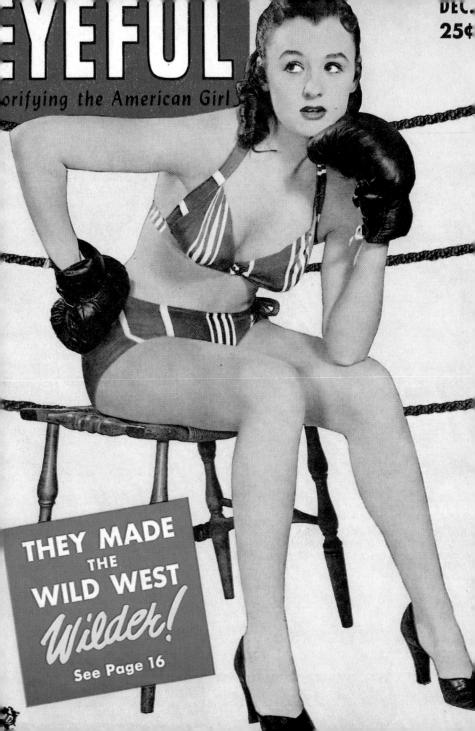

rifying the American Girl

25

ROMA PAIGE

Vhat's Wrong With Wimmen? In Parl Whim

Wanna lose your head quick? Just volunteer to help Baby paint! She'll just brush it-off!

> Be on hand when a babe adjusts her hose! Your head follows the gams!

Don't LOSE YOUR HEAD!

Fastest way to lose the old nob is to challenge your doll to box, Joe! lose your dome is just to chomp on watermelon!

Play basketball with an athletic amazon, 'n she will knock ya block offl

WHAT'S COMIN' OFF here? Looks like guys are losin' their heads over somethin'! What gives? Well, here are some easy ways to lose your head, so, if you value that noggin of yours, better avoid these dangerous situations, Mister!

SYEFU

lorifying the Americ

ħ

BIG DAME HUNTER See page 30

лі 2!

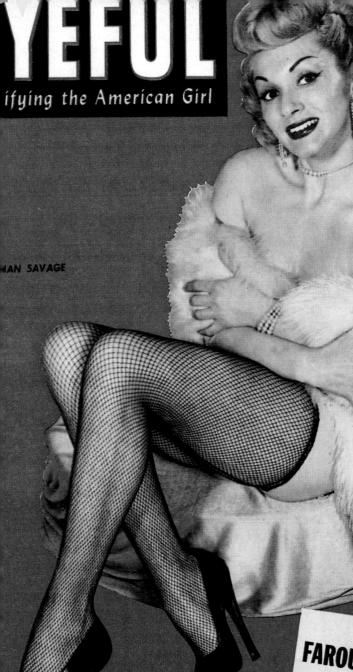

Meet FAROUK'S LATEST! see page 12

JUNE 25¢

"A dumb girl," giggles Patti La Mar, "counts on her fingers, but a smart girl counts on her legs!"

Bettie Page, artists' model, says, "Among the makers of one-piece bathing suits, the thigh's the limit!"

4-44

KINSEY cackles!

Exotic dancer Fay Dare says, "A fat girl needs no other protection!"

*

Rita Romero says, "For every man over 85 there are seven women ... but it's too late then!"

ADVICE to the Lovelorn FROM THE LOVELIEST BABES IN TOW

Blonde chorus chick Jo Ann Grace says, "There is no better honeymoon bait than Niagara falsies!"

CALLING ALL MEN

"If you think a gal is cold," says Joan Low, "Remember, so is dynamite, until you start fooling around!"

Says Cindy Barr, "Every woman has a secret desire to write — checks!"

Jean Lamont says, "Diamonds don't grow on trees, but the right kind of limbs get 'em!"

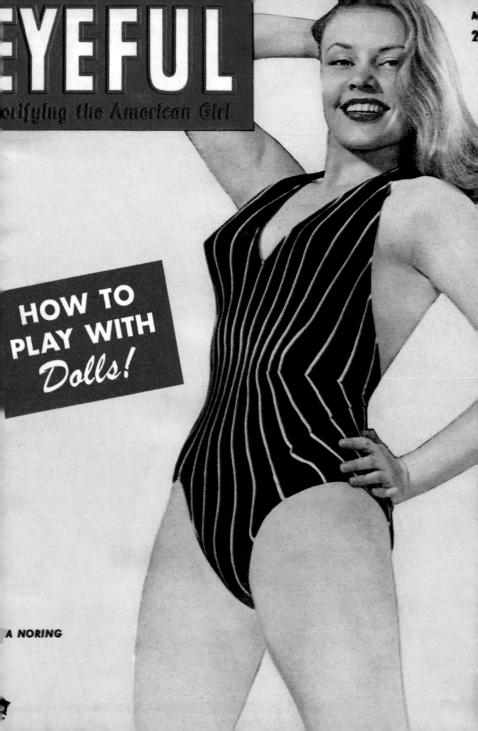

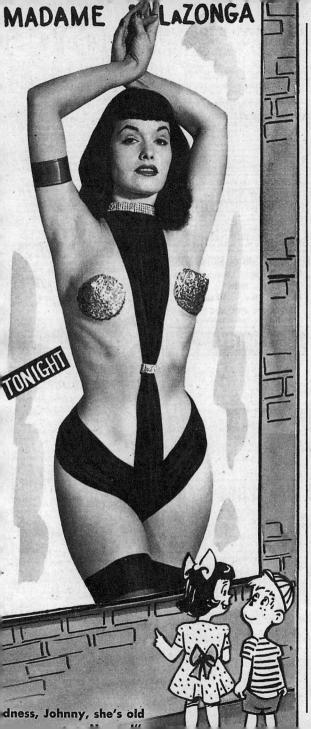

Stage II-1'
Stage Undies
DOPERA HOSE Latter Meth Black Sun
Tan, Flesh and White \$5.00
OPERA HOSE, NYLON, Black Flesh and Nude
□ OFERA HOSE, FURCE SUK, Black, Flech 5.00 □ OFERA HOSE, PURE SUK, Black, Flech 5.00 ○ OFERA HOSE, SUPPORTER, Black, Flech 2.50 □ (IOHTS, LASTEX MESH, Waite High, Black 7.50 □ STRIP RASSIERE, Black, Flech, Waite 1.50 □ STRIP RASSIERE, Black, Flech, White 1.50 □ STRIP BRASSIERE, Black, Flech, The STRI
and Nude
TIGHTS LASTER MESH, Waist High Black
Flesh and Sun Tan
G-STRING, NET, Black or Flesh
STRIP BRASSIERE, Black, Flesh, White 1.50
STRIP BRASSIERE, RHINESTONED, Black,
Flesh or White
PANTIES, CABLE NET, Black, Flesh or White 1.50
BRASSIERE, CABLE NET, Black, Flesh or
STRIP PANEL & BRA SET
STRIP SEQUIN BREAST CUPS, S or M, Pr. 3.00
CAN-CAN GARTER BELT, 24 to 34 4.00
CAN-CAN LASTEX MESH HOSE, Black 4.00
CAN-CAN MESH ELBOW GLOVES, Black 3.00
BLACK LACE PANTY & BRA SET
PIN UP, Silk or Velver, Panty & Bra Sets 5.00 BIKINI SET, Panty and Bra
STRIP PANEL & BRA ST. 10.00 STRIP PANEL & BRA ST. 5.00 STRIP SEQUIN BELAST CUPS, S or M, Pr. 3.00 CARCAG, PARTER BELAST CUPS, S or M, Pr. 3.00 CARCAG, PARTER BELAST CUPS, S or M, Pr. 3.00 CARCAG, PARTER BELAST, CUPS, S or M, Pr. 3.00 CARCAG, MESH ELGOW GUOYES, Black. 4.00 CAN-CAN MESH ELGOW GUOYES, Black. 3.00 BLACK LACE PANTY & BRA STL. 4.00 BLACK LACE PANTY & BIAR STL. 6.00 DI BLACK LACE PANTY & BIAR STL. 6.00 BLACK LACE PANTY & BIAR, STL. 5.00 BLACK LACE PANTY & BIAR, STL. 5.00 BLACK LACE PANTY & BLACK, MORT STER STL. 5.00 BLACK LACE PANTY & BLACK, Short Steeve 4.25 5.00 DEGTARD, Mercerized, Black, Long Steeve 4.25 5.00 DANCE BELT, Gride Elastic. 3.50 DI GHARD, MERCERIZE, MERLANT TYC. 5.95 DI HART STRIP PARAMERT, MARKAR, TYC. 5.95 DI HART STRIP CONT OF STRING, Beaded or Silk 710 Fringed Brasicier to March. 5.00 CART STRIP CONT OF STRIPM, ONE PIAC COMP 500 <tr< td=""></tr<>
LEGTARD, Mercerized, Black, White 5.00
LEOTARD, Mercerized, Black, Long Sleeve 4.75
TIGHTS, Mercerized, Black 4.00
SKATERS SKIRT, Circular Tune 4.95
SKATERS TRUNKS, French Cut 2.95
RHINESTONED G-STRING, Beaded or Silk
Fringed, Size by Hip Measurement 20.00 Fringed Brassiere to Match
LEOTARD-LASTEX MESH, One Piece Com-
plete, Neck to Toe Covers Entire Body 20.00
Lace Trimmed
STAGE UNDIES
302 WEST 51st STREET . NEW YORK CITY
CHECK EACH ITEM WANTED
MAIL TODAY
Check Size Small Medium Large
t enclose \$
I enclose \$
t enclose \$
I enclose \$ you pay.postage Send C. O. D. I will pay postmon
I enclose \$
l enclose \$
1 enclose \$
l enclose \$
I enclose S
l enclos 5
I enclose S
Adress.
I erclos 5
I enclos 5
I erclos 5
I enclos 5
I enclos 5
I enclos 5
I enclose 5. You pay postage you have been been been been been been been be
l erclos 5
I enclos 5
I enclos 5 you pay, postage Send C. O. D. I will pay postage Address. City
I enclos 5
I enclos 5 you pay, postage Send C. O. D. I will pay postage City
I enclos 5 you pay postage Send C. O. D twill pay postage Address. City
I enclose 5
I enclos 5 you pay postage Send C. O. D twill pay postage Address. City

YEFUL rifying the American Gⁱ

ALL BABES ARE WOLVES

0ct. 25¢

"Once a man is interested in curves," says Timi Thomas, "he has no further use for the straight and narrow!"

Deni Lowe knows a man who is getting so old he looks at a Marilyn Monroe calendar to tell what day it is!

THROC HAACTA

GRON and BARS Dr

dis

an sarius for sou, boys:

Geneva Chavez Pat Garden 10 THE CALL Girls are like checks in a bank, Pat's a lot like other girls, Of that there is little doubt;

Some of them are only blank While others are filled out!

Parts a lot like other girls, Pretty eyes and well-kept curls. Like the rest she has a torso, Only here is cart of more col

TWO

Laura Lane

> Bettie Page

And sleeps very well, I am told. Last night I slept in my bare skin,

Š.

-

Her leg's a pretty stockingful, Says Bettie with a laugh; And we'll agree that that's no bull — We just a little a little

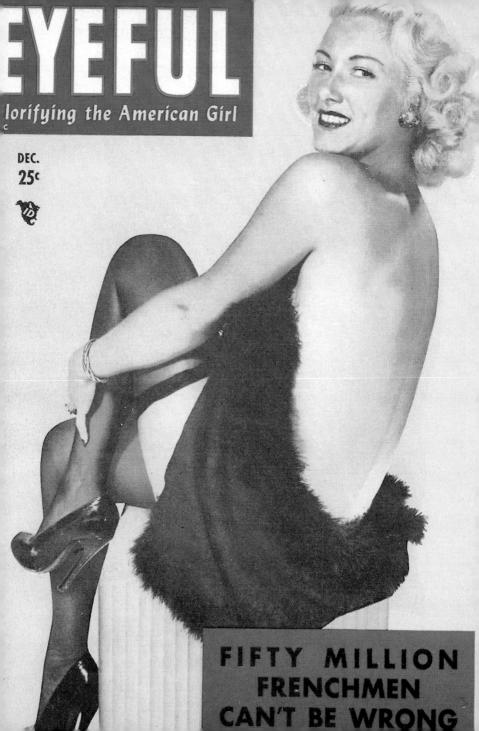

AMAZING "OLD WORLD DOPE" MAKES FISH BITE EVERY DAY

Catch your limit every day, "Century-Old" Romany formula for all fresh and salt water fahermen. Worms or minflow-live or artificial bait, doped with GYPSY Fish Bait Oil throws off an irresistible odor which attracts fish like magic.

ORDER BY MAIL Supply so imited, not yet sold in stores. Tested, proven, satisfaction guaranteed. Only \$1.00, 3 for \$2.00. Send cash, check or money order. If C.O.D., charges extra. Order GYPSY Fish Bait Oil from:

FISHERMANS PRODUCTS CO. Dept.322W, 2832 Niazuma Ave. Birmingham, Alabama

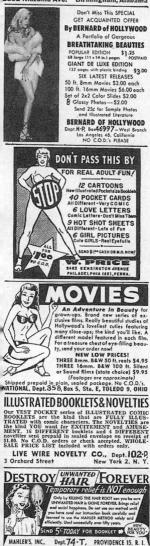

Lassie wore this in a beauty contest. She didn't win or place, but she sure SHOWED!

Lassie Mc Tauisk

Curvy movie starlet Roma Paige is just 21, and is 5'6" tall. Those eyes are blue!

den la

Grab a rocket ship and zoom up 'n peek at Lollie Love, 119 lb. scanties model!

6

Here's a Hollywood-bound lovely! It's Jane Porter, brown-eyed show girl and dancer from Chicago. III

THESE STARLETS

THE REAL

OUGH TO MAKE YOU MOONEY, SON!

Gimme a telescope! It's Patti Warren, and that chassis rates a closer look, eh, boys? Yippee!

Heavenly Bodies with Worlds of Power!

FYEFUL prifying the American Girl

QUEEN OF THE RUNWAYS

ł

YLLIS APPLEGATE

HOW TO STAY A BACHELOP

MY GRAY HAIR IS NATURAL LOOKING AGAIN savs JAN GARBER. Idol of the Airlanes

Ideal of the Airlands No matter what color your hair was black, red, brown, blands Cherr dives gray hair youthil. Sector of the sector of th

YOU LOOK YEARS YOUNGER YOU LOOK YEARS YOUNGER TOP SECURE has been a favorite with famous personalities for years, Exclu-sive formula imparts mainral looking streak or injure hair, NOT A TINT. Sciuti Ffed. Tax incl.) for 0 ot, bet-lie, ppd. No COD's, please. Money suits, Abin of California. Room AM 1403-19 W. Sth St., Los Angeles 17, Calif.

ILLUSTRATED BOOKLETS

The kind YOU will enjoy. Each one of these book-lets is size 3/5 by 4/5 and is ILLUSTRATED with 8 page curcon ILLUSTRATIONS of COMIC CHARACTERS and is full of fun and entertain-ment. 20 of these booklest ALL DIFERENT sent prepaid in a scaled anvelope upon receipt of \$1.00. No checks or CO.D. onders accepted.

TREASURE NOVELTY CO. 2 Allen Street, Dept. 31-B, New York 2, N. Y.

Investigator Training

Experience unnecessary. Many opportunities. Send for Free particulars. Free credentials.

Exchange Secret Service System 4360 Broadway Chicago 13, Ill.

A genneman in my room? Just a moment, I'll ask him!"

Posed By DODDIE DAIDO

SYLEFUL prifying the American Given

A PAIGE

76 Girls Did AS MEN DO

ари 25'

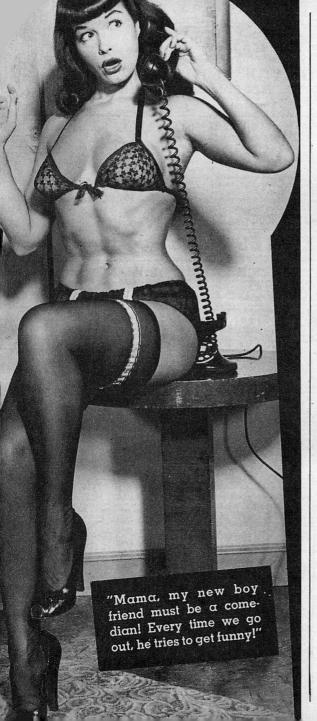

Afflicted With Getting Up Nights, Pains in Back, Hips, Legs, Nervousness, Tiredness.

If you are a victim of the above symp-toms, the trouble may be due to Gland-ular Inflammation. A constitutional Dis-ease for which it is futile for sufferers to try to treat themselves at home. Medicines that give temporary relief will not re-move the cause of your trouble

To men of middle age or past this type of inflammation occurs frequently. It is accompanied by loss of physical vigor, graying of hair. forgefulness and often increase in weight. Neglect of such in-flammation causes men to grow old be-fore their times preventive conflict and fore their time - premature senility and possibly incurable conditions

Most men, if treatment is taken before malignancy has developed, can be suc-cessfully NON-SURGICALLY treated for Glandular Inflammation. If the condition is aggravated by lack of treatment, surg-ery may be the only chance.

The NON-SURGICAL treatments afforded at the Excelsior Institute are the result of 20 years research by scientific Technologists and Competent Doctors

The War brought many new techniques and drugs. These added to the research already accomplished has produced a new type of treatment that is proving of great benefit to man as he advances in years.

The Excelsior Institute is devoted ex-clusively to the treatment of diseases of walks of life and trom over 1,000 cities and towns have RECTAL

RECTAL COLON Are often as sociated with Glandular In-flammation,

We can treat these for you at the same

ILLUSTRATE

vears old

time. R

been successfully treated. They found soothing and comforting relief and a new zest in life.

LOW COST EXAMINATION On your arrival here our On your arrival here our Doctors make a complete ex-amination. You then decide if you will take the treatments needed. They are so mild they do not require hospitali-zation. A considerable saving in expense.

Write Today for Our > The Excelsior Insti-tute has published a New FREE Book that deals only with dis-eases peculiar to men. Gives 'factual knowl-edge' that could prove of utmost importance obligation. Address

EXCELSIOR INSTITUTE Dept. 4666, Excelsior Springs, Mo. Centlemen. Kindly send at once your New FREE BOOK. I am_ NAME. ADDRESS

OWN_			
	1.11111	 114.1211	-

STATE.

TO

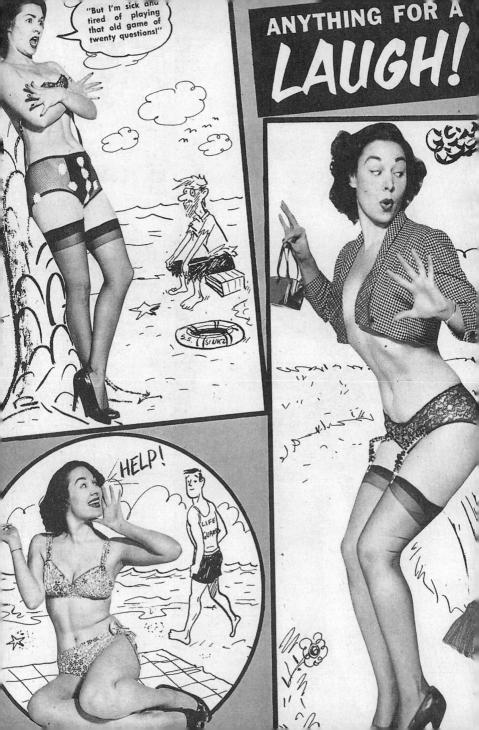

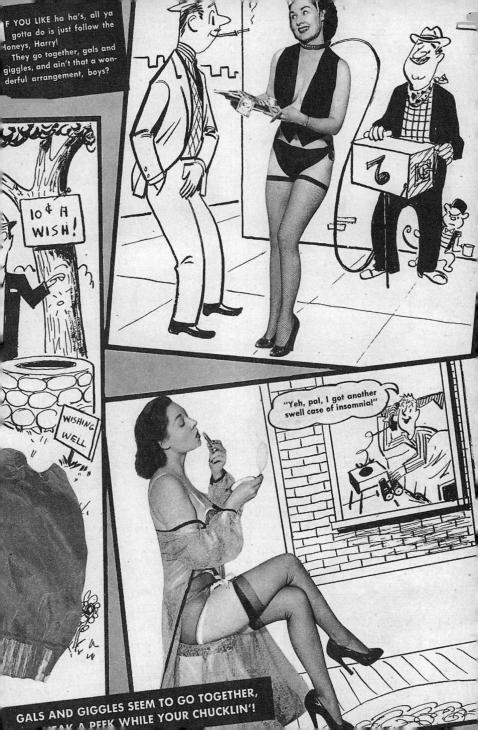

1943-1955

It was Peter Driben who created most of the cover illustrations for Harrison's magazines, closely followed by Earl Moran and Billy de Vorrs. However, the first issue of Titter was adorned by a work from the pin-up artist Merlin Enabit (1903– 1979). Enabit, the "wizard of colour", true to his first name, decided to make his own paints organically from natural dyes and even published a highly successful book on the subject, in the 70s. Besides featuring innumerable bathing belles and the usual photostories, Titter also made frequent allusions to its roots in the burlesque, celebrating the good old days of the cancan. During its first year, an object much plugged in the advertisement section was the legendary tie which glowed in the dark. This was supposed to bewitch the bashful lady of one's dreams with its subtle invitation: "Will you kiss me in the dark, baby?". It was an accessory pre-eminently suitable for export to the Old World, which still had to live with the blackout.

Die meisten Coverillustrationen der Harrison-Magazine stammten von Peter Driben, ihm dicht auf Earl Moran und Billy De Vorss. Die Startnummer von Titter zierte ein Werk des Pin-up-Künstlers Merlin Enabit (1903–1979). Enabit, der "Wizard of Color", verstand seinen Vornamen als Auftrag. Seine Farben stellte er auf natürlicher Basis selbst her und veröffentlichte in den 70er Jahren sogar ein recht erfolgreiches Buch darüber. Neben den zahllosen Badenixen und den typischen Fotostories wies auch Titter immer wieder auf seine Wurzeln in der Burleske hin und pries die guten alten Tage des Cancan. Im Startjahr heftigst im Anzeigenteil beworben wurde die legendäre, im Dunkeln leuchtende Krawatte, die jede noch so zurückhaltende Dame durch die subtile Frage: "Will you kiss me in the dark, baby?" becircen sollte. Ein offensichtlich für den Export in die Alte Welt, die noch mit der Verdunklung leben mußte, geeignetes Produkt.

La plupart des couvertures des magazines de Harrison étaient dues à Peter Driben, que suivaient de très près Earl Moran et Billy De Vorrs. C'est une œuvre du dessinateur Merlin Enabit (1903–1979) qui fit la couverture du premier numéro. Enabit, le «magicien de la couleur», concevait son prénom comme une mission. Il fabriquait lui-même ses couleurs à partir de matières naturelles, et il alla jusqu'à publier dans les années 70 un ouvrage sur le sujet qui connut un assez grand succès. A côté des innombrables naïades et des histoires en photos classiques, Titter ne cessait de renvoyer à ses origines burlesques avec une prédilection pour le bon vieux temps du cancan. La première année, la partie publicitaire mit le paquet sur la fameuse cravate fluorescente qui était censée ensorceler la plus réticente des dames de cœur à qui l'on posait la subtile question : «Veux-tu m'embrasser dans le noir, baby ?». Produit qui semblait se prêter remarquablement à l'exportation sur le vieux continent, où il fallait vivre encore avec le black-out.

augi 25

A Mirthquake of GIRLS, GAGS and GAYETY

TASSELS in the AIR

Are we right or wong that Jadin Wong is the kind of a gal around whom you could build your dream tassels? She's a "Miss America" is gorgeous Rosemary La Planche, who appears in Hal Roach Productions. An d when this beauty takes a dip, the photographer gets a picture that's a pip.

> Most people regard a jinx as a hard-luck sign. But that's before they met statuesque Jinx Falkenberg, Columbia Pictures' starlet, who is anybody's lucky daze!

> > an

can only happen in he movies, fellers, his business of wear-1g bathing suits that ever get wet. So you an't blame Marguere Chapman, Columia starlet for not wimming. Who'd vant to spoil a picture like this?

5-4-0

And here's another reason why the beaches are full of peaches this season. Gosh, when a lovely like this is on view, nobody minds a bathing suit "shortage." In fact, the shorter the better ---photo!

They're making the

mild manas and

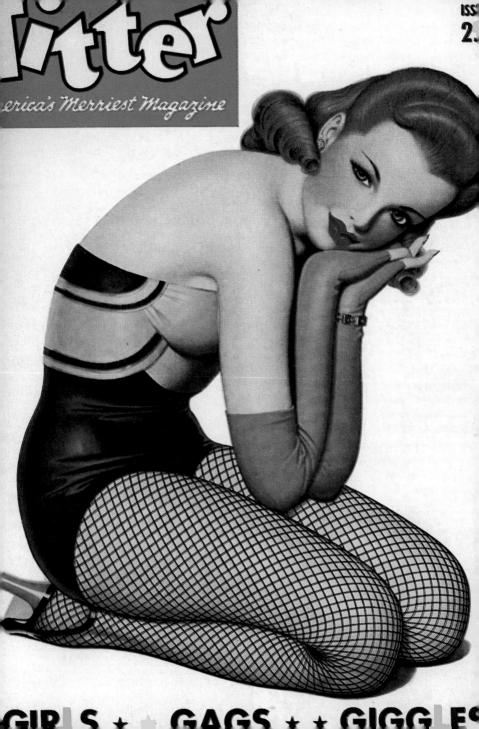

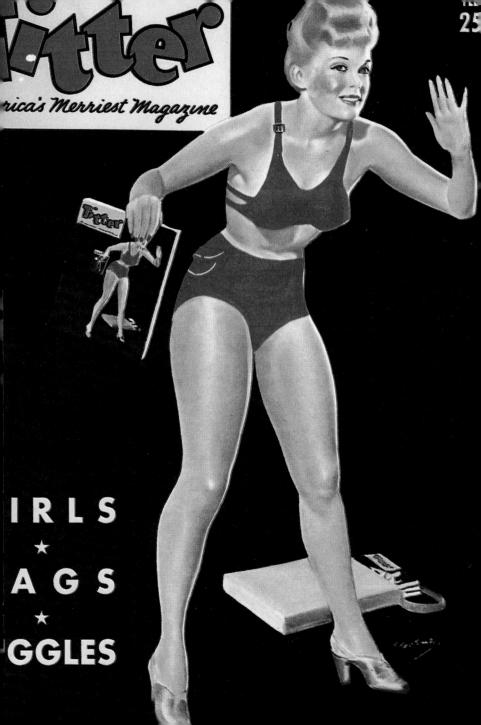

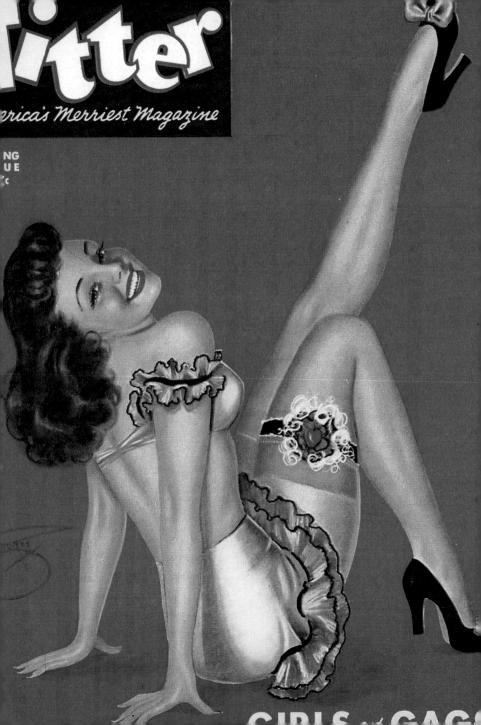

Wait a minute, kiddies, don't take a powder yet. Fuse stick around you'll get a real kick out of this beautiful pin-up of gorgeous Ren Andre, Hollywood dancer. Yowsah, she's dynamite!

BBBIEVC

This sea-going life may be strictly the bunk, but I'm hammock a swell time.

"I'll get the hang of this yet!"

10

Swing IT SISTER!

Now, don't lose your head honey!

(A BED-TIME STORY CONTINUED)

Trying to keep your balance in one of these swaying canvas cradles isn't easy, but Felice has a sway with her so she should do all right. Anyway she's not going to quit until she's done her daily doze in. At the moment our sailorette is a little confused, because these ropes keep getting all snarled up and they're driving her knottier by the second. In fact, things are going from bed to worse and Felice just can't understand how she'll ever be able to get any sleep. But don't be too worried honey, you can always get some shut-eye on a swing and a prayer, and if you have too much trouble just call out the shore patrol, that's one way of getting a-rest-ed.

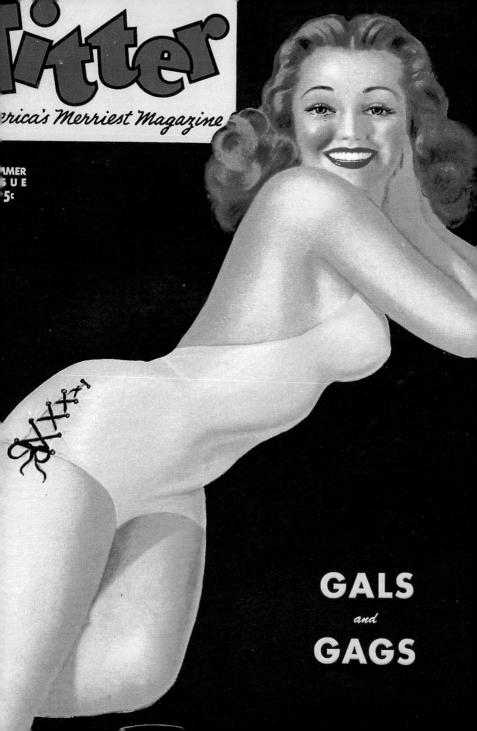

Yessir, fellers, we always knew Betty Grable packed a wallop and these pictures sure do prove it. Right now Betty's ready to defend her title as the pin-up champ. Just don't go away, honey, we'll be back for some of that punch next thirstyl

Folder Glovely

Playing piano with her toe is jazz part of Lana's daily routine.

or note reason at all Lana suddenly tad her harp set on learning to play a nusical instrument. As a matter of fact ve're all for it if fiddle make her hepby! However, she can't decide which nstrument to study so she's giving ach one a try. Looks like she's winlow-sharp-ing. That's why you can ee our baby playing clarinet, saxaphone, drums and piano, and she cerainly looks the notes, tone you think o? Well, if we can read between the ines we believe she prefers the saxaphone, and drum to think of it why shouldn't she? Didn't she just finish eading "How Green Was My Vallee"?

HEP-PINESS AHEADI

> This melo-dear didn't have time to go to music school so she hired a private tooter!

You've got to have strong lungs for a clarinet, but Lana is wind-some enough, hey gents?!

the way this slick chick beats that drum it sure looks cymbal, doesn t it, fellers?

5

 \leq

TIF CUTIF

T ()

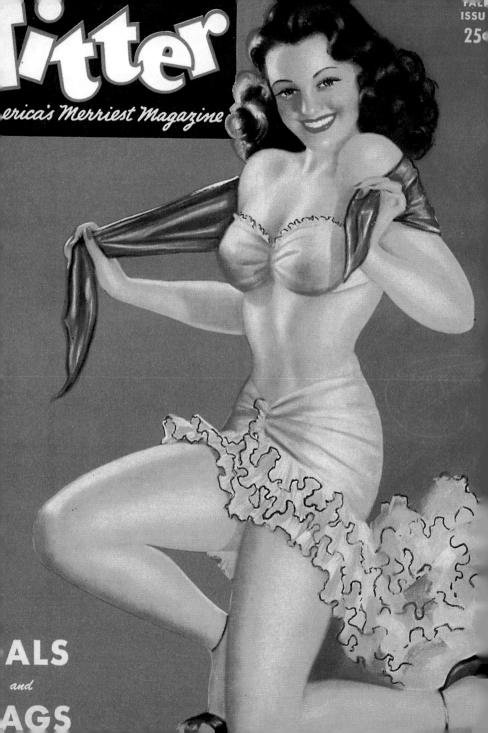

rica's Merriest Magazine

Revies of AUTIES arrels of FUN

OF THE TOWN

ail, Nail, the Gang's All ere! Aren't you tried of silin' like that, honey?

LITTLE thing like gas 1 rationing isn't gonna op Beth, fellers! She's alrays on the go, anyway, ind now she's makin' herself a scooter so she'll be able to scoot around town whenever she feels like it! Beth found you don't need much material to build one of these things (not with the build you've got to start with, anyway, babyl) - so after rounding up some wheels and a couple of boards, she was all set to start playin' planksl Well, more power to you, honey! You're makin' a wheel good try, so we know you'll get it made scooter or later!

Gee, you look sawed of busy, baby!

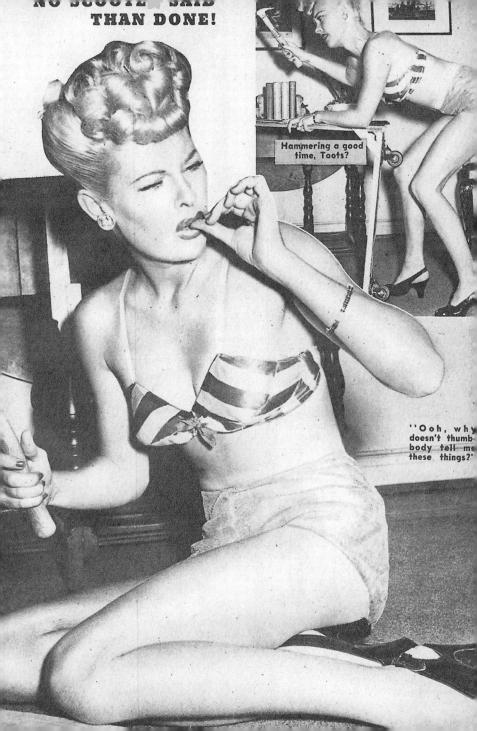

Pardon us for steering at you, darling!

OAST OF THE TOWN-CONTINUED

's rollin' 'fun, gang! Beth's ound that buildin' a scooter's a Jre way to steer up excitement! he says she's not much of a menanic, but we think she's done s scooter job as anyone could! iee, baby, if you didn't mechanmistakes you just wouldn't be uman! Now that she's really got nings rollin', though, Beth's inda proud of her scooter, espeally since it didn't coast her a ent! She's just hopin' she won't old up traffic, 'cause she'd hate) be caught with a stallin' car! w, you'll do all ride, honey! ee, you've made a traffic hit with us already!

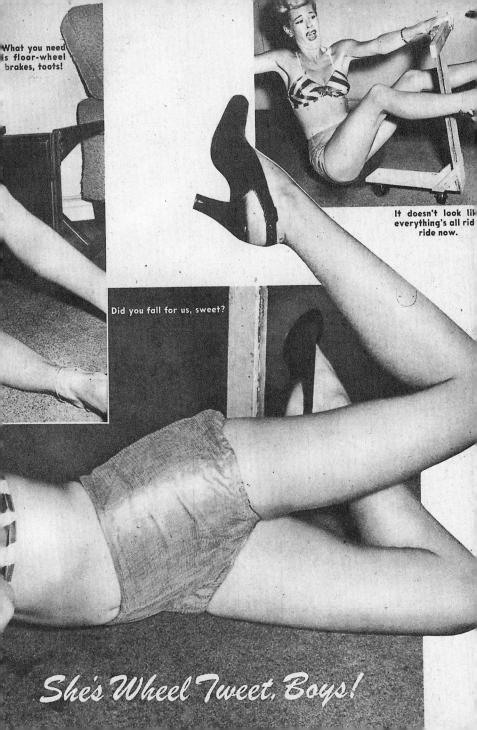

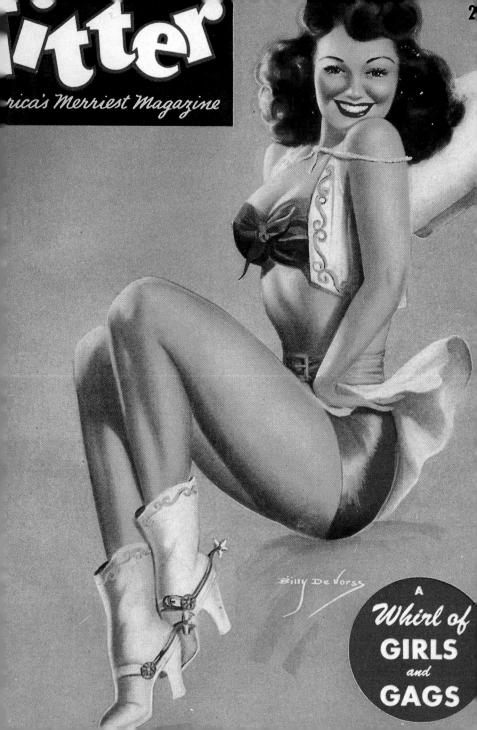

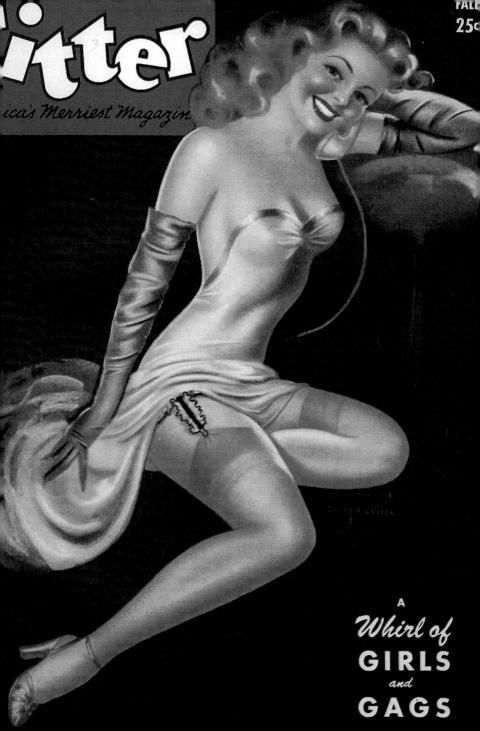

YOUR ORDER

TO

THIS NEW STARTLING REVEALING BOOK

TH

Lile

rsonal Physician for 15 years

Natroduction OTTO STRASSER

Intimate KURT KRUEGER

Now at last is revealed the truth that has only been hinted and rumored. Mr. Robert Arndt, well known authority on Nazi Germany, has through painstaking research and secret sources amassed the true facts about Hitler's private life.

NEVER BEFORE PUBLISHED

This startling information has never before been disclosed so clearly, frankly, and truthfully. The true facts are now presented in this startling volume. You will know exactly who Hitler knew and just how well.

ACTUAL PHOTOGRAPHS

This book contains ortual photographs of the important women who have been associated with Adolph Hitler. This amazingly documented book can now be yours absolutely free. Read on, learn how to get your copy.

The PERSONAL PHYSICIAN LER TALKS

Dr. Kurt Krueger, Adolph Hitler's personal physician for more than 20 years. escaped to this country and now reveals all that he knows of Hitler's depraved body and soul. He tells for the first time Hitler's confidential confessions, his inhuman aberrations, his madness for power, his bloodlust, and the real reasons for these horrible abnormalities. This great work has an introduction by Upton Sinclair and has been hailed by leading newspapers. This is no ordinary book. It is a clinical case history of Adolph Hitler, the madman who has brought so much agony and suffering to the world.

NEVER BEFORE SUCH A LITERARY MIRACLE

Imagine! Dr. Krueger had to live the subject matter of his epoch-making book. His knowledge made Hitler fear and hate him. He fled Germany for he was on the list to be brutally murdered. So he dedicates this literary miracle to the world in the hope that the truth about Hitler will help destroy him. You must

read this book. Your family and friends should read it. Simply send the coupon and your copy of "I WAS HITLER'S DOCTOR" and free copy of "THE WOMEN IN HITLER'S LIFE" will be sent to you immediber you ately. Supply is limited may reso act now. turn."I Was Hitler's Doctor" Biltmore Publishing Co. 45 East 17th Street New York 3, N. Y.

for refund in 10 days if you are not completely satisfied, but even if you do, you keep your copy of "The Womon in Hitler's Life" as a free gift,

Ro

mem-

10 DAY TRIAL COUPON 10 DAT TRIAL COUPON BILTMORE PUBLISHING COMPANY 45 East 17th Street, Dept. H-W-1609 New York 3, N. Y. [] Pitasa send my cony of "It WAS HITLER'S DOCTOR" and my free copy of "The Women in Hiller's 14th", J will pay pesima \$1.38 plus postage charges on delivery. If at the end of 10 days 1 am ind completely statisfiel T may return it for refund and keep the free gift. (If you prefer enclose \$2.30 with jour order, Books will be sent postpald. Same guarantee as

NAME A	GE
ADDRESS	
CITY ZONE	E

ŀ

Miliel of GIDIG GAGE

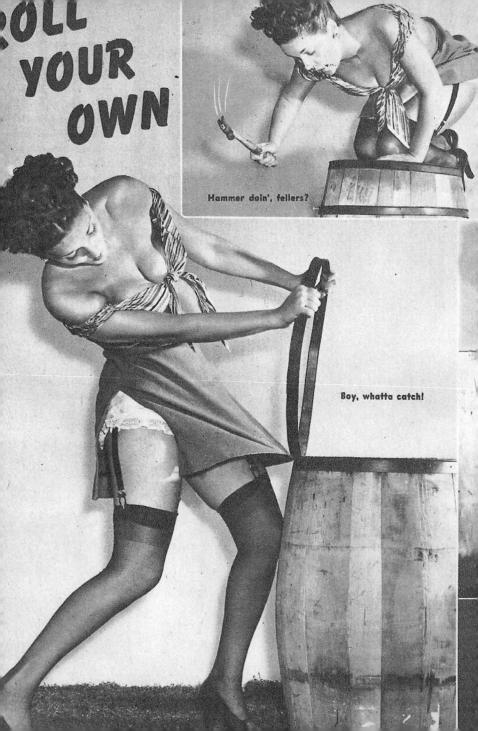

Now you've put your foot in it sweetheart.

Having .

BARRE

of Fun!

rel House Betty has rolled out a barrel, ers, long enough to show us how to roll oop. We think she must be a little hooped though, because Betty hasn't even seen oop since girls used to wear them. Our by seems to be having a barrel of fun, rway, which is okay as long as it staves being bored. Say, why doesn't one of u guys show the lovely lady how to twirl t thing? She doesn't even know which l of a hoop is which, in fact, she doesn't we that when you get a hoon from a

fellers, s a steady for you.

sus's mouin'

unnm

and the second state of th

Gee, baby, you look half gone.

Maybe she could support a family too. Well, fellers, Betty seems to be having a tough time trying to make that hoop roll. She just can't seem to learn to tap it with a stick-the right way, probably because she's been tapping too many kegs, lately at the old barrel havse. Well, even if you can't make a hoop-mobile, honey, you sure have a neat bag of tricks to do with a barrel. Yessir, gang, she's really doin' roll rightas long as she doesn't fall off the thing. Say, beautiful, why don't you fall off the wagon instead, it'd be much more fun and wheel be a-round, we hoop-we hoop!

Atta, girll W knew you' come thru!

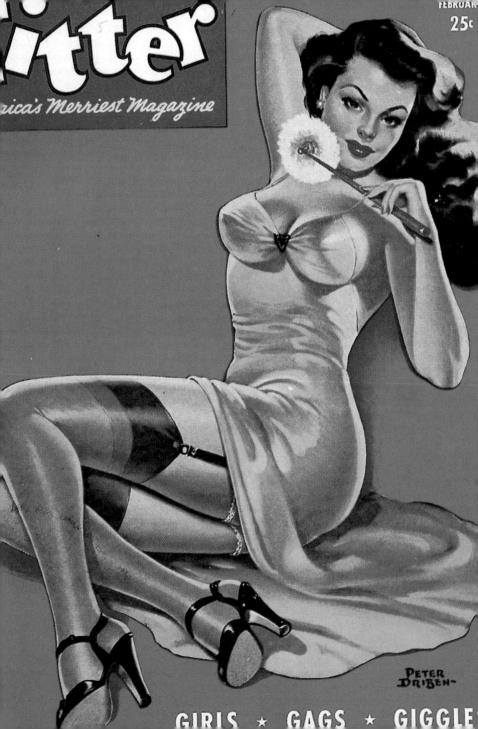

Funtastic Funy

Don't triffe with this raven-haired charmer, at least not while mounted on her super-high heels, she convincingly depicts the part of an untamed jungle beauty. No power could stay her whip hand once she lashes out. Even the wild beast bow in deference to the strength of this fantastic fury.

Woo-Woo! kat them mus-!We mean in water, shrimp.

TAN

2. What are yo cutting, baby Guess you're cut-up!

N.E.

R

5

5

00

D

E

sees a drownin'! t's only a re maid.

WAS MEN AND SWIMMIN'

4. Attababy! Olga run to the rescue. The rescu is up to you, honey

11 1

5. Cast your life-preserver, toots, Man overboard! G'wan, no man could be over bored with Olga. Olga's been made Li guard at Coney Islan Yesterday was her fir day, and the first thing t babe did was to put a "Li Guard" sign across h chest because Olga ha seen life guards use t breaststroke. Beside Olga didn't want anyboc in the navy to think sl was a bosom's mate. Su denly came a woman's c for help: "Surf me-I' drownin'!" Our cut grabbed a life-preserv and flung it into the ocea "Here's a life-saver Olga yelled to the woma "No good!" the wome yelled back. "I hate t flavor, I want peppe

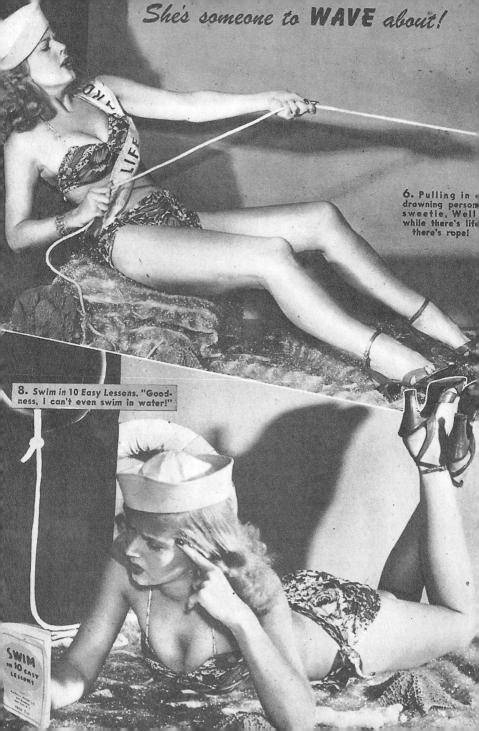

FE GODDESS, CONTINUED)

ga hauled in the life-prerver, but the woman wasn't ngin' onto it. "She must like e ocean's bottom," muttered ga. "Three times she's gone wn already!" Then Olga got r Swim in 10 Easy Lessons ok and, to save time, read sson 10. "When you've ought the drowned person hore," it said, "use the Schaef-r method." "The book's azy!" Olga snapped. "If I haeffer life by gettin' her shore, then I've already used e Schaeffer method!" So Olga ent to the edge of the dock and ved-into the sand. "Now, all gotta do is wait till the tide's st, then walk out and pick her o." Provided, some of them oney Island wolves don't pick you up first, eh fellers?

7. Gosh, is that a life-preserver or a cruller? It must be a life-preserver 'cause in a life-preserver, the sinker's in the drink.

9. Gonna jump in sugar? Goodness nose it's too cold!

Pres

10. Oops! Ol didn't land on l bread - baskonly on the sa

Se Jas

GALS * GAGS * GIGGLES

PETER DRIBEN- 2

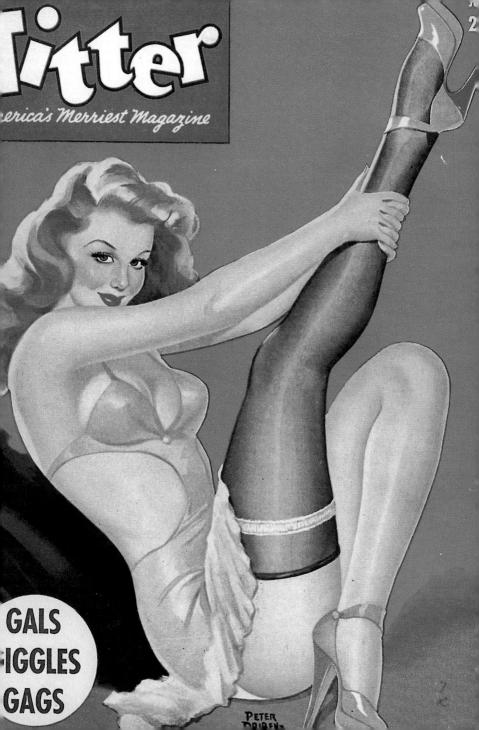

THIN-UP GIRL A SPECIAL MASSAGE with all the FATS AND FIGURES

2. "Hey, Bertha, go easy with my leg; I wanna lose ham, not gam."

1. "Here" Turkish to honey." don't m such a about it.

Mone.

Wa

Bath

Min

Steam Bath

Veronica's a pretty brunette, but our cutie's waistline has a habit of increasing its dimension. Now as much as we hate dimension it, Veronica's so afraid of becoming as large as Goliath that the babe spends money just to Goliath on Madame Bertha's massaging table. Bertha, y'know, is that blonde masseuse who lives on the fat of the land. In fact, Bertha treats every customer like a long lost son. Yep, the minute you walk in, Bertha kills the fatted calf. But yesterday Bertha said, "Veronica, you're very obese." Wow! Was Veronica sore! "Obese forgive me," cried Bertha. But it was no dice. Stop fightin', gals! Remember, obese on earth, good will toward men.

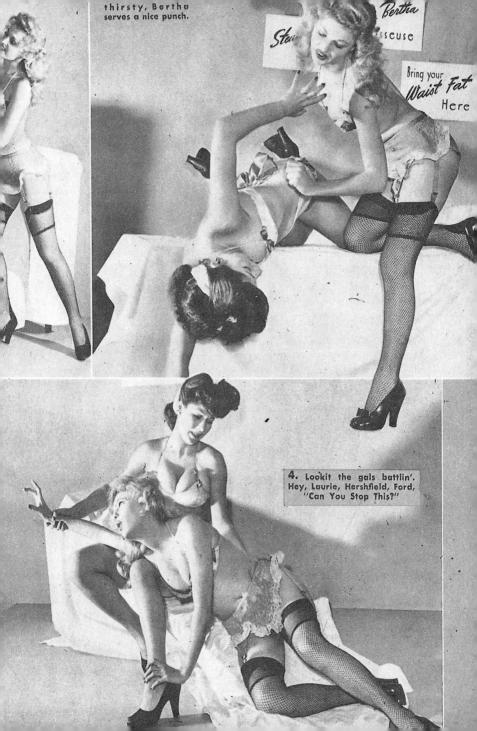

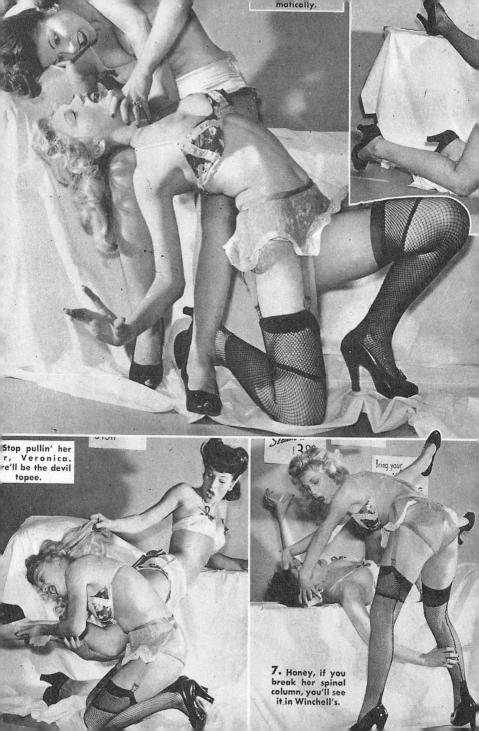

taken ten pounds off a colossus. Gosh, it was the colossus thing to murder y'ever saw. In fact, Bertha kneaded Veronica's muscles so vigorously that if Veronica had had a hammer in her hand, Bertha would have kneaded an ambulance. But suddenly Veronica gave Bertha a taste of her own medicine; and we must admit it left Bertha with a Swedish taste. Gee, Veronica began to pound the blonde with a rollin'-pin, front and back. But why front and back, Veronica? "Because I like my dead battered on both sides." (Okay, fellers, who'll volunteer to take a massage to Garcia?)

Bring your Fat Here

9. Put down that rollin' pin. "Oh, dough away and let me batter her."

тшо Swedish Fightin'-Gales

PETER DRIBEN-

GALS GIGGLES GAGS

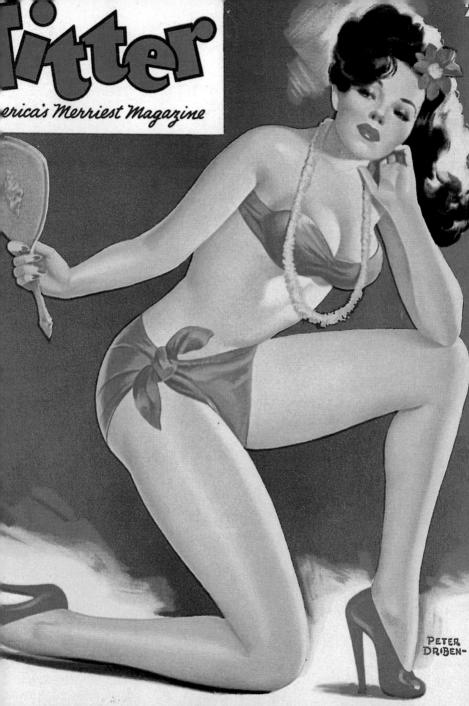

2:

CALS * GICCIES * GAG

1 heavy-ribbed old fashioned coret firmly molds Pat Headlee's figure fullness, transforming her to an hour-glass honey of incredible proportions. Twixt a full 35 inch hip and bust measure lies a closely constricted waist, which when measured, marks the tape at the unbelievably low figure of 17 1/2 inches.

I.T.

CONTRACT NON

merica's Merriest Magazine

JARL 254

GALS GIGGLES GAGS

10-0

(6

CO.CO.

Abject terror and total despair mark the classic features of gorgeous Georgette Walters, dark-haired, alabaster skinned metropolitan model, who sinks to her knees to depict a Turkish delight who pleads for a life outside of the unsurmountably high harem walls.

GIRLS GIGGLES GAGS

PETER DRIBEN

AP 2

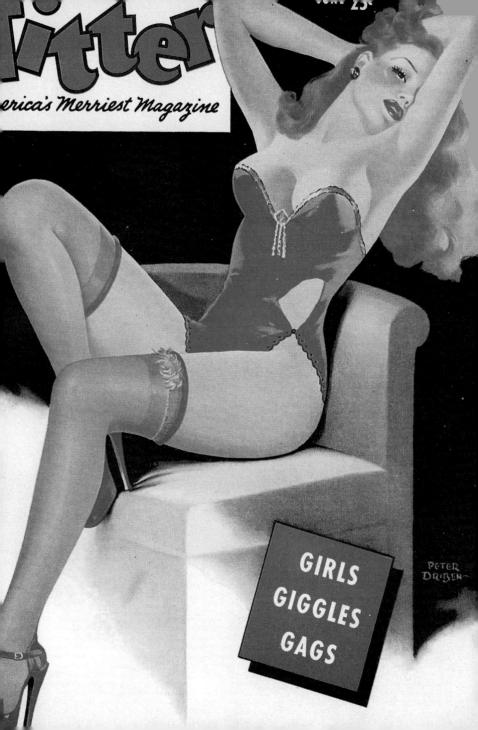

merica's Merriest Magazine

GIRLS GIGGLES GAGS

PETER DRIBENT 2:

10

A brief, but encasing, black corset binds Arline Forest's waist in such a miraculous fashion as to reduce that naturally tiny contour to a 16½ inch measure. Thus, tightly laced, Arline is breathlessly, beautifully breathtaking.

for I all and ? I ?

Míracle

Mold

1. Now this is what we call Table d'Hot!

LER

South for saw eyes!

The

30

2

-

2. Ah-ha, we knew our sweet would end up under the table!

¥...-

* Toots is on De-Mend All The Time!

*.

ABLE is one modern gal who knows the fix of life - so she claims! Yep, our blonde beauty is right at home with hammer and saw, and though Mable may be a hammerteur carpenter, she's a sight for saw eyes when she's working!

Take a look at these pictures of Mable at work, and learn how not to repair a table! Y'see, the darn thing wobbled, so our baby figured all she had to do was saw off a little from the three longer legs. And talking about legs, gang; take a look at those pins supporting Mable! They're not wood, but they're oak with us! Tree what we mean?

4. Look, gents, a t-able-bodied gal!

(%

5. Yeah man, here's a leg-cellent view of our sweetie! ankie, roots. w all the ankl

THE FIX OF LIFE (Continued)

Things didn't go so well for our baby, though. Seems like Mable swung the hammer and hit her own thumb!

"Gee, this is thumb-thing!" our sweetie cried. "It will certainly teach me a finger two!"

Toots tried sawing the legs next, then hacking at them with an axe. Is she a good carpenter? Well, we axe you – could anyone do worse? To tell you the truth, Mable didn't get the table repaired, but she made a swell pile of fire wood out of it. That's okay, toots. Just leave your lumber with our operator!

> 6. We're glad to see you're back on the job!

9. Now is that nice, we axe you?

1

ha

17.

8. What a lovely bandage, dear. How much did it gauze?

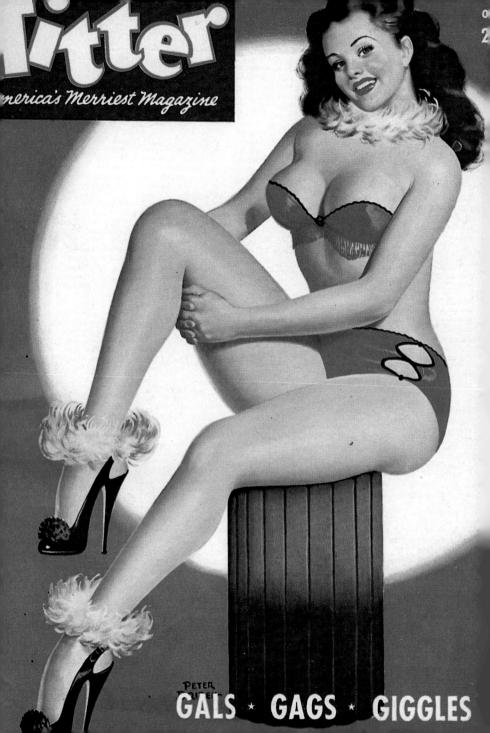

Locks of chain cleverly gripped about the white wrists of diminutive Doris Drake render her helpless—a pitiful pretty in the hands of her merciless captor. Thus bound and shackled, the versatile Doris, hopeful young actress, convincingly portrays the most difficult and exacting slave role.

ð

8

Con ca

00x

BOUND TO Shrill

dec. 25°

SILK-STOCKING SIRENS BRAWLING BEAUTS (ASP-WAISTED VENUSES)

Be Honest with Yourself— Is Your Married SEX LIFE a Success?

THIS BOOK CAN HELP MAKE IT SO

No longer need young couples enter marriage timid and embar-rassed-without knowing the important intimate facts of sex-mo longer need half-truthan and "second-hand" information lead them to hidden dangers. NOW, for the first time, two well-known doc-tors TELL ALL in this BIG double-value 376-page book-two books bound in one cover to bring the price down? This book is the latest and ontof the most complete on sex. Contains up-to-the-has been left duct. Nothing that should be known about sex has been left out.

MARRIAGE SECRETS REVEALED

Learn sex techniques, avoid serious mistakes, obtain lasting satis-faction-follow simple, clear directions. Know how to be sweet-hearts forever, no matter how long married. The doctor answers actual sex questions asked by real people. Your own personal problem may be answered here.

GUIDE FOR THE MIDDLE-AGED

How unsatisfactory relations can be corrected—sexual activity prolonged—change of life period. Also recent discoveries and in-formation that may help CHILDLESS COUPLES WHO WANT A BABY. Most EFFECTIVE PERIOD.

SEX ANATOMY COLOR PICTURES

70 excellent illustrations show sexual anatomy of men and women. Combination of pictures and text SHOW you as well as tell you with FULL PAGE PICTURES IN COLOR!

FREE BOOK SEX and This War Illustrated

IF YOU ORDER AT ONCE! A fearless exposé by a U. S. Navy Commander (retired) and a physician. 64 PAGES.

-PARTIAL CONTENTS-

Results of Sex Devial German Women's Corps and Nazi Soldiers War's Effect on Sezual Activity Camp Followers—Racketeers A Naval Commander's Compaign Against Sex Diseases

Against Sax Discoses You'll never want to part with this book! That's why we gladly send it for your private reading. Keep it for 5 days. If not 100% sat-infied, you may return it. Nothing to risk-send cou-pon now!

SEND NO MONEY-We Send C.O.D., If Desired

SIMON PUBLICATIONS, INC., DEPT. J-8 220 FIFTH AVENUE, NEW YORK 1, N. Y.

2 BOOKS IN I COVER

> FULLY ILLUS-

TRATED

IN WEDDED LIFE (AND) DOCTORS CONFIDENTIAL ADVICE

THIS

RUUR

WITH ORDER

(Canada or Foreign-No C. O. D. Send \$3.50)

2. Gee, that's a nice hand to hold

MARTHA is a cute little kid who loves to play cards. In fact, she's quite a card herself! If there's anything our honey enjoys, it's a good, rousing game of solitaire. "Only the way I play it, you've got to discard a piece of clothing every time you lose a hand," Martha says. "It's a lot of fun!" Yeah, you shed it, baby, you shed it! Our sweetie calls this game Strip Solitaire, and the thigh's the limit. Only one can play, but Martha won't mind if we kibitz while she tries to beat the cards. Pull up a chair, Oscar, our honey is one queen who's not card to take!

4. Peek-a-boo, ace-y you!

Pay Stripped Attention, Gents: Here's A Fu

5. Ah, yes, gents, here's one queen who'll always take the jack!

6. Look; cookie's losing her clothes, and that's not the calf of it!

7 Ah-ha, so you lost your skirt. Well you've got pin-nies from Heaven!

QUEEN OF HEARTS (CONTINUED)

Gosh, Martha must be lucky at love 'cause she's sure having tough luck with her cards. She lost the first game and had to take off her blouse. She lost the second game and discarded her skirt. She lost the third game and took off her hose. If this keeps up, sugar's motto will be, "Off with the old, and on with the nude!" We were afraid that when our sweetie lost another game, she'd be one queen with a royal blush, but our smart cookie used two aces to take the place of her bra. Say, we like that idea, honey. Any of you guys like to hold this queen? She's beautiful-in spades!

8. Wow, that's ace-y on the eyes!

ose.

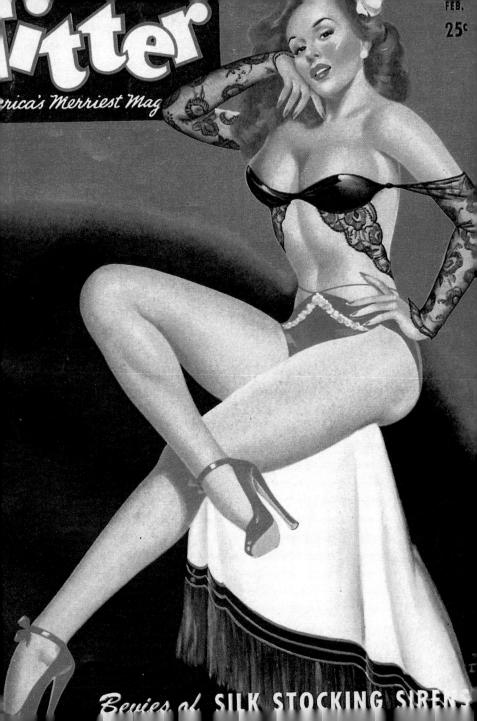

ere's a brand new recipe for a dish i delightful dreaming: take one part aliant blonde, two smooth stems of the loveliness from toe to thigh, a all curving 34 inch bust, a perfectly dented 25 inch waist, lush 35 inch ps—mix well with a generous helpog of handsome plaid. Then presto, sing out of the crowds of sheer amrosia we have June Frew, a honey who is really sweet and hot.

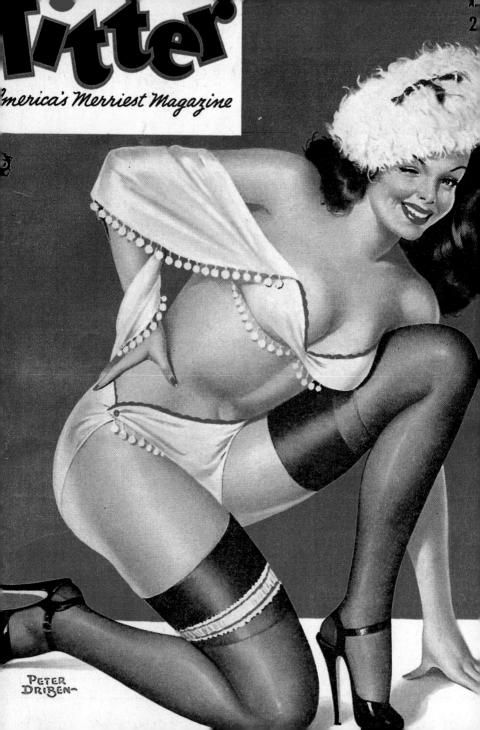

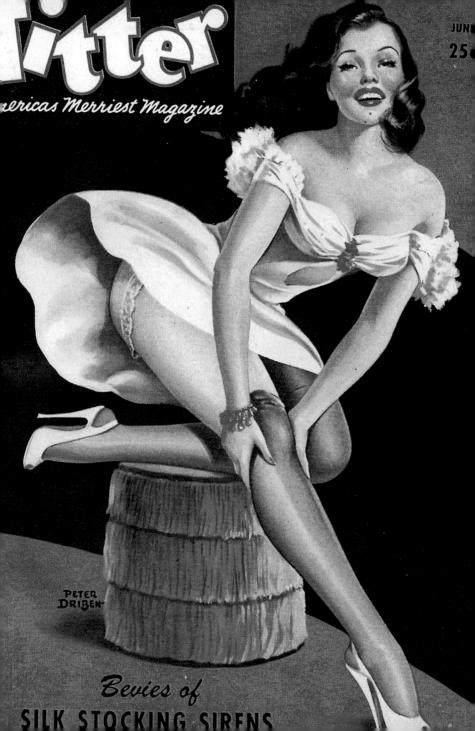

B ROADWAY'S favorite comedian, funnyman Teddy Werbel, scored such a success at his latest show in one of Gotham's brightest nite-spots that the guy just had to go out and celebrate. But the morning after! Wow! What a head Teddy had! So the wise lad hurried off to see lavely showgir! Nevada Smith. "She'll help me;" Teddy figured. "Maybe she knows some easy way to get rid of those moaning-after blues!" Say, pal, one look at gorgeous Nevada would make a corpse sit up and take notice!

** ★ ★

**

²² Showgirl Nevada Smith and Comic

a cold in the head!"

4. "I'm sorry, baby. I'll never touch the stuff again."

193.

2. "Water? Ugh! They wash dishes in that!"

v Werbel Find Their Lost Week-End!

6. Frease, may I have a little sip of ginger ale?"

5. "No, no coffee!" My gosh, Java hear of anything worse?"

> THE MORNING AFTER (Continued) Sure, Nevada knew just what to do but do you think Teddy would listen Not him! The poor, sick chump refuse to do anything but suffer, and he really did that! "Say," murmured craft Feddy, "maybe a hair of the dog wha bit me might do some good. The las time I was here, I hid a crock in the chandelier, just for such an occasion!" Out came the jug, and our hero starter celebrating again. Y'see, the "gut thought so much of his charming companion, he wanted to drink so he could see double!

" I knew you'd unrstand. Do you w 'Sweet Adeline'?"

9.90

ADAK

7 "Ah-ha, I've "The Lost Weekend' fool"

12P

Here Are a Few

Timely Tips On How

To Cure a Hangover

seen

SILK STOCKING SIRENS

POTER .

SILK TOCKING SIRENS

mericas Merriest Mag

25

PETER. DRUGEN=

NEW LOOKERS #5

The fifth in a new series of genuine 4×5 inch glossy hotos of the most beautiful girls in N. Y. Silk Stock-ing alamour girls in mischievous exciting poses. You've tried the rest now get the Best. Send \$2 cash for full complete set of 4×5 inch clossy photos to:

GOLDIE FOTO SERVICE tox 696, Grand Central Sta., New York 17, N.Y.

PHOTOGRAPHS

NOT PIN-UPS-NOT ART PHOTOS-NOT DRAPED NOT HAS-BEENS

These photographs are so good your money will be re-funded if you are not completely satisfied. Send only \$1.00 for assortment in sealed plain wrapper. Give age.

HOLLYWOOD EXTRAS Box 848, Preuss Station, Los Angeles 35, Calif.

BODY BEAUTIFULS

You've been looking for pictures like chees! Real life studies of lovely females in chriling poses. These photos are a must for your Art Collection: for the artist, illustrator or photographic student, Immediately available at an introductory price of only 25 mice of complete set; sent in plain wrapper. Order youts now! Send 52.00 cath to:

ESS-EN-ESS CO. Box 322, Times Square Sta., New York 18, N.Y. GORGEOUS MODELS

The curves and features of the girls stand out in exciting relief. Set of eight delightfully different poses, size 5" x 8", complete with stereoscopic viewer. Sent prepaid for \$1 in plain wrapper.

STEREO-ARTS INC. 3565 Kensington Ave. Philadelphia 34, Po.

Actual Photographs of smart lovely girls in snappy poses. 10 all different photos, \$1.00 60 ALL DIFFERENT PHOTOS FOR \$5.00. (Over 50 thrilling sets available.) Shipped prepaid. Remit in cash or money order only. DO NOT SEND POSTAL NOTES. Murray Wilkins, 417 Hill Street, London, Ont., Can.

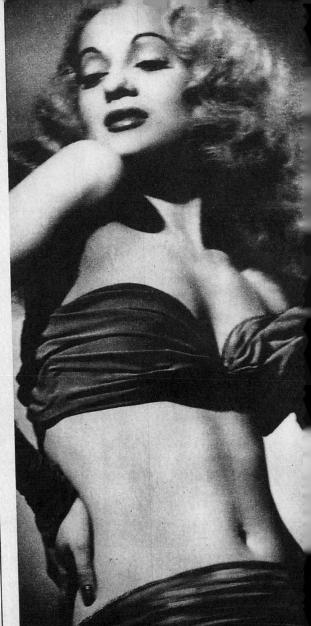

Christine Ayers is a burlesqueen has thrilled audiences from coo coast. No wonder for her soft dimpled shoulders and fabul buxom form are thrilling to b - - wain and e

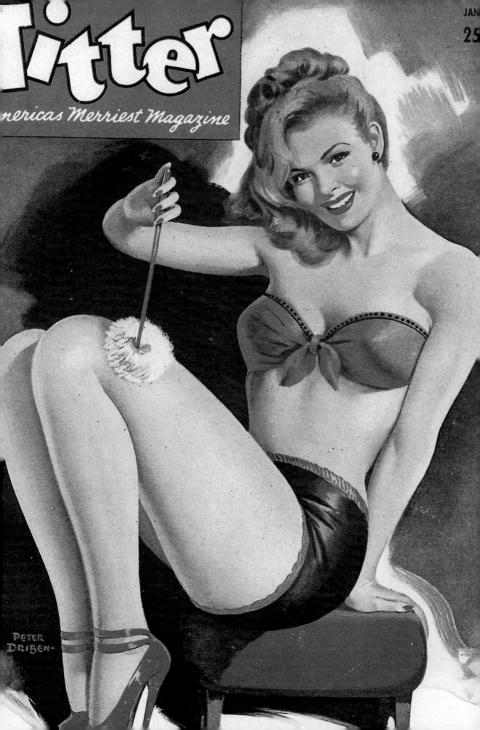

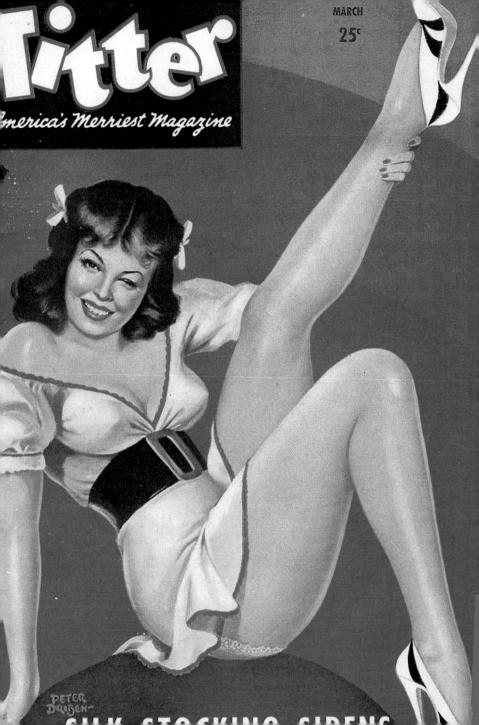

BEAUTIFUL BUT ROUGH Page 20

ETTING GERTIES GARTER Page 24

PETER DRIBEN- MAY 25°

... do you prefer this back view? Eileen's a winner from any point of view!

ill for a

.

Do you like Eileen Raye posed in tightly laced boots from the front or

Blue eyed Terry Palmer's lush lines are at their enticing best like this . . .

BOUT

...or better this way? Ohh, sugar, your curves are gorgeous from any angle, eh boys? \bigstar

K

20

HOW CHORUS GIRLS ARE MADE Page 30

WOMEN are FALSI Page 20

յու 25

ARRIED MEN MAKE BAD JSBANDS Page 14

SIY COMANA AND MENTO

JANET LANE

There's no telling what'll happen in the country, so these beauties come is upertioning in the

Sia

C TONE

LOLIE PENT

Sugar.

The see

the Sec.

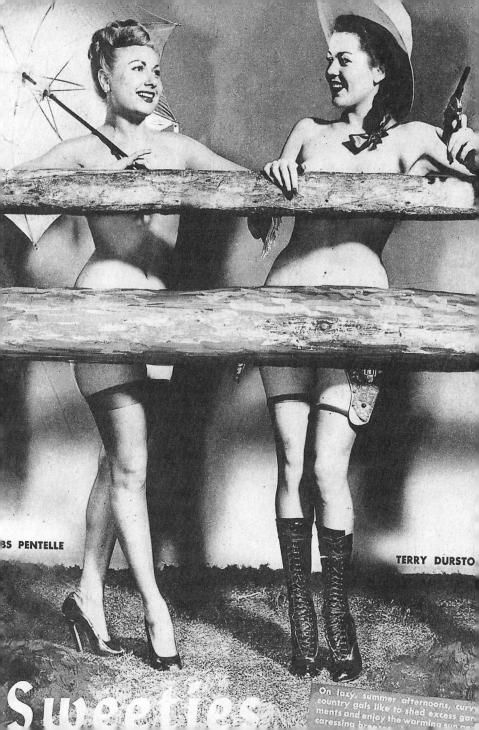

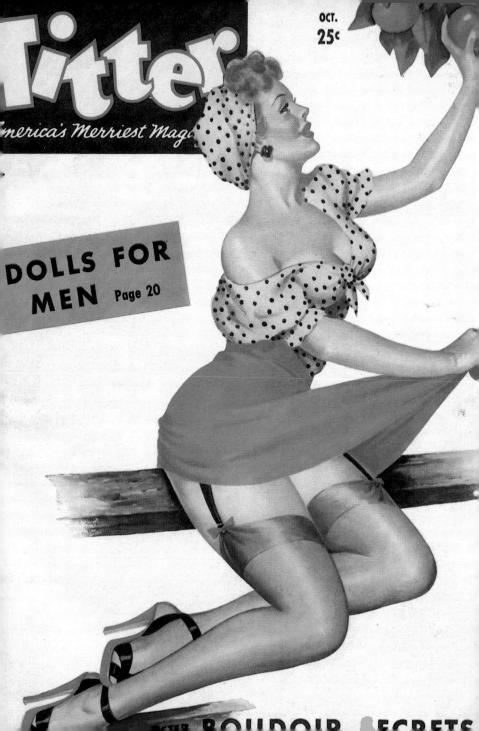

Stage Undies

YOU

PAULS OPERA HOSE. NYLON. Flesh & Black \$5.00 OPERA HOSE, ELASTIC MESH, Black &
OPERA HOSE, ELASTIC MESH, Black &
Sun Tan \$5.00
BLACK LACE PANTY & BRA SETS \$4.00
OPERA HOSE, SUPPORTER, All Elastic, Flech & Black S2.50 TIGHTS, Waist High, Lastex Mesh, Black &
Sun Tan \$7.50
All Elasti, Flesh & Black \$2.50 TIGHTS, Waist High, Lastex Mesh, Black & Sin Tan PANTIES, CABLE, NET, Full Chorus, Flesh, Black & White Black & White B
Black & White G. STRINGS, NET, Fine Elastic Trimmed Flesh
& Black 75c
Legs, Sizes 2 (to 30 54.00 CAN-CAN GARTER BELT, Flesh & Black 55.00
CAN-CAN LASTEX MESH HOSE, Black \$4.00 CAN-CAN MESH ELBOW GLOVES, Black \$3.00
STRIP PANTY, FINE NET, Hook on Side Type, Black or Flesh
Black or Flesh \$1.50 STRIP PANEL AND BRA SET \$10.50 STRIP BRASSIERES, FINE NET, Thin Elastic
GARTER BELT, IMPORTED NET, All ELavie Lecs, Sice 2 to 30 CAN-CAN GARTER BELT, Hich & Black 55,00 CAN-CAN LASTEX MESH HOSE, Black 53,00 STRIP PARLE LAD WIG CLOVES, Black 53,00 STRIP PARLE AND BRA SET 51,55 STRIP PARASIERES, FINE NET, Thin ELaster Top and Blatom, Black or Flech Rincrostor Creations 51,50 STRIP PARASIERES, FINE NET, with Rinkrostor Creations 52,00
RHINESTONE G. STRING, Beaded or Silk
Chainette, Size by Hip Measurement \$20.00
Chainette: Size by Hip Measurement \$20.00 FRINGED BRASSIERE To Match \$5.00 DANCE BELT, Girdle Elastic \$31.50 REHEARSAL SET, Midriff and Trunk \$4.95
PIN UP TYPE, Silk or Velvet; Panty and Bra Sets.
Ideal for Rehearcal or Photography \$10.00 SKATERS SKIRT, Circular Type \$4,95 SKATERS TRUNKS, French Cut \$2,95
STAGE UNDIES, Dept. HGP-2
302 WEST 51st STREET NEW YORK CITY CHECK EACH ITEM WANTED
MAIL TODAY
Check Size Small Medium Large
☐ I enclose \$ you pay postage ☐ Send C. O. D. I will pay postmen
Name
Address
City State Cash or C.O.D.
STAGE UNDIES
A LIVE ART MODEL
A MODEE
Would cost you \$10 an hour. you can save money by using the new and different book
the new and different book
Drawing
Drawing
THEFEMALE
THEFEMALE
THE FEMALE FILE THE FEMALE FILE THE FEED AND A STATE OF THE STATE OF
THEFEMALE
THE FEMALE FILE THE FEMALE FILE THE FEED AND A STATE OF THE STATE OF
THE PERMALE FILE PERMALE
THE FERMALE THE FERMALE FREE FOR DATE OF THE STATE THE FERMINE THE FERMINE THE STATE OF THE STATE THE ST
THE FERMALE THE FERMALE FREE FOR DATE OF THE STATE THE FERMINE THE FERMINE THE STATE OF THE STATE THE ST
THE FERMALE THE FERMALE FREE FOR DATE OF THE STATE THE FERMINE THE FERMINE THE STATE OF THE STATE THE ST
THE FERMALE THE FERMALE FREE FOR DATE OF THE STATE THE FERMINE THE FERMINE THE STATE OF THE STATE THE ST
THE FERMALE THE FERMALE FREE FOR DATE OF THE STATE THE FERMINE THE FERMINE THE STATE OF THE STATE THE ST
THE FERMALE THE FERMALE FREE FOR DATE OF THE STATE THE FERMINE THE FERMINE THE STATE OF THE STATE THE ST
THE FERMALE THE FERMALE FREE FOR DATE OF THE STATE THE FERMINE THE FERMINE THE STATE OF THE STATE THE ST
THE FERMALE THE FERMALE FREE FOR DATE OF THE STATE THE FERMINE THE FERMINE THE STATE OF THE STATE THE ST
THE FERMALE THE FERMALE FILE OF ALL
THE FERMALE THE FERMALE FILE OF ALL
THE FERMALE THE FERMALE FILE OF ALL
HE BENGENIC Hormone

AID IT Dear Editor, I agree with Gregg Sherwood, when she says, in your June issue, that no man will ever take her over his knee and spank her! Why the very idea! Me allow a husband or boy friend to wallop me with a hair brush across thin panties? Why my Mom stopped spanking me after my 14th birthday. I could NEVER love a man who'd spank my bottom! Louise Barr, New York City Baby Lake is right ! I could NEVER love a man who didn't take me across his knee and soundly spank Dear Editor, me when I need it (which is often). My husband not only takes the hairbrush to me now - but he did when he was courting me. That's his privilege. It's very painful, because my hubby is thorough and he leaves no protection on my seat of learning when he spanks me, but I recognize his right to wield a hairbrush, strap, or any other corrective implement where it will do me the most good. I'm married to a MAN, and he takes no nonsense from me. Mrs. Charles L. M., Chicago, Ill Dear Editor. I don't understand your American girls. When I was a tiny tot my Mother spanked me with.her palm. Later Mummy and Daddy slippered me or hairbrushed me - and jolly hard too. In school all of us girls were soundly birched on our panties when we were naughty (the boys were caned - I know because we peeked). But, where is the argument? Of COURSE women must be punished. I guess I'll never understand American women - nor American men if they don't assert their right to chastise their women! Pamela B. T. L., Toronto. You don't print enough pictures Dear Editor, of gorgeous girls wearing tightly laced corsets. Maybe a lot of readers don't like them, but you are disappointing ME, I can tell you! PLEASE, Mr. Editor, more pictures of shapely damsels, laced until they can scarcely breathe. There is NO substitute for this essential

beauty aid! More corsets!

Marvin R., Denver, Colo.

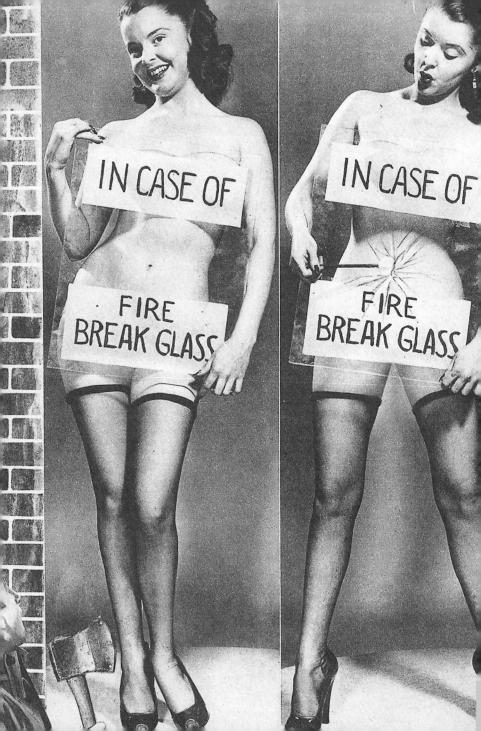

Blazing Redhead

FIRE BREAK GLASS

Sound the siren, Rollo! And hand me my hearl! Radheaded Jackie Cavanaugh is such a sultry bundle of loveliness that the firemen are likely to get burned! In fact they look overcome theaty — and we can't blame 'em! A native, the file of lovelines that they look overcome theaty — and we can't blame 'em! A native, the file of lovelines that they look overcome theaty — and we can't blame 'em! A native, the file of lovelines that they look overcome theaty — and we can't blame 'em! A native, the file of the file of the source of the you look at her, with her five-foot-six of soft curves, her flaming tresses and that tempting smile. She thought the 'In Case Of Fire Break Glass' was a cute idea—and we expect a few hundred guys to dash out and join the nearest fire department. Outta our way, Oscar!

DEC.

25°

nerica's Merriest Magazine

RAINY DAYS ARE FUN

DADEC IIVE IT DAILCU

FEB. 25°

IVE WAYS BABES SAY NO

WHAT MAKES MEN BLUSH?

APRI 25

America's Merriest Magazine

EX FROM NINE TO FIVE

500

There was a young girl from Peru, Who decided her loves were too few. So she walked from her door, With a fig-leaf, no more, And now she's in bed with the flu!

* * *

Louise: "Is Jimmy careful when you go riding with him at night?

Emma: "I'll say he is. He comes to a full stop at every curve!"

He kissed Helen. Hell ensued! He Left Helen— Helen sued!

* * *

A smart girl is one that quits playing ball when she makes one good catch!

Miss Sixteen: "I want a man with a future." Miss Thirty-Five: "I want a future with a man!"

* * *

Did you hear about the aging burlesque queen who thought about the good old days and heaved a thigh!

* * *

A boxer by name of O'Flynn Who always was able to win, Had a beautiful nude On his tummy tattooed And nobody noticed his chin.

* * *

"Junior. Jun–IOR! "Yeah, ma?" "Are you spitting in the fish bow!?" "No, but I'm coming pretty close!"

* * *

Frown: "I understand your girl friend is a typist. Does she use the touch system?"

Clown: "Well, you don't think she bought all those swell duds out of her salary, do you?"

A woman's face may be a poem; but she is always careful to conceat the lines in it!

Dolly: "Only last week you said it was a great life if you didn't weaken."

Polly: "Yes, but since then I've found out it's sometimes a greater one if you weaken just a little bit!"

* * *

He gave up liquor, wine and food He never went to bed; He swore off smokes and women, too, He had to-He WAS DEAD!

* * *

Irate Parent: "I'll teach you to make love to my daughter, sir."

Young Man: "I wish you would, old man, I'm not making much headway."

* * *

Bounder: "I know her well. She sat on my lap when she was little."

Rounder: "I know her better. She sat on mine last night."

* * *

Devastating Dolly says "the worst a girl's past the better presents she expects!"

* * *

Beach Peach: "Ooooh, I can tell you're a man a girl can trust!"

Beach Rounder: "Hmmm, didn't I meet you here last summer? Your faith seems familiar."

GAY PAREE

Q UI, OUI, messieurs, regardez ces chapeaux pour bebe, direct from Paris (Paris, Texas, that is, and fresh off the freight train), each and every one a unique creation of that style genius and madhatter, M. Guillaume Henri de Harrison-Schultz. Interviewed at his atelier where he was putting the finishing touches on a brimless, off-theface frying pan for Lady Helpus, wife of the famous Lord Helpus, the master said he was trying to portray two scrambled eggs in mock flight over a beer barrel. "Le dernier cri," he said, "the latest cry"though it looked more like the lats gasp. Lovely hats, but they'll never replace the pinwheel beanie.

ARE YOU A SAP WITH GALS?

ROZ GREENWOOD

JL 2

H^{ERE'S} a trim, tidy pretty who's sheer TNT—tall 'n' terrific! It's Gene Drake, the statuesque brunette with the green eyes and gam-orous gams. Gene is California bred and our dough is on this cookie as one of the nicest dishes around.

Tall and Terrific!

AUL 25

\$6

HOW DO YOU

KNOW SHE

LOVES YOU ?

nerica's Merriest Magazine

CONNIE CEZON

HAREM ON IS HANDS!

nerica's Merriest Magazim

0

ост 25¢

URRI CANE

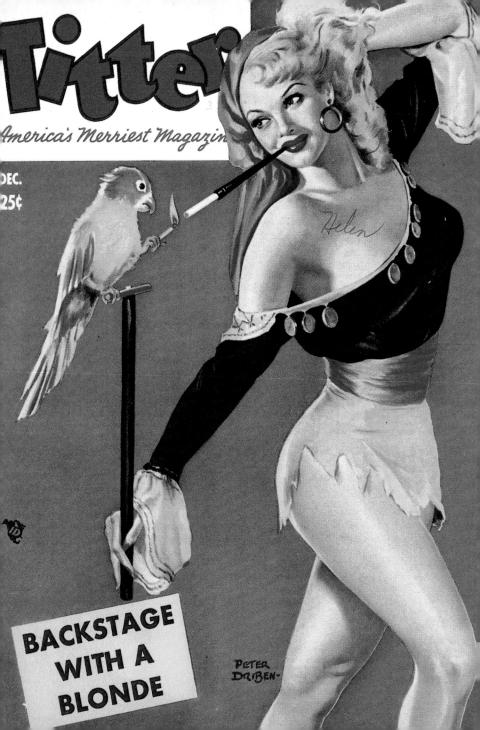

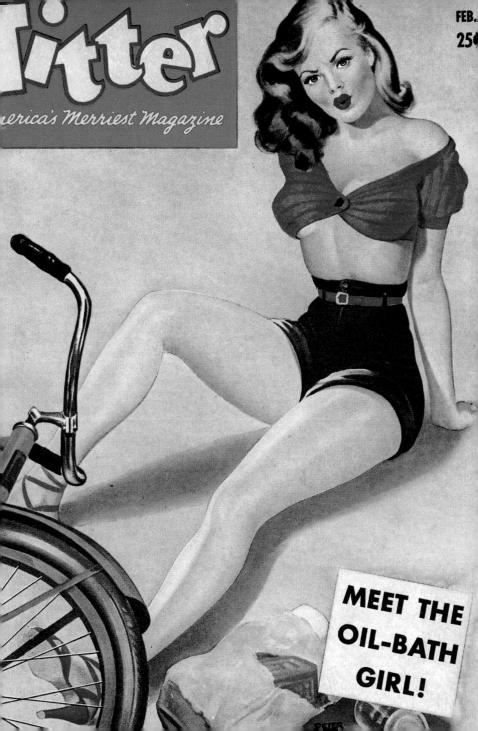

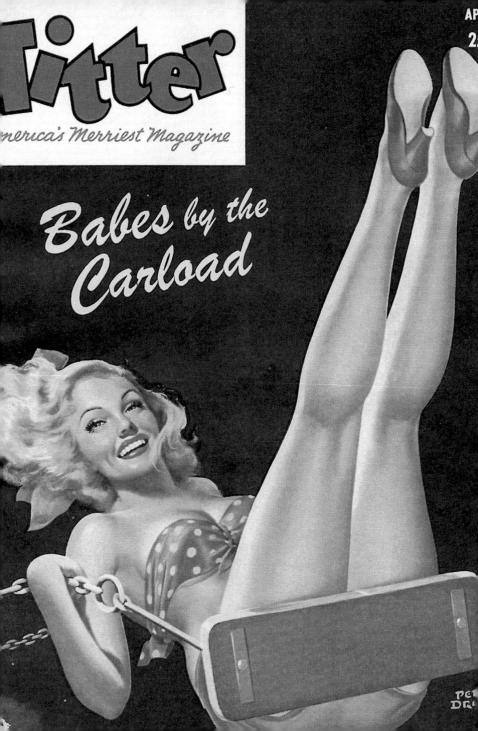

merica's Merriest Maga

INE 5¢ ine

Ray's a brownbeauty, 5' 7" 7½ lbs. How like her, Cy?

> Mimi Pall, a Louisville lovely with cinnamon red hair and dimples. Spicy, hey?

Naughty but Nice!

> She's the nets, Broadway's Linda S vage, only 19 and Copacabana cuteee

This sassy sweetie is Maralyn Baker, owner of prize-winning gams that are 201/2-14-8" at thigh, calf, and ankle.

> If y'like blondes you'll lo Kara Brian with her 34½" bu 24" waist, 34" hips, 19" thig

AU 21

Ł

EVEN WAYS TO WIN A BABE!

Þ

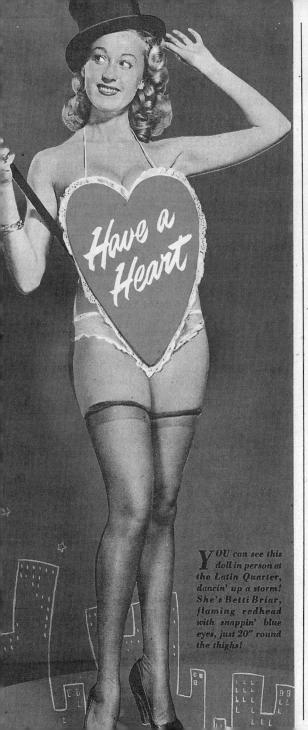

World's Greatest Collection of Strange & Secret Photographs

Strange as Secret Protographs Now you can travel round the world with the your own eyes the weidest peoples on earth. You witness the strangest customs of the red, white, brown, black and yellow races. You attend their starling rites, their mysterious practices. They are all assembled for you in these five great vol-umes of The SECRET MUSEUM OF MANKIND,

GOO LARGE PAGES Recet the world's Greatest Collection of Burning Frindling Photos from Arris. Torture Flotos from grands Photos from Arris. Torture Flotos from of other. There are almost 600 LARGE PAGES of Ca Boots, exch page 57 square lacks at said

1000 PHOTOS

TOU See actual courtable practised in every, more than the second of the

Cont	ents	of 5-	Volu	111	ne Sel
Volume	1-The	Secret	Album	of	Africa
Volume	2-The	Secret Secret	Album	of a	Europe
Volume	4-The	Secret	Album	of	America
Volume	B-The	Becret	Album	20	Oceania.

5 PICTURE-PACKED VOLUMES

SCART WISCHN OF RANKED VOLUTI BECRET WISCHN OF RANKING consiste of a bib mice any one of these volumes, and pares, you mind it dimousle to last Yoursel of the second second second second of the second seco

METRO PUBLICATIONS 363 Broadway, Dept. 1708 New York 13. N. Y. Send me "The Secret Musedim of Minh rest volumes bound together. I will pay 1.36, plus postage on arrival, If in 5 du of delighted, I will return the books and fund my \$1.98. Name..... Address..... City. CHECK HERE if you are enclosing \$1.98, thus Baying the mailing costs. Canadian & Fersign orders, \$2.50 in advance.

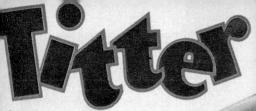

America's Merriest Mag

ct. 5¢

£

WHY FRENCH GALS ARE POPULAR!

SIX WAYS TO HAVE FUM!

Di 2:

THE FRENCH DO IT BETTER

IN THIS ISSUE: LADIES'NITE IN A TURKISH BATH

DRIBEN.

FE 2.

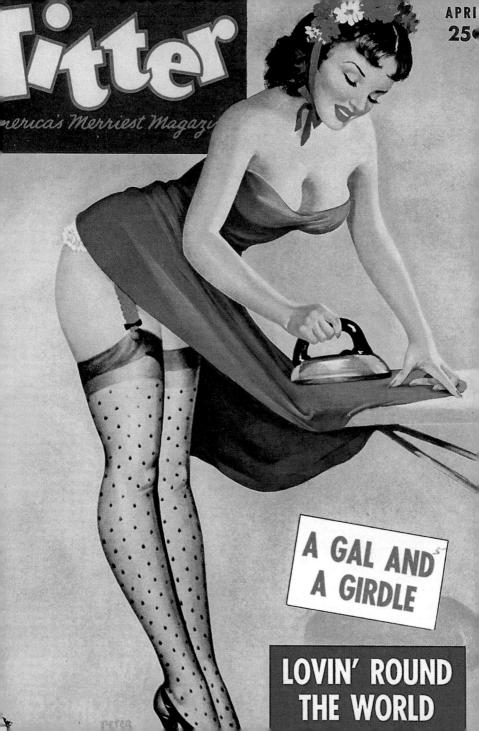

IN THIS ISSUE: LOVIN' IS HER BUSINESS!

JUN 25

Inter

America's Merriest Magazine

à

Just a couple on the scrub t oughta was in back, the

Just a couple of candidates on the scrub team. Someone oughta wash out that guy in back, though. A spy!!

100

wonder Dolly's cleaning n this game. She learned oll her own-dice, pals!

0

U.S. NAVY SEE THE WORLD BEFORE 0

Help! Stop the ship! Our honey's just found out a hammock's like a bronco!

These cuties sure shoot to thrill. They'll get you in the heart too!!

THERE'S somethin' about a sailor, fellers, particularly sea. sigh-wrens like this. It seems that Cassie and Dolly decided to help Uncle Sam, so they joined the Navy, which is sure a funny place for a coupla whacks like these to land! Anyway, this is what happens when chorus girls go gob. Up anchor, gang!

AUGU 25

merica's Merriest Magazine

HOW A BASHFUL **BRIDE BEHAVES**

nerica's Merriest Magazin

ост. 25¢

IOW TO GET N AND OUT OF BED!

N THIS ISSUE:

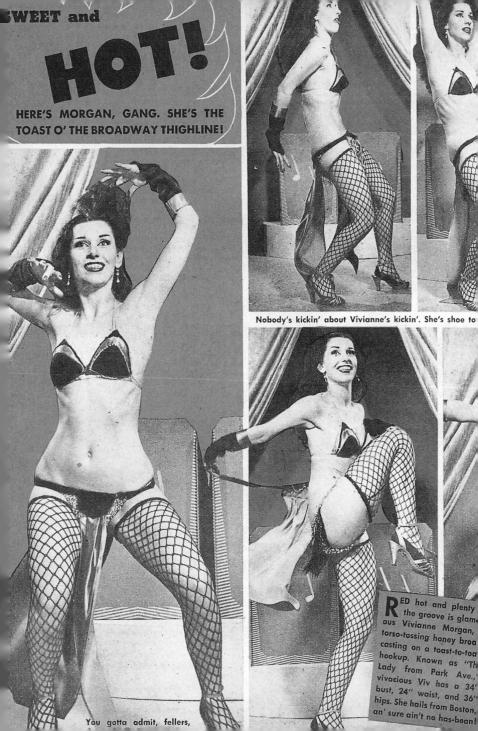

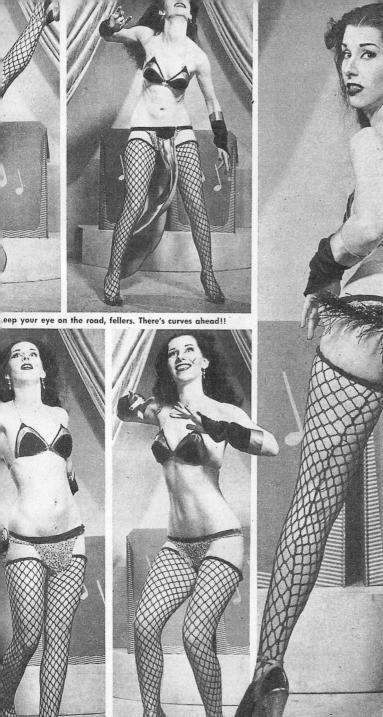

* Our runway riot hails from

ORRID TORSOS FROM PARIS!

IN THIS ISSUE:

MAN

nerica's Merriest Magazine

6

DEC 25

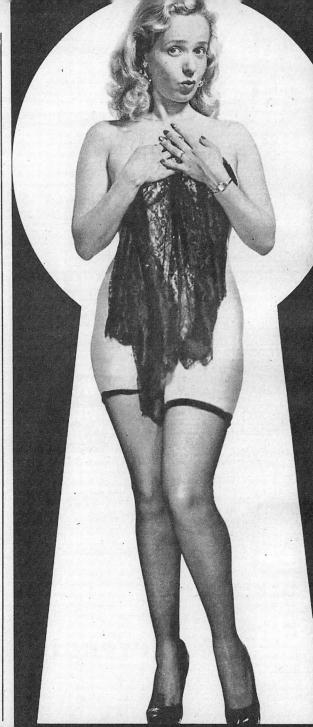

Hit it! Nite clubbers go mad when sizzling Suste steps a hot rhumba on bass drum!

アン

100-

BEAT it BABY

A DOLL WITH A DRUM 'N' DAZZLE TAKES BROADWAY!

OTTEST act on the nite club circuit consists of the cutest babe you ever saw, plus a set of trap drums and a world of rhythm! Curvy Susan Price has blase Broadwayites in the aisles when she beats the skins and tosses her torrid torso to a boogie beat!

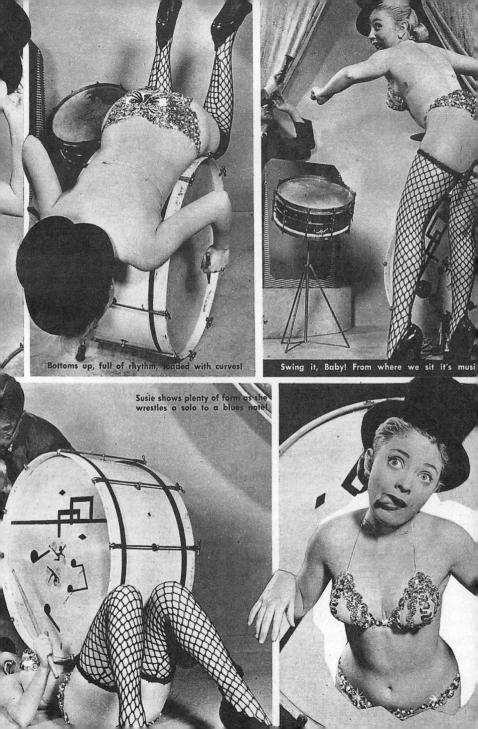

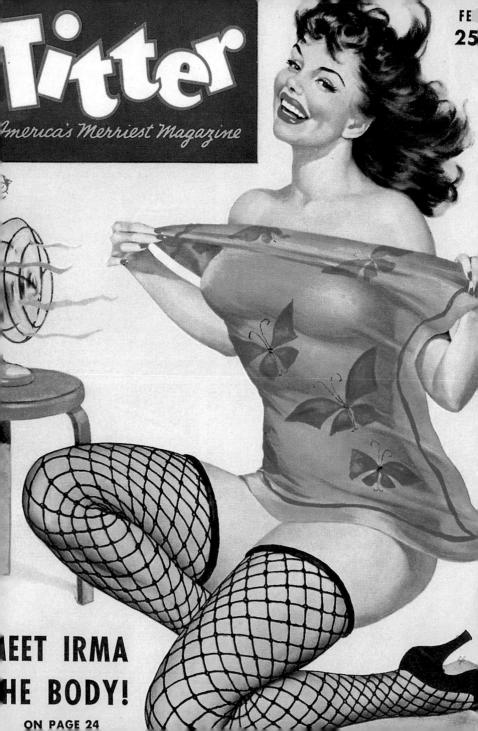

Undercover Girls

HERE'S A CHANCE TO SNEAK A PEEK AT WHAT THE BROADWAY BABES COVER UP!

> Mmmm! It's Vicki Verrill! No wonder she's an artists model! This curvy blonde has a perfect figure! She's a lovely 36" at bust and hips!

> > 1.

C'mon out, Jonnie James! We wanna see those famous curves! Jon's 5'8", 'n' weighs exactly 118 lbs.!

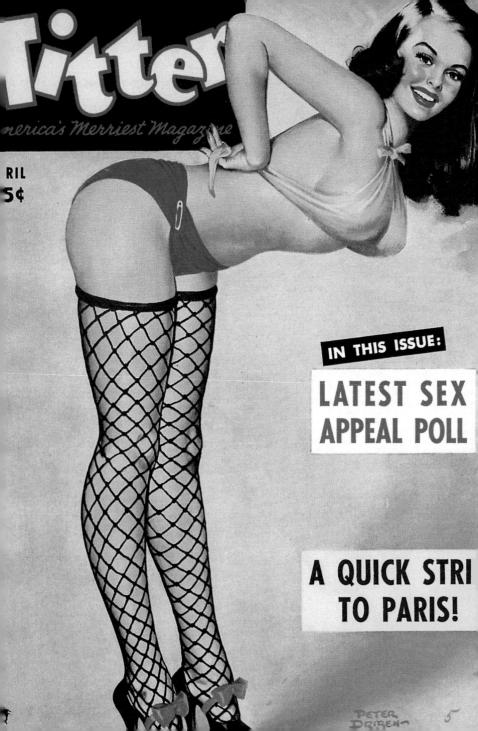

2 JUNE USI 250 mericas Merriest Magazine Peter Drigen-**Broadway** • Hollywood

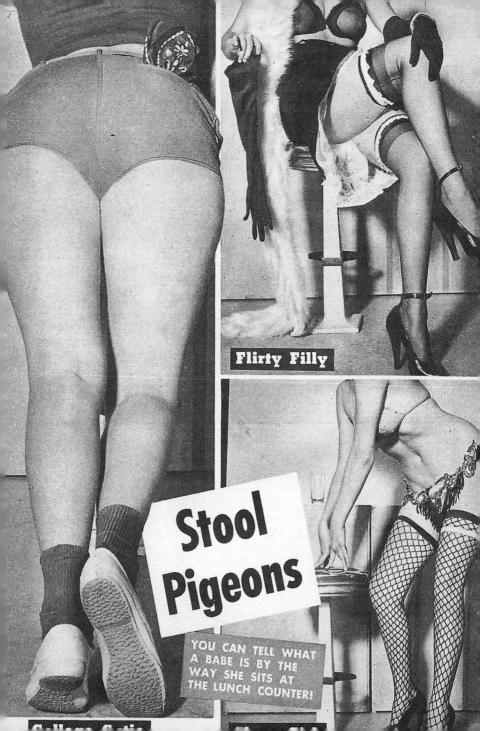

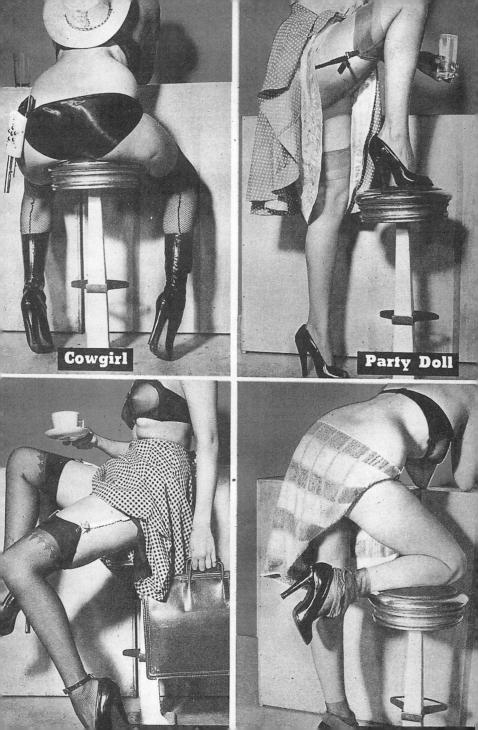

A SORT OF THE IN-ECTUAL TYPE, YOU DW, GLASSES 'N ALL!"

Rollicking BEDSIDE FUN

> .. and You will too when You possess "the **Pleasure Primer** The Ideal Playmate

THOUSANDS ARE ENJOYING

Here's enterainment for open minds and ticklish spines. Here's lusty, merry recreation for unsqueamish men and women. Here's life with' apologies to none. Collected, selected from the best there is, this zestful Primer is an eye-opener for the inexperienced; wisdom for designing; merriment for all. It is guaranteed to make the lassies giggle and he-men erupt in boistercus bellyful. Here is no rouge for the straitlaced or satisfaction for the morbid. Served bellyful. Here is no rouge for the straitlaced or satisfaction for the morbid. Served Primer is a blueprint for uninhibited living. Call it a gay evening's entertainment or an ideal bedide companion, you'll dally over its contents time and time again. YOU ARE INVITED TO EXAMINE THE PLAS-URE PRIMER 10 DAYS AT OUR EX-PENSE TI IS GUARANTEED TO PLEASE OR YOUR PURCHASE PRICE WILLY BE REFUNDED AT. ONCE! Plang Book Co., 109 Brood St., New Yok A.D.Y.

PLAZA BOOK CO., Dept. P-416 109 Broad SL, New York 4, N. Please send THE PLEASURE PRIMER on 10day trial. If I'm not pleased, I get my purchase

ice I	refunded at once.	
1	postage.	Postpaid pay postman 96c plus
NAI	ME	
ADI	DRESS	
CIT	Υ	STATE
	Chesda and Earslan-	SI 25 with order

I by

Cover Picked of from nov. 42 Georg Real

Beauties

Steffa

AUV 2-

BROADWAY HOLLYWOOD NIGHTCLUB

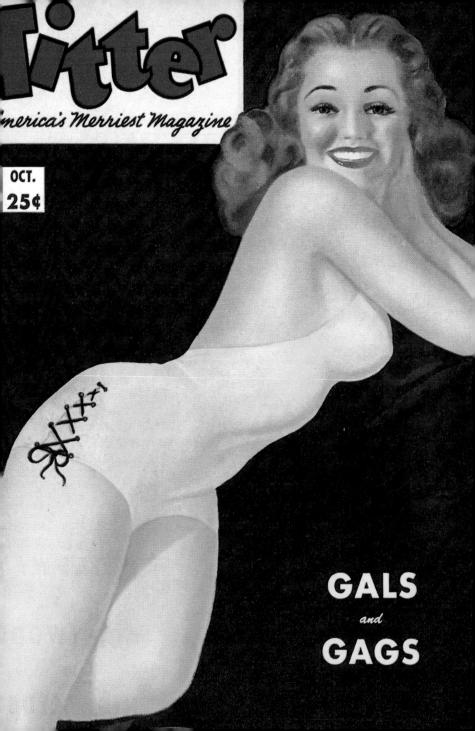

Hain STEMS!

Meet Pat Savon 5'4" bundle of c vy charm! Pat's ly 19, 'n' blue-ey

Wynn Martin, platinum blonde show gal from Texas, weighs

-

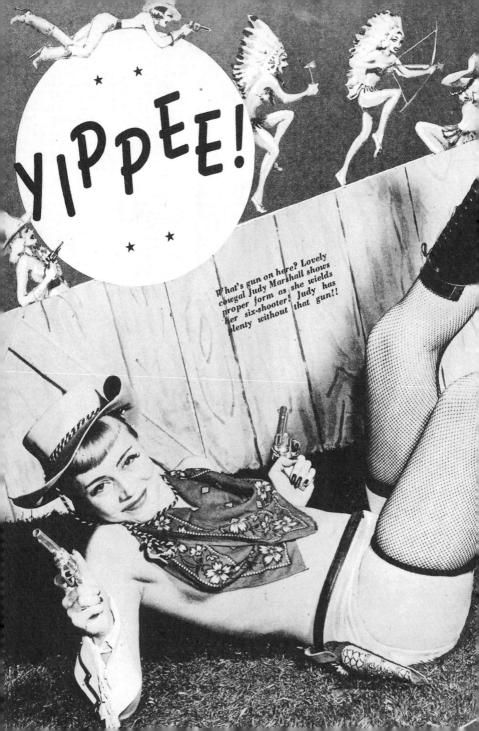

Well, fan my scalp! If all squaves shape up like Noreen Bates I'm a-headin' out West pronto! She's tall 'n' terrific! She'll do! Wahoo! ----

WANTA SEEK FEMME AND FORTUNE? "BETTER GO WEST, YOUNG MAN!" SAYS TWO-GUN TESSIE!

. A.L. MARTIN

merica's Merriest Mag

DEC. 25¢

ROADWAY HOWGIRLS OLLYWOOD MODELS

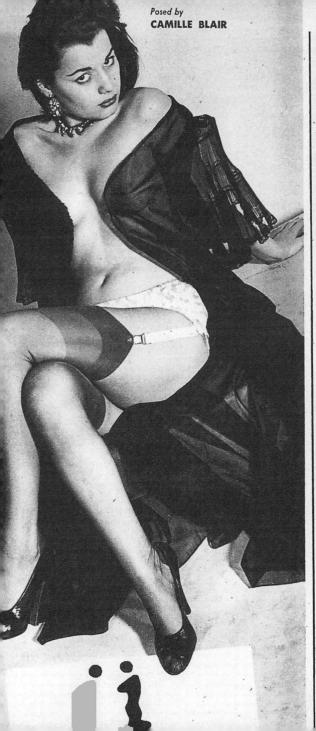

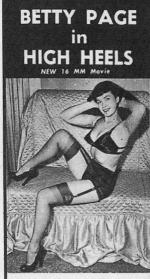

I have just made up a new High Heel movie featuring pretty Betty Page called "Betty Page in High Heels" which I know you will enjoy viewing. There are several close ups of Betty walking around in 6 inch high heel patent leather shoes, while attired in long kid gloves, black bra and panties, and long rolled stockings. The movie runs 100 feet and sells for \$12.00 complete. It is well lighted throughout.

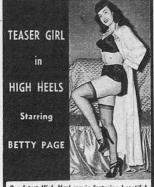

Our latest High Heel movie featuring beautiful model Betty Page WAS MADE SPECIALLY TO PLEASE YOU. We know you will want to see more of this popular model. Betty wears black bra, panties and black stockings. Several closeups of her walking in high heels.

The movie runs 100 feet long and sells for \$12.00 complete.

SPECIAL OFFER: BOTH HIGH HELL MOVIES SINT TO YOU FOR ONLY \$22.00 POSTPAID.

We can sell you 100 High Heel photos of Betty Page at 20c each or all 100 photos for \$15,00. Mail your order NOW to

Dept. GL-1, 212 E. 14 St., New York 3, N. Y.

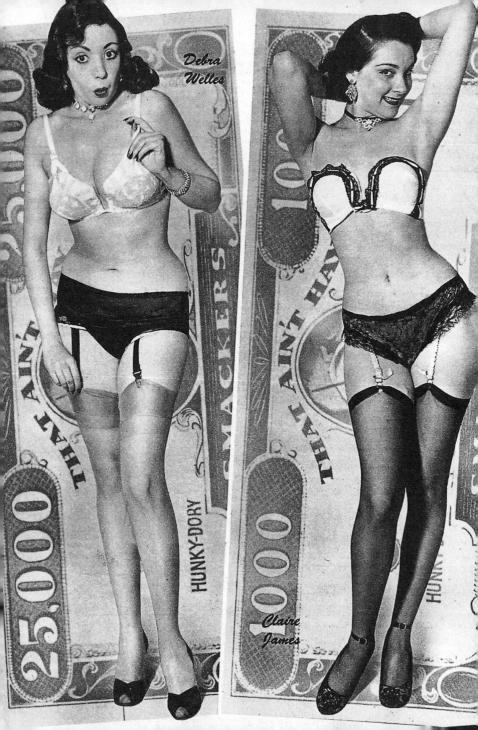

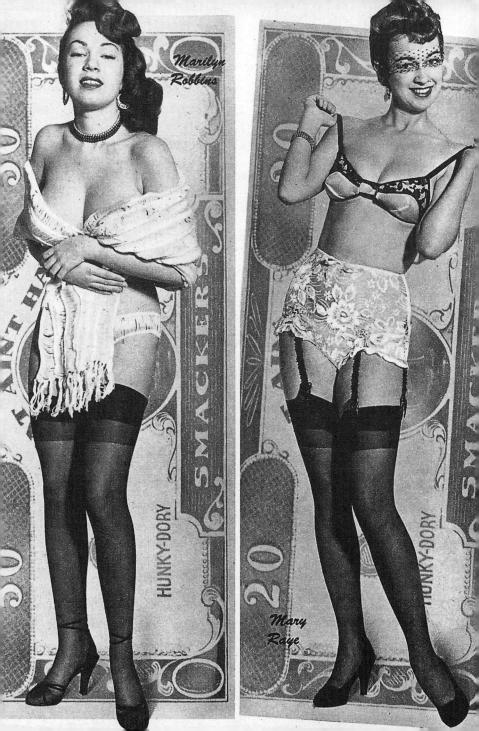

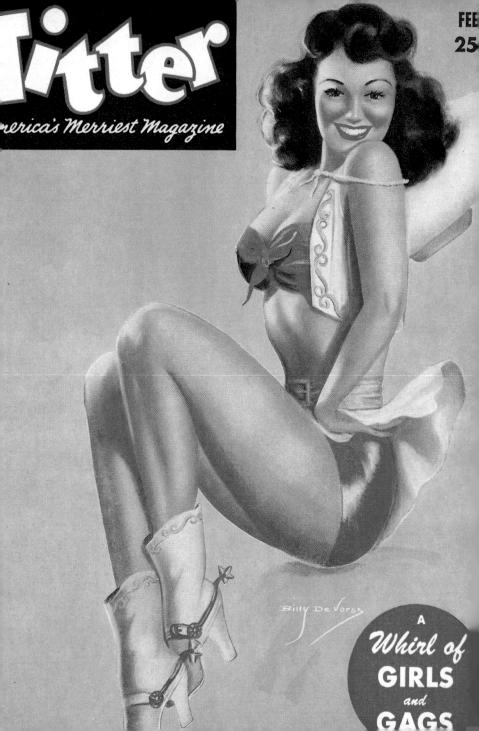

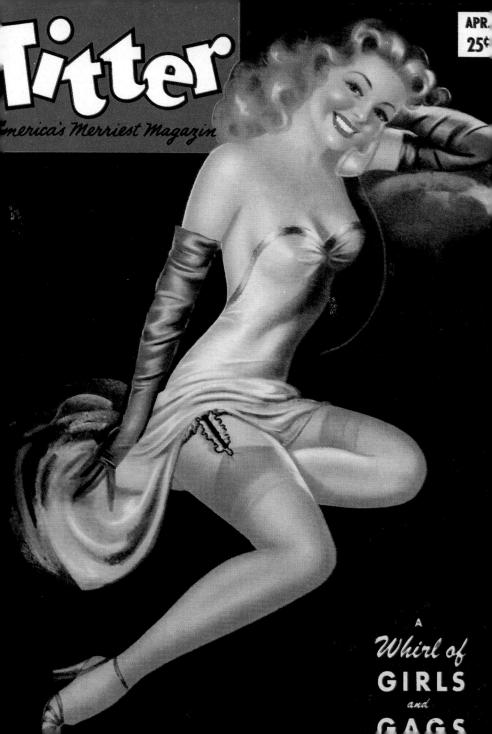

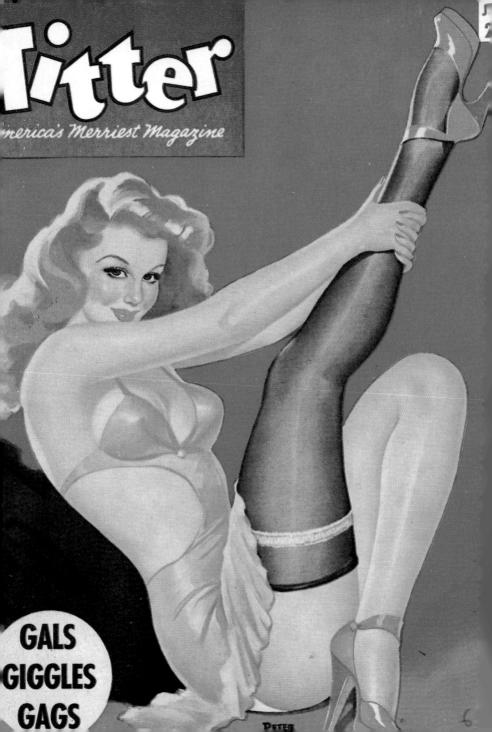

AUG. 25¢

erica's Merriest Magazine

Danger! BABES AT WORK!

PEEKS AT BURLEY TREATS!

Will you be taken care of in your old age, like Daddy here? Check this!

Do you find it difficult raising the money for premiums? Try this trick, boyl

EUIII

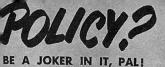

2

Do you have extended coverage? This is very important as you can see, menl

I LOST. MY

SHIRT

ON THE

DODGERS

Does it help you make both ends meet? If not, the policy ain't solid, Jackson!

> HEN DID You last read your in surance policy, pair we mean Get into with elokers in HI you're covered in cases like the ones in these pictures. You may uncover

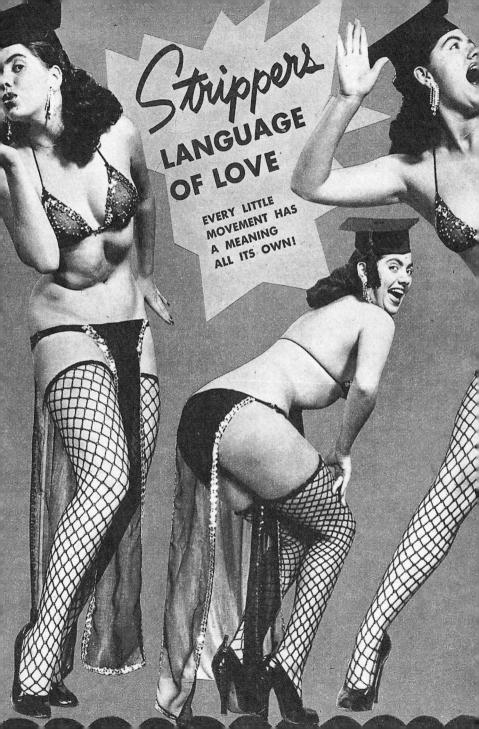

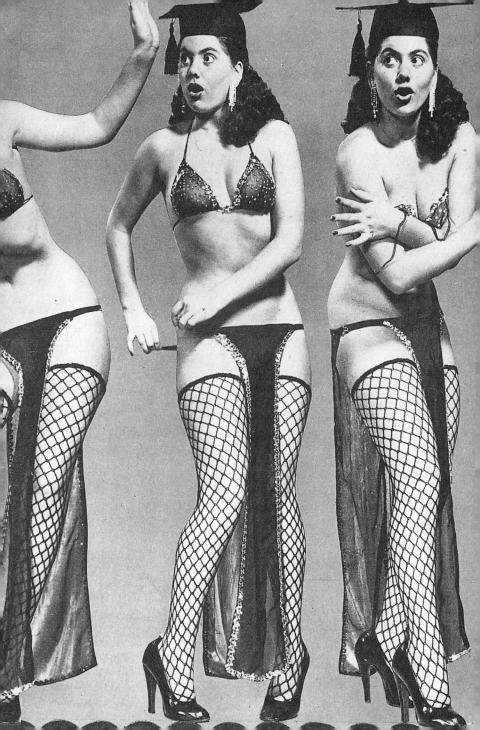

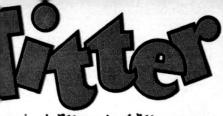

DEC.

25¢

erica's Merriest Magazine

Bevies of EAUTIES Barrels of FUN

SOME SIZZLING NUMBERS FOR YOUR LITTLE BLACK BOOK!

TELEPHONE

Here's quite a number It's Dolores Rowden th show girl! She measure 38" at bust 'n hip line

Karin Lane, blonde model

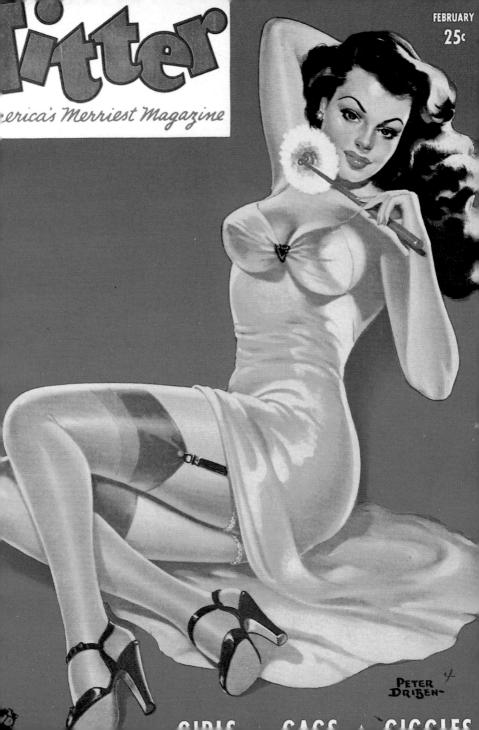

No matter how you look at show girl Patti Sweet she shapes up, eh, boys? Meybe her well-distributed 114 lbs. cause that!

5

6

Figures do lie! Here's Baby Dunne, Broadway's favorite chorus gal! Baby's bust and hips are a perfect 36", boy!

THESE DOLLS ARE ALL CURVES

See what we mean? Babs Fontaine has her eye on you!! Babs is an artists model 'n she's okay from any angle!

> Sneak a peek at Greta Borg, Sweden's gift to show business! She's just 20, is a blonde, and adores Yankees!

TUIC WAY TO PET TUE DIPUT ANDIE

RIIT VA GATTA TIIDN THE DAGE

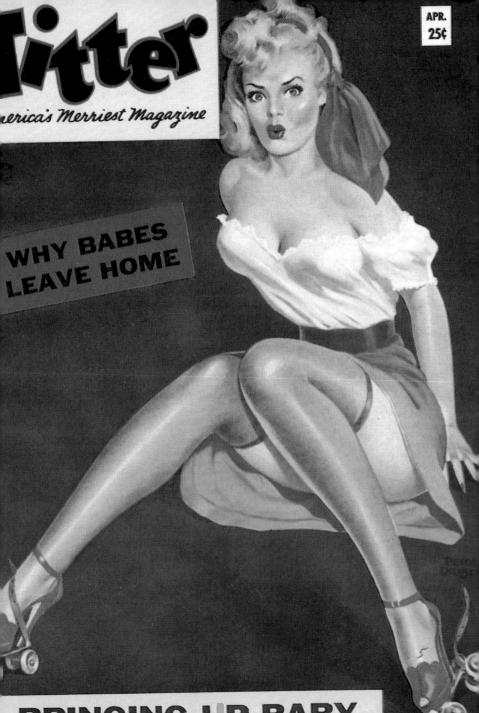

RRINGING UP BABY

BLONDE YES DUMB NO!

THE SULTRY GAL WITH THE BLONDE FRINGE ON TOP IS PLENTY HEP, BOY!

Lily Christine the famous blonde dancer and actress, pulls down a grand a week! Does that sound dumb, pal?

Blonde chorus chick Pat

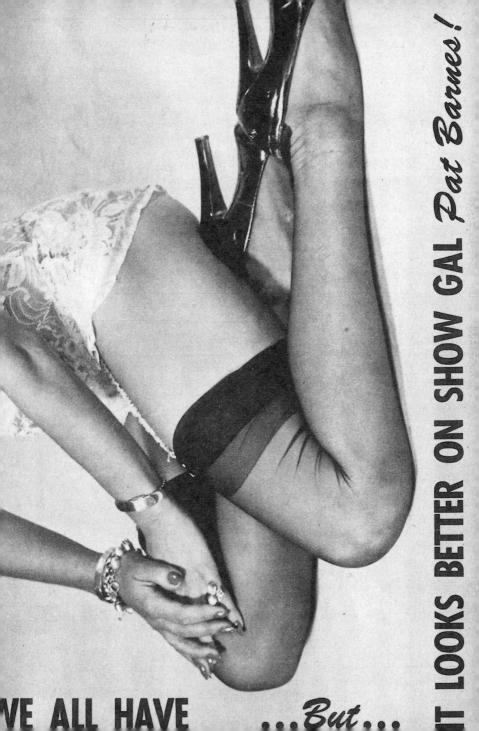

As Harrison still had no real rivals, he simply went on copying himself. But Wink contained a number of innovations, one of which was to reprint, in the late 40s, John Willie's legendary "Sweet Gwendoline" comic strip in the form of a serialized double-page story. Willie had already published parts of his bondage saga about the dastardly Sir d'Arcy in his magazine "Bizarre", but this probably never got beyond a small underground circle of fans. The fresh air of the newsagent's stand above ground may have been something strange for him, but otherwise the circumstances were right. For commercial reasons a fetishistic interest had meanwhile been introduced into Harrison's magazines – girls in chains, whipwielding "wild sirens", and spanking stories. The unglamorous, girl-next-door models of the photostories, who hoped no more than to turn an honest penny, were no doubt unhappy with these new melodramatic requirements, but that was what the readers wanted. The day shift at the Harrison headquarters began, so Tom Wolfe liked to put it about, when the boss, who had once again spent the night in the office, was awoken by the sound of clanking chains, which some hapless model was dragging to the photo shoot herself. Da ihm noch niemand richtig Konkurrenz machen wollte, kopierte sich Harrison weiter selbst. Zu den Besonderheiten von Wink zählt allerdings der Abdruck von John Willies legendärem "Sweet Gwendoline"-Comic als doppelseitige Fortsetzungsgeschichte Ende der 40er Jahre. Willie hatte Teile seiner Bondagesaga um den ruchlosen Sir d'Arcy bereits in seinem Magazin "Bizarre" veröffentlicht, doch dürfte dies nur ein kleiner Undergroundzirkel registriert haben. Die Luft über der Ladentheke war für ihn etwas Neues, aber die Rahmenbedingungen paßten: Models in Fesseln, peitschenschwingende "wilde Sirenen" und Spankinggeschichten waren den sauberen und jedem Melodram abholden Mädchen der Fotostories mittlerweile verkaufsfördernd an die Seite getreten. Die Tagschicht bei Harrison begann, so kolportiert Tom Wolfe, wenn der Chef, der mal wieder im Büro übernachtet hatte, vom Geräusch scheppernder Ketten geweckt wurde, die ein geplagtes Model eigenhändig zum Fototermin anschleppte.

Puisque personne ne voulait encore lui faire véritablement concurrence, Harrison continua à se copier lui-même. Il faut toutefois compter parmi les singularités de Wink la parution sur deux pages, sous forme de feuilleton, du célèbre comic «Sweet Gwendoline» de John Willie à la fin des années 40. Willie avait déjà publié dans son magazine «Bizarre» des extraits de sa saga sado-maso qui mettait en scène l'infâme Sir d'Arcy, mais seul un petit cercle d'initiés devait encore s'en souvenir. L'air qu'on respirait autour du comptoir était pour lui quelque chose de nouveau, mais les conditions de base étaient là : à côté des gentilles filles qui se souciaient tout aussi peu de glamour que de mélodrame, on avait fait apparaître entre-temps dans les histoires en photos des modèles enchaînés, des «sirènes lubriques» agitant des fouets et des histoires de fessées, dans le but de stimuler les ventes. Tom Wolfe rapporte que l'équipe de jour arrivait quand le patron, qui une fois de plus avait passé la nuit dans son bureau, était réveillé par un bruit de chaînes qu'on traînait et qu'un modèle résigné acheminait lui-même jusqu'à l'endroit de la séance photo.

GALS PIN-UPS GAGS SUM I S S 2:

ropss

GIRLS GAGS GAYETY

A Fresh MAGAZINE

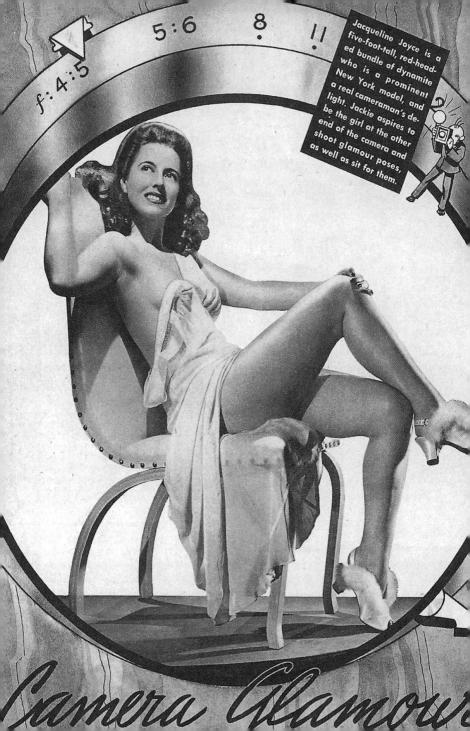

RINK Fresh magazine

GIRLS GÁGS GAÝETY SUMMER 25c

Lee Brooks, Broadway actress and Hollywood model is 5 feet 7 has a 24 inch waist and a 35 hip and bust.

ites.

C.

lt wouldn take a brin expert to kn that hold June No calls for trump

5

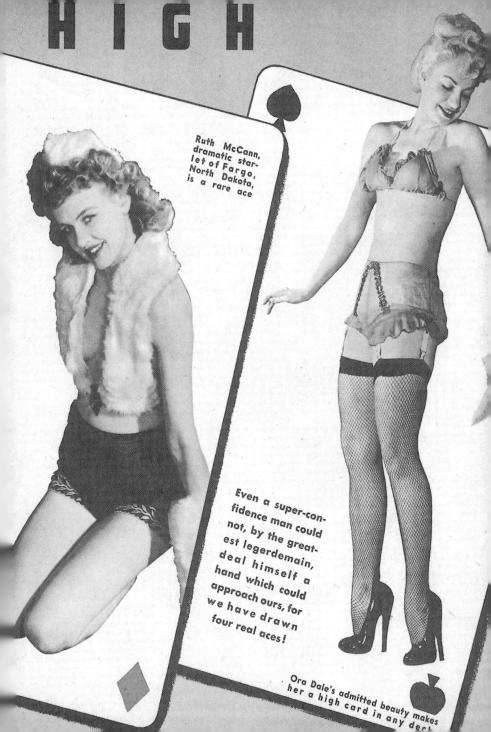

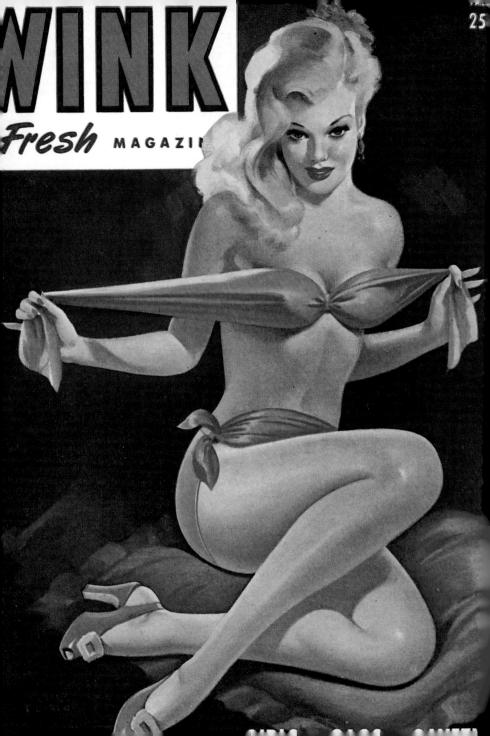

S A R O N G S I R E N

Brandishing her whip, Janice Cullen, gorgeous brunette model depicts a wild, jungle beauty, beating her way thru the impenetrable jungle where fierce beasts lie in wait to pounce upon the unwary intruder.

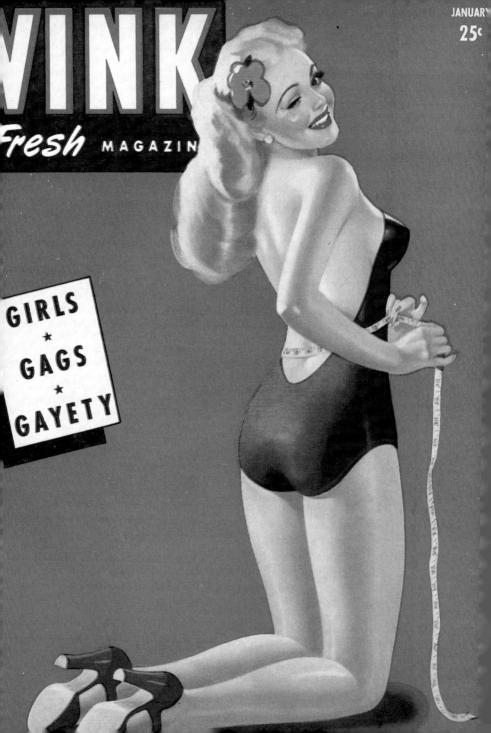

BOLD BEAUTY

Hip length auburn hair, sparkling, dark eyes, a tiptilted nose, a ripe red mouth, and a full form which corsets in at an intriguing 19 inches; shapely stems, and fairy-like feet, shod in six inch heels—put them all together and they spell Irene Coppers. A dainty and talented dancer, Irene is also gaining renown as a model.

MERRY MIRTHFUL MAIDENS

1D

DRIB

This streamlined image of enslaved loveliness is June Raymond, golden haired model, who a la Lamour, sinks to her shapely knees, lifts her graceful hands and pleads formercy. June's enactment of an imprisoned siren, begging for release is so ens chantingly dramatic as to stamp this 19-year, old lovely as a likely andicate for stage and screen conquests.

shovelin' snow, baby? Well shovel over and make room for us.

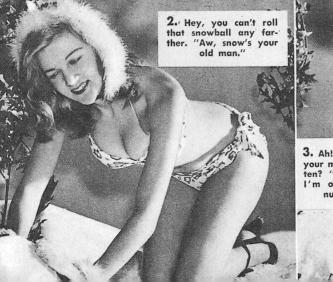

3. Ah! Puttin' on your mittens, kitten? "Why not? I'm o - mitten nuthin'."

SHE HAS Snowman OF HER OWN

0,00

4. Oops! Those two snowballs you've got are icy. Yoo hoo! Icy you.

a's boy friend gave her the air just because our little inder wouldn't sit on his knees. And Helga's so lonefor him that the chick decided to build a snowman to his place. Gee, Helga worked like an Eskimo dog in the ; and so great was her puppy love that to keep her moving, the babe kept calling, "Mush! Mush!" st, Helga built up such a big pile of snow it was easy t the drift of what our honey was doing. Hey, Helga, snow looks like an airplane. "Oh, yeah? Well, I have 5. Toots, are you puttin' your hat on the snowman 'cause he has a coal in his head? SHE PUT HER Pile in A Snow Bank

7. Looking for a winter sport, honey?

(FREEZY TO LOOK AT, CONTINUED)

Well, Helga finally got her snowman built up and ev her hat and an apron on him-yes, and a pipe in his Why the apron, honey? "Well, fellers, I figured if I c up to him, his heart would melt, and-gee, I wouldn' him to soil his nice new snowsuit." Gosh, honey, snowman's heart melts, it'll be the icest thing you eve Did he smoke the pipe? "Only for a minute. Y'see he v to trade a can of tobacco for a nice toboggan, but

"Boys, I love to hug snowman." Aw, slush.

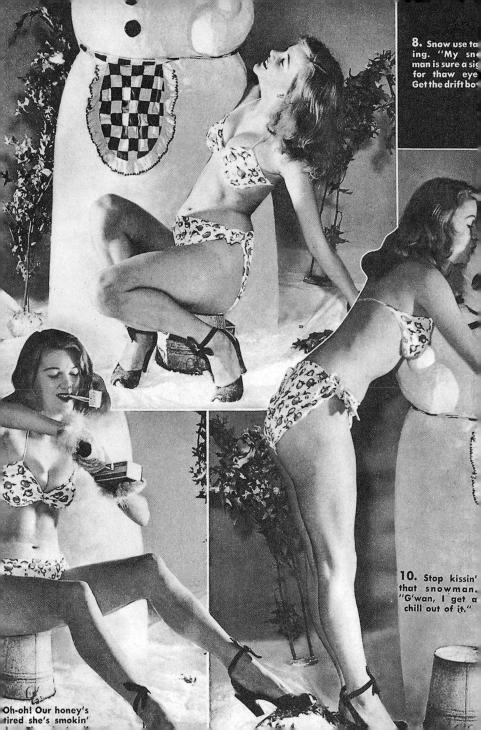

PETER DRIBEN- MERRY MIRTHFUL MAIDENS

31

Like two, beautifully formed statues, Sherry Britton, enthralling brunette and Dorothy Karlyle, exciting redhead show off the true magnificence of their full, young curves.

EOPARD LADY

r, fellers, remember the last time you went to the circus and thought you were drinkin' Ballantine's 'cause you saw three as all the time? Well, do you remember Bedelia, the deathyin' tamer of leopards? Of course you dol Well, boys, Bedelia's k again with her ferocious leopard for a limited encagement. It this time, fellers, I'm feedin' my leopard homogenized milk." milk, honey? "So he'll have Vitamin D and not Bite-a-man-?" (If he were our leopard, we'd feed him Carbona to knock spots out of 'im.) But just the same, Bedelia's the bravest gal o ever stepped behind the bars of a leopard's cage. And in front of bars-Oh, brother, can Bedelia tame wolves.

1. A leopard or a tiger? "I don't know; I've got spots before my eyes."

2. Put down that whip! A leepard's not a dog. "But I wanna whippet."

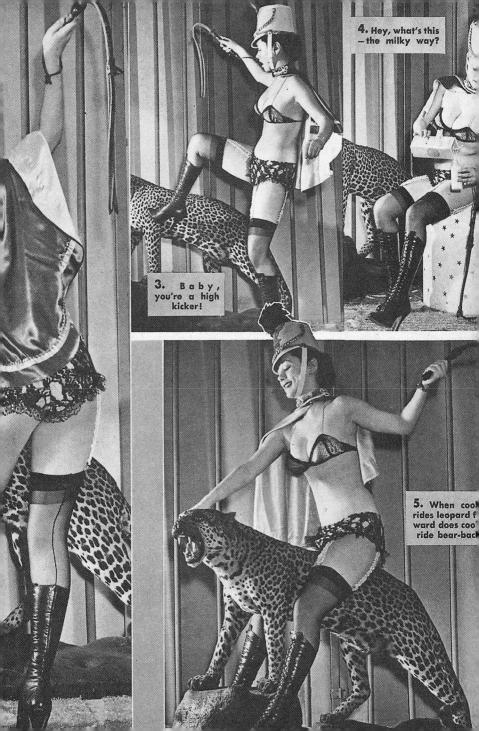

She TAMES to please

Al.

6. Gonna roll out that drum, baby? Well you're roll right with us.

itin

7. Don't open your trap like that, honey; you'll

(LEOPARD LADY, continued)

But yesterday poor Bedelia was scared out of wits. Yep, our little circus performer was so soc her spine was actually Tingling, Brothers. And w d'you think scared her? A mousel "Gee, it's my fault," sobbed Bedelia. "Everybody warned me mouse-ing conditions are terrible in the city." (can the mouse help it if your act is chees?) kiddin', gents, Bedelia the Brave was so frighte that the babe locked herself in the cage to pre herself from the ferocious mouse. And what al the leopard, hon? "He thought the mouse we sheep and took it on the lamb." (C'mon, you Ti Mouse-keteers. all for hon, and fun for all. Pla

There and the street of

in the

9. Don't you dare enter that cage, mouse. "But cheese the gal of my dreams." 1

10. Ah, she's a barred girll

MERRY MIRTHFUL MAIDENS

Pere

AUG 25

MERRY MIRTHFUL MAIDENS

DRIBEN-

Please be ful, honey, nightstick rourself!

1

Stalling ALL CARS

2. Thumb chassis, he fellers? And she's not badge kid, either. rgie, an arresting, captivating guardess of glamour, has t been appointed traffic cop at a busy intersection. It's going be busy there, all right, because the boys won't obey rgie's signals. They won't GO away, and they wan't STOP ing to make a date. Yeah, they all want to get caught in arms of the law. Gosh, to see this beauty on duty you'd nk she was working in a movie-house boxoffice: all she does hand out tickets. And when she blows her whistle, every in in the neighborhood makes a bee-line for her. No, it's the whistle—it's the siren that gets 'em. Whatever you do, lows, don't get fresh with this cutie 'cause she really knows w to handle a man-acle! Yep, when it comes to beautiful policewomen, this gal takes the cop cake.

3. Look at her, boys. This cop's a graduate of the Police Anatomy. Some Anatomy! 4. Officer, your hip is showing!

STOP

5. Why bumper and a fender?

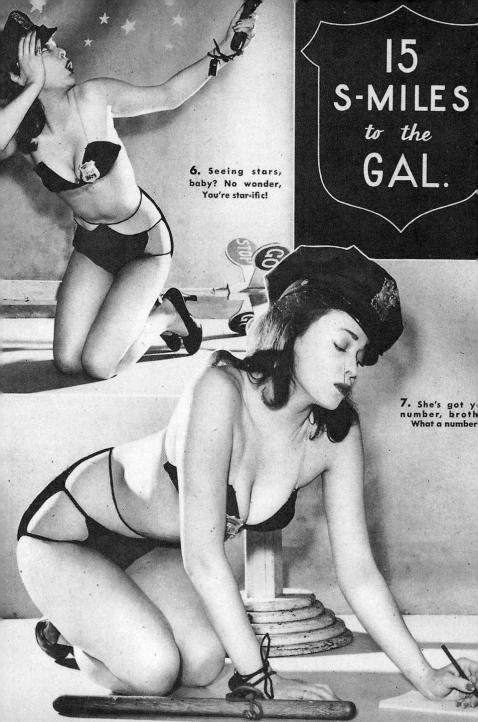

ALLING ALL CARS (CONTINUED)

argie's been standing so long between northbound ad southbound traffic that she's almost muscle-bound. It the drivers—they're spellbound! As a matter of fact, anybody passes Margie without looking at her shield, e cop on the next corner gives him a ticket for passing keen sight. Yes, boys, here's copper that's pure gold. en in plainclothes her luscious figure is detectable id that's no bull. Margie got her training on the homile squad, and you can see she really knows how to ear clues! For awhile our honey was a quarter cop hat's right, Oscar, she had two-beats!), but recently ots was promoted for capturing the most dangerous minal in town. Ah, yes, our baby's really tops in throbbers!

• Having a ripping good me? That's the ticket, toots.

She Whistles Vhile She Works

9. Oh-oh! Here's Margie on the GO again.

25c

MERRY MIRTHFUL MAIDENS

PETER.

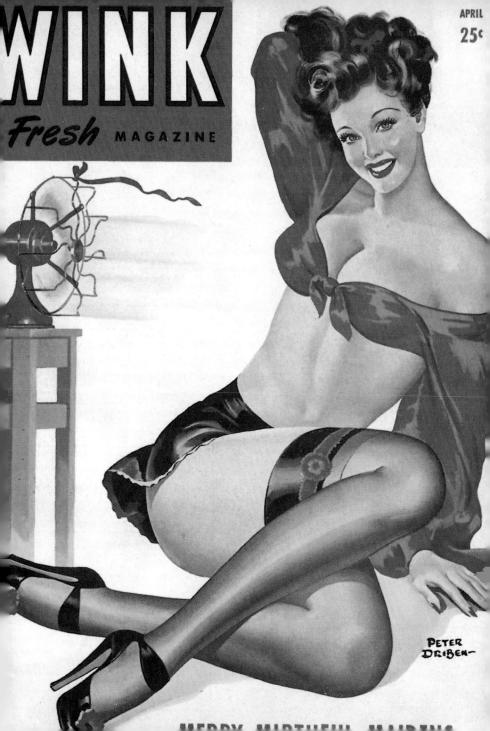

MERRY MIRTHFUL MAIDENS

DRA

A SHOK IS

JUNE 25°

Fresh MAGAZIN

AUG. 25°

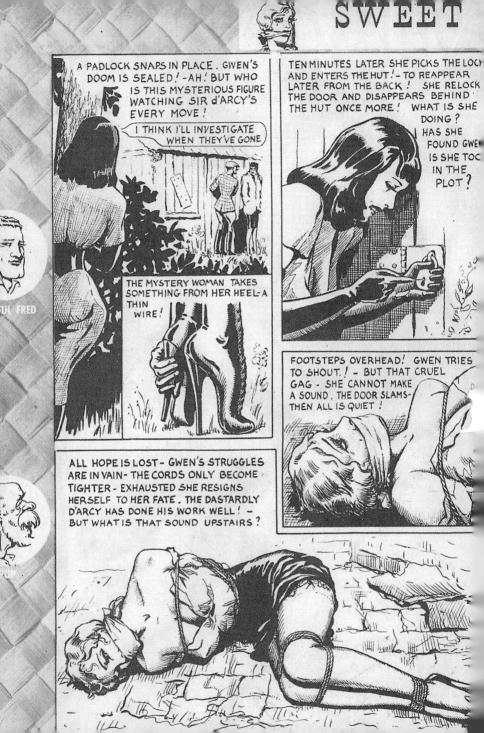

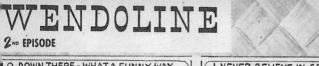

MERRY

muu

PETER DRIBEN-

Calf Chic

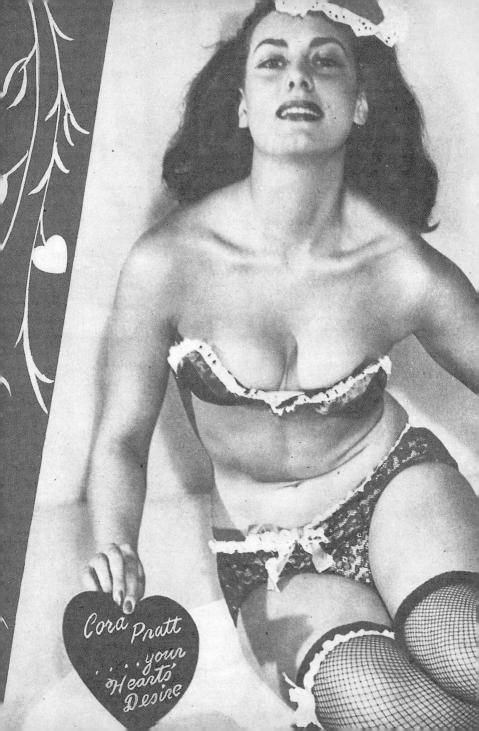

Does your pulse race? Does your heart skip a beat? Do your senses float when you behold a vision as bewitchingly beguiling as Cora Pratt? If all those things happen, bud, then you are normal. This delightful doll is so delicately and delicionsly put together that each lush curve evokes appreciative hosannas from all red-blooded males.

HEART-THROB

DEC. 25°

> HIGH-HEELED HONEYS FIGHTIN' FEMMES CURVEY CORSET CUTIES LONG-HAIRED LOVELIES PIN-UP PRETTIES

Beauty

othing can frighten nor weaken is dominant damsel who grips st a trusty whip with which she n easily vanquish her foe. So -powerful is this amazing aman that all cringe in fear as she ikes her triumphant tour thru is care is full-bosomed, roundoped Sylvia O'Reagan, a noted w York model and showgirl.

FIGHTIN' FEMMES

HIGH-HEELED HONEYS

PETER DRIBEN-

MUNK

Whirl of Girls

APRIL 25c

HIGH-HEELED HONEYS FIGHTIN' FEMMES CURVEY CORSET CUTIES LONG-HAIRED LOVELIES

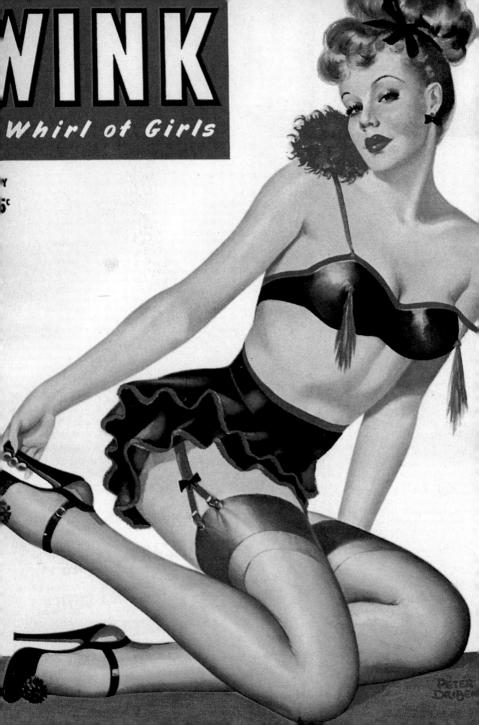

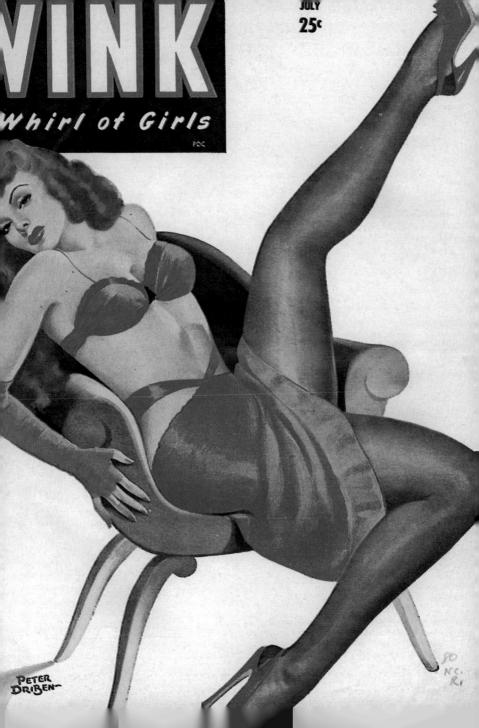

Lovely in Lingerie

Tempting Taffy Towne makes a portrait of blonde beauty as she glances mockingly into your eyes. The smoothly flowing tresses of this torrid bundle of feminine charms perfectly top off the catalogue of her physical attributes, soft curves and svelte lines, thrillingly revealed by a black chemise.

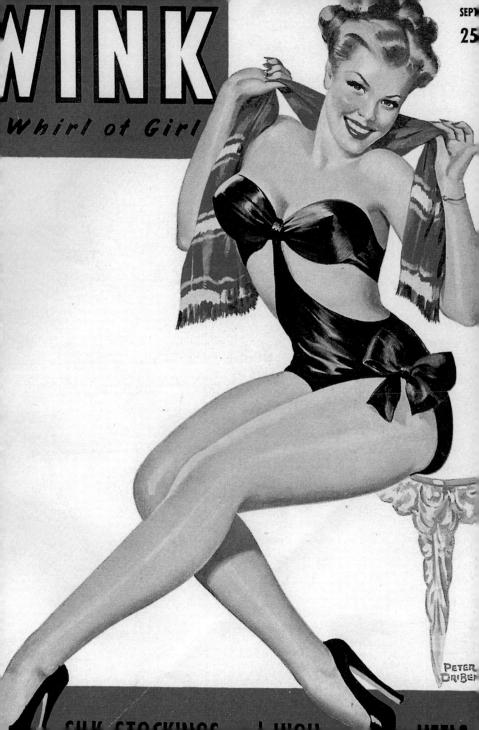

EIGHTH EPISODE

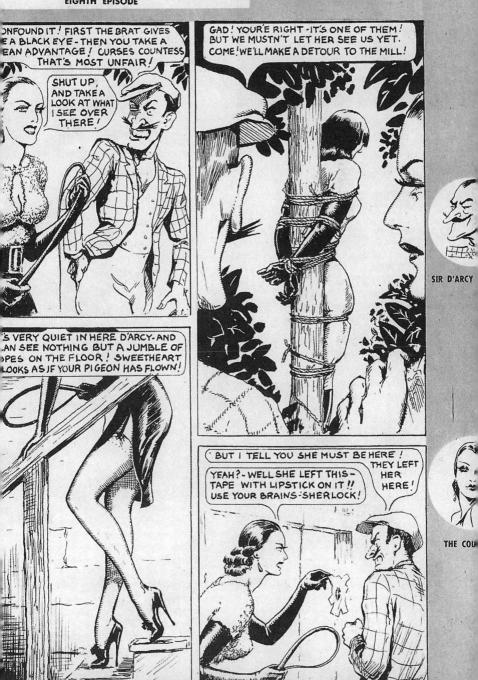

BEWITCHING BEAUTIES BRAWLING BELLES CURVEY CORSET CUTIES

Y

SILK STOCKINGS and HIGH HEELS

PI

250

SILK STOCKINGS

HIGH HEELS

JAN. 25°

PETER DRIBEN- ooting Favorities Favorities biologies biologi

hese shapely legs belong to a dazzling blonde whose dancing has thrilled many a cheering nightclub and burlesque crowd.

> These entrancing limbs in black mesh hose belong to a talented dancer with an exotic name. Does that supply a clue?

No more gorgeous legs ever twinkled across the footlights than these, property of a languid lovely on the opposite page. Slender but co are the graceful of this fair charm in case you need clue, her last nam rhymes with "Sailar."

No one can forget the strange, haunting beauty of Dagmar and the exotic dances in which she outshines her talented rivals.

lo you recognize er? Yes—it's Mary ack, bewitching in n intriguing costume feathers-and not uch of anything else.

> blonde Evelyn Taylor is an Sparkling ever-popular favorite lovers. She has a following from coast to coast. with

This alluring languorous beauty is Dorothy Karlyle. No siren in all history could hope to match her sultry charms,

1

HERE THEY ARE, THE POPULAR OWNERS OF THE SHAPELY LEGS ON PAGE 16. HOW MANY **DID YOU GUESS RIGHT?**

famous nightclub burlesque star, one ally Keith is the sensations of and and

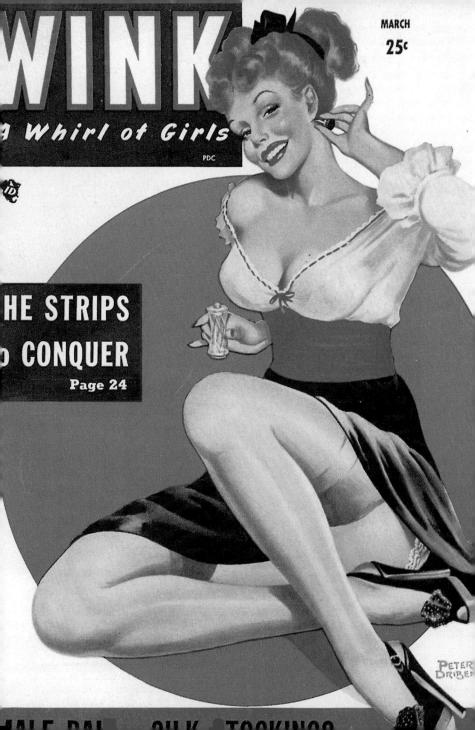

Yep, gents, this parcel posed is wrapped perfect for the males!

Ah, just an old American costume! Ain't it cute, gents?

Lovely June Raymond's Form Took Broadway By Storm! Wow!

SHIONS IN FLESH Page 12

25°

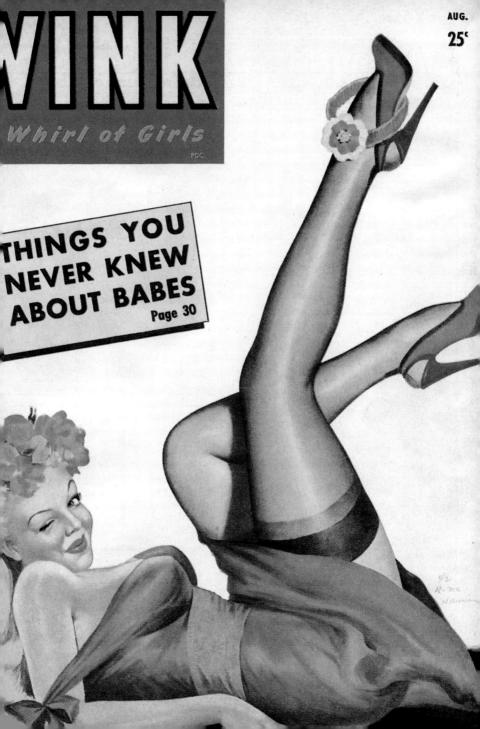

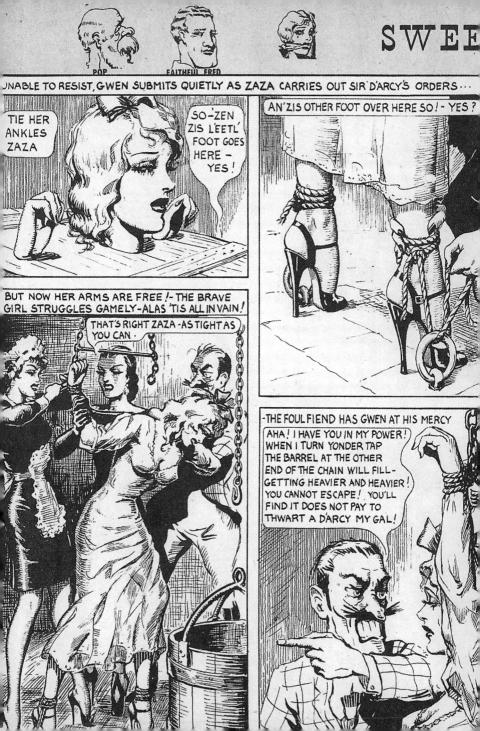

WENDOLINE Episode Thirteen

SIR D'ARCY D'ARCY

THE COUNTESS

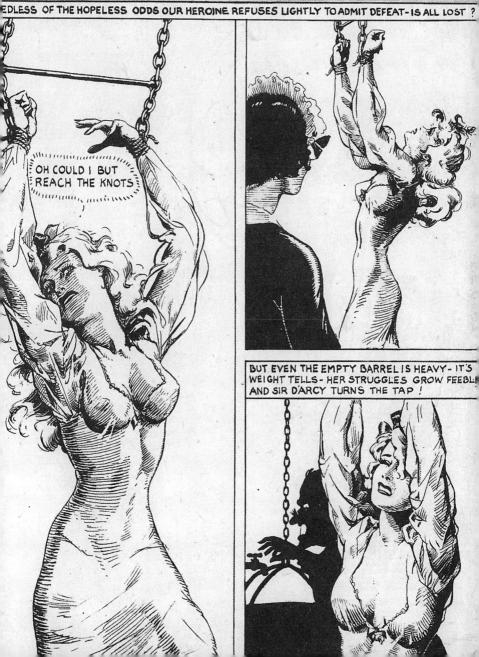

00 25

*

SHOULD BABES

BE SPANKED?

Page 22

.OVE BELOW HE KNEES Page 12

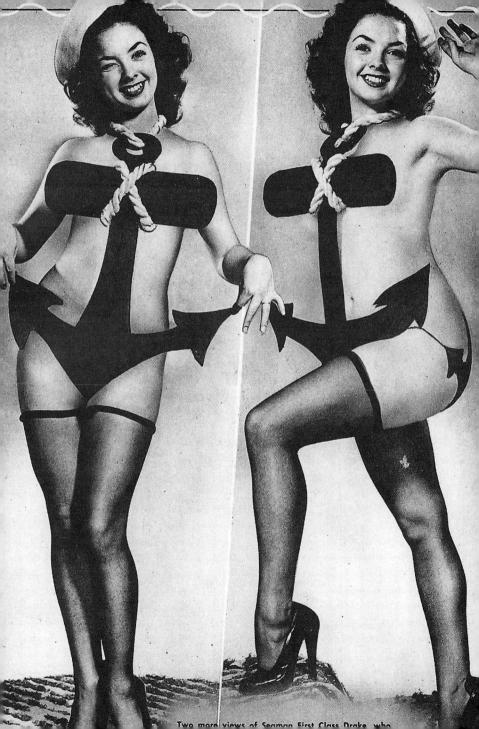

When shapely Dreena looks at us like this, we quake all over. You too, Jack?

From this point of view, Dreena's dynamic fu leaves absolutely nothing to be desired ei

HOW'D you like to have the key to lovely Dreena Howell's heart, men? She's a brown-haired artists' model of exciting proportions, a provocative wink and a captivating smile, as you can see. Originally she hailed from Massachusetts, but she's been making good in the big city of New York for two years. And it's pretty easy to see why!

Tempting Thriller

Reclining in this languorous pose in her skyscraper six-inch heels, she's surely a key-utiel

VMirl of Girls

6

the the rate

14.

DEC. 25c

WHAT YOU ON'T SEE AT THE BEACH

S IT ART DR SEX?

M OVING or not, these pix have our heads reeling, eh, pals? Should we call this pose a film strip or are we getting netty from looking at those lovely long legs of raven-haired Millie Lee? A 24 inch waist contrasting with a 36 inch bust and hips to match make Millie a good Hollywood bet. Theme song for her first picture will be: "Has anybody cinema baby?" And Millie can sit in the balcony with us anytime, aisle say!

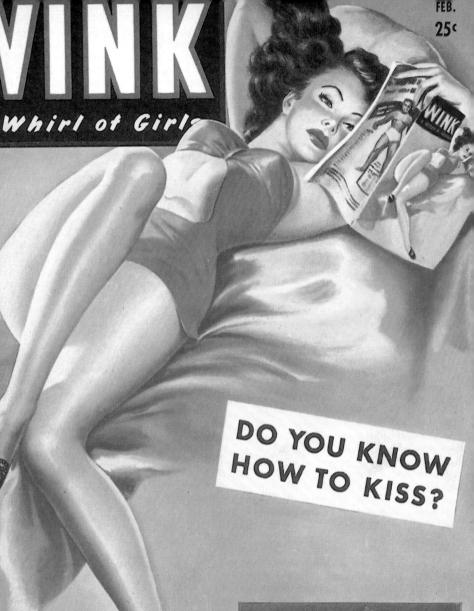

PETER DRIBENT HOW TO FIND YOUR MATE

ORCHESTRA

IIII street

Es.

6.00

FR'RY

HE CU

THU

Whirl of Girls

APRIL

25¢

PETER

EX IS JUST A NUMBER

WHY GALS

LEAVE HOME

VOLUME 5

APRIL 1950

NUMBER !

Harry Roberts, Editor

Art Direction by Rea

Contents

											٥٥
S	UN Y	VAL	LEY F	R	DLI	С					
A	RT '	THR	OBS								1
			ow								
6	YPS	Y JI	VE								1
B	OYS	WI	L BE	B	OY	S					1
L	ook	Y B	REA	к							1
			SPO								
			LS LE								2
V	VIN,	PLA	CE /	AN	ID	SH	ow				2
			к								2
в	E-BC	DP B	OUN	IC	E						2
			DOD								
			AN								3
B	OYS	DO	MA	KE	P/	155	ES				3
			SS S1								3
			WH								
			XT?								
L	OOK		'EM	N	ov	V					
			AG								4
			CRE/								5
			IN T								
									10.00		

Wink is published bi-monthly by Wink, Inc., 201 We 52nd Street, New York, N. Y. Copyright 1949 by Win Inc. Entered as second-class matter August 26, 1948, o the post office at New York, N. Y., under the act March 3, 1879. Single copy 25c – Yearly subscription 51.50 – Foreign subscription 52.50. All rights reserve by Wink, Inc. All material submitted will be given caref officient and material public the subscription.

×

ROSE PICCOLA, executes a tough two-wheel turn, and now it's all out for full speed ahead!

on

V

WHEN the "Skating Vanities" went on a tour of Europe, some wiseacres predicted the Continent would freeze up like Garbo in front of photographers. These guys figured the allegedly suave Europeans wouldn't go for a gang of American gals wheeling and free-wheeling around on plain roller skates.

MHZ

They were wrong. The general All-American looks of the gals, their skating ability and the exciting tricks they pulled were just too much to ignore. They were given accolades whenever they came out in their scanties to do their acts.

Their Indian War Dance performance doesn't boast any scalpings or Custer massacres, but it does have some good-looking dolls who know their business—skating. And their interpretative dances would do credit to the ballet, whether in Paris, New York or Podunk.

Such stars as Peggy Wallace, Eileen McDonnel and Rose Piccola are the backbone of a jam-up good show. When they whirl and twirl, there's an awful lot to be said for the guy who invented the cheap skate. Check the pictures, and you'll see exactly what we mean. But here's a final warning — don't try this stuff yourself ... it's DANGEROUSI.

EEN McDONNELL, one of "Vanities" feature clust

PEGGY WALLACE, one of the world's top free-style skators, scores with graceful glides and exciting acrobatics in the colorful "Navajo War Dance."

HEELS

Whirl of Gir

×.

JUN

25

VY gal who aspires to become an actress be able to convince oducer that she can ray any type, from a tingenue to a siren. his is how pretty startwa Norring interprets ata Hari who might eawar to be won or lost. Don't frown, clown, just enjoy Taffy Towne, with hair that's blonde, eyes of blue and fetching figure, too!

> Isn't that a fancy fur piece that sveite Terry

Deaches and Dreams One of the nicest things about gam-orous, jet-haired Jeanne Carmen is her gorgeous green eyes. Aye-aye!

Ah! Here's red-headed Bettye Windsor, the photographer's delight, caught by the camera in an un-gartered moment!

AU 25

HAT IS YOUR EYE-Q

Remember the name Jane Mannon, possessor of these charms. You may yet see her in movies and can say you saw her first. 100

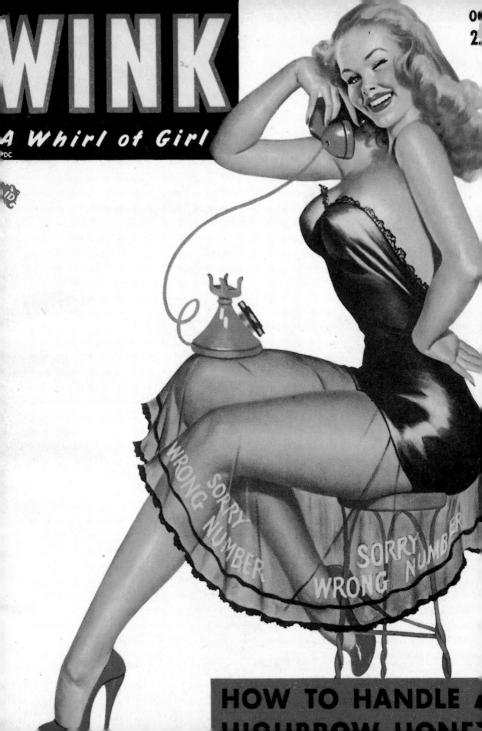

THERE'S a little bit of spice in every good little gal and a little bit of sugar in every bad little gal — and that's what makes them so naughty but nice. The good little gal here is Nina Marbin, who can pose her 5' 5" with such poise! Please to note that Nina refused to go in for that crazy fad of the short, boyish bob. Congrats, Nina!

1111

FAMOUS NIGHTLIFE BRAWLS

DEC

Willen

Whirl of Girls

F

BABES ARE O. K. AS A HOBBY BUT--!

You Can't Stand Excitement, scar, Skip These Pages, Quick!

0

She sings, tool And here Jess runs lover a tune between shows

ZOOM, ZOWIE, WOWI That's it, Buster, when you're talkin' bout flaming-haired Jessica Rogts, the one and only "Wow" girll as is the dancin' dynamo who has udiences blisterin' their palms om coast to coast. Here we give ou a peek behind the scenes as is titanic redhead kills a little time her dressing room between

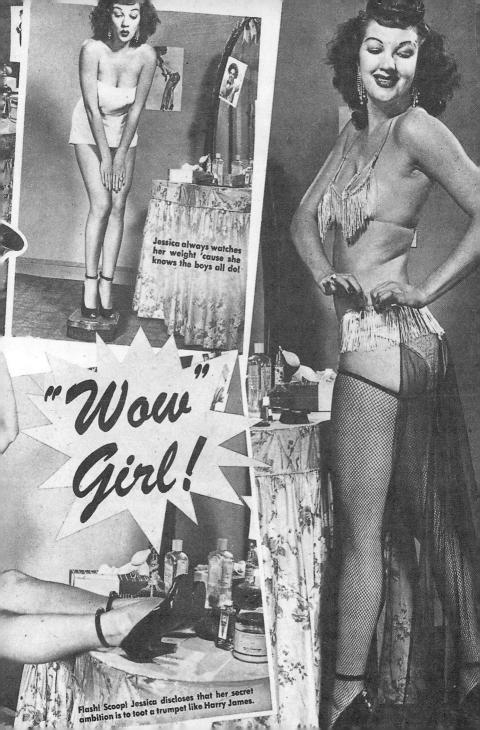

500

A

THE Folies Bergere maintains its spicy outation with dolls like eri Ballou, curvy cutie m Marseille.

> 7he R E N C O C

GETTING BALD? More Hair Grow In 30 Days Or Don't Pay A Cent!

0

Ø

0

Ø

0

Most BALD PEOPLE COULD HAVE SAVED THEIR HAIR Had They **ACTED** in Time!

"I recommend SAYVE because it's the best Science can do to SAVE YOUR MAR" - Rocco, Personal Barber of the Late THOMAS A. EDI-SON.

Once you notice symptoms of TOO MUCH HAIR IN YOUR

COMBINGS, ITCHY SCALP, EX-**CESSIVE DRYNESS OR OILINESS**

ACT IMMEDIATELY!

BEWARE of too much hair in your comb, it is a dangerous symptom!

Once you are BALD it's too late, nothing can help you, not even SAYVEI So don't delay delay may cost you your hairl SAYVE keeps your sick scalp free of lichy dandruff, seborrhea, and stops the hair loss they cause.

SAYVE KILLS the hair-destroying germs (1) Pityrosporum Ovale, (2) Staphylococcus Albus and (3) Cornebacterium Acnes, Lead-ing dermatologists feel that in killing these ditions that result in **BALDNESS**: SAYVE has been extremely successful with "Diff-cult" hair and scaip conditions! So restful is the new and improved amazing SAYVE formula that you'll grow more virile hair WiTHIN 30 Days or you return the unused portion and your money will be retunded

SAYVE is an exclusive laboratory-created formula. Used by Rocco, Barber to the Late Thomas A. Edison. DON'T DARE TO DE-LAY! MAIL COUPON and test it at home for 10 days: FREE at our expense!

GUARANTEE

If the SAYVE HAIR FORMULA isn't better than any product or treatment you have ever had, if you don't grow more virile hair in 30 days, if it desart do for you what it has done for others, if you are not delighted with it re-turn it and your money will be refunded in full. SAYVE is guaranteed to both MEN and WOMEN! HHHHHHH

E turn it and your money will be retunded in full. SAYVE is guaranteed to both MEN and WOMENI SAYVE HAIR COMPANY Dept. 11 318 Market Street, Newark, N. J. HE DEPTERSPECTOR STREET, Newark, N. J.

SAYVE HAIR COMPANY, Dept. 111
318 Market Street, Newark, N. J.
Sio murrar street, newdia, n
D Enclosed find \$5. (Cash, check or money order. Send postage prepaid.
C Send C.O.D. I will pay postman 85 plus postage
Name
Address
City
I understand if not delighted with the new and im proved SAYVE hair formula. I can return the unuse

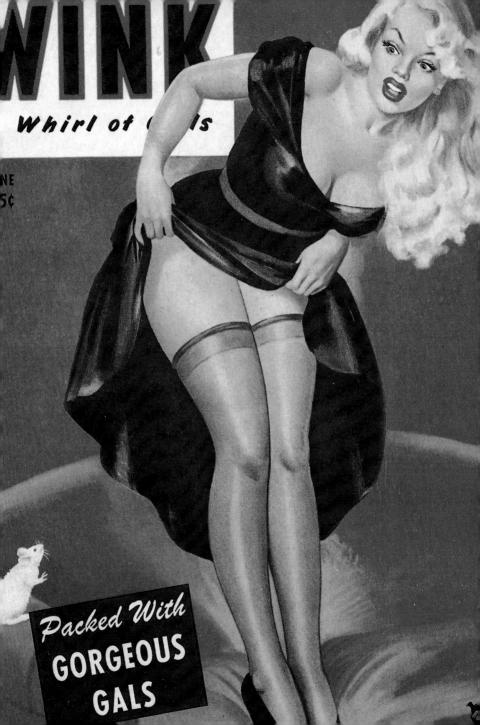

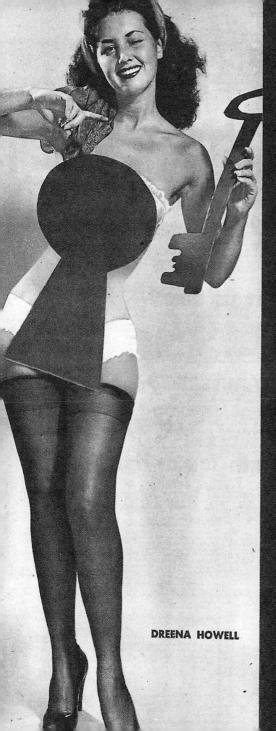

VOLUME 6 JUNE 1951

NUMBER 6

Harry Roberts, Editor Art Direction by Reale

Contents

WINSOME TH	REES	ON	1E						8
THERE'S MUS									
THAR CUR	VES								10
DOLLY'S DINE	R								12
MILLION DOL	LAR	BA	BY	OF	TH	IE			
RUNWAY .									14
STARE-WAY T	O Tł	ie s	TA	RS					16
BETWEEN THE	AC	TS							18
COULD YOU .									
MORE? .									20
TOOTSIE FROM	M TA	HIT	1_						22
WELL-BRED -	AND	BU	TTE	RE	D TO	00			24
IS YOUR MAT	E NE	URC	DTI	C?					26
JAMAICA GIN	IGER								28
SUGAR 'N' SP									30
SOMETHING F	OR .	THE	BL	101	/ S				32
BE-BOP BETTY									34
BROADWAY T	INTY	PE							36
FAMOUS LAST									38
SASSY, SAUCY									40
ARMY, NAVY,									46
IN THE BAG .									48
HOT RHYTHM									
PIN-UPS									
				42,	44	, 5	Ur.	52,	20

Wink is published bi-monthly by Wink, Inc., 201 West 52nd Street, New York, N. Y. Copyright 1931 by Wink, Inc. Entered as second-class mother August 26, 1948, at the post office of New York, N. Y., under the act of March 3, 1879. Single copy 25c — Yearly subscription 51.90 — Foreign subscription 52.50. All rights reserved by Wink, Inc. All material submitted will be given carfold by utilitation but with material must be groomapoiled by utiliattention, but such motorial must be accompanied by suffi-cient postage for return and is submitted at the author's risk. Printed in U. S. A.

*

G ATHER round gates, an' grab a gander at this real gone gal leading her jivesters down the rocky road of a be-bop jam session. Now when those blue notes are rollin', this kid is so gone she knows from nothin' but notes, and the world could come to an end. Stay with us – here we gol

> "Pianissimo at the start," says Betty.

> > Look, momma, no music! this Carnegie Hall?

> > > 10 10

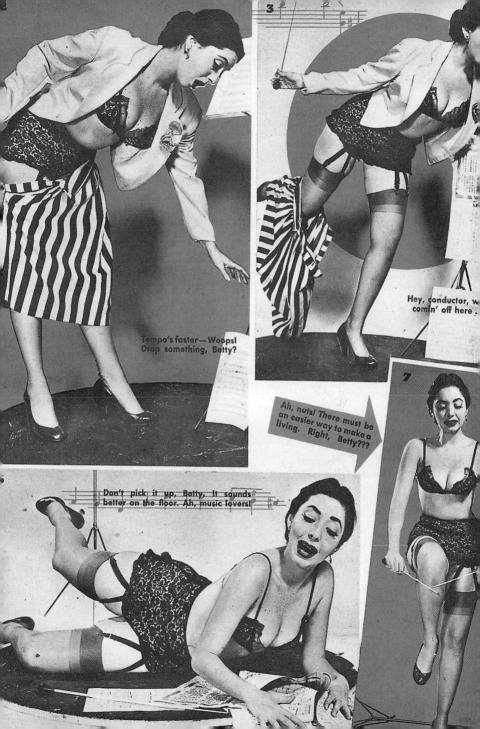

G-STRING BOMBSHELL

NEVER TRUST A DAME!

AU 25

World's Greatest Collection of Strange & Secret Photographs

Strange as Secret Photographs New you can travel round the world with the most daring adventurer. You can see with your own aves the weidest peoples on earth. You witness the strangent customs of the red, white, starting rites, their mysterious practices. They are all assembled for you in these five great vol-umes of The SECRET MUSEUM OF MANKIND.

GOO LARGE PAGES are the the write Arraiss contestion of the transfer Photos from Arras. Torure Photos multip Photos from Arras. Torure Photos multip Photos from Arras. and Arraita, and others. There are almost 600 Large Pages out, each page 57 source inches is a start

the pure of square include its fairs" to them the pure of square include its square include its square squa

Contents of 5-Volume Set The Secret Album The Secret Album The Secret Album The Secret Album The Secret Album

5 PICTURE-PACKED VOLUMES

The SECRET MUSEUM OF MANKIND consists of fir re-packed volumes (solidly bound together for conv ading). Dip into any one of these volumes, and a m its pages, you find it dimcuis to tear yourself

When the curtain goes DOWN, the show is on!

.

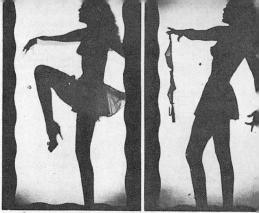

Fifty million Frenchmen went wild about this shadow

Y OU'VE certainly seen a dream walking, pals, but now you can see a shadow dancing, in the curvy person of lavely Lotus Du Bois as she performs her shadow magic. Lotus is a French cutie, straight from Paris. She's just 23, is 5'10", has green eyes and red hair. Her bust is 36, waist 25, hips 36½" and she tips the beam at 135. Let's know how you like this "screen test," fellers!

hadow Magic

> Lotus is one shadow no one would want to chase away. Agree?

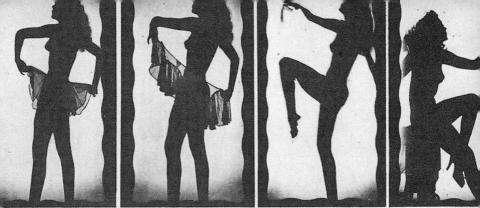

s ought to prove, fellers, that you should never be afraid of shadows, especially when they're like this eyeful.

Why worry about five oʻclock shadow, pals? Here's a midnite one!

Just Lotus and her shadow. But what a combination, chums!

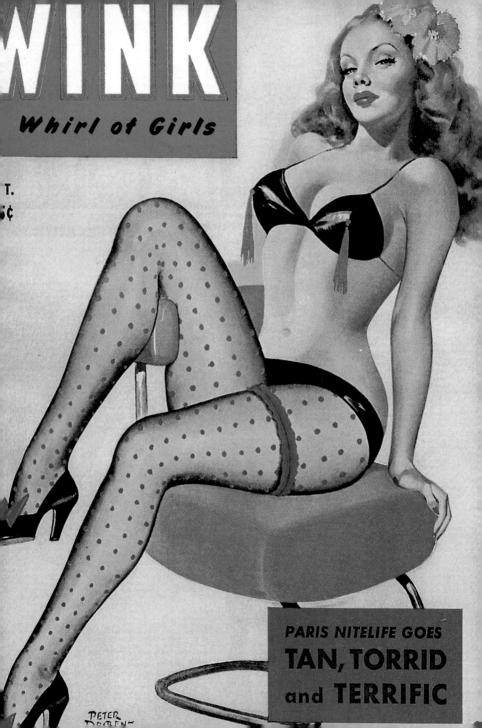

GAL with the \$50,000 BODY

Whirl of Girk

DEC. 25¢ Lili's a champagne blonde, with green eyes.

with the \$50,000 BODY!

ERE she is, boys, the one 'n' only Lili St. Cyr, greatest exotic dancer of 'em all, the gal with the \$50,000 frame!

Yessir, that's the figure a bunch of insurance men recently placed on her, and y'can't beat figures, especially Lili's!

Let's face it, pals, this is one blonde who's gold-plated!

Insurance men worry about risk.

IIGHT SCHOOL FOR LOVE

NIN NK

40

FEB. 25¢ The sighs the limit, gents, so feast your eyes on Julie Forth, a blue-eyed blonde with a 24" waist, 341/2" bust, and curvy 35" hips.

Sigh Lines

How do ya like the lines of Betti Page, Joe? Those shimmering

Meet Margo Lane, pat. She's 5'7" from toe to top, and just 123 lbs. on her bathroom scales.

*

*

Sultry's the word for netty but nice Donna Desmond, brown-eyed honey from Savannah.

×

*

*

IN THIS ISSUE:

Whirl of Gir

6

•

GLAMOUR GOES TO BED!

PETER

A 1 2

NO PARK

I BET ON THE WRONG HORSE!

FROM BED TO WORSE!

JUN 25

Zowie! If a long look at Marla Savage doesn't make ya pop your top, pal — you need vitamins! For the record, she has a 35" bust, 'n' 36" hips. Hmm!

Eye-Poppers!

Take off y'r blinders, Bennie, an' feast y'r peepers on the sultry charms of bruA sassy lassie who's plenty classy — that's redhead Gene Drake with the laffin' green eyes and that smile julla dimples. Like her?? Maria Palmieri is a zlin' Italian import, you can see here why is in such demand top scanties model. Ri

*

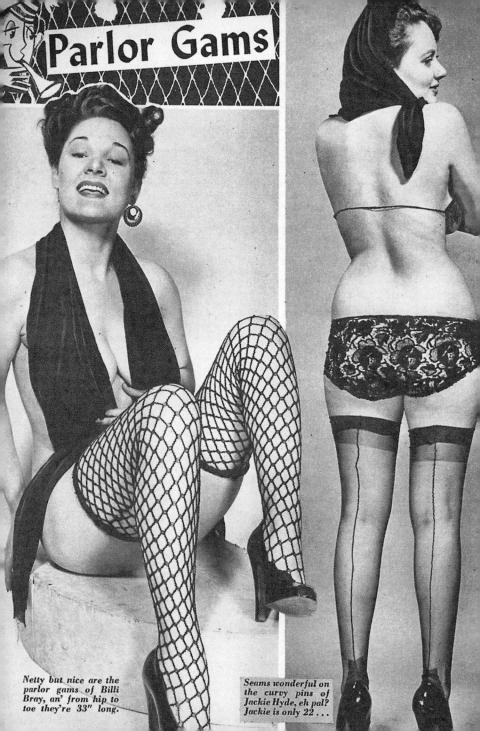

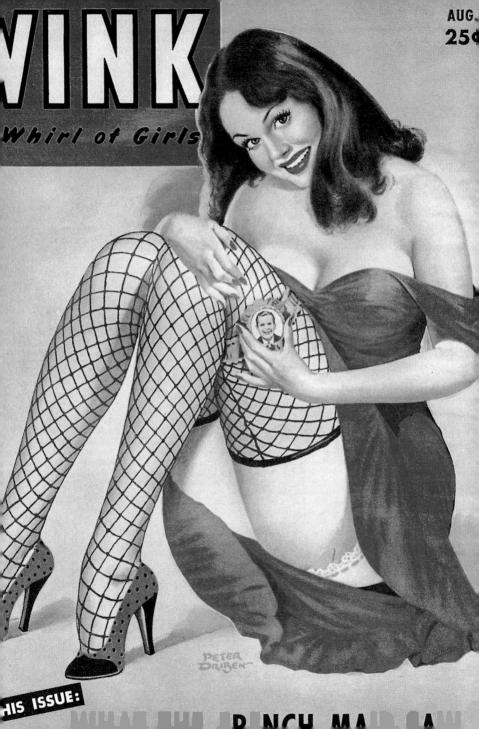

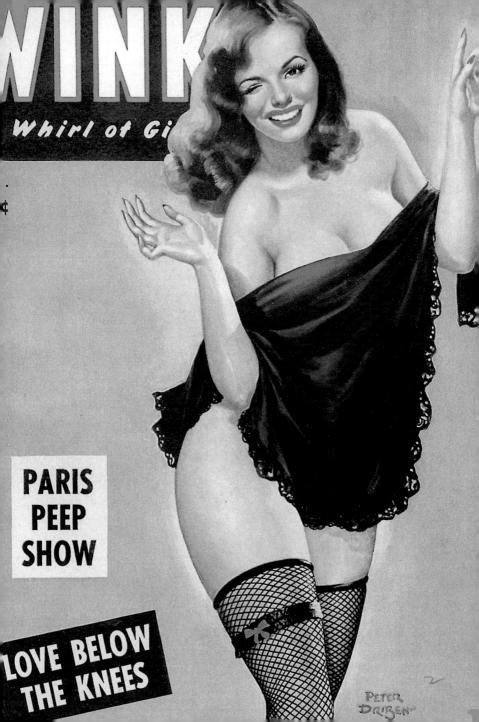

DEC.

25¢

QUEENS OF STRIP ALLEY

DROBEN

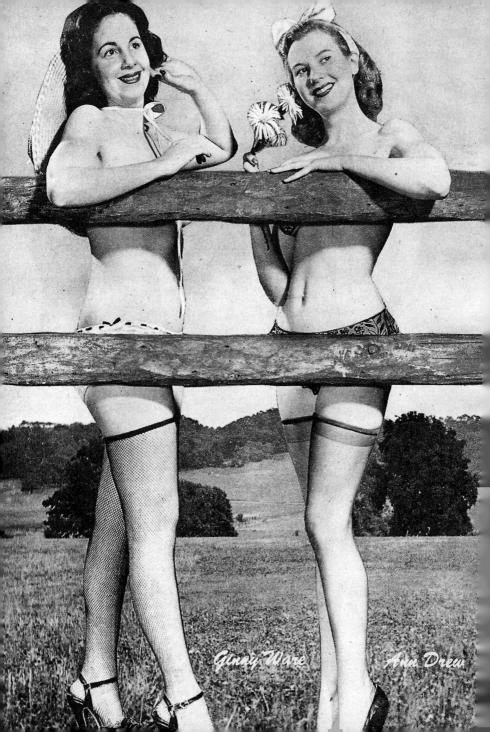

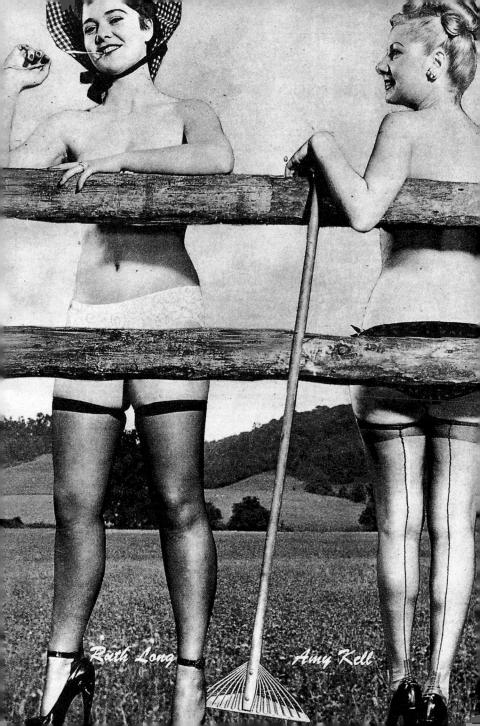

O.K. FOR PARIS... TOO **HOT** FOR BROADWAY!

ON DAGE 24

FEB 25

OFF !

have my own

Tavi Teichman Northfield, N. J.

"All my own studio work is taken by on Atlantic City

1. 1. 1

City

stantly use my WSA Boardwalk

traini

studio"

You don't need previous art training. You don't have to travel to a distant school. You don't have to risk a big sum of money. WSA now offers you its famous, complete, and modern home study course in Commercial Art, Designing and Cartooning-the same high calibre instruction that has started thousands on their way to profitable careers in art.

Here's the Amazing "1-2-3" Way We Teach You

Only WSA Offers You This 38-Year Proven Method: Commercial Art, Cartooning, Lettering in One Complete Course

Six to seven months' trial plan proves you can learn at home in spare time. We teach you from the beginning with our step-by-step method, perfected during our 38 years of teaching experience. Many students begin to earn extra money even before they finish the course.

Two complete art outfits included. You get the first one when you enroll-with all the material you need to start. Later you receive the advanced outfitboth without extra cost. Don't delay. Take your first step now toward drawing for money and pleasure. Mail coupon for

Free 32-Page Illustrated Book "Art for Pleasure and Profit": explains methods, a variety of commercial oppor-tunities, tells about scores of successful graduates. Earn \$100 a week and more as your own boss in the fascinating field of art.

	1
MAIL COUPON FOR FREE BOOK	art
WASHINGTON SCHOOL OF ART Studio 522K, Washington 5, D. C.	6
Send me without obligation your Free Book, "Art f and Profit," with full information. (No salesmar (Please Print)	
lame State Age	
Address	

State

Zone

1 am interested in your TRIAL PLAN 1 am ELIGIBLE GI VETERAN

Everything to Gain-Nothing to Lat. TRIAL PLAN proves You can Drago

Blonde show girl Jennie Maran says, "Two is company, but three is a lot safer!"

> LUSCIOUS BABES PITCH CURVES AND GAGS!

"Just give a gal enoug rope," giggles gorgeou Glori Gale, "an' she get a preacher to tie knot in it!!!"

Lass Laff

1

"Know what a shotgun wedding is?" smiles peeler Penny Page... "Well, it's a case of WIFE or death!"

Lyn Long, cute scanties model, says, "A tightwad is better than no wad at all!"

STRIPPERS BARE HIDDEN TALENTS!

THIS ISSUE:

MUK

Whirl of Girls

APRII 254

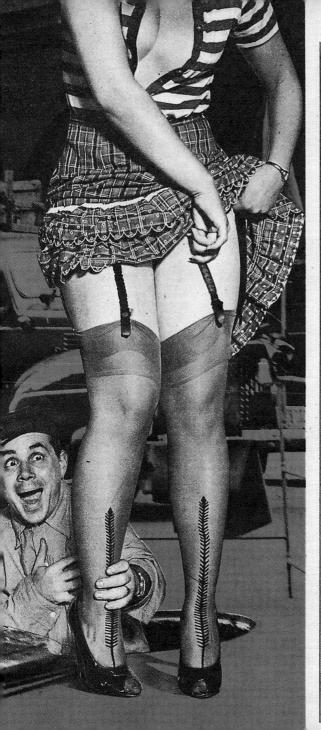

MAKE CRIME YOUR BUSINESS

steady good pay as a Finger Print Expert or Investigator. I.A.S. trains you—by easy, study-at-home lessons. Learn this exciting work in your spare time.

NOW IS THE TIME TO START

New Bureaus of Identification are continually being established. Many industrial plants now finger print all their employees. Naturally the need for more Finger Print Experts is evident. Fit yourself now to hold down a fine job as a recognized Expert in Crime Detection.

employ I. A. S. students or graduates, every one of whom learned FINGER PRINT IDENTIFICATION — FIRE-ARMS IDENTIFICATION, POLICE PHOTOGRAPHY, AND CRIMINAL INVESTIGATION—the economical I. A. S. home-study way!

The same opportunity is open to you. Just give us a chance-well train you for a good job in this fascinating work. It's neither expensive nor difficult to learn. Don't delay! Cash in on the constant need for finger print technicians and criminal investigators.

FREE! "BLUE BOOK OF CRIME"

Packed with thrills! Reveals exciting, "behind the secnes" facts of actual criminal cases. Tells how scientific investigators solved them through the same methods you learn at I. A. S. Explains, too, how YOU can get started in this thrilling work at low cost Don't wait-get your coupon in the mail NOW!

INSTITUTE OF APPLIED SCIENCE (A Correspondence School Since 1916) Dept.2264 1920 Sunnyside Ave., Chicago 40, III. CLIP AND MAIL COUPON NOW INSTITUTE OF APPLIED SCIENCE 1920 Sunnyside Ave., Dept.2264, Chicago 40, III. Gentlemen: Without Colligation, send Identification Bureaus employing your stutdents or graduates, together with your low prices and Easy Terms Offer. (Liereature will be sent OKLY to persons stating their age.) No salesman will call.

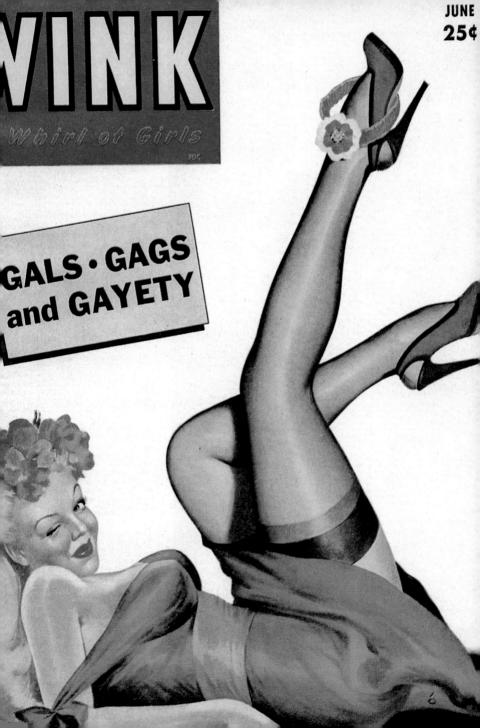

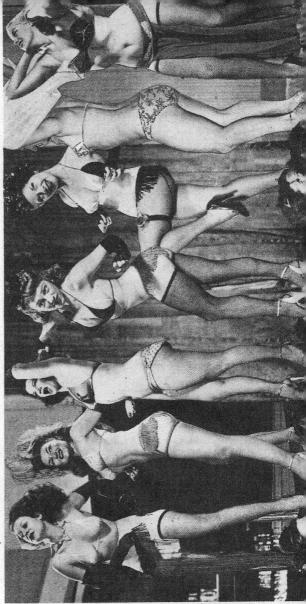

Strip - athon

Ever wish you had the chance to judge a beauty contest? Well, here's somethin' better! You can pick the winner of the Stripathan! Study these curvy peelers from head to toe, and see if you can pick the collection of curves that deserves the prize!

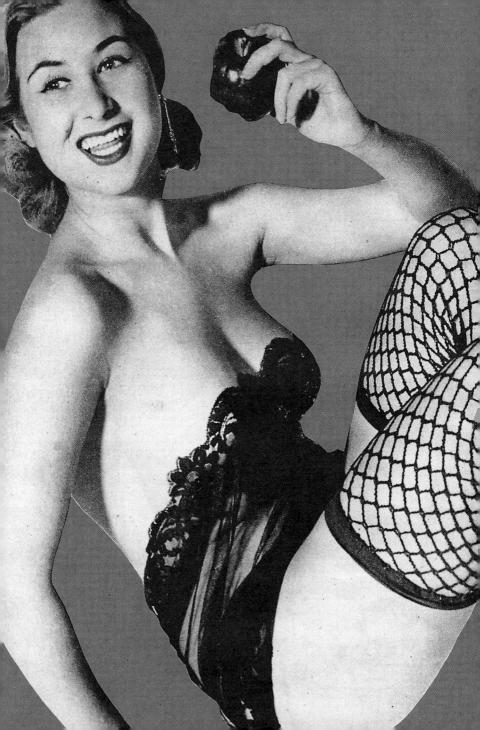

"I WONDER IF THAT'S A MACINTOSH APPLE SHE'S EATING!"

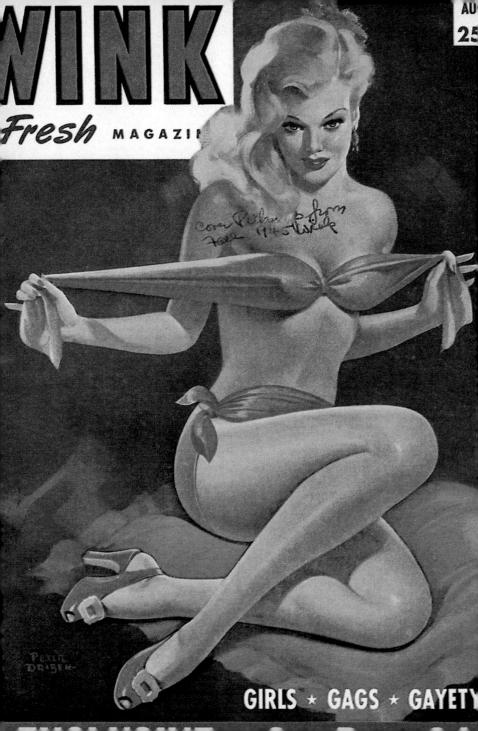

OCT.

25¢

PET

Danger--**BLONDE BOMBSHELL!** on page 18

3

Get this in a flash or you will be on the pan! Miss it and you're probably fried!

Hollywood Charades:

THE NEW GAME THE MOVIE SIRENS AN PLAYING! TRY TO GUE THE SLANG TER ILLUSTRATED BY TH ACTION IN EACH PICTUR

Listen Nosyl If you don't grind this one out, you're made of stone! Get it, pal? This show is a HITI It better go on the road! 'N' Joe Jerque better hit the dust!

OUT IN the mad movie center all the stars and sultry sirens are laying a new kind of quiz game! It's alled Hollywood Charades!

PARK

Idea is to act out well known exressions, slang or otherwise, and bet our friends they can't guess the term Ilustrated! The best scores among the follywood set have been made by ute but unknown starlets!

Here are a few! The clues are in ne pictures! The answers are right elow! See how YOU make out, and emember, no peekin' at the answers!

> your nose to the grindstone: 3. Hit the road! 4. Taking a powder! 5. Money to burn!

Can you take it a cinch! Where th smoke, there's pov

This guy is dough-loaded! Got so much it's go-

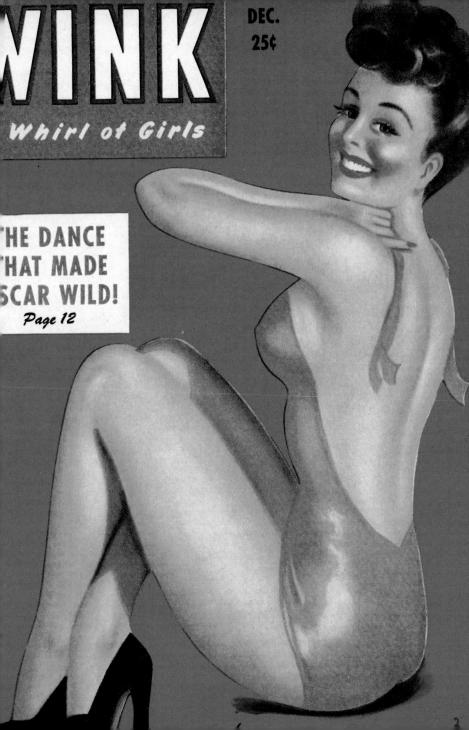

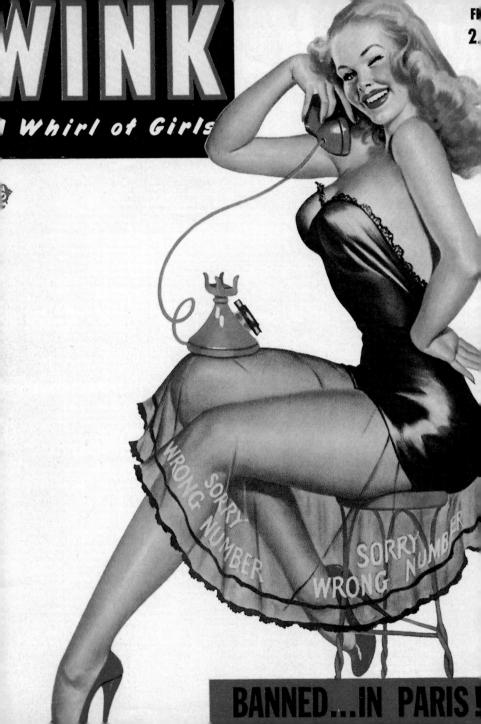

Marriage is just like sittin' in a bath tub. After you get used to it, it ain't so hot!

in ante

Cam Bla

16

Sizes are often deceiving! Sometimes a woman's thumb has a man under it!

WHAT BABES DON'T KNOW

Whirl of Giri

ŧ

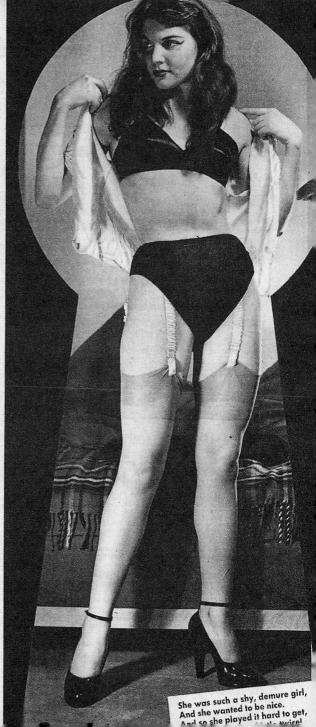

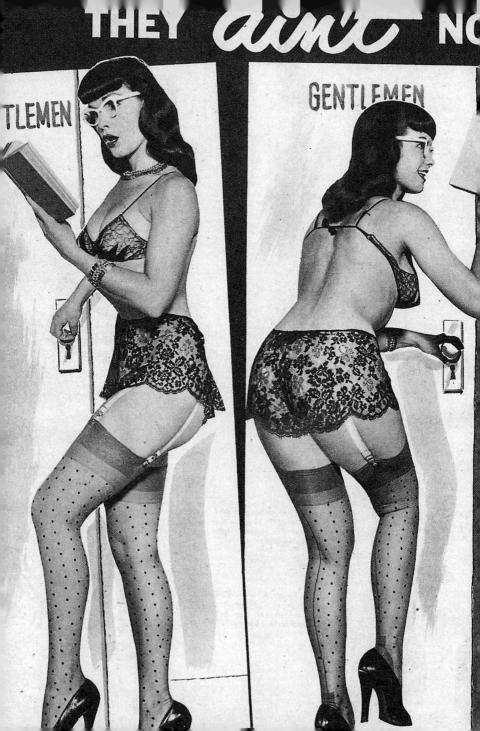

GENTILEMEN! GAL TO ADORE OPENS WRONG DOOR - AND GETS FRAMED!

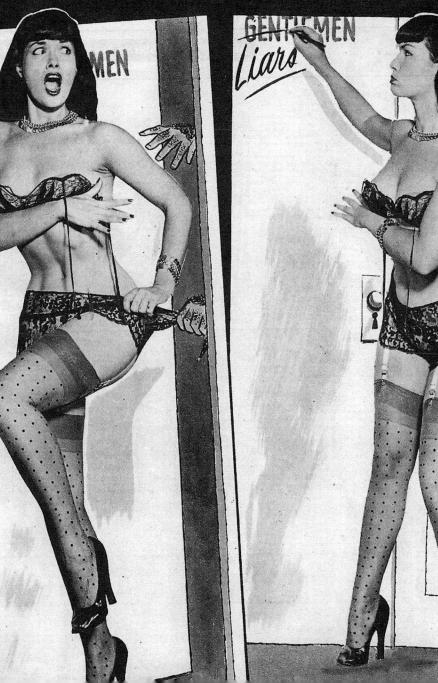

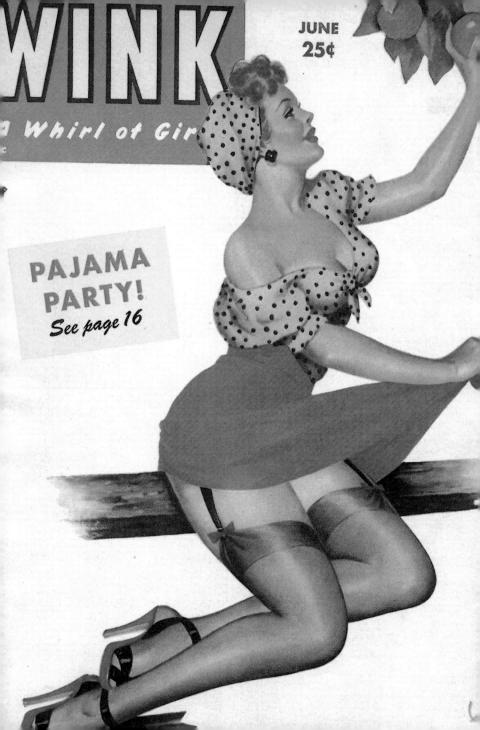

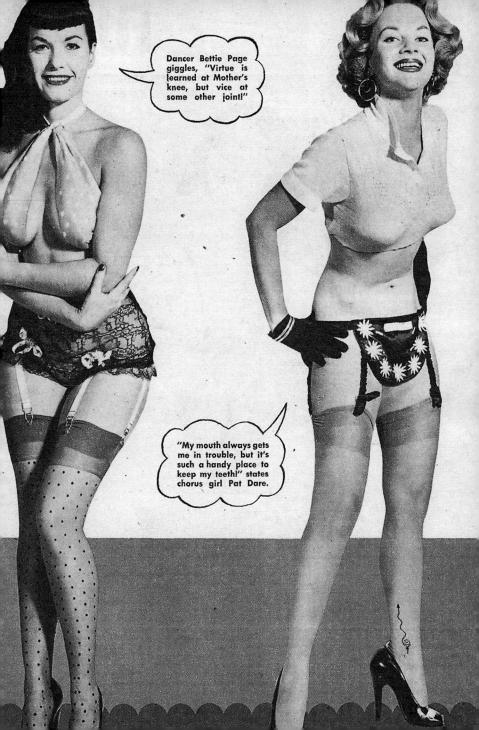

aug. 25°

S

INSEY and the HORUS GAL!

RESTLING

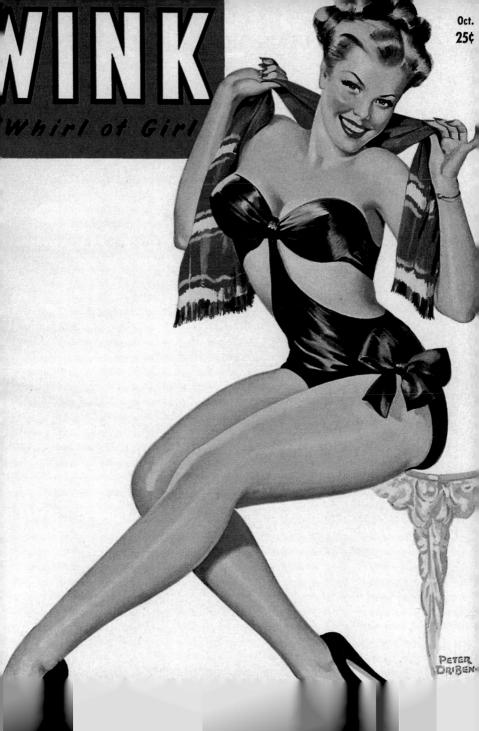

Listen, you big ape! Do you help the girl friend shop like this?

At busy corners, an ape is a nice help to a helpless babe! Nice armful, Gus!

BETTIE PAGE, page one chorus chick, is in the neadlines again, boys! Beautiful Bettie has a tame gorilla as her constant escort! Ir may sound crazy, but Bettie ain't bothcrazy, but Bettie ain't both-

GALS THINK MEN ARE BEASTS, AND THIS DOLL THINKS A GORILLA IS

Gus the gorilla is hand around the house! We who could refuse Bettie

He's a good skate when Baby decides to take the air, and tough if you whistle at her!

0,

Bettie's a knockout, 'n Gus

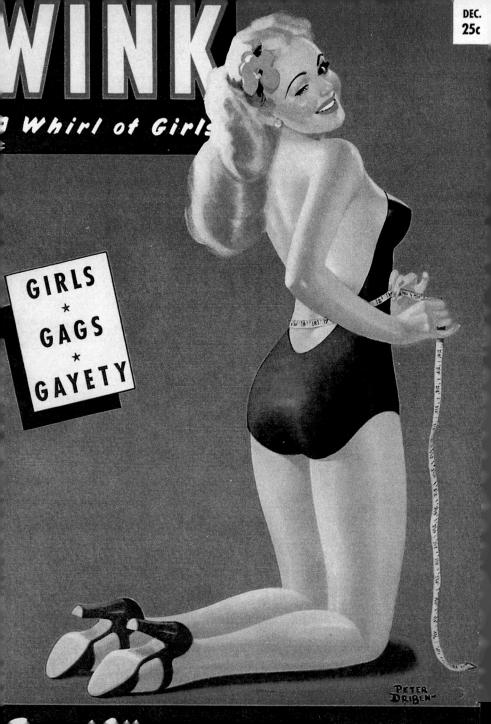

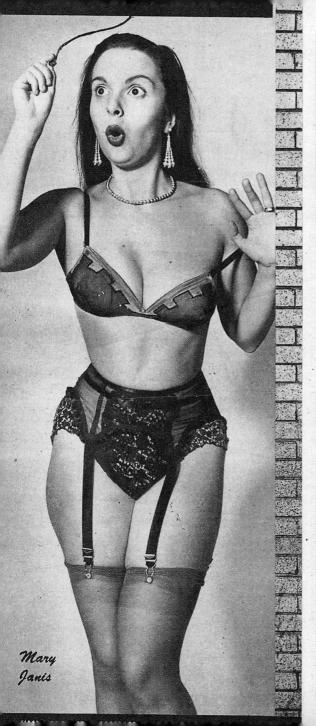

No C.O.D. to APO, FPO, or outside Continental U. S. A.

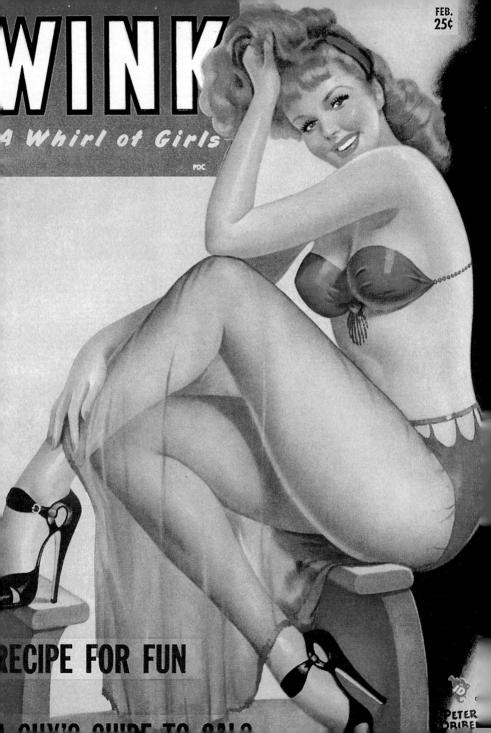

BETTY PAGE DANCE MOVIE! "Joyful Dance by Betty

Once again beautiful model Betty Page gives a sterling dance performance in her latest 16mm movie called "Joyful Dance by Betty". In this new movie Betty dances with abandon and you will enjoy Betty's motions and facial expressions while dancing. The movie runs 100 feet in length and is well lighted with several close-ups of Betty, and sells for \$12.00 complete in 16 mm size and only \$8.00 in 8 mm size complete.

Betty is attired in Bra and Pantie outfit and ralled stockings and wearing 6 inch High Heel Shoes of Patent Leather.

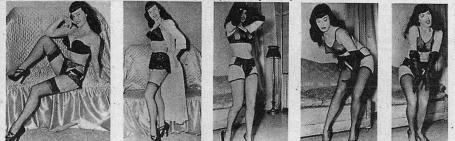

Scenes from Movie - "Joyful Dance by Betty" starring Betty Page. There are 11 IRVING KLAW Dept. 59 212 East 14th St., New York 3, N. Y. different photos of Betty taken to illustrate movie at 25c each. All 11 photos for \$2.20

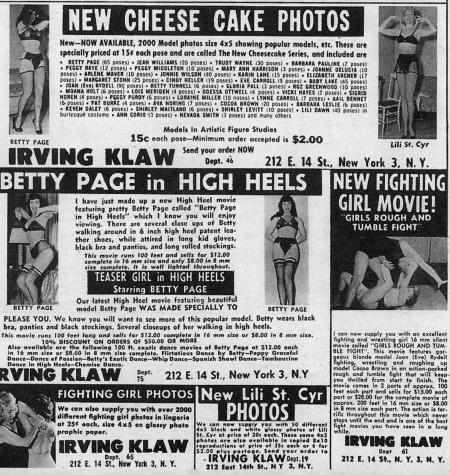

Dept. 65 212 E. 14 St., New York 3, N. Y.

Whirl of Girls

C

6

7

GAY Nighties

APR. 25¢

YOU UP A TREE? AN EYEFUL AND AN EARFUL AND YOU'LL BE OKAY!

13

BABES IN

THE

Freda Olsen says, "My new boy friend must be a gentleman farmer. He tips his hat to every tomato he passes!"

> "A bachelor," says Marilyn Martin, "Is a guy who never Mrs. anything!"

The STORIES BEHIND THE HEADLINES

MARCH 25¢

1946–1958

When Whisper landed in the kiosks in April 1946, its outsize format announced that this time Harrison had come up with something special. Peter Driben has designed for the cover a loud, pulpstyle action scene that actually related to a real article inside. The contents cited authors' names, and Harrison's clientele, which until then had been quietly forgetting the world of war in the largely peaceful land of oh-la-la, found themselves being transported helter-skelter to a squalid paradise of sexual-ethical disorientation, violent excesses and increasingly sordid scandals. "Babylon" was the destination on the train ticket, and Harrison stoked the engine's boiler with growing enthusiasm.

Whisper never achieved sales figures higher than about 600,000 copies (compared to 4 million for "Confidential") but it was a wild heady magazine. After Harrison was compelled to sell it together with "Confidential" in 1958, it eked out an existence in various publishers' hand until the early 70s. Bereits das Überformat, in dem Whisper im April 1946 an die Kioske kam, deutete an, daß Harrison sich hier etwas Besonderes ausgedacht hatte. Peter Driben hatte für das Cover eine laute Actionszene im Pulpstil entworfen, die tatsächlich Bezug zu einem richtigen Artikel hatte. Das Inhaltsverzeichnis nannte Autoren, und Harrisons Klientel, die bislang die kriegerische Welt hatte vergessen können, fand sich plötzlich auf dem Weg in ein aufregendes Schmuddelparadies sexual-ethischer Desorientierung, gewalttätiger Exzesse und zunehmend wüsterer Skandale. "Babylon" stand auf dem Fahrschein, und Harrison heizte mit zunehmender Begeisterung den Kessel an.

Die höchsten Verkaufszahlen, die Whisper erreichte, lagen bei 600.000. Exemplaren (im Vergleich: an die 4 Millionen bei "Confidential"), aber es war ein aufregendes und wildes Magazin. Nachdem es Harrison 1958 zusammen mit "Confidential" verkaufen mußte, siechte es noch bis zum Beginn der Siebziger Jahre unter wechselnden Herausgebern dahin.

Le grand format de Whisper, qui sortit dans les kiosques en avril 1946, indiquait que Harrison venait d'imaginer là quelque chose de spécial : la couverture criarde qu'avait conçue Peter Driben et qui représentait une scène d'action dans un style très peu relevé, avait effectivement rapport à un article. Un vrai article, et le sommaire mentionnait les noms des auteurs ! Les lectures de Harrison, qui avaient pu jusqu'ici oublier la guerre dans la contrée paisible des frivolités émoustillantes, se retrouvaient dans un train traversant un paradis sordide et trouble où régnait la désorientation sexuelle et éthique, où tout n'était qu'excès violents et ramassis de scandales. Destination «Babylone», c'était inscrit sur leurs billets, et Harrison chauffait la chaudière avec enthousiasme.

Les meilleures ventes de Whisper tournèrent autour de 600.000 exemplaires (celles de «Confidential», par comparaison, dans les 4 millions), mais c'était un magazine excitant et même hard. Après qu'Harrison se fut résolu en 1958 à les vendre tous les deux, Whisper changea souvent d'éditeur avant de s'éteindre doucement au début des années 70.

KNOWS ALL . SHOWS ALL

WY LAMAZ FO

The Inside Story

11

¢

A Decade of Hollywood Sin Magic Chemical Restores Manhood Reno-Glittering City of Vice Lady Wrestlers Hit the Mat Aging Stars and Their Child Grooms

Hot Racing Tips

THE INSIDE STORY

- Cafe Society Runs Wild
- Dancehall Hostess Confesses
- Rejuvenated Man Speaks
- Murder on the Sixth Tee
- Gorgeous Pin Ups

and a

JULY 15¢

LNOWS

ALL Shows All

- Abortion Billion Dollar Racket
- . Cushes Menen Dider the Bashe

INOWS ALL

QUEEN OF THE COUNTERFEITERS

THE INSIDE STORY

SEP

15

- Hollywood's Legalized Polygamy
- · Lovelies turn to "Pro" Wrestling
- · Rejuvenation Thru Male Hormos
- Fate of Faithless Wives
- Broadway "Play Girl" Tells All

BREATHLESS Brunette

Here's the other side of the argument, and a good convincer for the bruncitle side of the picture. Joan Berkstend is a raven-haired hymph, whose Sparish and Engtish blood combine to make a ravishing total. Joan has the facial appeal of a LaMare, topping the curvaccounses of a Tarner.

17

True Facts Revealed

5

Brunded By Love Wild Matrons Corrupt Youths Exposing Film's Phoney Glamour Heiresses Elope With Hired Help Murder Stalks A Strange Affair Brawny Beauts Wrestle Enchanting, Eye-Filling Pin-Ups

decembi 159

RACKET GALS EXPOSED!

thru the

YHOLE

PETCR

DRIBEN

MORE PAGES MORE PHOTOS MORE FEATURES

NOVEMBER

True Facts Revealed

- Lashed to Death
- Cross Country Vice
- New Grappling Queens
- Gorgeous Pin-Ups

INSIDE THE HAREMS OF AMERICA! NHS. RER THRU the

EYHOLE

PETER

True Facts Revealed

MARCH

✓ How Heiresses Buy Love

Shakedown Sweeties Exposed 1

Stage and Screen Go Brutal

Ferncinus Fighting Femmes

SCARLET CITIES EXPOSE THRU the. KEYHOL 17 DRIREN

ue Facts Revealed

Party Girls and Big Business Trange Rituals of Cultists Way's Side-Street Sirens Trawny Battling Babes

True Facts Revealed

FHRU

The EYHOLE

JULY 25^c

IOW REEFER PARTIES BREED VICI

HSP

N

- Debutantes Fight Dirty Fiendish Tortures of History Broadway Rackets
- Hollywood's Shocking Escapades

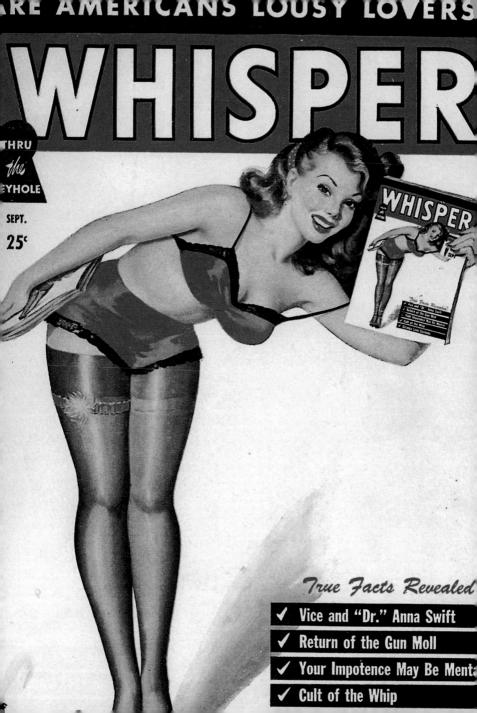

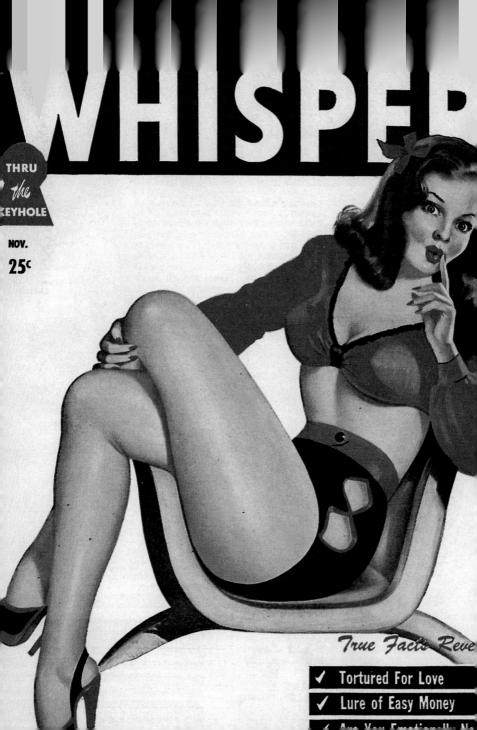

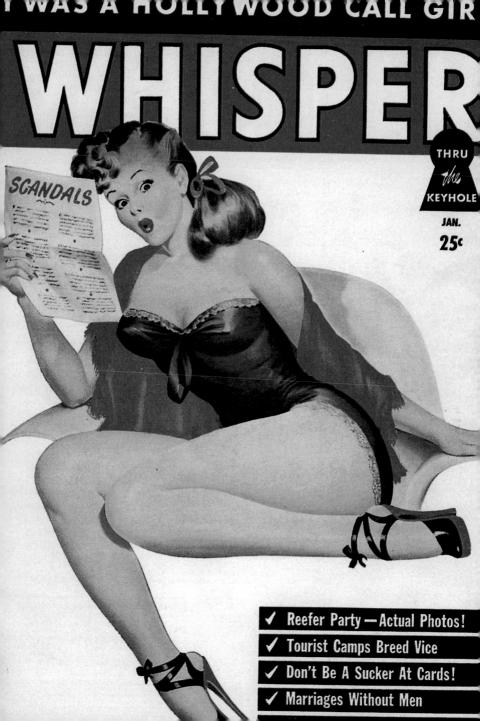

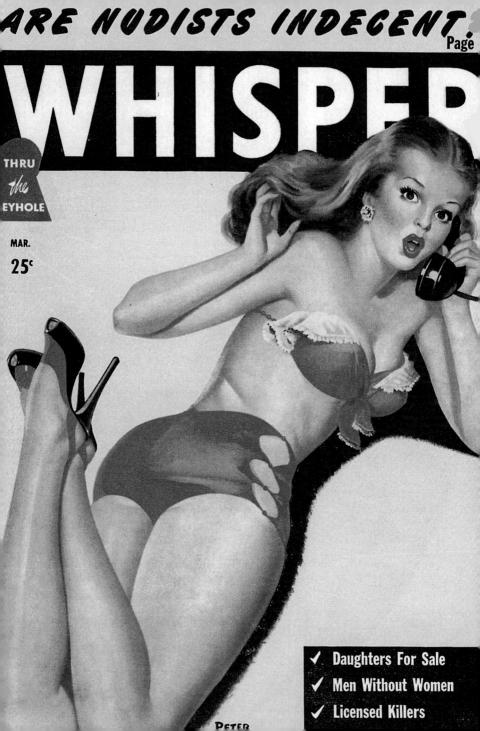

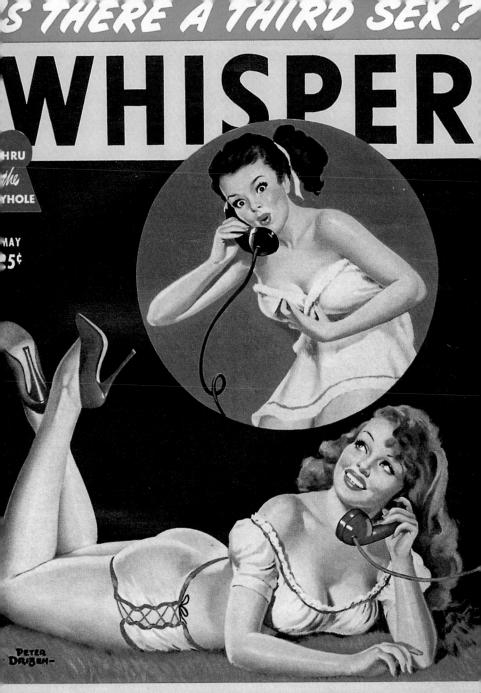

EENS OF VICE . LIFE in an INSANE ASYLUI

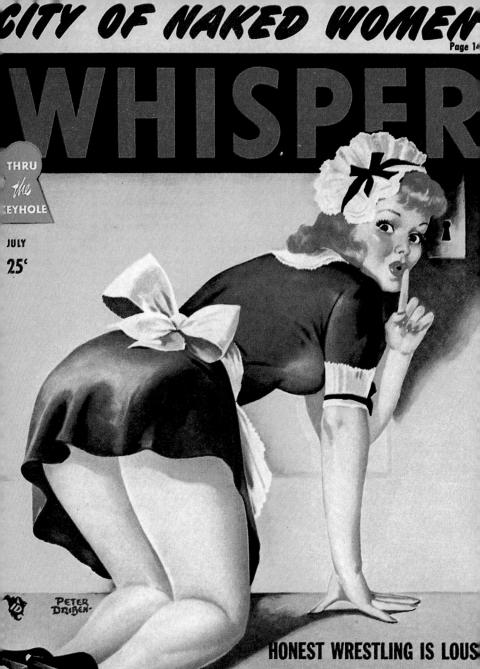

HE SELLS SEX DIARIES ARE DYNAMITE

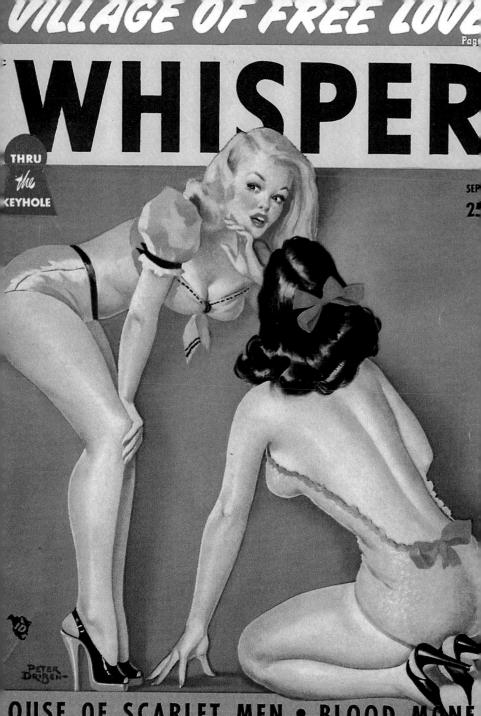

OUSE OF SCARLET MEN BLOOD MONE

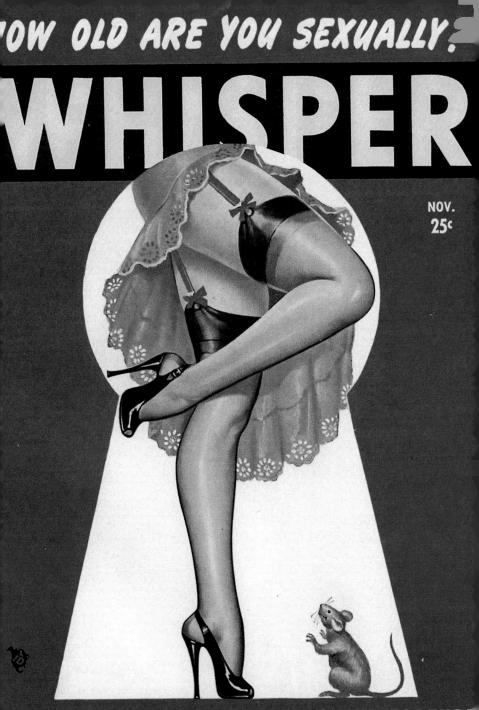

NZEDRINE PARTIES • CAN YOU STAND TORTURE

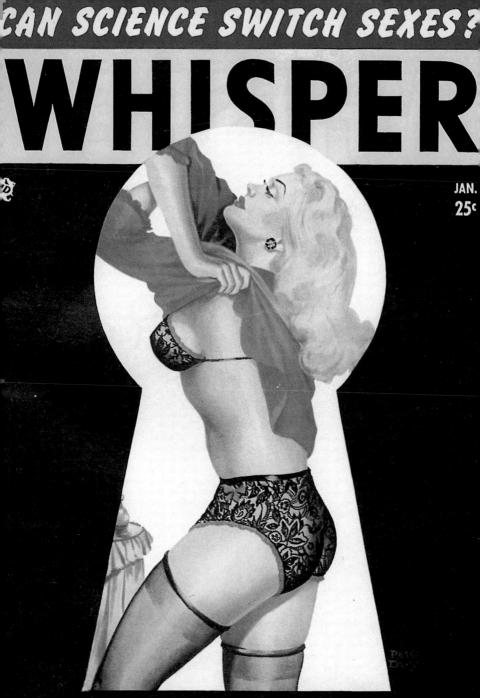

ONFESSIONS OF A NUDIST! • WIFE SWAPPING

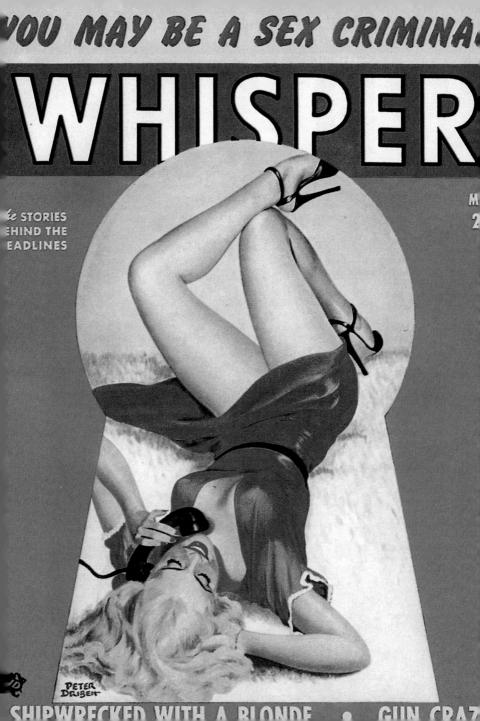

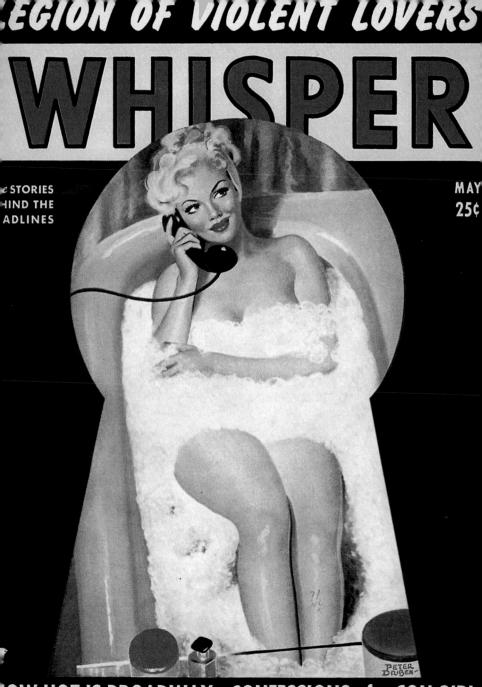

IOW HOT IS BROADWAY • CONFESSIONS of a CON GIRL

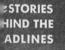

10

Miss Broadway of the Month LINDA LOMBARD See page 10

THE TRUTH ABOUT ZOMBIES . NUMBERS RACKE

AN WE LIVE FOREVER

R

JUL

25

WHICPER

SEPT

25¢

The STORIES BEHIND THE HEADLINES

> MISS BROADWAY of the MONTH JUNE KIRBY See page 10

ą

VILS OF HYPNOTISM . BABES TAKE A BEATING

EX BEHIND THE IRON CURTAIN . 10¢ A THRIL

WHISPER

E STORIES

THAT DID 8,000

NOMEN CONFESS

TO DR. KINSEY?

HALF WOMAN — HALF LION WHAT BING SAW IN PARIS? INSIDE WHITE SLAVE RINGS DO WIVES RUIN ATHLETES?

JAN.

25¢

MY 24 HOURS IN A HAREM. WHISPER

MARC

25¢

CONTRACTOR STORIES

IRILITY OVER THE COUNTER MAZING VIRGINS OF VENUS NIGHT IN NAUGHTY PAREE URLY BABES OF THE MAT!

PETER

SLAVE GIRLS FOR SALE WHISPER

DO NOT

DISTURB

M

2

ADLINES

IE TREE THAT OWS HUMANS! OWGAL TURNS DY WRESTLER

VE WOMEN TO EVERY MAN NO SMOKING NO SMOKING ROL PORESSING ROL

6

0

C STORIES HIND THE ADLINES

> FREE LOVE IN PRISON FEMALE JOE LOUIS? WHY I AM A STRIPPER SCARLET PORT OF SIN BITCH OF RUCHENWALD

WHISPER

SEPT

25¢

e STORIES HIND THE ADLINES

IEY HID THEIR SEX! IRLESQUE SECRETS IN WITH 500 WIVES INERS IN SILK! ICKS OF A PICKUP

WHICKEDEST GAL

NO

25

e STORIES HIND THE

IRED FOR LOVE HE THIRD SEX?

S ONE WOMAN ENOUGH? WHISPER

HIND THE

"GIRL FRIEND" IS A HE FEMMES BEHIND FIXES! IS NUDITY MODEST? INVEST IN A BLONDE!

JAN.

25¢

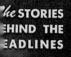

-OLLIES "GAL" WAS A BOY

ISPER

MARC

25

4

MUGGING MAMSELLES BABES ON THE LOOSE BATTLE OF STRIPPERS EXPOSED: SECRETS OF A GIRL PANHANDLER! STORIES ND THE DLINES

DAILY TATTLER

Ran

OW PARIS EXPORTS SIN

E

MAY

25¢

CINSEY "PHONIES!" ODIES FOR SALE! OVE CITIES OF U.S. SENSATIONAL: GYPSY RACELET FIGHTERS

AN FREAKS MAKE LOVE WHISPER

STORIES

checking Copy

ALIMONY FOR MEN!
 VENDETTA VENGEANCE
 "I PASSED FOR WHITE
 GIRL HEAD HUNTERS!
 SEY AND EDENICH ADMY

JULY

25¢

HEV SHARE THEIR WIVES. WHISPER

SEPT.

25¢

STORIES

ISLE OF LOST GALS! FEMME SERGEANT OF THE FOREIGN LEGION! SCANDAL III BATHTUB! LOVE ROBBERY OF

WHICE TESTS FOR SEA. WHICE REPER

NOV.

250

WE STORIES

WHY WIVES CHEAT! YOU MAY BE WORTH A MILLION DOLLARS! BEAUTIES FOR HIRE! GIRL GANGSTERS OF

VOMEN OF DEVIL'S ISLAND WHISPER

e STORIES HIND THE ADLINES

checken

PETER DRIBENT FREE LOVE FOR ALL "PEYOTL" SEX KICK. MARRIED THE DEAD EXPOSED: SHE RULE

MARCH

25¢

WHISPER

M

2

We STORIES EHIND THE EADLINES

POSED FOR THE DDLERS OF SMUT!")W TO KISS A SNAKE! DIES OF PARLOR "A" RL YOURS FOR 5 IN SLAVE BOOM!

WOMEN OF ROPA EN. D JULY

25¢

Exposed:

SULTRY SPIES

0F

BIG BUSINESS

TORIES ID THE LINES

TRIBE TRIES GIRL GYPSY FOR SIN! WHITE SLAVERY ON THE HIGH SEAS!

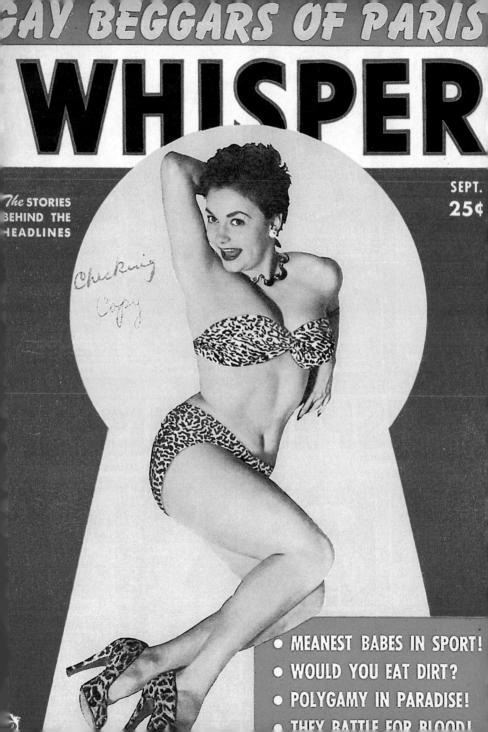

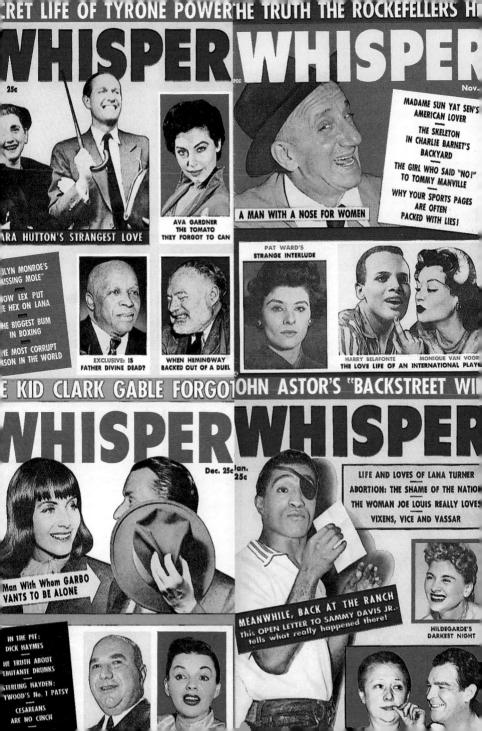

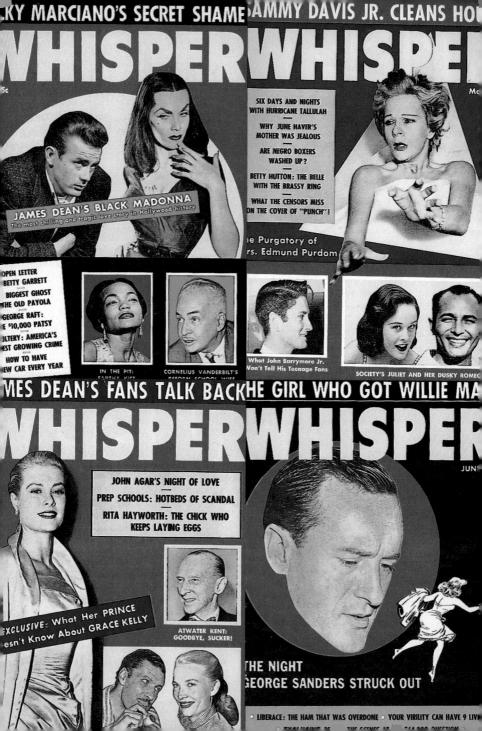

MES DEAN'S FIRST LOVERCHIE MOORE'S Coast-to-Coast HAR SP Aug. 25¢ e Night I ARNAZ The WILD PARTY That **Helped SINATRA Forget** sn't Even **AVA GARDNER** If Safe! NT: SCHOOL FOR SADISTS? + AVA GARDNER AND THE LATIN - AMERICAN AFFAIR + ARS, CARRADINE'S OTHER JOHN + THE MARINES' TOUGHEST FIG . HOW I SOLD TV SETS . OPEN LETTER TO SUSAN HAYWARD NE MEADOWS IS SAYING "I'VE GOT A SECRET!" . PIGEON KILLERS, INC. . AYNE MANSFIELD: CC OF MM + NEW DRUG ELIMINATES OLD A PRESLEY FANS SPIT BÀC DEAN Vs. ELVIS PRESLEY • Dec Feb. 25c chulewy CA FROM HERE TO MATERNITY Starring: GRACE KELLY (Assistant Producer: PRINCE RAINIER) Liz Taylor and Monty Clift: The Match That Burned Up A Town!

L'S OVERNIGHT POP . DANA ANDREWS: 100 PROOF LOVER

HOW JAMES DEAN GOT AN OSCAR . WYATT EARP AND THE FILL

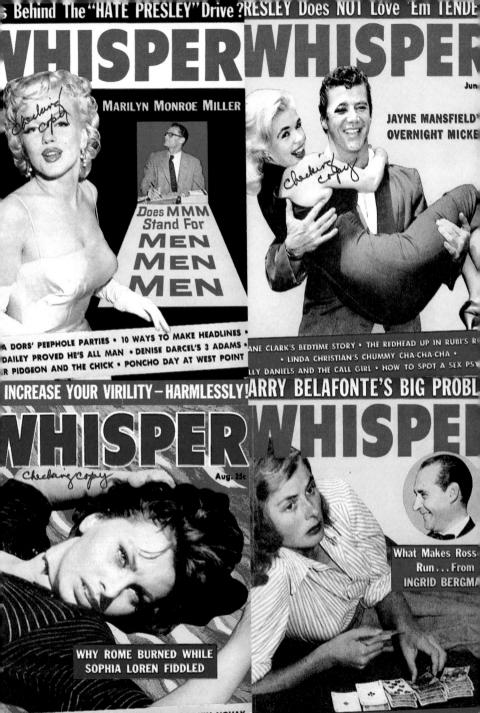

ARD DUFF'S FORMER EVES THE MEN WHO MADE KIM NOVAK

THE WILDING'S WILDEST NIGHT . 18 WAYS TO PICK UP A

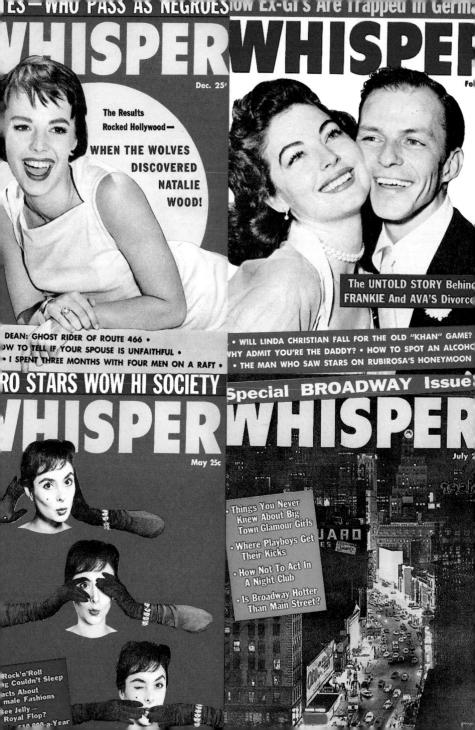

1947–1955

It seems that Harrison did not quite trust the new recipe that he was trying out in Whisper. Whereas there he was already practising a cheap trash aesthetic, retailing neighbourhood models as black-magic priestesses or as the victims of brutal gypsy rites in the Balkans, or flatly maintaining that the craters on the Moon were bomb craters resulting from an interstellar dispute, the latecomer from Harrison's stable remained true to the old cocktail of "Girls, Gags & Giggles" with a couple of fetishistic themes tossed in for good measure.

The first issue boasted "highlights" such as "How to become a playboy", a centrefold model in chains, and a double-page pin-up poster urging readers to buy enough copies of the magazine to redecorate their flats. It was a rather stale old brew, but the mixture still worked. Harrison looked to see what the war had left of the "famous Parisian boudoirs", and his copywriting hacks – men of letters to the last – delighted in a new vocabulary when they came to wax lyrical about sensuality: "As devastating as the mysterious atom bomb is Paula Stratton..."!

Offensichtlich traute Harrison der neuen Mischung, die er mit Whisper ausprobierte, noch nicht recht. Während er sich dort bereits in einer .. esthétique du schlock" übte und Models aus der Nachbarschaft als Schlangenpriesterinnen oder Opfer rüder Zigeunerbräuche auf dem Balkan verkaufte und Mondkrater kurzerhand zu Bombentrichtern einer interstellaren Meinungsverschiedenheit erklärte, hielt sich der Nachzügler in Harrisons Stall getreu an die alte Rezeptur aus "Girls, Gags & Giggles" und ein paar Fetischmotiven. Zu den "Highlights" zählten der Ratgeber "Wie werde ich ein Playboy?", ein Centerfold in Ketten und eine Doppelseite mit einer Pin-up-Tapete nebst Aufforderung, möglichst so viele Exemplare des Magazins zu kaufen, daß es für eine Wohnungsrenovierung reicht. Ein etwas altmodisches Pflänzchen, das Harrison da in sein Bukett gesteckt hatte, aber die Mischung zog noch. Man schaute nach, was der Krieg von den "berühmten Pariser Boudoirs" übriggelassen hatte, und Harrisons Texter erfreuten sich an einigen neuen Vokabeln, wenn es darum ging, das Hohelied der Sinnlichkeit beherzt anzustimmen: "As devastating as the mysterious atom bomb is Paula Stratton"

Manifestement, Harrison n'osait pas encore se fier entièrement à la nouvelle mouture qu'il expérimentait avec Whisper. Tandis qu'il s'essayait, dans ce magazine, à une «esthétique du schlock», qu'il vendait des modèles pris dans son voisinage comme des prêtresses contorsionnistes ou des victimes des coutumes barbares de gitans des Balkans ou encore déclarait carrément que les cratères lunaires étaient des entonnoirs de bombes dus à des guerres interstellaires, le benjamin de l'écurie de Harrison s'en tenait à la vieille recette de «Girls, Gags & Giggles» et à l'adjonction de quelques fétiches. Parmi les «têtes d'affiche» qui devaient attirer les lecteurs, le premier numéro proposait en page centrale un modèle enchaîné, une page-conseils expliquant comment devenir un play-boy, ainsi qu'une petite spécialité de la maison, à savoir deux pages de papier peint dont les motifs représentaient des pin ups, avec conjointement une invitation à acheter autant d'exemplaires qu'il serait nécessaire pour refaire un appartement complet. Un cocktail certes un peu démodé mais qui marchait encore. On se mit après la guerre à examiner ce qui restait des «célèbres boudoirs parisiens», et les infatigables rédacteurs d'Harrison, qui avaient tous la plume facile, s'en donnèrent à cœur joie : «Paula Stratton fait autant de ravages que la mystérieuse bombe atomique.»

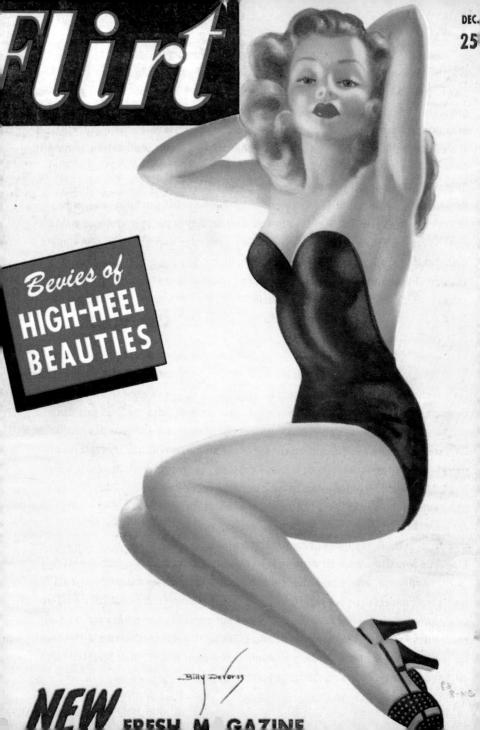

VIES of

MARCH

bu don't have to traveling salesto get this one.

The state of the s

Remember Pearl Wh fter this movie, th alled her Peril Whi

Turn on the quess, boys

Would you guys like to sous' of the border a little vacation?

HERE you are, fellers, see how much you know about the movies. Just study these pictures and the clues they contain. Each picture represents a popular movie. And just to show you June Frew, our lovely model, has nothing up her sleeve, we put her in those cute costumes. All you have to do is guess the title of the movie the picture represents. If you can't guess 'em, you'll find the answers on the bottom of the right-hand page. Then try 'em on your girl friend, and make your own score. If you don't score, whadda we care!

5. Gosh, wish this pretty hitch-hiker was going in our direction.

4. Say, this two-gun gal must be outside the law!

FRESH MAGAZIN

c

AY 5c

Flir

IGH-HEEL CUTIES

Steffa

GAGS and GAYETY

1

AUGUST

FRESH MAGAZINE

Bevies of 11-HEEL 10NEYS

Peter Driben-

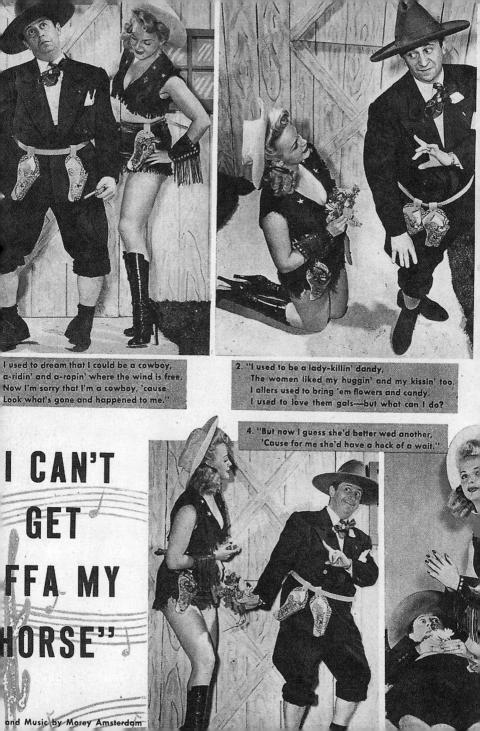

'She said for me she'd leave her home and mother. I said I'd wed her later, and we made a date . . .''

Someday they'll bury me out on the prairie, Out there among the sagebrush where the skies are blue, And when they dig a grave for me to rest in, They'd better make it big enough for two!"

FAMED COMIC MOREY AMSTER ACTS OUT HIS OWN SON

THINGS are tough, all over, and even the Wild Woolly West ain't what it usta was, according Morey Amsterdam, famed Broadway and radio co Just to prove that the fate of the modern bronc bu is a sad one, Morey has written a very popular ba called "I Can't Get Offa My Horse." In these pictuhe and beautiful June Frew, in the role of a blo cowpuncheress, act out the song.

6. "I cain't get offa my horse. All day and night i ride among the cattle. I can't get offa my horse, 'Cause some dirty dog put glue on the saddle!"

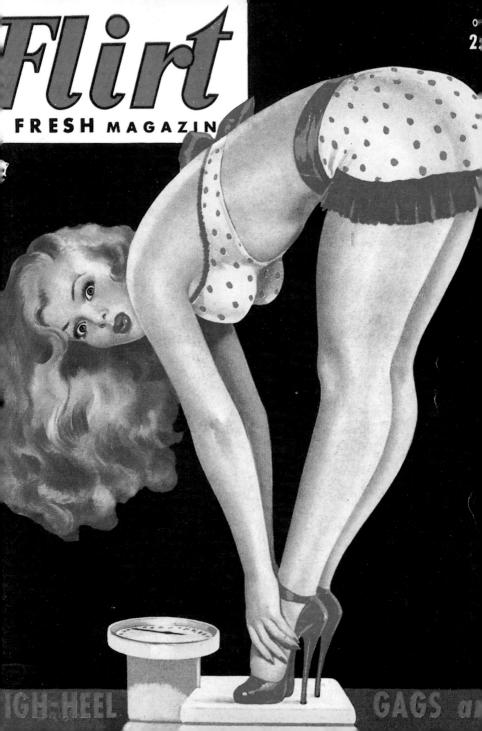

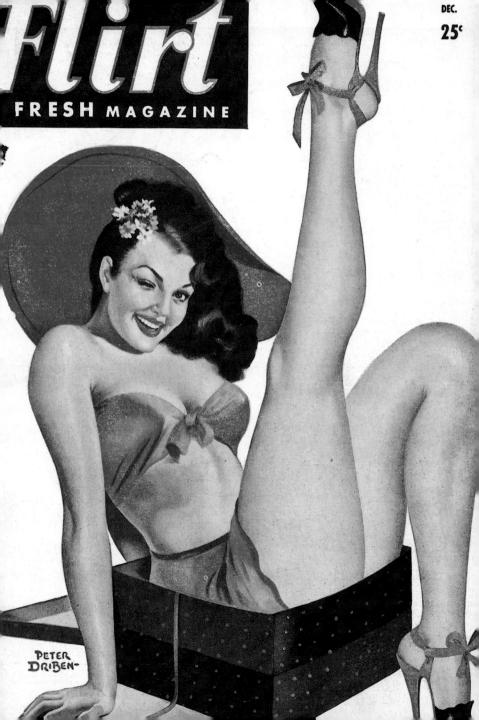

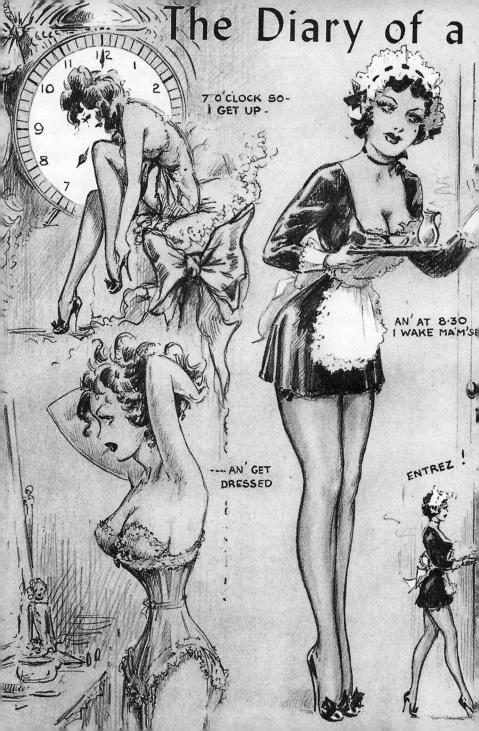

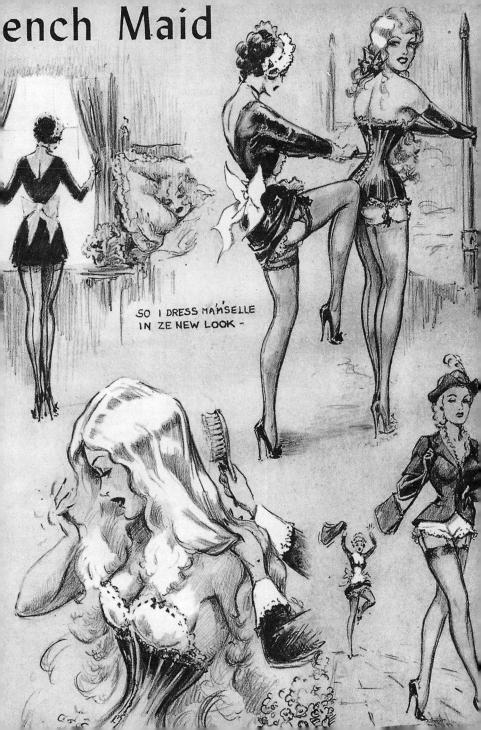

JAN. 25°

GAGS and GALS

> PETER DRIBEN-

FRESH MAGAZINE

WHO SAID BLONDES ARE DUMB Page 18

APR

25

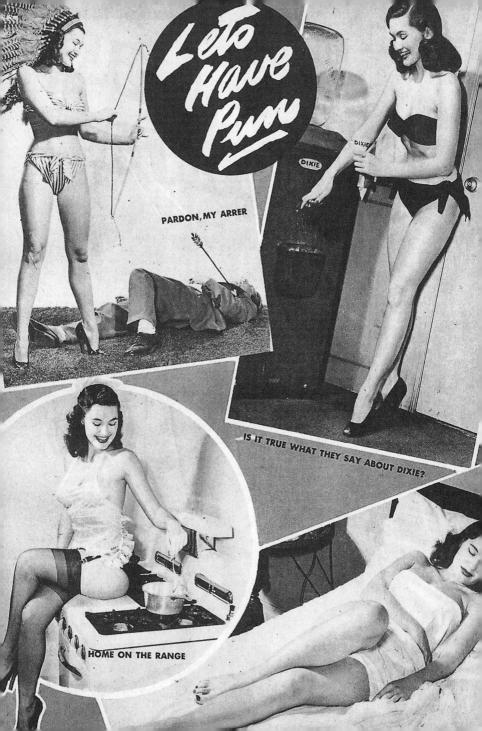

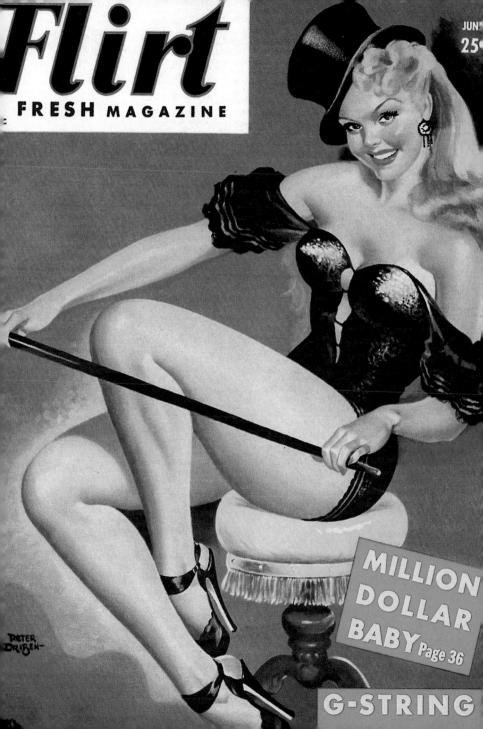

Diary of a French

E

RL

I TAKE TUTU SHOPPING - AN' HADAME INSIST ZAT'E 'AVE A VER' LONG LEASH SO'E CAN RUN AROUN'. AS I 'AVE ZE MANY PARCELS I TIE ZE LEASH TO ZE WRIST SO TUTU CAN'T RUN AWAY -

so-

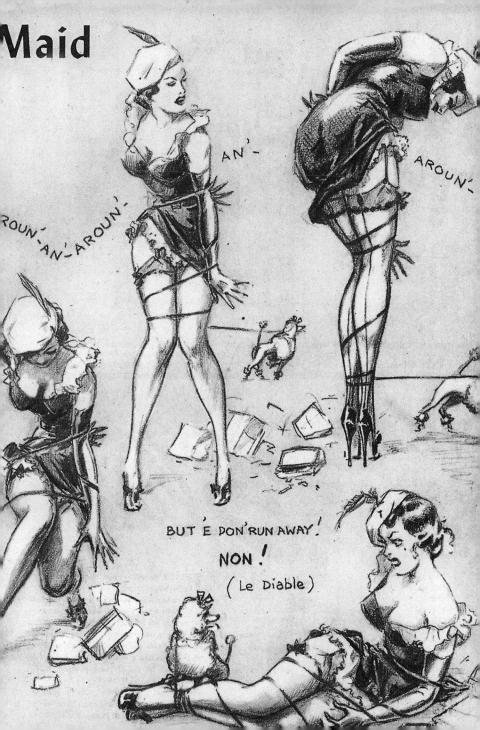

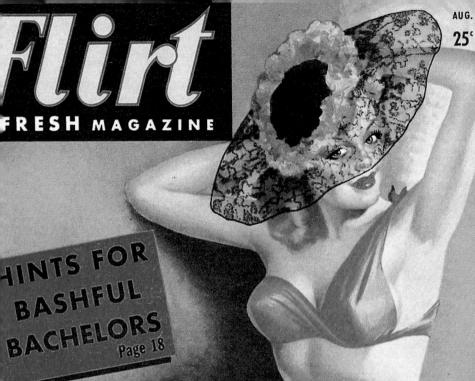

CHOOL for STRIPPERS

It's time to retire, says Christine, and if you guys will just turn your backs, she'll be off to the Land of Nod. To that we say nodding doing!

Retiring Misses

Ready for beddy, these glamorous pajamazons are sure to widem YOUR peepers

FUN AFTER MIDNIGHT

Page 14

WHAT GALS LIKE IN MEN Page 22 。 2

"You like?" Toni asks the boys. There's a lot standing on those tall heels. Toni is said to have the most glamorous figure in Paris. The legs alone are insured for a million francs!

1

PARIS

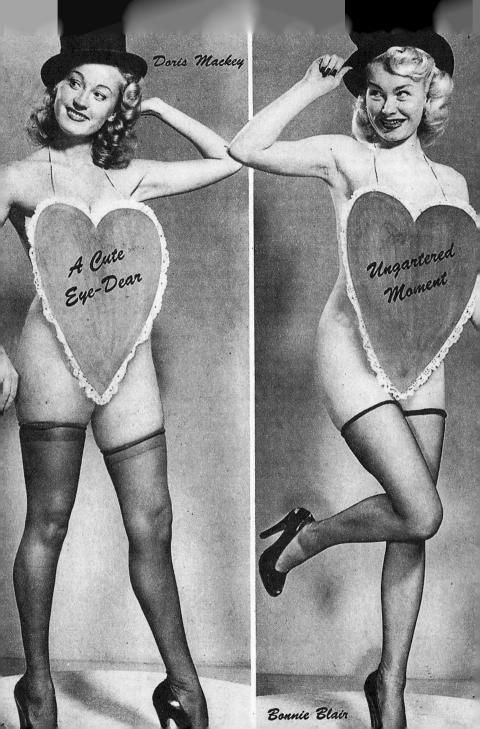

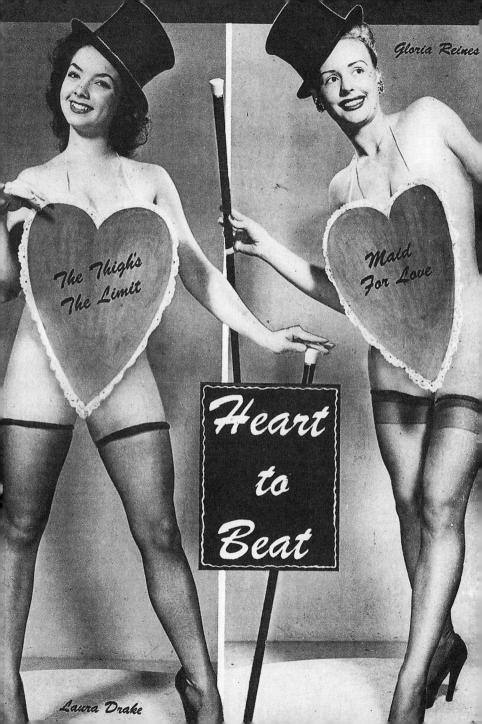

DEC. 25°

EDROOM ASHIONS

WE VIDCIN OF MONTMADTE

ų

FUN IN THE BOUDOIR

FEB. 25°

3

ITA

DANCE OF THE

APR

25

56

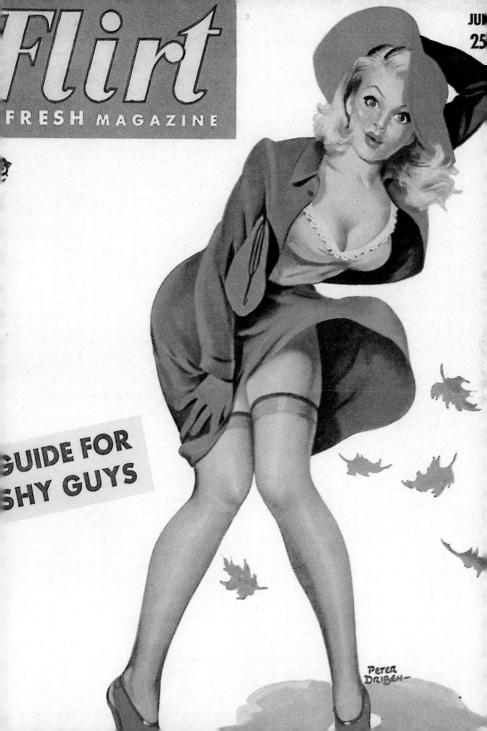

flirt

FRESH MAGAZINE

Euscious Lovely

Hang on to your scalps, gents! Anita Collins is swinging into her Tom Tom Tempo, or Hopi Hop. Swing it, sweet Sioux!

Tom

4

U'UN'S

Tom Tempo

EAD for the stockade, men, the injuns are coming! Heading the war dance is Anita Collins, big chief of Broadway's whoopee wigwams. If this is what our Early Settlers saw, no wonder they decided to stay! It's a wild and whirling stomp like the Blackfeet used to do, only now its strictly Hotfeet. How do you like it, Paleface? Has it got you whooping for more?

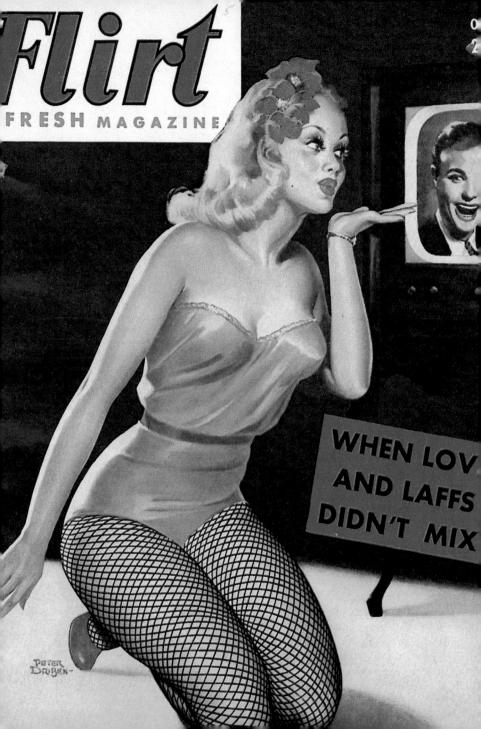

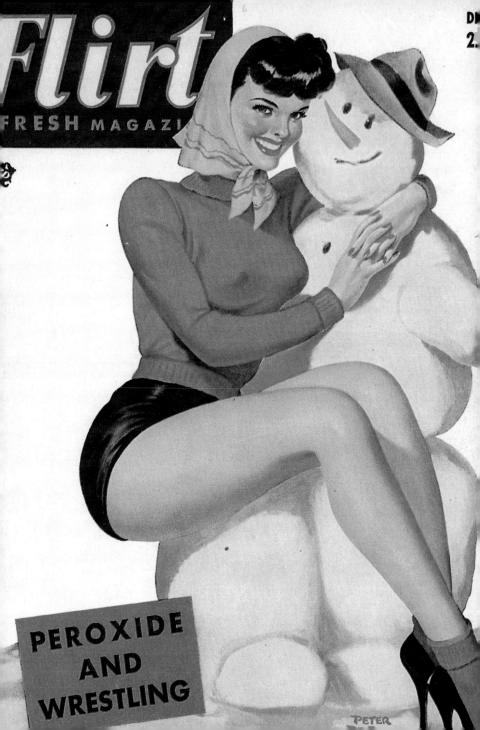

Gregg Sherwood Turns Cartoonist

H, brother, plenty can happen when a lovely showgirl decides to turn cartoonist and offer competition to strips like Lil Abner and things like that. But you certainly can't blame our platinumblande beauty from Wisconsin for trying. A collegebred eyeful, glamorous Gregg always did have a yen for a career in art, only nobody wanted to take Chinese money. So Gregg set up her own studio and what happened to her makes a comic strip in itself. What we wanna know is why Gregg has to worry about pencil lines when her own are so famous already. Betcha all agree, tho, that she's a real art throb!

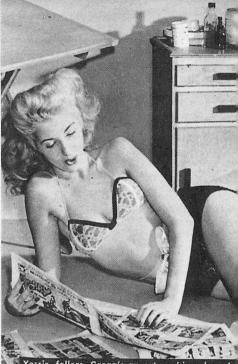

Yessir, fellers, Gregg's an art-working showgir

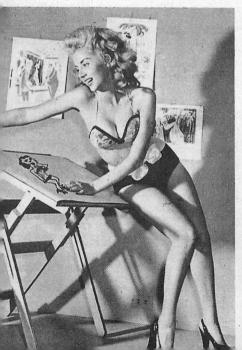

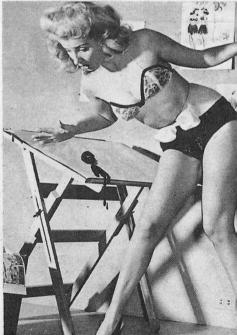

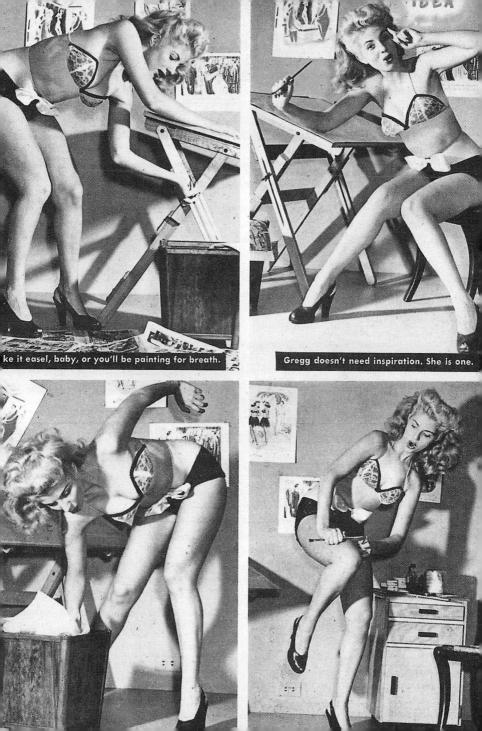

"YOU ARE UNDER ARREST"

There's a Thrill in Bringing a Crook to Justice Through Scientific **CRIME DETECTION!**

We have taught thousands of men and women this exciting, profitable pleasant profession. Let us teach you, too, *in your own home*. Prepare yourself in your leisure time, to fill a responsible, steady, wellpaid position in a very short time and

Be A

Expert

NGFR

at very small cost. What others have done, you, too, can do.

Over 800 of All U. S. Bureaus of Identification Now Employ I. A. S. Trained Men As Heads or Assistants

Here's a Partial List of Them

> Send for FREE Complete list of over 800 Bureaus where our Students or Graduates are now working

State Bureau of Connecticut State Bureau of Ohio State Bureau of Aricone State Bureau of Aricone State Bureau of Treas State Bureau of Treas State Bureau of Treas Key West, Florida Charleston, S. C. Lincoln, Nebraska Portamouth, N. H. Albany, N. Y. Albany, N. H. Albany, Ohio Granite, Ohio

Montgomery, Ala. Phoenix, Arizona Glendale, Calif. Seattle, Washington Madison, Wis, Miami, Florida Leavenworth, Kans. Annapolis, Min. Yicksburg, Miss. Hertford, Conn. San Juan, Poto Rico Ketchikan, Alaska Honolulu, Hawaii

Not Expensive or Difficult to Learn at Home

Scientific Crime Detection is not as simple as it might appear. It's not an occupation at which anyone without training might succeed. It's a science—a real science, which when mastered THROUGH HOME TRAINING gives you something no one can EVER take from you. As long as you live—you should be a trained expert—able to make good in scientific crime detection. "We will teach you Finger Print Identification—Fire-arms Identification— Police Photography—and Criminal Investigation." That's what we told the men who now handle those jobs in Identification Bureaus throughout the nation. And now we repeat, but THIS time it's to YOU... Just give us a chance and we'll train you to fill a good position in the fascinating field of scientific crime detection.

NOW IS THE TIME TO START!

New Bureaus of Identification are being established since the war. Many industrial plants now finger-print all of their employes. Naturally, the need of more Finger Print Experts is evident. Fit yourself now to hold down a fine job as a recognized Expert in Crime Detection. You can learn this fascinating profession in your *own home* and you can pay as you learn.

"BLUE BOOK OF CRIME"

CALCE: It's a thriller, filled from cover to cover with exciting information on scientific crime detection. It tells about some of the most interesting crimes of modern times, and how the criminals were brought to justice through the very methods which you are taught in the I.A.S. course. The book will tell you, too, how at a cost so low you shouldn't even think of it, you can get started on this important training without delay. Don't wait. Clip the coupon and send it along *TODAY*. No salesman will call.

INSTITUTE OF APPLIED SCIENCE (A Correspondence School Since 1916) Dept. 226-D 1920 Sunnyside Ave., Chicago 40, III.

Clip and Mail Coupon Now	
	INSTITUTE OF APPLIED SCIENCE Dept. 226-D 1920 Sunnyside Ave., Chicago 40, III.
	Gentlemen: Without obligation, send me the "Blue Book of Crime," and complete list of Identification Bureaus employing your students or graduates, together with your low prices and Easy Terms Offer. (Literature will be sent ONLY to persons stating their age.)
	Name
	AddressRFD or Zone
	CityStateAge

RESH MAGAZINE

BOXING'S PRETTIEST REFEREE!

FEB.

25(

NIGHTS IN A BARRED ROOM!!!

Jane went to jail — not hers the fault! She beat an egg; they charged assault. She burned the toast; "Arson!" they said. Cheating at solitaire? "Not guilty," she pled.

For "crooked seams" in her nylon gams The prison gate behind her slams. The mean old judge gave her ten days But the guys gave Jane loud hurraysl

Once, playing ball, Jane "stole" a base. Against poor Jane they built a case. She'd like to be some guy's soul-mate But now she's jailed — and no cell-mate!

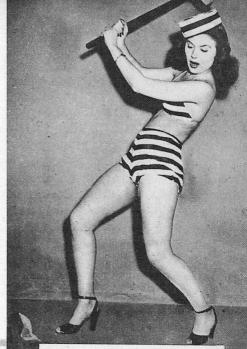

The warden said, "Start breakin" stones! "From those big rocks, make little ones!"

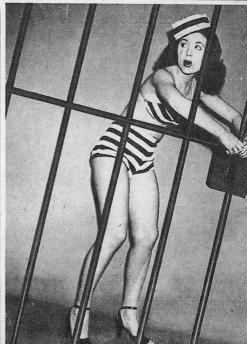

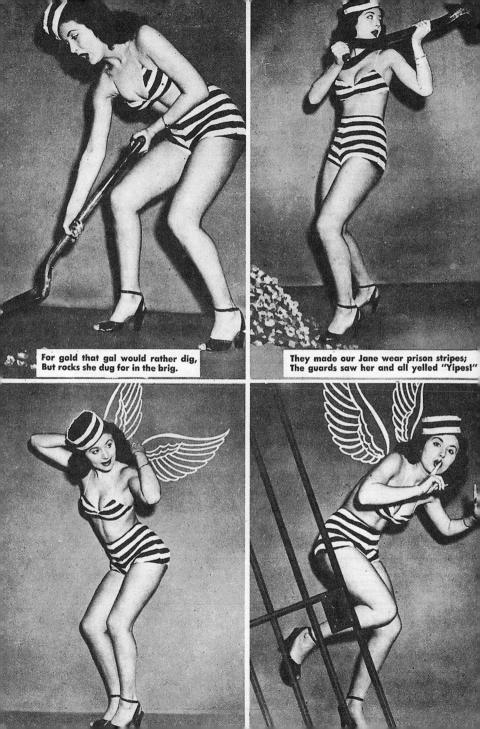

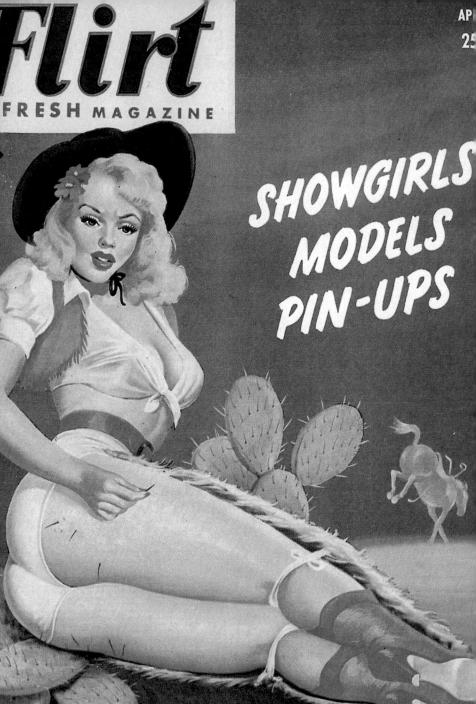

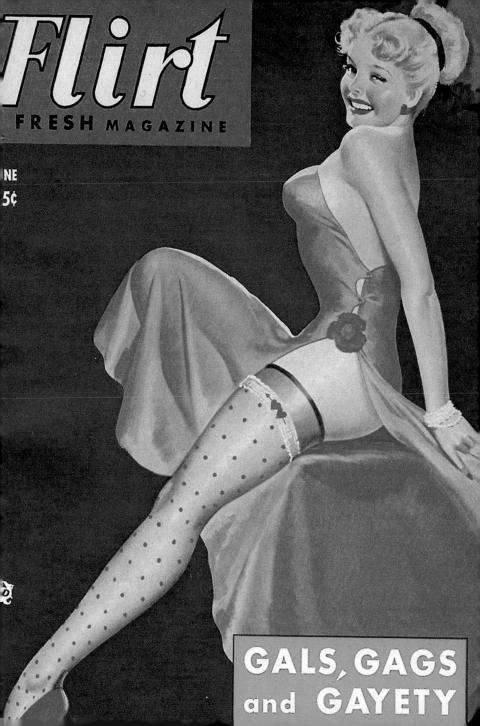

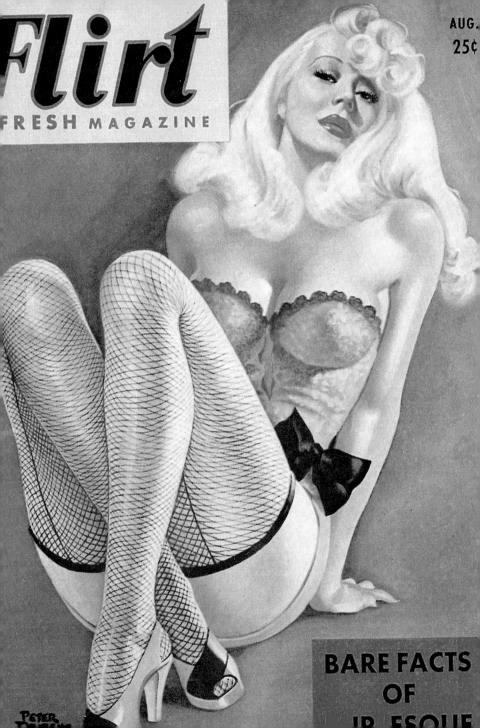

H DAD 3 some n to soone your yes, par, after a tough evening vatchin' TV. This is China Corey, who earns myton money by modeling sweaters in Chicago. China brings to her job a 35%" bust, 25" vaist, 35" hipsand 19% thighs, just for good mensure!

LOVELIFE OF A SHOWGIRL

WOO'EM, WOW'EM

PETER

ост 25

World's Greatest Collection 01 Strange & Secret Photographs

Strange & Secret Photographs Now you can travel round the world with the most daring adventurer. You can see with your own eyes the weidest peoples on earth. You witness the strangest customs of the red, white brown, hale and yollow races. You attend that startling rites, their mysterious practices. They are all assembled for you in these five grant the umes of The SECRET MUSEUM OF MANKIND.

600 LARGE PAGES world's Grates Collection of 1 branchs. Here are Excite Photos of the provide the second photos of the photos of the second photos of the second photos of the photos of the second photos of the second photos of the photos of the second photos of the second photos of the photos of the second photos of the second photos of the photos of the second photos of the second photos of the photos of the second photos of the second photos of the photos of the second photos of the second photos of the photos of the second photos

1000 PHOTOS

rt stories that det

Contents of 5-Volume Set The Secret Album of Africa The Secret Album of Europe The Secret Album of Asia The Secret Album of America The Secret Album of Oceania

5 PICTURE-PACKED VOLUMES

bundreds and hundreds of large and Ci

Specimen Photos

Spectratics - Civilized Love vz. Bavai tes and Culta-Strange Crimes, Crimina otems & Taboon-Mysterious Customs-D a Round the World ,000 Strange and Secret Photos

SEND NO MONEY

sign and mail the coupod, Romember, iss is 91% inches high, and opened. Kemember also that this 50 Volume S \$10. And it is bound in expensive bon't put this off. Fill out the coupon, mail, and receive this buge work at c

The GH COST F LOVIN'

Rint

DE 25 No. 1 on our hip parade is Randi Brown, a browneyed beaut from Boston who's only 19. Neat, eh?

0

Hips 'n' Miss

And here's stunning Kris Nodland givin'

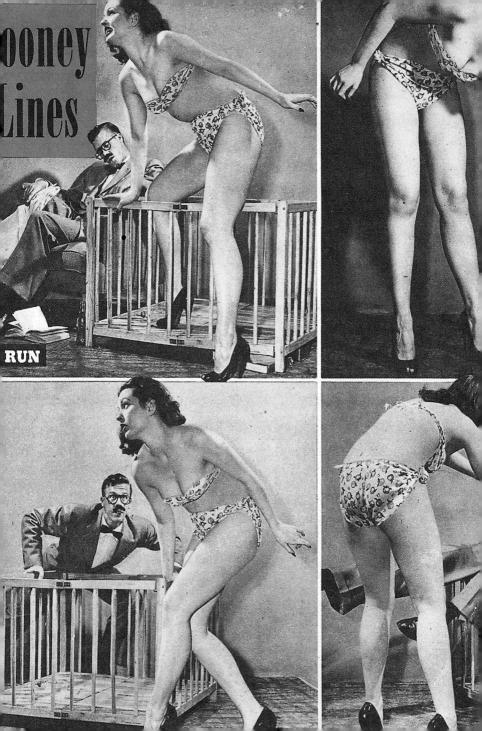

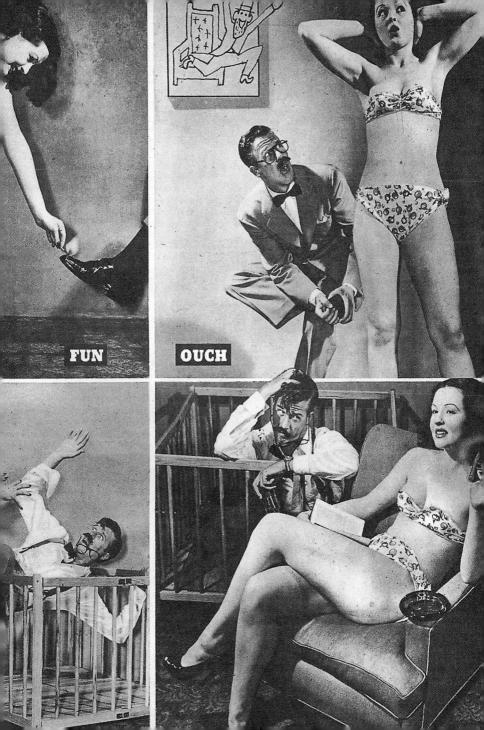

FRESH MAGAZINE

FEI 25

PETER

IN THIS ISSUE:

How to KEEP YOUR HONEY WARM

-

RIL ¢

IN THIS ISSUE:

HEY, Oscar, pull up a chair and jeast your peepers on the curvesome charms of Holly Day. She's a lassie with a classy chassis, an' we can prove it. F'rinstance, Holly's 5'8" from top to tootsies, a neatly packaged 133 lbs. and she's 34" at the bust, 24" waist, and 35" round the hips. Only 19, Holly comes from way down yonder in Arizona, but she's now modeling in Gotham. When it comes to gays, she likes 'em tall, handsome 'n' rugged. Well?

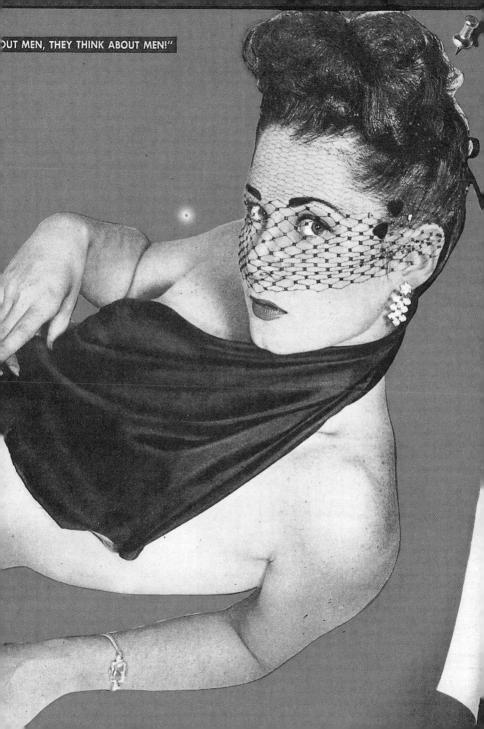

A PEEK IN A PARIS BOUDOIR!

Flir

FRESH MAGAS

N THIS ISSUE:

RESH

MAGAZINE

FATER GIRL

AUGUST

Joan Leeds is prejurred against the wintry blasts. This = doll is 5'7" from toe to top. Ahhhh! Pull a chair close to fiery redhead Kristee Kraft, bub, and thav ⇒→ out. Her glamour gams are 36 inches long!!

Let it snow, Joe. It's June in January when cuddly Dot Dixon turns on that warm smile... Dot has 39-inch hips.

THE BEST PLACES TO SMOOCH

FRESH

M

GAZIN

25

FRESH MAGAZIN

DEC. 25¢

PETER

"COME ON-A MY BOUDOIR!" See Page 24

10

Please Renee! that's no way to act when Marie blows her top!

Ne.

FOREIGN LEGION

TWO DAZZLING DOLLS GET A BANG OUT OF THE CHARGE OF THE HIP BRIGADE!

15

Up 'n at 'em, gals! Renee and Marie show the finest of form as they aim to please!

- de

oke screen wanted for water neuvers! Need help, Babee?

Goin' our way? Weary Legia

Thighs right on the beauty r rade. Comin' down our block

40 MILES

TO BROADW

FE 8 25

THIS ISSUE: IN GETTING **GERTIE'S GIRDLE!**

Tetec

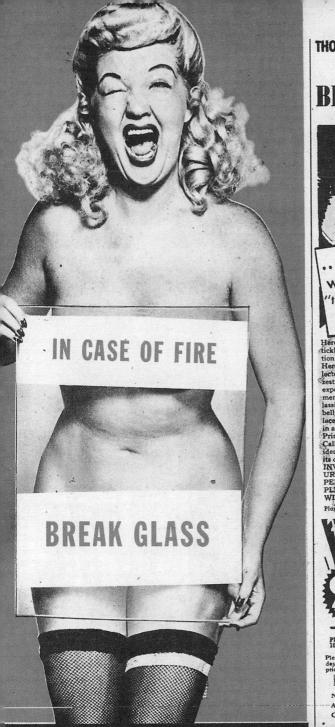

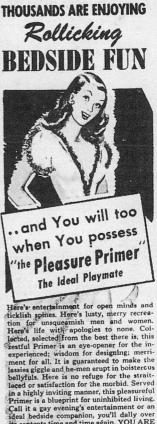

Call it a gay evening's entertainment of all y over its contents time and time again. YOU ARE INVITED TO EXAMINE THE PLEAS-URE PRIMER 10 DAYS AT OUR EX-PENSE OR YOUR PURCHASE PRICE WILL BE REFUNDED AT ONCE! Plans Book Co., 109 Broad SL, New York 4, M.Y.

DON'T MISS Page 24!

IN THIS ISSUE:

APR 25

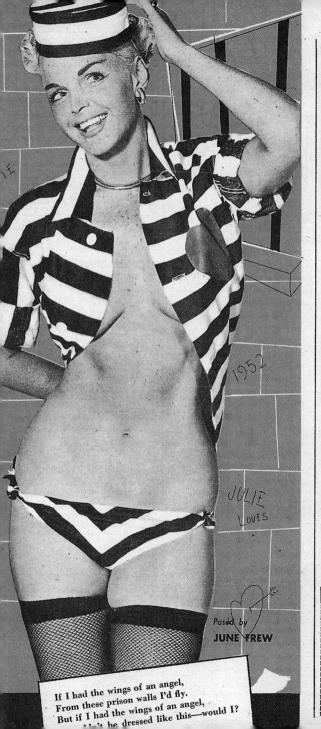

steady good pay as a Finger Print Expert or Investigator. I.A.S. trains you-by easy, study-at-home lessons. Learn this exciting work in your spare time.

NOW IS THE TIME TO START

New Bureaus of Identification are continually being established. Many industrial plants now finger print all their employees. Naturally the need for more Finger Print Experts is evi-dent. Fit yourself now to hold down a fine job as a recognized Expert in Crime Detection.

employ I. A. S. students or graduates, every one of whom learned FINGER PRINT IDENTIFICATION -- FIRE-ARMS IDENTIFICATION, POLICE PHOTOGRAPHY, AND CRIMINAL INVESTIGATION-the economical I. A. S. home-study way!

The same opportunity is open to you. Just give us a chance-we'll train you for a good job in this fascinating work. let's neither expensive nor difficult to learn. Don't delay! Cash in on the constant need for finger print technicians and criminal investigators.

"BLUE BOOK OF CRIME" -

Packed with thrills! Reveals exciting, "behind the scenes" facts of actual criminal cases. Tells how scientific investigators solved them through the same methods you learn at I. A. S. Explains, too, how YOU can get started in this thrilling work at low cost! Don't wait-get your coupon in the mail NOW!

INSTITUTE OF APPLIED SCIENCE (A Correspondence School Since 1916) Dept.2264.1920 Sunnyside Ave., Chicago 40, III.

CLIP AND MAIL COUPON NOW
INSTITUTE OF APPLIED SCIENCE 1920 Sunnyside Ave., Dept. 2264, Chicago 40, 111.
Gentlemen: Without obligation, shend me the "Blue Book of Crime," and list of Identification Bureaus employing your stu- dents or graduates, together with your low prices and Easy Terms Offer. (Liter- ature will be sent ONLY to persons stat- ing their age.) No salesman will call.
Name
AddressRFD or Zone
CityAge

VIES of AUTIES

JUNI 25

Flint

RESH MAGAZINE

SUST 5¢

GH-HEEL CUTIES

Steffa

GAGS and GAYETY

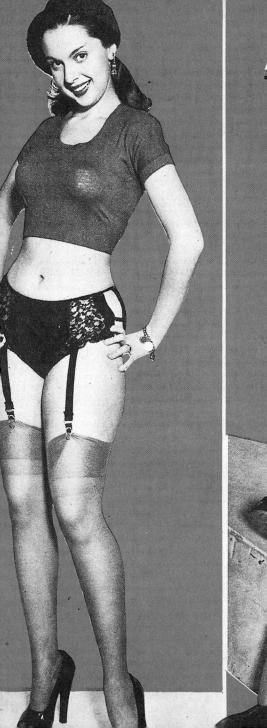

And She Can

INDA LAWRENCE. CURVY CHORUS CHICK, SAYS, "HEAVEN WILL PROTECT

-Catan area

We'd go a long distan to sneak a peek at lo haired stren Gene Ba Her hips are 36", 'n' i waist is only 24"! Wo

įĈ

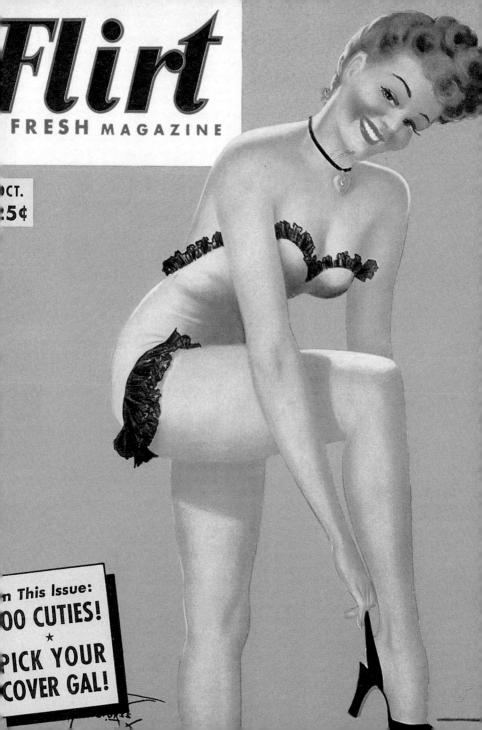

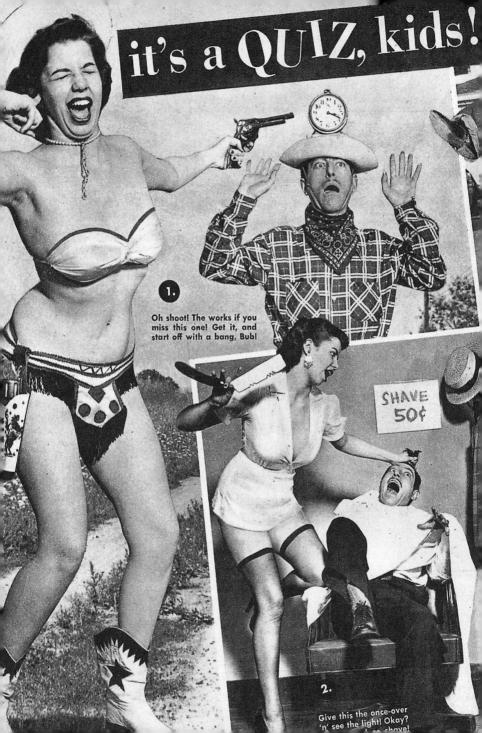

Stir your brains and figure this or you'll go crazy! You crazy?

This burn sure wishes the doll could steer! It's burn information!

> Her name is Kitty, the catl He's about to feed herl If you play poker, it's easyl

EACH PICTURE REPRESENTS A SLANG TERM! FIGURE 'EM OUT WITHOUT PEEK-IN' AT THE ANSWERS, FELLERS!

3.

Alswers: 2. Once over lightly. 3. Once over lightly. 4. Feed the kitty! 4. Feed the kitty! 5. Shir crazy! Alswers: Alsw

DEC. 25c

This Tosue WHAT IS YOUR EYE-Q?

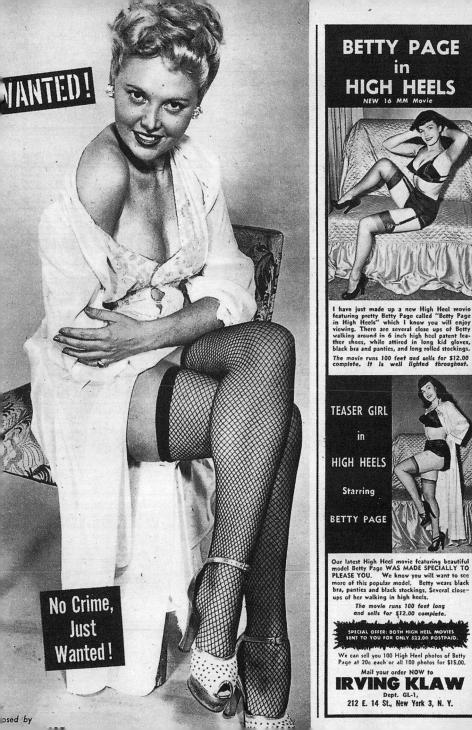

RESH MAGAZINE

lir

WHO SAID BLONDES ARE DUMB Page 18

FEB. 25¢

Exciting...bewitching bra with daring peek-thru lace and matching sheer black rayon panty. They'll cling to her every curve. She'll tease and tantalize . . . you'll love her in it! In Bewitching Black Sizes 32-38

Only \$5.95

La-De-I **Naughty French Negligee**

> She'll thrill you ... Sheer, shimmering rayon . . . French-style negligee. So revealing ... soft lace peplum swings with her every movement. WATCH the dipping dare neckline. LA-DE-DA! In bewitching BLACK, only

> > sizes 32-40 \$9.95 sizes 42-48 \$11.95

IF NOT SATISFIED RETURN IN 10 DAYS AND YOUR MONEY WILL BE REFUNDED.

GUA RA N

GAN-CAN **Naughty French** Chemise

Revealing, peek-a-boo lace . with a saucy slit at the hip' .. a daring dip at the neck. She'll wear it with or without shoulder straps. Oo-la-la! So Frenchy!

Colors: Bewitching Black and Angel White

> Sizes 32-40 only \$7.95 \$9.95 Sizes 42-48 In Black Only

French style Nightie

Sheer witchery ... Peek-a-boo lace reveals all her charms . . . clinging sheer black rayon caresses her every curve ... and one shoulder strap holds everything! You'll love her in it!

> In Bewitching Black Sizes 32-40 only

mba Sheer Black Nightie

She'll be thrilling, alluring, when she wears sheer, shocking rhumba. A brief clinging top stops short revealing her bare midriff ... exciting ... enticing ... sheer, silky rayon skirt clings, caresses her every curve. In Black Only

Sizes 32-38 only \$7.95

SATISFAC TION FENWAY FASHIONS **DEPT. 531** 303 Fifth Ave., New York 16, N.Y.

Please send me the following:

SENT IN PLAIN WRAPPER

Style	Color	Size	Price			
LA DE DA	The second		\$9.95	Sizes	42-48	\$11.95
TANGO			5.95			
CAN CAN			7.95	Sizes	42-48	\$9,95
TEMPTRESS	and the second		9.95			
RHUMBA			7.95			
Amount enclose Send C.O.D. 1 v				fees.		
NAME						
ADDRESS						
CITY			STATE			

Admiring males pop their peepers as Bettie fights against the naughty wind!

OH.

ottie Page starts out r a walk, and her skirt caught in the breezel

Life Is Like That!

A SKIRT TOSSED BY A NAUGHTY BREEZE ATTRACTS MORE EYES THAN A BIKINI!

Whatever will the poor girl do? Well, the audience ain't kicking!

Ahal Bettie has an idea, and sneaks into a store!

- Cayl

So, she buys a Bikini, and all the dopes pass her byl Such is Life!

VER GO to the beach, and after the first admiring look around at the Bikini-clad beauties, go about your business and read a paper? Bet you have! But, let a naughty Spring breeze lift a skirt and your eyes pop out! Life is like that, and the short And the

Bewies of HIGH-HEEL BEAUTIES

Billy De

APR. 25¢

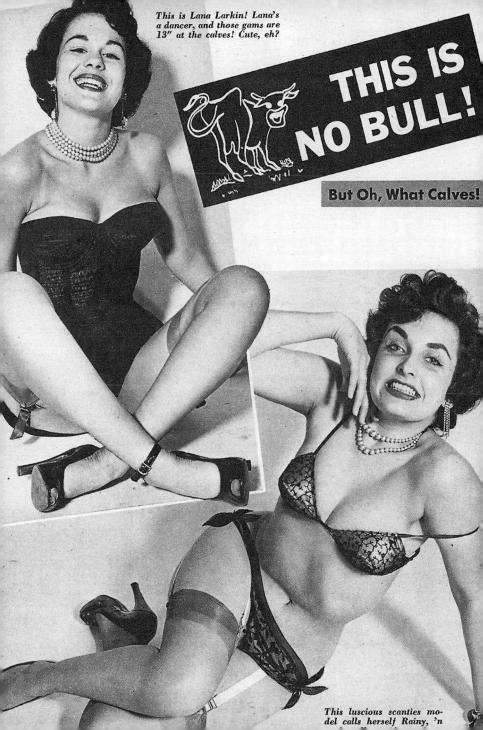

BEST BETS

OF THE BROADWAY

PETS

Flirt

JUN 25

NITINA - FDANAI

Bare Facts YOU OUGHTA KNOW!

3

DRIBEN

AU 25

WHY GUYS Go To Paris!

0c 2!

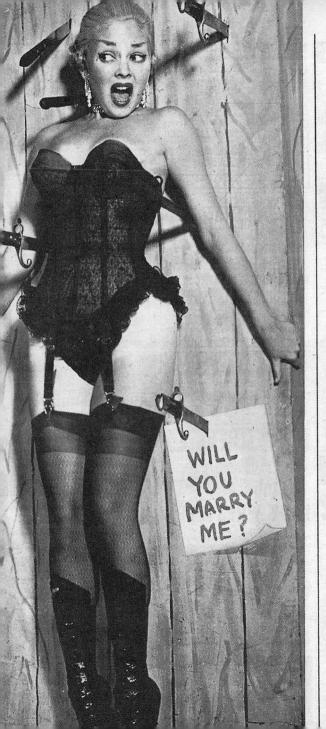

"NOW I'M THE BOSS"

Efriam Weber, Former Foundry Worker, Wins Success as a Skilled

Custom UPHOLSTERER

"Some difference between being the boss in my own successful upholstery shop and my old job as moulder in a foundry. No more dusty, heavy work for me. In every way my family and I are 100"; better off, thanks to UTS."

WHAT DO YOU WANT? Your Own Business?---Substantial Sparetime Earnings?-A Steady Job?-A Profitable Homecraft?

They're All Waiting for You in the Big-Opportunity Field of CUSTOM UPHOLSTERY

Right AT HOME in your sparetime, you can do what Erriam Weber and hundreds of other UTS graduates have done-casily-enjoyably-PROF-ITABLY. The fact is ... There's a growing, thele and box walling everywhere. Or, if you're tired of working for Bosses-sick of worrying about money, layoffs and slack seasons-then cus-tom furniture upholstery offers you a golden op-partunity to build a builance stat home, open your owne and earn a comfortable living all year round. EARN WHILE YOU LEARN

Best of all you can earn good money in your sparetime at the same fime that you learn this fascinating trade.

YOU MAKE SLIPPER CHAIR CLUB CHAIR

At last the pretchall for the Work At last the pretchall for the Work statistical for the statistical for the you issue that the same the tools consider frames, the same materials to make beautiful cut-tools, complete frames, the same materials to make beautiful cut-ship costs work over 1239 you can sell or use yourself; a lesson they to Statist Kear Own Uphol-Supply Service.

YOU LEARN BY DOING

TOULLEARN BY DOING PLUS SUP COVERS SUP COVERS TOURS to keep for sell Fasting and the support or sell support for sell support for support

Big Illustrated FREE Book Gives Full Details

Our FREE book. "Your New Way to a Successful Ca-reer," tells how you learn all about this ever-growing trade at home and the many men and women who are finding happiness and success the UTS way-No need to leave your bot ill you're ready for a new big pay, big profit coportunity. Training in New York School anso available. WRITE TODAY.

Unholstery CR-8305. 3. N. Y.	Trades 721 Broad	School, way, New	Dept. York		
MAIL	COUPO	N TOD	YAQ		
	LSTERY -8305, 121				I. T.
	FREE bool		N. Y. 8	hool Trai	ining
Name	•••••				
Address.		·····		······	
cuy	Check	here if Ke			

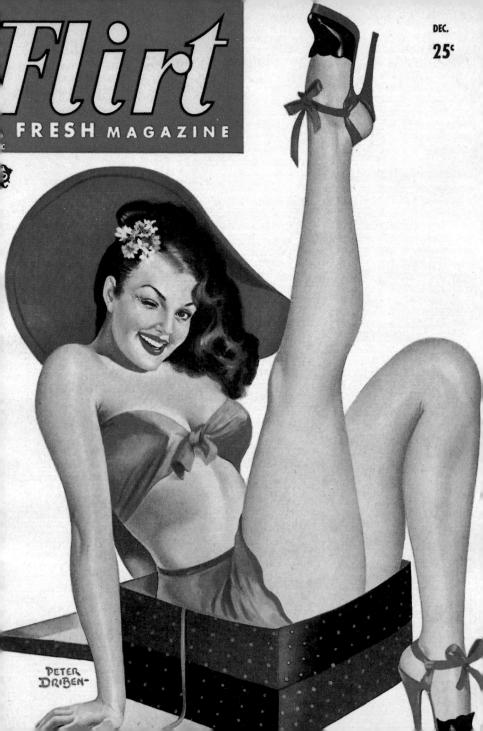

AMAZING "OLD WORLD DOPE" MAKES FISH BITE EVERY DAY

Catch your limit every day, "Century-Old" Romany formula for all fresh and salt water fishermen. Worms or minnows-live or artificial bait, doped with GYPSY Fish Bait Oil throws off an irresistible odor which attracts fish like magic.

anteed. Only \$1.00, 3 for \$2.00, 5.00 for GYPSY Fish Bait Oil from:

FISHERMANS PRODUCTS CO. Dept. 322W 2832 Niazuma Ave. Birmingham, Alabama

5- TODAY FOR BOOKLET IN TOTATO

Dept. 74-T. PROVIDENCE 15. R. I.

MAHLER'S. INC.

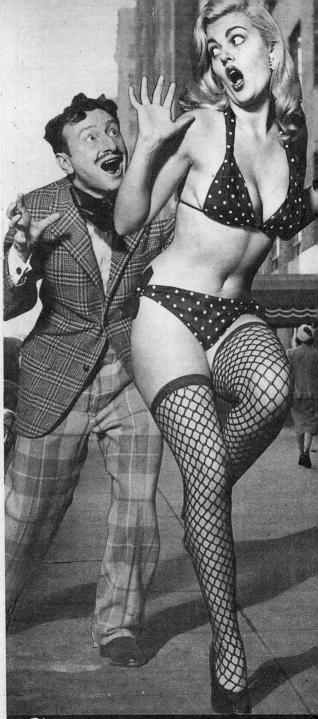

She "Do you think of me when you're away darling

WHERE BE A SPORT. FIGL Meet Bettie Page, artist model! Is she Irish, or maybe French? Nope! She hails from Tennessee, suh?

> This is Jane Russ. Her bust and hips measure a perfect 36". Where's she from? Jane's a Londoner.

THEY FROM?

UT WHAT COUNTRY GAVE US THESE FIGURES!

Chorus gal Robin Adayre could be a Scotch lassie, but actually this 116 lb. siren is an Ooh, La, La, from naughty Paris, boy!

Dwight Daring, peeler and exotic dancer, hails from Covenhagen. Denmark! She

BETTY PAGE DANCE MOVIE! "Joyful Dance by Betty

Once again beautiful model Betty Page gives a sterling dance performance in her latest 16mm movie called "Joyful Dance by Betty". In this new movie Betty dances with abandon and you will enjoy Betty's motions and facial expressions while dancing. The movie runs 100 feet in length and is well lighted with several close-ups of Betty, and sells for \$12.00 complete in 16 mm size and only \$8.00 in 8 mm size complete.

Betty is attired in Bra and Pantie outfit and rolled stockings and wearing 6 inch High Heel Shoes of Patent Leather.

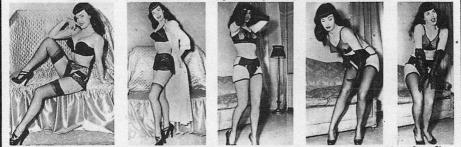

IRVING KLAW Dept. 59 212 East 14th St., New York 3, N. Y. Scenes from Movie - "Joyful Dance by Betty" starring Betty Page. There are 11 different photos of Betty taken to illustrate movie at 25c each. All 11 photos for \$2.20

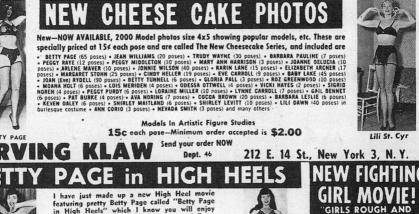

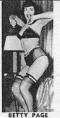

I have just made up a new High Heel movie featuring pretty Betty Page called "Betty Page in High Heels" which I know you will enjoy viewing. There are several close ups of Betty walking around in 6 inch high heel patent leather shoes, while attired in long kid gloves, black bra and panties, and long rolled stockings.

Our latest High Heel movie featuring beautiful model Betty Page WAS MADE SPECIALLY TO

RETTY PAGE

PLEASE YOU. We know you will want to see more of this popular model. Betty wears black bra, panties and black stockings. Several closeups of her walking in high heels.

Dies, partites and Diack stockings, Several closeups of her walking in high heels. This movie runs 100 feet long and sells for \$12.00-complete in 16 mm size or \$8.00 in 8 mm size. 1066 DISCOUNT ON ORDERS OF \$30.00 RM movies of Betty Page at \$12.00 each Also evaluable are the following 100 fr. exoits. flictatious bance by Betty-Peppy Graceful Dance-Dance of Pasion-Betty's Exolic Dance-Whip Dance-Spanish Shawl Dance-Tambaurine Dance in High Heels-Chemise Dance.

Dept. 212 E. 14 St., New York 3, N.Y. NG KLAV

I can now supply you with an excellent fiphing and wratling pirl 16 mm silent movie called 'GRIS. SOUCH AND TUM-BLE FICHT''. This movie features gor-geous blonde model Joan. (Eve) Rydel fiphing, wrestling and roughing up model Cacoo Brown in an action-packed rough and lumble fiphit that will keep movie comes in 2 ports of approx. Too feet each part and sells for 31500 such part or 325.00 for the complete movie of approx. 200 feet in 16 mm size or 58.00 is 8 mm size each part. The action is te-rific finoughout this movie which never slops unit up, you have seen in a long while.

TUMBLE FIGHT

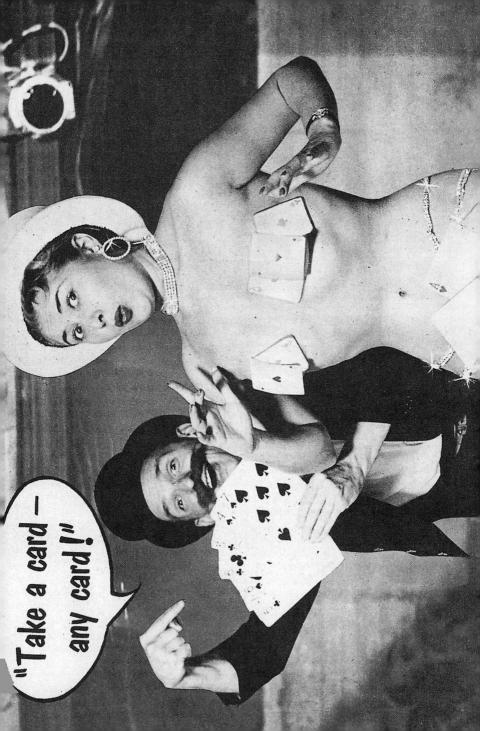

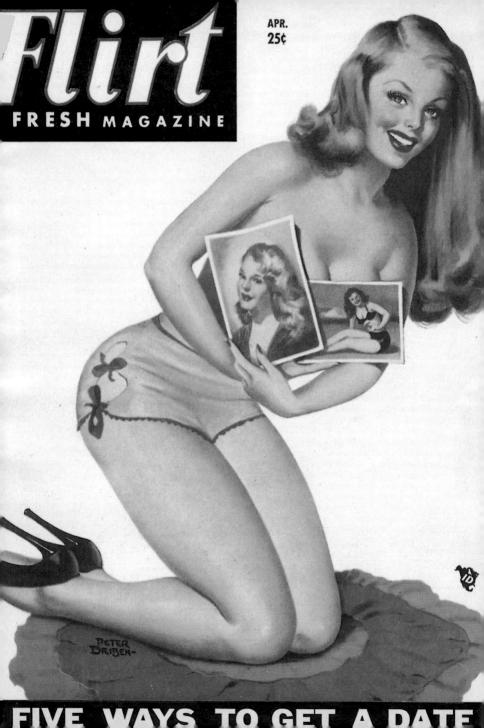

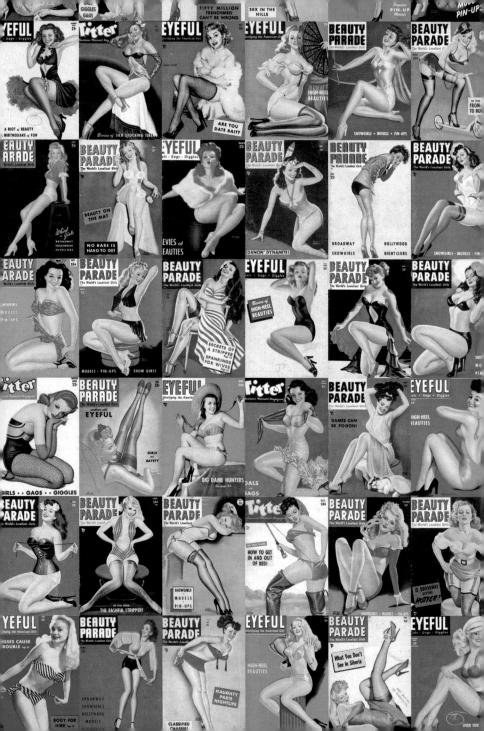

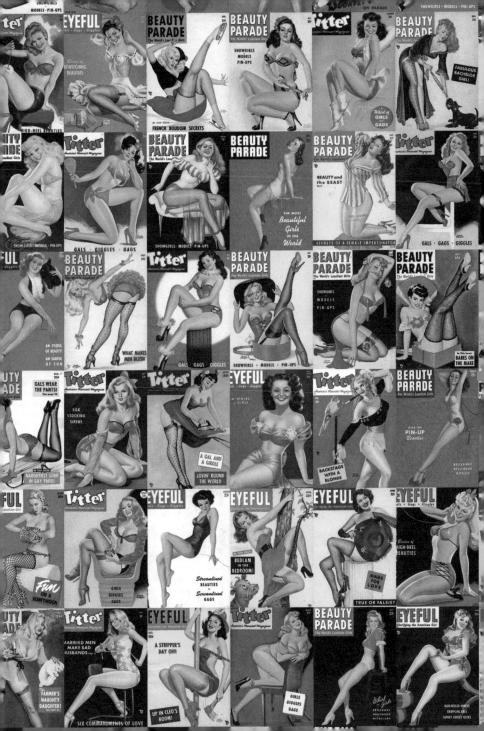